Hilliard and Oliver

*The lives
and works
of two
great
miniaturists*

by

MARY EDMOND

ROBERT HALE
LONDON

Copyright © Mary Edmond 1983
First published in Great Britain 1983

ISBN 0 7090 0927 5

Robert Hale Limited
Clerkenwell House
Clerkenwell Green
London EC1R 0HT

Photoset in Horley Old Style by
Kelly Typesetting Limited
Bradford-on-Avon, Wiltshire
Printed in Great Britain by
St Edmundsbury Press
Bury St Edmunds, Suffolk
Bound by Woolnough Bookbinding Limited

Old Mr Hilliard, Mr Isaac Oliver inferior to none in Christendom for the countenance in small.

Henry Peacham, 1612

Limning . . . is a thing apart from all other painting or drawing . . . and it excelleth all other painting whatsoever in sundry points.

Nicholas Hilliard, c. 1600

Preface

Whether or not we are aware of it, much of our knowledge of what leading men and women in Elizabethan and Jacobean England actually looked like derives from the work of two brilliant portrait-miniaturists (or *limners*, as they were then called): a west-country Englishman, Nicholas Hilliard, and Isaac Oliver, born in France but brought to London as a child when his parents came over as Protestant refugees. Hilliard was nearly twenty years older than Oliver, who studied under him in youth before becoming his formidable rival at Court and in society. An exhibition of miniatures by the two men was organized at the Victoria and Albert Museum in 1947, the four-hundredth anniversary of Hilliard's birth: publication of this book coincides with the second major exhibition on the same subject, being held at the Museum in 1983.

The artists' works have always been highly prized, so much so that they rarely come on the market: when a miniature for which Hilliard probably received about £3 in 1574 was put up for sale by the sitter's family in 1980, it realized the record sum of £75,000. Yet until now there has been but one book about Hilliard, published in 1961 by Erna Auerbach, and none on Oliver – although I have been able to draw upon the fruits of research made public in and since 1947, notably by Noel Blakiston, Graham Reynolds, Sir Roy Strong and Jim Murrell. In addition, I have quoted extensively from Hilliard's own *Treatise concerning the Arte of Limning* as newly edited by R. K. R. Thornton and T. G. S. Cain of the University of Newcastle-upon-Tyne.

Art historians, when writing on their chosen subjects, naturally concentrate on them as artists: the fact that they were also sentient beings belonging to particular societies at particular periods of history is sometimes obscured. By way of much original research among the vast quantities of manuscript records surviving in England, I have sought to relate the lives of Hilliard and Oliver to those of their contemporaries –

poets and playwrights (Oliver and Shakespeare were almost exactly of an age), courtiers, lawyers, City dignitaries, explorers and merchant venturers. Some of the artists' sitters are newly identified, or plausible identities suggested; and in the case of some dated miniatures of prominent people, the dates are related to events in their lives which probably occasioned the commissioning of the works. Much-debated problems set by such works as Hilliard's *Young Man among Roses* are debated afresh; and I have re-examined important documents which have been repeatedly misquoted in the past, on the mistaken assumption that printed summaries of them are complete transcriptions: this applies in particular to State Papers at the Public Record Office and to collections reported on by the Historical Manuscripts Commission.

The characters and patterns of life of Hilliard and Oliver seem to have been very different. The Englishman emerges as charming, impulsive, self-confident, somewhat arrogant – and his name crops up, probably quite innocently, in connexion with secret agents, Catholic recusants, plots against the Queen's life and the Overbury murder; while 'Monsieur Isaac', as he was called at Court, seems to have been prudent, well-organized and circumspect. Hilliard's father-in-law became Chamberlain – in effect, chief executive – of the City of London, the Hilliard family lived for years in the heart of the City, and the artist's son and fellow-miniaturist, Laurence, married into the City merchant class; all the evidence about Oliver, on the other hand, indicates that he, and his miniaturist son Peter, remained determinedly within the immigrant community, and they lived on the edge of the City in Blackfriars, a precinct providing special privileges for foreigners.

Anyone doing original research owes innumerable debts of gratitude, most of which have to remain unacknowledged. I must, however, mention Miss Susan Hare, Librarian of the Worshipful Company of Goldsmiths, for allowing me frequent access to their splendid manuscript records which provide so much information about Hilliard, members of his family and professional colleagues, and for her expert advice; also Miss Betty Masters, Deputy Keeper at the Corporation of London Records Office, for access to and advice on manuscripts relating to the governance of the City; and, for the City generally, the staff of Guildhall Library. Sir Robert Cecil, later first Earl of Salisbury, was Hilliard's principal patron, and I have had valuable advice and help from Mr Robin Harcourt Williams, Librarian and Archivist to the present Marquess. In particular, it is a pleasure to have been allowed to reproduce, for the first time, one of Hilliard's six surviving letters to Robert Cecil, an outstandingly beautiful example of the work of the artist as

calligrapher. Miss Janet Arnold, and Mr O. P. Moss of Exmouth, helped me with the identification of an Oliver and a Hilliard sitter respectively, and Mr Beric Lloyd generously reported his discovery of a will relating to the young Isaac Oliver. I owe warm thanks to the Duke of Buccleuch for a memorable afternoon spent studying his collection of miniatures at Bowhill; and Mr John Murdoch and Miss Anne Buddle helped me to secure illustrations for the book.

Finally, I am ever mindful of our unknown forebears who wrote the manuscripts without which research would be impossible; of all those who cared for them over the centuries, and rescued them from the flames of 1666, the bombs of the 1940s and other unpublicized disasters; and of the staffs of repositories great and small, in London and elsewhere in England, who carry on the work today.

M.E.

NOTE

For the convenience of the reader, I have modernized the spellings in quotations from sixteenth- and seventeenth-century texts, and added some punctuation. A great many of the quotations are from Hilliard's *Treatise* on limning, and there would have been no virtue in preserving the original spellings, which are not necessarily his own, since the text of the work survives only in a single transcript written shortly after the artist's death.

Contents

	List of Illustrations	13
1	The Miniature	19
2	Young Hilliard	25
3	Hilliard's Early Career: 1570–76	37
4	A Scottish Adventure	54
5	The Hilliards in France: 1576–78	59
6	Hilliard Back in London: 1578–87	69
7	The Limners, the Poets and the Courtiers: the 1580s	81
8	Family Matters: the First Mrs Oliver and the First Mrs Hilliard	97
9	Professional Matters in the 1590s: Oliver Rivals Hilliard	110
10	Hilliard's Home	126
11	The End of the Elizabethan Age	132
12	The Jacobean Age Begins: 1603–12	142
13	More Family Matters: Isaac Oliver and the Court Musicians, Laurence Hilliard and the City Merchants	159
14	The Last Years: 1612–19	169
15	The Lines Extinguished	182
	Abbreviations	191
	Notes	192
	Select List of Sources	217
	Index	223

List of Illustrations

All works reproduced are miniatures, and shown actual size, except where otherwise stated. All measurements in inches.

Colour plates

Facing page

1. Self-portrait miniature by Nicholas Hilliard, aged 30
 in 1577: 1⁵/₈ diameter, inscribed with age and year 64
 Crown Copyright, Victoria and Albert Museum
2. Richard Hilliard, father of the artist, aged 58 in 1577: by
 Nicholas Hilliard: 1⁵/₈ diameter, inscribed with age and year 64
 Crown Copyright, Victoria and Albert Museum
3. Alice Hilliard, *née* Brandon, wife of the artist, aged 22 in
 1578: by Nicholas Hilliard: 2³/₈ diameter, inscribed
 with age and year (also shown enlarged) 64
 Crown Copyright, Victoria and Albert Museum
4. Unknown man, aged 24 in 1572: by Nicholas Hilliard:
 2³/₈ × 1⁷/₈, inscribed with age and year 65
 Crown Copyright, Victoria and Albert Museum
5. Young Man among Roses: by Nicholas Hilliard:
 5³/₈ × 2³/₄, inscribed *'Dat poenas laudata fides'* 65
 Crown Copyright, Victoria and Albert Museum
6. Robert Devereux, 2nd Earl of Essex: by Isaac Oliver: 2 × 1⁵/₈ 80
 Reproduced by gracious permission of Her Majesty The Queen
7. Unknown man, aged 27 in 1590: by Isaac Oliver:
 2¹/₈ × 1³/₄, inscribed with age and year 80
 Crown Copyright, Victoria and Albert Museum
8. Henry Wriothesley, 3rd Earl of Southampton, aged 20 in
 1594: by Nicholas Hilliard: 1⁵/₈ × 1¹/₄, inscribed with age
 and year 80
 Reproduced by permission of the Syndics of the Fitzwilliam
 Museum, Cambridge

Facing page

9. Self-portrait miniature by Isaac Oliver, aged about 30: $2^1/_2 \times 2$
 National Portrait Gallery, London 81

10. Girl holding apple, aged 4 in 1590: by Isaac Oliver:
 $2^1/_8 \times 1^5/_8$, inscribed with age and year 81
 Crown Copyright, Victoria and Albert Museum

11. Girl holding carnation, aged 5 in 1590: by Isaac Oliver:
 $2^1/_8 \times 1^3/_4$, inscribed with age and year 81
 Crown Copyright, Victoria and Albert Museum

Between pages 152 and 153

12. Unknown man, called 'Sir Philip Sidney': by Isaac Oliver:
 $4^5/_8 \times 3^1/_4$
 Reproduced by gracious permission of Her Majesty The Queen

13. Lady, called 'Frances Howard, Countess of Essex and Somerset':
 by Isaac Oliver: 5 diameter
 Crown Copyright, Victoria and Albert Museum

14. Queen Elizabeth I, unfinished: by Isaac Oliver: $2^3/_8 \times 2^1/_8$
 Crown Copyright, Victoria and Albert Museum

15. Queen Elizabeth I: by Nicholas Hilliard: $2^5/_8 \times 2^1/_8$
 Crown Copyright, Victoria and Albert Museum

16. Unknown lady: by Nicholas Hilliard: $2^7/_8 \times 2^1/_8$
 Reproduced by permission of the Syndics of the Fitzwilliam
 Museum, Cambridge

17. Lady, called 'Mrs Holland', aged 26 in 1593: by Nicholas Hilliard:
 $2^3/_8 \times 2$, inscribed with age and year
 Crown Copyright, Victoria and Albert Museum

18. Lady in masque costume: by Isaac Oliver: $2^1/_2 \times 2$
 Crown Copyright, Victoria and Albert Museum

19. Head of Christ: by Isaac Oliver: $2 \times 1^5/_8$
 Crown Copyright, Victoria and Albert Museum

Black and White plates

Between pages 24 and 25

1. Mary Cornwallis: attributed to George Gower: portrait, oil on
 panel, 46×37
 City of Manchester Art Galleries

2. Mary Fitton, Maid of Honour: artist unknown: portrait, oil on
 canvas, 43×34
 F. H. M. FitzRoy Newdegate

3. Man against a background of flames: by Nicholas Hilliard: $2^5/8 \times 2$
 Crown Copyright, Victoria and Albert Museum

4. Thomas Bodley, aged 54 in 1598: by Nicholas Hilliard: $2 \times 1^5/8$, inscribed with age and year
 The Bodleian Library, Oxford

5. Sir Francis Knollys the younger, aged 29 in 1585: by Nicholas Hilliard: $2 \times 1^3/4$, inscribed with age and year
 The Duke of Buccleuch and Queensberry

6. Queen Elizabeth I, aged 38 in 1572: by Nicholas Hilliard: $2 \times 1^7/8$, inscribed with age and year and 'ER'
 National Portrait Gallery, London

7. Jane Boughton, *née* Coningsby, aged 21 in 1574: by Nicholas Hilliard: $1^3/4$ diameter, inscribed with age and year
 Sotheby Parke Bernet & Co

8. Robert Dudley, Earl of Leicester, aged 44 in 1576: by Nicholas Hilliard: $1^3/4$ diameter, inscribed with age and year
 National Portrait Gallery, London

9. François de Valois, Duc d'Alençon: by Nicholas Hilliard: $1^3/4 \times 1^1/4$
 Kunsthistorisches Museum, Vienna

10. Self-portrait miniature by Nicholas Hilliard, aged 30 in 1577: enlargement (Colour plate 1 shows actual size)
 Crown Copyright, Victoria and Albert Museum

11. Sir Francis Drake, aged 42 in 1581: By Nicholas Hilliard: $1^1/4$ diameter, inscribed with age and year
 National Portrait Gallery, London

12. Francis Bacon, aged 18 in 1578: by Nicholas Hilliard: $1^1/4 \times 1$, inscribed with age, year and '*Si tabula daretur digna Animum mallem*'
 The Duke of Rutland

13. Sir Walter Ralegh: by Nicholas Hilliard: $1^7/8 \times 1^5/8$
 National Portrait Gallery, London

14. Sir Charles Blount, later Earl of Devonshire, in 1587: by Nicholas Hilliard: $2 \times 1^1/2$, dated and inscribed '*Amor amoris premium*'
 Sir John Carew Pole, Bart.

Between pages 88 and 89

15. Colonel Diederik Sonoy, aged 59 in 1588: by Isaac Oliver: $2^5/8 \times 2^1/8$, inscribed '*Sonder erch Verhouue*'
 Her Royal Highness, Princess Juliana of the Netherlands

16. Unknown man, aged 71 in 1588: by Isaac Oliver: $2^{1}/4 \times 1^{3}/4$, inscribed with age and year
Ashmolean Museum, Oxford
17. Youth, aged 19 in 1588: by Isaac Oliver: $2 \times 1^{5}/8$, inscribed with age and year
Brinsley Ford
18. Man clasping a hand from a cloud, 1588: by Nicholas Hilliard: $2^{3}/8 \times 2$, inscribed with year and 'Attici amoris ergo'
Crown Copyright, Victoria and Albert Museum
19. Unknown youth: by Nicholas Hilliard: $2 \times 1^{5}/8$
Crown Copyright, Victoria and Albert Museum
20. Leonard Darr, aged 37 in 1591: by Nicholas Hilliard: $2^{3}/4 \times 2^{1}/4$, inscribed with name, age and year
Private collection
21. Boy, called 'Henry Prince of Wales': by Isaac Oliver: $7^{1}/2 \times 6$, drawing, pencil and coloured chalk on paper
The Duke of Buccleuch and Queensberry
22. Self-portrait miniature by Isaac Oliver: enlargement, detail (Colour Plate 9 shows actual size)
National Portrait Gallery, London
23. Unknown man, called 'Thomas Howard, 2nd Earl of Arundel': by Isaac Oliver: $2 \times 1^{5}/8$
Private collection
24. Unknown man: by Isaac Oliver: $2 \times 1^{1}/2$
Private collection
25. Unknown lady: by Isaac Oliver: $3 \times 2^{1}/4$
Reproduced by gracious permission of Her Majesty The Queen
26. Unknown lady, called 'Frances Walsingham, Countess of Essex': by Isaac Oliver: $2^{1}/8 \times 1^{3}/4$
The Duke of Buccleuch and Queensberry
27. Unknown lady: by Isaac Oliver: $2^{1}/8 \times 1^{7}/8$
Private collection

Between pages 120 and 121
28. Letter from Nicholas Hilliard to Sir Robert Cecil, dated 2 June 1599 (slightly reduced)
The Marquess of Salisbury
29, 30. 'Sir Arundell Talbot', and endorsement dated Venice, 13 May 1596: by Isaac Oliver: $2^{3}/4 \times 2^{1}/8$
Crown Copyright, Victoria and Albert Museum

31. Edward Herbert, 1st Baron Herbert of Cherbury: by Isaac Oliver: $7^{1}/_{8} \times 9$
 National Trust, Powis Castle: on loan from the Powis Estates Trustees
32. Catherine Knyvett, Countess of Suffolk: by Isaac Oliver: $2 \times 1^{5}/_{8}$, inscribed '*Infelix Spectator*'
 The Duke of Buccleuch and Queensberry
33. Unknown lady: by Nicholas Hilliard: $2^{3}/_{8} \times 1^{7}/_{8}$
 Crown Copyright, Victoria and Albert Museum
34. Sir Richard Leveson: by Isaac Oliver: $2 \times 1^{5}/_{8}$
 Reproduced by permission of the Trustees, The Wallace Collection, London
35. King James I: by Nicholas Hilliard: $2^{1}/_{8} \times 1^{5}/_{8}$, inscribed '*IACOBVS. DEI. GR. MAGNAE. BRITANIAE. FRAN ET. HIBE REX*'
 Crown Copyright, Victoria and Albert Museum
36. King James I: by Nicholas Hilliard: $2 \times 1^{5}/_{8}$, inscribed '*IACOBVS. D.G. MAG. BRIT. FR. ET. HIB. REX*'
 Scottish National Portrait Gallery, on loan from Buchanan Society
37. Queen Anne of Denmark: by Isaac Oliver: $2^{1}/_{8} \times 1^{3}/_{4}$
 National Portrait Gallery, London
38. Queen Anne in masque costume: by Isaac Oliver: $2 \times 1^{5}/_{8}$, inscribed '*Seruo per regnare*'
 Reproduced by gracious permission of Her Majesty The Queen

Between pages 184 and 185
39. Prince Charles: by Nicholas Hilliard: $2 \times 1^{5}/_{8}$
 Crown Copyright, Victoria and Albert Museum
40. Henry Prince of Wales: by Isaac Oliver: $5^{1}/_{4} \times 4$
 Reproduced by gracious permission of Her Majesty The Queen
41. Lady, called 'Lucy Harington, Countess of Bedford': by Isaac Oliver: 5 diameter
 Reproduced by permission of the Syndics of the Fitzwilliam Museum, Cambridge
42. Lady, called 'Mary Queen of Scots': by Nicholas Hilliard: $2^{1}/_{2} \times 2$, inscribed '*VIRTVTIS AMORE*'
 Private collection
43. Mrs Oliver, wife of the artist: by Isaac Oliver: $2 \times 1^{5}/_{8}$
 Private collection

44. Richard Sackville, 3rd Earl of Dorset: by Isaac Oliver: $9^1/4 \times 6$,
 signed '*Isaac Olliuierus. fecit. 1616*'
 Crown Copyright, Victoria and Albert Museum
45. Princess Elizabeth, later Queen of Bohemia: by Isaac Oliver:
 $2 \times 1^5/8$
 Reproduced by gracious permission of Her Majesty The Queen
46. Man, called 'Henry Carey', later 2nd Earl of Monmouth, aged 20 in
 1616: by Nicholas Hilliard: $2^1/2 \times 2$, inscribed '*Encores Vn* * *Luit
 pour moy*', with the year and age of sitter on a separate card on
 which the miniature is mounted
 Private collection
47, 48. Peter and Anne Oliver: drawings by Peter of himself and his
 wife: both $3^3/8 \times 2^5/8$
 National Portrait Gallery, London

1

The Miniature

The painting of portrait miniatures in watercolour is a unique phenomenon in the history of art, and it has a continuous history in England, and England alone, over more than four hundred years, from the first half of the sixteenth century until the present day.

In the sixteenth and seventeenth centuries, the art was known as 'limning', and this provides the clue to its principal begetter – the illuminated manuscript – for the word has the same Latin root as 'illuminating'. The miniature was a personal, private possession, portable and wearable, and so by its very nature small: but the modern word for it does not relate essentially to the size of the work, but comes from *minium*, Latin for the red lead which provided the technical base for the rubricators and illuminators who used it for their book illustrations.

In France the portrait miniature was freed from the pages of the illuminated bound book by a Court painter of Flemish origin, Jean Clouet, who died in 1541; it was he who combined the techniques of Burgundian illuminators with the detachable portraiture of the medal or coin. But there this form of art did not take root, probably because of the great popularity of enamels.[1] In England it was quite otherwise.

The Court of the Dukes of Burgundy was the most magnificent in northern Europe, and during its golden age the renowned manuscript workshops of Ghent and Bruges were busily employed providing book illustrations for it. It was to be expected that after the establishment of the Tudors on the English throne in 1485, Henry VII – and, to a much greater extent, Henry VIII – would import artists and craftsmen from the continent to enhance the glory of their new dynasty; as Nicholas Hilliard was to write in later years, foreign-born artists were in general the best: '. . . of truth, all the rare sciences, especially the arts of carving, painting, goldsmiths, embroiderers, together with the most of all the liberal sciences, came first unto us from the strangers [foreigners], and

generally they are the best and most in number.'[2] Sir Roy Strong accounts for the rise of the Tudor miniature by the increased activity of the Royal Library, staffed by Flemish illuminators;[3] and it is a fact that Henry VIII was able to secure the services of members of two of the leading Ghent-Bruges families, the Bennincks and the Horneboltes. Simon Benninck, born at Ghent in the 1480s, was regarded as the best illuminator in the whole of Europe;[4] he eventually settled in Bruges where he died in 1561. But his eldest daughter, Levina, who became a miniaturist, married George Teerlinc of Blankenberge and came to England, where Levina was appointed 'paintrix' to the Tudor Court[5] and her husband a Gentleman Pensioner in the Royal Household.

The Hornebolte family[6] had been established for some generations in Ghent, where Gerard became head of a large and important studio and was made Court painter to Margaret of Austria, Regent of the Netherlands, in 1515. He was renowned principally for his miniatures in Books of Hours and other illuminated manuscripts. His daughter Susanna, like Benninck's daughter Levina, was also an artist; in May 1521 Albrecht Dürer – for whom Nicholas Hilliard was later to express great admiration – met Susanna and her father in Antwerp and saw an illumination by her, a *Salvator Mundi*, which he considered to be a remarkable achievement for a young girl. It is not known for certain when Gerard, his wife Margaret and his son and daughter, Lucas and Susanna, came to England, but it was probably in about 1525, when Lucas first appears in the Royal Household accounts, receiving a substantial wage in September of 55s.6d.[7]

The Horneboltes may have decided to come to England simply because of the unrest and economic depression in northern Europe. But it seems very probable that they entered the service of Henry VIII through the Boleyn family, who were already influential at Court. Anne Boleyn's ambitious father, Thomas, had first become a courtier during the reign of the King's father, Henry VII; and in 1513 – two years before Gerard Hornebolte became Court painter to the Regent of the Netherlands – he was sent on a diplomatic mission to her Court, and spent more than a year there, so that he would have come to know the Hornebolte family. He placed his daughter Mary at her Court as a Maid of Honour, and probably Mary's little sister Anne as well, although she was too young to hold an appointment. The Boleyns were described as being 'more Lutheran than Luther', and it is likely that the Horneboltes, too, were of the Lutheran persuasion and that their move to England – like that of so many later continental artists and craftsmen – was for religious as well as economic reasons.

Gerard Hornebolte either died or returned to the continent in the early 1530s, but his children Lucas and Susanna remained in England; Lucas was appointed King's Painter and was granted a property in the parish of St Margaret's Westminster, where he would have had his home and studio. And with him the real history of the English portrait miniature begins. A miniature of Henry VIII of 1525–6, now in the Fitzwilliam Museum at Cambridge and accepted as being by him, already exemplifies the technical and stylistic links between the work of the Flemish book painters and that of the early English limners: it is contained within a circle, although the miniature as a whole is rectangular; it has the familiar blue background and is enclosed by a band of gold; and the features are modelled with touches of transparent watercolour over a smooth, opaque coloured ground then known as the 'carnation'.[8]

Hans Holbein the Younger had paid his first visit to England in 1526; he returned in 1532 and settled in the little City parish of St Andrew Undershaft at the top of Cornhill, where he was carried off by plague at the age of forty-six in October or November of 1543. To Lucas Hornebolte belongs the honour of having taught the great man – in London – the techniques of limning, which he employed to produce the masterpieces now surviving from the last few years of his life.

Hornebolte did not receive the enormous annuity of 'well over £60, more than twice that the King awarded to Holbein', as Roy Strong supposes. That would have been very much more than any royal limner, Nicholas Hilliard and Isaac Oliver included, would receive for many years to come. In fact, from his first appearance in the records in 1525 until his last, Hornebolte's wage remained at 55s.6d. a month, or just over £30 a year, and therefore almost the same as Holbein's.[9]

Hornebolte's sister Susanna is said to have married twice in England – firstly John Parker, a Yeoman of the Robes at Court who died in 1537 or 1538, and secondly a man called John Guylmyn, also employed at Court, as Serjeant of the Woodyard (that is, in charge of firewood); Susanna herself is said to have become an attendant of Anne of Cleves and later of Catherine Parr. She must have died before 1557, for when her husband Guylmyn made his will on 18 October of that year, he already had a third wife called Ellen (maiden name probably Leigh) – 'Susanne', as he says, having been his second. He was dead by mid-June 1558 – five months before the accession of Queen Elizabeth; and he describes himself as 'gentleman harbinger of the Queen's [Mary's] Majesty'. He leaves two children, Henry – a son by the first wife – and Anne, a daughter by Susanna Hornebolte; the will provides the interesting information that

young Henry Guylmyn's principal godfather had been Henry VIII himself. The testator appoints the Bishop of Ely as one of three men to oversee his will and help to care for his children.[10]

Lucas Hornebolte, Susanna's brother, had died a few months after Holbein – he was buried at St Martin-in-the-Fields on 10 May 1544; but Simon Benninck's daughter, Levina Teerlinc, was still working at Court when the first great English master, Nicholas Hilliard, burst upon the scene at the beginning of the 1570s – only in his early twenties, but already with a complete mastery of the traditional techniques of his art. It was at this time – in 1573 – that the earliest English printed book on the techniques of illumination, entitled *Limming: A very proper treatise, wherein is briefly sett forthe the arte . . .*, came out; the first essay on the art of miniature painting, *A Treatise concerning the Arte of Limning*, is by Hilliard himself, and appeared in about 1600.

Hilliard had no doubts about the genius of Holbein – who died some four years before his own birth; he describes him as 'the most excellent painter and limner [portrait- and miniature-painter], the greatest master truly in both those arts after the life that ever was; so cunning in both together, and the neatest, and therewithal a good inventor; so complete for all three as I never heard of any better than he'. And Hilliard and Oliver continued to paint as Holbein had done, on fine vellum: to quote Hilliard again:[11] 'Know also that parchment [vellum] is the only good and best thing to limn on, but it must be virgin parchment, such as never bore hair, but young things found in the dam's belly. . . . It must be most finely dressed, as smooth as any satin, and pasted, with starch well strained, on pasteboard well burnished, that it may be pure, without specks or stains, very smooth and white.' (Hamlet remarks: 'Is not parchment made of sheep-skins?', to which Horatio replies: 'Ay, my lord, and of calves'-skins too.') Finally, the little 'tablet', as the limners called it – cut to round, oval or rectangular shape as desired – was placed face downwards on a grinding stone of some hard substance such as serpentine, jasper or porphyry, and burnished to ensure a perfect union of the vellum painting-surface and its support – which was usually cut from a playing-card.

Pigments could be bought from an apothecary, but the artists had to spend many hours making them sufficiently fine and pure. They were then dried and stored in boxes or papers until needed, when the limner put a little of the powder into a mussel shell or a turned ivory box and mixed it with his index finger with water and gum arabic. Hilliard recommends water 'distilled from the water of some clear spring, or from black cherries, which is the cleanest that ever I could find, and

keepeth longest sweet and clear'. Pieces of mother-of-pearl were commonly used as palettes in Hilliard's and Oliver's time. Their brushes, then called 'pencils', were usually made from the hairs of squirrels' tails, which were stiff enough to hold the watercolour; these were cut, shaped and tied, fixed into quills and mounted on sticks of wood or ivory.

Hilliard and Oliver used much paler carnations than their predecessors, and their practice was to have a number of vellum-covered 'tablets' prepared beforehand with varying degrees of colour, so that, when beginning a new work, they could pick out the one best matched to the complexion of the sitter. Many of their delicate carnations have faded considerably over the centuries. One can only suppose that it is this which led a French author to write of Hilliard, as recently as the 1920s, that while he had had some reputation in France in his own day, his works were poor, with portraits of extreme pallor, timidity of design and coldness of execution: '*On sait la pauvreté des ouvrages de Hilliard, où s'étalent sur fond bleu les plus pâles visages, les plus timidement dessinés, les plus froidement peints qu'on puisse voir.*'[12]

For the limner's studio, the main requirement was that its light should be 'northward, somewhat toward the east, which commonly is without sun shining in', as Hilliard says. Everything must be scrupulously neat and clean, and the limner should wear silk 'such as sheddeth least dust or hairs'. The artist must never touch his work with his fingers, or any hard thing, but only with a clean brush or a white feather; and he must take care not to breathe on it, especially in cold weather. There is a warning against the sixteenth-century version of pollution: 'the colours themselves may not endure some airs, especially in the sulphurous air of seacoal', the coal then brought to London by coaster.[13]

To begin with, miniatures belonged almost exclusively to the small world of the Court: in Hilliard's words,[14] the art of limning is 'for the service of noble persons very meet'. And we know that Queen Elizabeth kept her own miniatures wrapped in paper in the innermost sanctum of the palace. The information comes from Sir James Melville, Mary Queen of Scots' envoy; and his report suddenly illumines a little moment in history. The Queen had conducted him to her bedchamber in the Palace of Whitehall, and while her chief minister Sir William Cecil and the newly ennobled Lord Leicester talked together at the far end of the great apartment, she opened a cabinet 'wherein were divers little pictures wrapt within paper, and their names written with her own hand upon the papers. Upon the first that she took up was written, "My Lord's picture".' Melville held the candle, lighting up the intent face of Elizabeth, and pressed to see the miniature held in her long fingers; she showed it to

him with some apparent reluctance, and he 'found it to be the Earl of Leicester's picture'. Melville's report belongs to 1564; the German Paul Hentzner also saw the cabinet in the royal bedchamber when he was admitted to the Palace in 1598 – the visiting of palaces and stately homes has been going on for a long time; he described it as 'a little chest ornamented all over with pearls, in which the Queen keeps her bracelets, ear-rings, and other things of especial value'.[15]

Soon, commissions for limnings began to come from a wider range of society – partly because of the Queen's well-known reluctance to spend money, which meant that Court servants were customarily paid inadequately or not at all and had to turn elsewhere to make a living. From the very first, some miniatures were placed in turned ivory cases – a beautiful example is the case in the form of a rose for Holbein's *Anne of Cleves* in the Victoria and Albert Museum – with crystals over them to protect them. But in general, up to the end of Hilliard's and Oliver's days, miniatures – whether of the sovereign or the loved one – were worn. Ladies often wore them hung from a girdle (Plate 1), or pinned to a sleeve or to the bodice (Plate 2); a man would wear the picture of his beloved in a locket on a chain round the neck (Plate 3). Leontes in *The Winter's Tale*, in a paroxysm of unfounded jealousy about his wife and Polixenes, bursts out that he 'wears her like her medal, hanging about his neck'; and when Hamlet says to his mother in the closet scene:

> Look here, upon this picture, and on this,
> The counterfeit presentment of two brothers,

Burbage – playing the Prince – would have taken his father's miniature between finger and thumb, in the gesture of Hilliard's *Man against a background of flames* (Plate 3), and held it beside one of Claudius fixed to the dress of the boy playing Gertrude. (The word 'picture' then had the wide meaning 'representation'.)

'All painting imitateth nature, or the life', declared Hilliard; 'but of all things, the perfection is to imitate the face of mankind.'[16] Whether or not we are consciously aware of the fact, it is largely to the two great miniaturists Nicholas Hilliard and Isaac Oliver that we owe our clear conception of what leading members of Court and society in Elizabethan and Jacobean England actually looked like.

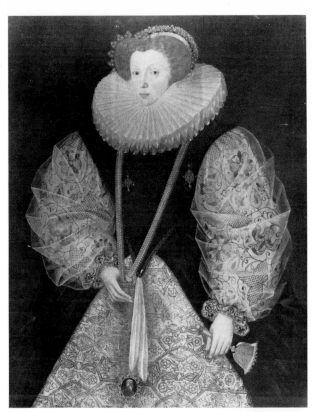

1. Mary Cornwallis: oil
on panel (46 × 37 in.)
attributed to
George Gower

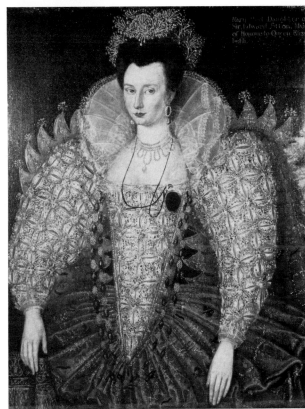

2. Mary Fitton, Maid of
Honour: oil on canvas
(43 × 34 in.) artist unknown

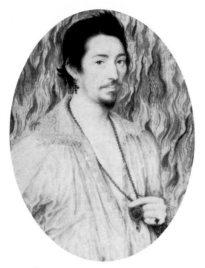

3. Man against a
background of flames
by Nicholas Hilliard

4. Thomas Bodley, aged
54 in 1598
by Nicholas Hilliard

5. Sir Francis Knollys the
younger, aged 29 in 1585
by Nicholas Hilliard

6. Queen Elizabeth I,
aged 38 in 1572
by Nicholas Hilliard

7. Jane Boughton, *née*
Coningsby, aged 21 in 1574
by Nicholas Hilliard

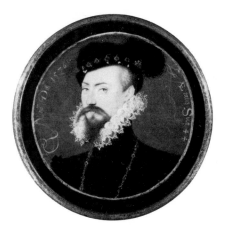

8. Robert Dudley, Earl of
Leicester, aged 44 in 1576
by Nicholas Hilliard

9. François de
Valois, Duc d'Alençon
by Nicholas Hilliard

10. Self-portrait miniature by Nicholas
Hilliard, 1577 (enlargement: Colour Plate 1
shows actual size)

11. Sir Francis Drake,
aged 42 in 1581
by Nicholas Hilliard

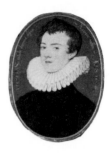

12. Francis
Bacon, aged 18 in
1578, inscribed 'Si
tabula daretur digna
Animum mallem'
by Nicholas Hilliard

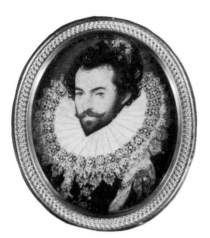

13. Sir Walter
Ralegh
by Nicholas Hilliard

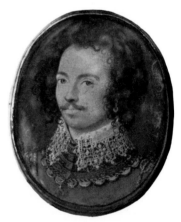

14. Sir Charles Blount,
later Earl of Devonshire,
in 1587, inscribed 'Amor
amoris premium'
by Nicholas Hilliard

2

Young Hilliard

During the reign of Queen Elizabeth, hundreds of Protestant refugees from France and the Low Countries fled to England to escape religious persecution – to the enrichment of the nation, since among them were painters, sculptors, jewellers, goldsmiths and skilled practitioners of many other crafts. But during the preceding five-year reign of Elizabeth's half-sister, the ardent Catholic Mary Tudor, the prevailing movement across the Channel had been in the opposite direction: many English Protestants fled to the continent to escape probable persecution or death at home. Among them was the 'princely merchant' of Exeter John Bodley, whose eldest son Thomas was to found the great library at Oxford bearing his name.

Mary Tudor came to the throne in 1553, and John Bodley left England soon afterwards: he then sent for his wife, children and whole 'family' or household, settling them for a time at Wesel in north-west Germany. With them was a young boy, also of Exeter – Nicholas Hilliard, no doubt a godson of John Bodley's brother of the same Christian name who was a member of the party.

A few years before, both John Bodley and young Hilliard's father Richard had been involved in the siege of Exeter, during the Catholic rising in the west against the Protestant Prayer Book of Edward VI; and, as the Chamberlain of the city wrote at the time,[1] they and men who, like them, were adherents of the reformed religion were still in a minority: 'In the city were two sorts of people, the one and the greater number were of the old stamp and of the Romish religion; the other, being of the lesser number, were of a contrary mind and disposition.' The writer describes forays from the besieged city and, in so doing, provides the first documentary reference to Richard Hilliard, goldsmith: he reports that a Flemish apprentice of Hilliard called John was attacked during one of these sorties, pretended to be wounded, killed his attacker and then

withdrew into Exeter with what he had taken from the dead man. All this was happening about two years after the birth of Nicholas – and the account provides evidence of both the prosperity and the independent turn of mind of his father. Richard speaks strongly to us in the miniature which his son painted of him some thirty years later (Colour Plate 2): the sitter is a sturdy man in his late fifties, with square jaw and high cheek-bones, his beard and curly hair grizzled; he is dressed in black befitting his class and station, his gown edged with rich fur.

This was the leading citizen who had found a place for his son in the Bodley household. Richard Hilliard was the son of John, a gentleman of Cornwall,[2] but he moved to Devon and became one of the most prominent goldsmiths in the flourishing city of Exeter; some of his work survives, including two Communion cups; a font-shaped standing dish of 1560–65, the earliest surviving marked Exeter piece; and a seal-topped spoon.[3] He played his administrative part, too, and was appointed a bailiff of the city in 1556 and sheriff in 1568. It was of course customary for sixteenth-century English fathers of good standing to place their young sons, and sometimes their daughters too, in house-holds of superior rank – as was that of John Bodley – often paying well for the privilege: this was no doubt what Richard Hilliard had done (although he may not have paid) – with the added incentive, in the 1550s, of keeping the eldest son of an avowedly Protestant family abroad and out of harm's way during the Marian reign of terror. The continental trip was a most unorthodox episode in the life of a sixteenth-century Devon boy, and one that until recently has gone largely unnoticed. And it was to have a very important bearing on the career of the first great English artist whose name and work are known.

John Bodley and his party, having left England for Wesel, soon moved on to Frankfurt, where a small English congregation was formed in the summer of 1554 by Protestant refugees: they were allowed to use the French church in the town, and the Scottish reformer John Knox, no less, was their pastor.

Eventually, in the summer of 1557, Bodley and his household were admitted to the English congregation at Geneva. And now the records are explicit: '*John Bodelley, natif de Excestre au roïaulme d'Angleterre*', was admitted on 7 June, and the registers of the English church list the whole party[4] – Bodley's wife, his sons Thomas, John and Laurence and daughter Prothese; his 'servants' or apprentices John Boggens and Richard Vivian; his maid Eleanor; his brother Nicholas; and Nicholas Hilliard. Hilliard was almost certainly born in 1547[5] (the year of the death of Henry VIII and accession of Edward VI), so that he was about

ten when the party reached Geneva. Thomas Bodley was a year or so older, and the two boys must have been close companions.

In later years, after a distinguished career during which he was employed on many diplomatic missions abroad, Thomas Bodley – who had matriculated at Magdalen College and become a fellow of Merton – wrote a letter to the Vice-Chancellor of Oxford, in February 1598; he was offering, at his own expense, to bring back Duke Humfrey's Library – dispersed half a century before because of the political and religious upheavals of the time, and the poverty of the University – to its former use; 'and to make it fit, and handsome with seats, and shelves, and desks, and . . . to stir up other men's benevolence, to help to furnish it with books'. As he wrote in his autobiography, he was thoroughly persuaded that 'I could not busy myself to better purpose, than by reducing [restoring] that place (which then in every part lay ruined and waste) to the public use of students'. It is fitting that in 1598, the year in which he launched his plan for the great library, he should have commissioned a miniature of himself (Plate 4) from the royal limner Nicholas Hilliard, his boyhood friend from Geneva days.

Members of other prominent English families had been with them in Geneva. One head of household – who actually died and was buried there, in May 1556 – was Sir William Stafford; his eldest son Edward, who was somewhat younger than Thomas Bodley and Nicholas Hilliard, became English Ambassador to France in the 1580s (having married, as his second wife, Douglas Sheffield, the woman with whom Hilliard's future patron, Lord Leicester, had had an affair). Another leading Protestant group, members of the Knollys family, also fled to the continent at the beginning of Mary's reign; Sir Francis, the eventual head of the family, was a refugee in Frankfurt and Strasbourg for a time, and other relatives went on – a little earlier than the Bodley group – to Geneva. Sir Francis was a first cousin by marriage of Queen Elizabeth – his wife Catherine was a daughter of Anne Boleyn's sister Mary – and all seven Knollys sons became courtiers during the reign, and all but one Members of Parliament.[6] Thus early, on the continent, did young Hilliard meet people who would later become his sitters and help to further his career.

Valuable though the continental visit was to Hilliard in many ways, the stern Calvinist stronghold of Geneva could not have provided a sympathetic nursery for the artistic temperament. Calvin himself controlled the spiritual and temporal affairs of the whole Swiss republic, and John Knox was a minister of the English congregation. All the young English boys in the congregation, Thomas Bodley, Nicholas Hilliard and

Edward Stafford among them, must have found the regime irksome –
and especially (if one may judge from surviving records, and from the
beautiful self-portrait miniature done when he was thirty) Nicholas
Hilliard (Colour Plate 1), who seems to have been of a strongly extrovert,
impulsive and non-conforming temperament. The young man in the
miniature, his lively face topped by the dark curly hair inherited from his
father, his black bonnet and doublet adorned with jewelled badges and
buttons which he had probably designed and executed himself, does not
look like one of sober and devout character; and there is no evidence that
he was ever of a particularly religious turn of mind. In this Isaac Oliver
would be markedly unlike him.

Holbein, whom Hilliard so revered, had himself spent some time in
Switzerland as a young man – in Basel, in 1515, he was designing
woodcuts for publishers, painting portraits and religious pictures and
working on decorative schemes for the Town Hall and for the façades of
several houses; he was in Lucerne in 1517 and 1519, and again in Basel in
1526, but the religious troubles there drove him to the Low Countries
and then to England. In 1528 he returned to Basel, but by then the
Reformation had reached the city in full force, and there was much
violence and iconoclasm. Many of the religious works which Holbein
had painted during his first visit were destroyed, and it is to all this – and
to the positive patronage of Henry VIII – that we owe the fact that he
spent the last few years of his life mostly in London; he found Switzer-
land as unsympathetic as Hilliard probably did in later years.

The boy, young as he was during his time in Geneva, would have well
understood why his great predecessor had found the iconoclasm of the
republic intolerable. As for himself, the atmosphere of the Bodley
household was probably oppressive. John Bodley was largely responsible
during these years for the Geneva or 'Breeches' Bible – indeed, it was
sometimes known as the Bodley Bible – which was published in 1560.
Bodley and Miles Coverdale, the ejected Bishop of Exeter, were chosen
as seniors of Knox's English congregation, and Bodley collected and
maintained the staff of translators of the Bible, set up an office to print it
and even did some of the translating work himself. The house must
always have been filled with learned, pious and sober-suited men.

However, if the atmosphere of Calvinist Geneva in general, and of the
Bodley household in particular, was not appealing, Hilliard had a chance
to study French, Dutch and German art at an early age and – perhaps
even more important – to become fluent in the French language. This
meant that when he paid a two-year visit to France some twenty years
later, he was able to establish himself with no delay and to make the

acquaintance of many leading French people, artists and writers among them.

The Geneva interlude was professionally important to him in another way: it allowed him to meet and to learn from the large numbers of goldsmiths arriving in the city, most of them refugees from Rouen and Paris. And the arrival of one man in particular was of the greatest significance. On 15 October 1557[7] – four months after the Bodley party – a large group of French Protestants was admitted, and among them was '*Pierre Olivyer, orfèvre, natif de Rouen*'. This was almost certainly the Pierre Olivier, goldsmith from Rouen who, eleven years later, settled in London as a Huguenot refugee with his wife and young son, their name soon becoming anglicized to Oliver. The son was Isaac, who went on to study under Nicholas Hilliard, and eventually to become his formidable rival as a Court miniaturist. Thus the first link between the two great London artists of Elizabethan and Jacobean days, the one English from Exeter, the other French from Rouen, was forged in the leading Protestant stronghold of continental Europe.

Elizabeth Tudor became Queen of England on 17 November 1558, and the following year saw her coronation and the Church Settlement which permitted the return of the Protestant refugees. John Bodley received permission to leave Geneva on 5 September 1559; he settled in London, and it has recently been persuasively argued[8] that young Nicholas Hilliard remained in his household rather than returning to Exeter. If so, the three earliest surviving miniatures by this precocious artist, dated 1560 (before he had even begun his years of apprenticeship), would have been painted in London: two are of himself at his then age of thirteen, and the other is a copy of a miniature of the executed Edward Seymour, Duke of Somerset. (Seymour, as Protector, had been responsible for the imposition of the Edward VI Prayer Book, thus provoking the west-country Catholic rebellion of 1549 which John Bodley and Hilliard's father were involved in putting down.)

In London, too, and not at home in Exeter, Hilliard would have been able to study the miniatures and large-scale works by Holbein which he so much admired. The great unanswered and probably unanswerable question is: who taught him the techniques of limning – as Hornebolte had taught Holbein? 'In his younger days', wrote the art-historian George Vertue in the eighteenth century,[9] 'the want of an eminent master to direct him, was supplied in a great measure by his strong affection to the study of nature'; but he can hardly have managed by the light of nature alone. 'Holbein's manner of limning I have ever imitated, and hold it for the best', he declares; but he must mean stylistically, not

technically. Holbein began with a drawing and scaled it down, whereas Hilliard followed the tradition of the Ghent-Bruges school, painting directly from life; and although he wrote in about 1600 of having 'ever' imitated Holbein, he had by then long since developed his own highly stylized manner.[10]

Levina *née* Benninck, and perhaps Susanna *née* Hornebolte also, painted portrait miniatures in the Flemish tradition at the English Court in the years after Holbein's death and before the rise of Hilliard. Susanna, as we now know, died before 1557, while Hilliard was a young boy, and probably while he was abroad with the Bodleys; Levina was possessed of only a modest talent and as yet remains a very shadowy figure in spite of attempts to attribute various works to her. She and her husband had a country house at the then fashionable village of Stepney, where she was buried at the parish church of St Dunstan on 25 June 1576; thus she lived on into the early years of Hilliard's career. Sir Roy Strong is convinced that it was she who must have instructed him in the basic techniques of limning, but there is as yet no known evidence for this. And it would be inconceivable if she had been born in about 1483, the date he gives, since she would have been in her late seventies by the time he painted his first boyish miniatures, and just on eighty by the time he began serving his formal apprenticeship. However, 1483 or 1484 was the year not of Levina's birth, but of her father's.[11] In the *Treatise*, Hilliard does not mention anyone as having given him instruction in anything; but in a passage on the colour white he writes: 'There is . . . an excellent white to be made of quicksilver which draweth a very fine line; this white the women painters use.'[12] Probably he had Levina Teerlinc and Susanna Hornebolte especially in mind. As we know, he considered that 'strangers' were in general the best artists, which would suggest that he learned the art of limning from one or more foreign-born practitioners. In Chapter 4 I shall suggest two male Flemish artists who might have played a part in his instruction.

He could well have had several instructors, and it is possible that he studied under one of the Englishmen who were painting miniatures at the time – John Bettes the Elder. This artist had probably worked in the London studio of Hans Holbein, so that Hilliard could have questioned him about the master whom he revered above all others. Bettes lived in Westminster and died before, or perhaps in, 1570 – not in 1576 as previously supposed. He may have been the 'Iohannes Bett' who was buried at St Martin-in-the-Fields on 24 June 1570, and if so, he was alive throughout Hilliard's years of apprenticeship.[13] It is probably not

without significance that his son, John Bettes the Younger, is reported to have studied under Hilliard.

Hilliard must have been very grateful to his father Richard for allowing him to remain in London while still so young, and after the years abroad. To quote his own – somewhat ungrammatical – words, 'surely he is a very wise man that can find out the natural inclination of his children in due time, and so apply him that way which nature most inclineth him'.[14] Richard himself had been apprenticed to a leading Exeter goldsmith called John Wall, and in the traditional manner he later married his former master's daughter, Laurence by name. Three of his four sons – Nicholas, John and Jeremy – became goldsmiths in their turn; the fourth, Ezekiel, was ordained. When the time came for apprenticeships to begin (this was normally at the age of fourteen or fifteen), Richard Hilliard placed the two eldest sons with leading London goldsmiths, while Jeremy pursued his career at home in Exeter.

Nicholas and John were probably both apprenticed in 1562. Certainly the term of Nicholas began in that year – on 13 November. Both boys lived and studied in Westcheap – at the western end of Cheapside near St Paul's, and close to Goldsmiths' Hall, which stood, and stands, just off the famous thoroughfare on its northern side. If Cheapside was the pride of the Elizabethan City of London, Goldsmiths' Row – on the south side – was the particular glory of Cheapside. The chronicler John Stow, in his *Survey of London* (1598), tells us that Thomas Wood, himself a freeman of the Goldsmiths' Company and one of the Sheriffs in the year 1491, built the Row, 'which is garnished with the likeness of woodmen'. It is, he says, 'the most beautiful frame of fair houses and shops that be within the walls of London, or elsewhere in England. . . . It containeth in number ten fair dwelling houses, and fourteen shops, all in one frame, uniformly builded four storeys high, beautified towards the street with the Goldsmiths' arms and the likeness of woodmen, in memory of his name, riding on monstrous beasts, all which is cast in lead, richly painted over and gilt, these he gave to the Goldsmiths with stocks of money to be lent to young men, having those shops, &c.' The Row stood opposite Wood Street on the other side of Cheapside, and Stow surmises that Thomas Wood's predecessors might have been 'the first builders, owners and namers of this street after their own name'. This worthy man was also 'an especial benefactor' towards the building of St Peter Westcheap at the Cheapside end of Wood Street, and the roof of the middle aisle was 'supported by images of woodmen'.[15] This, I discover, was the church where Hilliard's future wife was baptized.

The frontage of Goldsmiths' Row was 'new painted and gilded over'

in 1594, and Sir Richard Martin (a leading goldsmith and a colleague of Hilliard), being then Lord Mayor of London (for the second time), 'kept his Mayoralty' in one of the establishments: there was, of course, no equivalent of the Mansion House in those days. Martin was also Master of the Mint from 1581 until his death in 1617.[16]

Each house and shop had its own handsome sign, so that the Row must have been a riot of dazzling colour. To quote the Induction of Webster and Marston's *The Malcontent*, 'I'll walk but once down by the Goldsmiths' Row in Cheap, take notice of the signs and tell you them with a breath instantly. They begin as the world did, with Adam and Eve.' And the German Paul Hentzner, in his account of his visit to England in 1598, writes: 'The streets in this city are very handsome and clean; but that which is named from the goldsmiths who inhabit it, surpasses all the rest; there is in it a gilt tower, with a fountain that plays. . . . There are besides to be seen in this street, as in all others where there are goldsmiths' shops, all sorts of gold and silver vessels exposed to sale, as well as ancient and modern medals, as must surprise a man the first time he sees and considers them.'[17]

The so-called Cheapside Hoard of late Elizabethan and Jacobean pieces, found in 1912 when a house was being pulled down between St Paul's and the Post Office headquarters (and thus close to Westcheap), gives a good idea of what was 'exposed to sale' in the goldsmiths' shops. Most of the Hoard is now in the new Museum of London; a selection from it was shown at the *Princely Magnificence* exhibition of Court jewels of the Renaissance at the Victoria and Albert Museum in the winter of 1980–81. This consisted of nine chains set with jewels and enamelled work; twelve jewelled finger-rings; eighteen ear-rings, fan-holders, hair ornaments, reliquaries and crosses; four jewelled hat-ornaments and two jewelled hair-pins; four ornate buttons; four unset cameos (one a bust of the Queen in onyx); two unset intaglios; two unset gems of paste representing St John the Evangelist and Christ scourged; a gold and bejewelled scent-bottle with a chain; and two watches – one with an enamelled dial set in a single large emerald, the other an alarm watch which strikes the hours and quarters and provides astronomical information, its gold dial-plate richly ornamented.[18] All this illustrates the scope of the work done by the London goldsmiths, of whom Nicholas Hilliard was to become one of the most distinguished. Writing to Sir Robert Cecil in 1601,[19] he recalled how he had 'long been one of Her Majesty's goldsmiths and drawer of Her Majesty's pictures' – putting his goldsmith's work first.

George Vertue states that he was also 'very skilful in jewelling works

and enamelling, which he then performed to admiration, in which the Queen delighted to employ him', as did the nobles and gentry.[20] And Hilliard himself writes of limning excelling all other kinds of painting whatsoever in representing jewels, 'in giving the true lustre to pearl and precious stone . . . which so enricheth and ennobleth the work that it seemeth to be the thing itself, even the work of God and not of man'; the miniature, set within its case or box and intended to be 'viewed . . . in hand near unto the eye',[21] was itself regarded as a kind of jewel. As Olivia says to the disguised Viola in *Twelfth Night*: 'Here, wear this jewel for me, 'tis my picture.' And although Hilliard's *Treatise* purports to be an account of 'the art of limning', the artist's deep interest in and knowledge of jewels and goldsmith's work constantly obtrude. 'And now I think fit also', he writes at one point, 'to speak somewhat of precious stones, which will be meet for gentlemen to understand; and some goldsmiths will be glad to see it for their better instruction.' He draws an analogy between the 'five perfect colours in the world', other than black and white, and the five precious stones amethyst, ruby, sapphire, emerald and topaz.[22] 'The amethyst orient . . . is a hard stone. . . . There are divers more kinds of amethysts, as amethyst almain [German] and amethysts of divers other countries, cold regions, all of which are of divers other colours. . . . Some are purple, some violet, some carnation, some peach colour, and some a brown, smoky colour, like water wherein soot hath lain; and of all these colours there is great variety of each, some paler than others. . . .' But these are all soft stones, and of less value than the amethyst orient. The ruby is 'the most perfect red, and if he be without blemish, and so great and thick as he may bear the proportion of diamond cut, he flickereth and affecteth the eye like burning fire, especially by the candle light. . . . The balas ruby [from near Samarkand] is more pale, like a pale wine, and no perfect full colour, and it is therefore a softer stone, and [like the softer amethysts] of less value'. The sapphire is of 'two kinds or two colours, white and blue, which blue is the most excellent perfect blue that nature in anything yieldeth, or art can compose'. The white, 'if he be well cut, he is matchable with any diamonds, especially of the greater ones, for a great diamond is not so fair for his bigness commonly as a little one, and a little sapphire not so fair as a great one for his bigness'. The emerald is 'the most perfect green on earth growing naturally, or that is in anything'; as for yellows, 'the best is the topaz orient, a most perfect gold yellow. If this stone want of his yellowness, his value is the less, except he be pure white, and have no yellow at all, for then resembleth he the diamond, as doth also the white sapphire, which is somewhat harder than the topaz, but very little.

Topaz is better than white sapphire if it be naturally white, because it resembleth more the best water of a diamond, which is to incline a little to yellow; and will abide to be set and cut on tin on the diamond mill. . . . And the yellow topaz which is but by art (as by fire) burnt white will oftentimes return to his perfect yellow again, a thing admirable [to be marvelled at]. And a pale blue sapphire which hath a greenness in his blue will never burn white, but rather recover more blueness, which is greatly to be marvelled at likewise. . . .' The diamond 'is properly of no colour, but a clear water colour or air colour; so lucid and bright as, having his due form, his splendour or light is sometimes called his fire, and sometimes his water, by which his brightness and his hardness is known . . . the diamond is indeed the brightest and therefore the hardest of all the precious stones'.

Of jewels in general, Hilliard knows well from his own experience that 'an excellent workman [jeweller] can grace them above that which nature gave them, both in cutting and setting, making them in value double of that they were before'.[23]

The master under whom the young Hilliard served his apprenticeship was a goldsmith employed by the Queen. His name was Mr Robert Brandon, and he had become a freeman of the Goldsmiths' Company by redemption – purchase – in 1548. This was, and is, one of three ways of becoming a freeman of a City livery company, the other and much more common methods being by servitude (serving an apprenticeship of at least seven years with an existing freeman) or by patrimony – by virtue of one's father being a freeman.

Brandon, Hilliard's master, had his establishment at the sign of 'The Gilt Lion and Firebrand', later to be known simply as 'The Gilt Lion', no doubt with a splendidly gilded hanging sign. He was a wealthy and influential man, who served as Prime Warden (Master) of his great Company for the year 1582–3. On 8 January 1583 he was appointed Chamberlain – in effect, chief executive – of the City of London, and he held this important office until his death at the end of May 1591. It carried onerous responsibilities, including dealing with the admission of freemen, the disciplining of apprentices and the affairs of the vast numbers of orphans of citizens of London, whose assets were administered by the Court of Aldermen until they came of age; and – most important of all – collecting rents, raising loans, taking lease fines, paying wages, supervising repairs, in fact being responsible for the whole range of the City's finances, which meant that very large sums were constantly passing in and out of his office, the Chamber.[24]

I discover that Robert Brandon married twice: his first wife was

Katherine Barber, whom he married at the church of St Mary Woolnoth in Lombard Street on 13 June 1548; so it was she who kept a motherly eye on young Hilliard while he was studying under her husband and living above the shop with the family. The surviving Brandon children by Katherine consisted of two sons and five daughters – Edward and Rebecca, baptized at St Mary Woolnoth in 1551 and 1552; Alice, baptized at St Peter Westcheap on 11 May 1556; Charles, baptized there in 1557; and Sara, Martha and Mary, baptized at St Vedast Foster Lane during Hilliard's apprenticeship, in 1563, 1564 and 1566.[25] So Alice was six years old when Hilliard entered the household: it was she who was to become his first wife, and the mother of his children. She was the only one of the daughters to marry one of her father's former apprentices: Rebecca married a gentleman of Bedfordshire as her first husband, and secondly a man called Robert Keys; Sara's two husbands were both gentlemen of the Inner Temple; Martha married a freeman of the Grocers' Company; and Mary's husband was Mr John Martin, a son of Sir Richard Martin who has already been mentioned.

While Nicholas Hilliard was lodging and learning at the sign of 'The Gilt Lion', his brother John was at the sign of 'The Ship', marking the home and shop of Mr Edward Gylbert, who was Prime Warden of the Goldsmiths' in the year that the boy was apprenticed to him. Gylbert also served as an alderman for several years in the early 1560s, and was President of Bethlem and Bridewell in 1563–64.[26] Nicholas Hilliard was made free of the Goldsmiths' on 29 July 1569, his brother John on 5 September.

It was in the previous year that Pierre Olivier, the goldsmith from Rouen, arrived in London with his wife and young son, and to begin with they lodged with a pewterer called Harrison in Fleet Lane – the part of it which ran, and runs, westward from the street then and now called Old Bailey towards the Fleet River, flowing down to meet the Thames at Blackfriars from its sources on Hampstead Heath. The Fleet is now hidden in a sewer beneath Farringdon Street, but the general geography of the City is not greatly changed, and it is not difficult to imagine the little French family disembarking at Blackfriars Stairs with their worldly goods and trudging up the east bank of the Fleet until they arrived at Harrison's house. Pierre Olivier, a stranger in a strange land, no doubt quickly sought out the young apprentice – now in his early twenties – whom he had met as a boy in Geneva. One glance at the quality of Brandon's establishment and Hilliard's work would have satisfied him: it was agreed that Hilliard should instruct young Isaac Olivier in limning as soon as they were both old enough. By 1598 Dr Richard Haydocke (the

man who persuaded Hilliard to compose his *Treatise*) was writing of the two as the 'most ingenious, painful [diligent, meticulous] and skilful Master Nicholas Hilliard, and his well profiting scholar Isaac Oliver'.

3

Hilliard's Early Career: 1570-76

His apprenticeship completed, Hilliard entered the new decade a complete and versatile artist – limner, goldsmith, jeweller, calligrapher (small examples of his exceptionally beautiful hand appearing in inscriptions on early miniatures) and probably already also practising as an engraver.

His first surviving adult miniature, of high quality, belongs to 1571: it has been said to represent Oliver St John, first Baron St John of Bletsoe in Buckinghamshire. This is not possible: the first Baron – created on 13 January 1558/9 – was MP for Bedfordshire from 1547 to 1552, whereas the inscription on the miniature describes the sitter as being thirty-five years old in 1571 (which seems to be borne out by his appearance), so that he was only about eleven in 1547. The third Baron – a younger son of the first – was also called Oliver, and perhaps he is the sitter. He was one of the peers who sat at the trial of the Earls of Essex and Southampton after the abortive rebellion of 1601, and he died in 1618. Alternatively, the sitter might be a relative, Oliver St John *Esquire*, who lived in South Lambeth and also had a house in the City, near St Paul's Wharf. He died in 1571, the year in which the miniature was painted.[1]

If the sitter is the third Baron St John of Bletsoe, there would be an interesting link with Isaac Oliver. A beautiful full-length of a lady by the English portrait-painter William Larkin, who has only recently begun to emerge from obscurity, hangs in Mapledurham House near Reading and is believed to represent Lady Katherine, widow of the second Baron and sister-in-law of the third; Larkin and Oliver are known to have collaborated professionally – and at the time when the Mapledurham portrait was painted (*c.*1615), they were neighbours in the City parish of St Anne Blackfriars.[2]

In the year after he limned the supposed 'Oliver St John', Hilliard produced the splendid *Unknown man aged 24* (Colour Plate 4) which, as

Graham Reynolds has written, 'reveals a remarkable similarity of pose, lighting, linear vivacity and general conception to the large-scale portrait of Sir Henry Lee by Antonio Mor in the National Portrait Gallery'. This had been painted in Antwerp four years earlier, and Mr Reynolds suggests that in the interval the sitter had brought it back to England – and that Mor the Flemish painter constituted a major influence on the work of the young English limner.[3]

Elizabethan miniatures, and above all those of Hilliard, were often pregnant with hidden meaning – colours, pose, inscriptions, jewels and other accessories probably spoke their full message only to artist and sitter, or sitter and beloved, and they have provoked lively and continuing debate. In the case of Hilliard's courtly young man of 1572, there have been unsuccessful attempts to identify his gold medal hanging from the green ribbon. Green, from its associations with spring, usually symbolized love; and black, the colour of the sitter's bonnet and doublet, could signify constancy.

The blue background of the miniature, derived from the work of the Flemish book illustrators and characteristic of English miniatures until the 1590s, was done with a pigment then called blue bice; it was a natural copper carbonate made from the mineral azurite. This was very difficult to work as a watercolour, and artists overcame the problem by using a 'wet-in-wet' technique. Having outlined the contour of the figure with a fine brush and a watery mixture of the blue, they then swept the same mixture over the whole background area with a larger brush; finally, while this was still wet, a thicker mixture was applied with a third brush, achieving a smooth and brilliant finish.[4]

Hilliard doubtless began working at Court as soon as his apprenticeship was completed – or even before. His master, the Court goldsmith Robert Brandon, would have introduced him. But I suspect that another important influence was the Queen's cousin Sir Francis Knollys, members of whose family – if not Sir Francis himself – Hilliard had met in Geneva when he was a boy. Knollys was Vice-Chamberlain of the Royal Household from 1559 and was appointed Treasurer in July 1572. He was the maternal grandfather of the Queen's future favourite, Robert Devereux, second Earl of Essex, later to become a patron of Hilliard; and in 1585 Hilliard painted a miniature of the sixth of Knollys' seven sons (Plate 5), who was well known at Court as 'young Sir Francis'. He was MP for Oxford from 1572 until 1588, and for Berkshire from 1597 until 1625, and lived at the former monastic property, Reading Abbey, which his father had often used by permission of the Crown – 'The Abbey House' as the younger man calls it in his will. One of his daughters

became the second wife of John Hampden; another, Elizabeth, was the mother of Colonel Robert Hammond, who had custody of Charles I at Carisbrooke Castle before his return to London, trial and execution. This younger Sir Francis Knollys, who died in 1648, bequeathed 'all my pictures' – including, presumably, the miniature by Hilliard – to a grandson, Robert Knollys.[5]

Significantly, the year 1572, in which the father of 'young Sir Francis' was appointed Treasurer of the Royal Household, is also the year of Hilliard's first miniature of the Queen (Plate 6). It was a most happy conjunction that the reign of so spectacular an English sovereign should coincide with the best years of a man who, in addition to being a brilliant limner himself, surpassed all others in the invention of new painting techniques; he was perfectly equipped to portray her glittering presence.

Elizabeth is often described as parsimonious, even notoriously stingy. But the sovereign had then no regular source of income, and it would be more just to describe her financial policy as one of extreme thrift and caution. From the last years of her father's reign, the financial position had steadily worsened, and when she came to the throne, the country was encumbered by debt, inflation and a debased currency. Ever conscious that power depended upon solvency, the Queen was steadfastly determined to restore the revenues – in this resembling her grandfather Henry VII in character. But although in private she was a woman of abstemious and frugal habits, no expense was spared on her public appearances, which were deliberately designed for the greater glory of her realm. In the years when parliament and her ministers were still trying to persuade her to marry and secure the succession, she once drew the coronation ring from her finger when a deputation waited upon her, held it up before them and said: 'I am already bound unto a husband, which is the Kingdom of England.' And a later deputation was greeted with the famous words: 'Though I be a woman, yet I have as good a courage answerable to my place as ever my father had. I am your anointed Queen.' She devoted all her formidable powers to the exercise of her sovereignty.

Since Hilliard painted what he saw, we can be confident that the dress and adornments of the Queen in that first limning of 1572 – as in all the later ones – are exact in every detail, even to the white rose, freshly picked and pinned to her left shoulder. His method of portraying jewels – about which he is understandably somewhat secretive in the *Treatise* – is so convincing ('it seemeth to be the thing itself', as he says) that in one miniature of the young Queen a tiny real diamond, set in the centre of the cross surmounting the orb on which she rests her left hand, cannot

immediately be distinguished from the surrounding counterfeits.[6] It almost defies the modern techniques of microscopy, infra-red and ultra-violet examinations and X-radiography which in recent years have been employed at the Victoria and Albert Museum in a systematic study of the history of limning techniques. (Abraham van der Doort, in his catalogue of Charles I's art collections, records that this miniature by 'old Hilliard' was given to the King by 'the young Hilliard' (Laurence) and presented by the Earl of Pembroke, Lord Steward of the Household.)[7]

To represent coloured gem stones, Hilliard mixed the appropriate transparent pigment with a little turpentine resin; the mixture was then taken up with a heated metal point and laid and modelled over a burnished silver ground. In this he may have been adapting an easel-painting technique used by Holbein, who painted certain areas of drapery by glazing with transparent resinous paints over a ground of silver leaf.[8]

Hilliard was outstandingly original in his use of gold. Lucas Hornebolte had represented gold jewellery by painting the object with dark ochre and then heightening it with gold paint. But Hilliard, the trained goldsmith, used gold not as a powdered pigment but as a metal; for the borders of his work, and the inscriptions, he employed thick gold powder mixed with a minimum of gum arabic and then burnished 'with a pretty little tooth of some ferret or stoat or other wild little beast'.[9] He used powdered silver in a similar way for painting armour and jewellery, and represented diamonds by drawing and shading the cut of the stone over an area of burnished silver. Burnished silver was used, too, for the highlights of pearls, the main body of the pearl being raised with a thick blob of white. (In many of Hilliard's miniatures, the silver has now tarnished and is completely black.) 'Note also', says the artist, '[that] the satin ceruse [a non-metallic chalk/alum mixture, distinct from lead white] grinded with oil of white poppy whiteneth up pearls in oil colours most excellently; and it serveth not as the linseed oil doth, but it is long in drying. This is an experience of mine own finding out.'[10]

The 1572 miniature of the Queen is presumably the one referred to in a celebrated passage of Hilliard's *Treatise*. He has been discussing his belief that 'the principal part of painting and drawing after the life consisteth in the truth of the line . . . without shadowing' – although he realistically remarks later: 'If a very well favoured woman stand in a place where is great shadow, yet showeth she lovely; not because of the shadow, but because of her sweet favour, consisting in the line or proportion . . . but if she be not very fair together with her good

proportion, as if too pale, too red, or freckled &c., then shadow to show her in doeth her a favour.'[11]

However, in general he was against shadowing, 'especially [in] small pictures which are to be viewed in hand; great pictures placed high or far off require hard shadows, which become them better than nearer'. But 'the line without shadow showeth all to a good judgment, but the shadow without line showeth nothing; as for example, though the shadow of a man against a white wall showeth like a man, yet it is not the shadow, but the line of the shadow, which is so true that it resembleth excellently well; as draw but that line about the shadow with a coal, and when the shadow is gone it will resemble better than before'.

'This makes me to remember', he continues, 'the words also and reasoning of Her Majesty when first I came into Her Highness' presence to draw; who, after showing me how she noted great difference of shadowing in the works, and the diversity of drawers of sundry nations, and that the Italians, who had the name to be cunningest and to draw best, shadowed not, required of me the reason of it, seeing that best to show oneself needeth no shadow of place, but rather the open light. The which I granted. . . .' Note the confident tone: even allowing for the fact that this was written many years later, and that the writer may have allowed himself a little artistic licence, it seems clear from all the evidence of his encounters with the great ones of the realm that Hilliard never suffered from false modesty. The Queen, he continues, 'conceived the reason' for what he had been saying. She therefore elected to sit for him 'in the open alley of a goodly garden, where no tree was near, nor any shadow at all'. It conjures up a picture of the famous pair – the artist in his mid-twenties, the Queen in her late thirties, in the sunlit Privy Garden of the Palace of Whitehall, or perhaps at Greenwich or Hampton Court. Hilliard is about six feet from his subject: 'In drawing after the life, sit not nearer than two yards from the party, and sit as even of height as possibly you may.'[12]

He tactfully concludes the report of his first professional encounter with the Queen – after all, she was still alive when he wrote it – by saying that her question about shadowing 'hath greatly bettered my judgment, besides divers other like questions in art by her most excellent Majesty, which to speak or write of were fitter for some better clerk'.

Years after this episode, but before Hilliard wrote the *Treatise*, the Queen's godson Sir John Harington, in his translation of Ariosto's *Orlando Furioso*, wrote of Hilliard as being a limner 'inferior to none that lives at this day: as among other things of his doing, myself have seen him, in white and black in four lines only, set down the feature of the

Queen's Majesty's countenance . . . and he is so perfect therein (as I have heard others tell) that he can set it down by the idea he hath, without any pattern'. Hilliard himself, insisting on the overriding importance of the 'truth of the line', refers to this: 'as one [Harington] saith,' he writes, ' . . . he hath seen the picture of Her Majesty in four lines very like: meaning by four lines but the plain lines, as he might as well have said in one line.'[13]

Later in the *Treatise*, he writes of a long talk at some unspecified time with that 'excellent man' Sir Philip Sidney, 'that noble and most valiant knight, that great scholar and excellent poet, great lover of all virtue and cunning [knowledge, learning]'. Sidney was somewhat younger than Hilliard, and had been dead for about fourteen years when the *Treatise* was written. He had asked Hilliard about the problem of 'proportion': how was it possible to convey, in two miniatures of the same dimensions, that one sitter was 'a little or short man' and another 'a mighty, big and tall' one? 'I showed him', the artist reports, 'that it was easily discerned if it were cunningly drawn with true observations, for our eye is cunning, and is learned without rule by long use, as little lads speak their vulgar tongue without grammar rules. But I gave him rules, and sufficient reasons to note and observe. . . .' Once again the tone is of a man entirely at ease and confident of his own ability. He also writes of having known the late Sir Christopher Hatton, who first attracted the Queen's attention at a Gray's Inn masque ('dancing into her favour', as it was said), and in 1587 became Lord Chancellor. Hilliard demonstrates his sturdily independent approach to his art by declaring that Hatton was one of the handsomest men of his time, although according to the rules set out by Albrecht Dürer, the forehead should occupy a third part of the face, whereas Sir Christopher's was 'very low'. On the other hand, he says, 'infinite number of faces' which do conform to the rules 'are but ill favoured or unpleasant faces to behold'.[14] (It recalls Bacon's Essay *Of Beauty*: 'There is no excellent beauty that hath not some strangeness in the proportion. . . . A man shall see faces, that, if you examine them part by part, you shall find never a good, and yet all together do well.')

Hilliard praises Dürer's rules for painting and engraving but cheerfully continues:

Which rules of Albert for the most part are hard to be remembered, and tedious to be followed of painters, being so full of divisions; but very fittable for carvers and masons, for architects and builders of fortifications. . . . Now the reason why the rules of Albert serve more the carver than the painter is because he describeth and divideth the proportions of parts of men, like as of pillars or such other things, by measures of inches in length, breadth,

thickness and circumference: which measures serve not, nor can hold, in painting . . . because painting perspective and foreshortening of lines, with due shadowing, according to the rule of the eye, worketh by falsehood to express truth in very cunning of line and true observation of shadowing – especially in human shapes. . . . And here I enter my opinion [he predictably concludes] concerning the question which of the two arts is the most worthy, painting or carving: I say, if they be two arts, painting is the worthier.[15]

At the time, limning was generally regarded as being the highest form of painting: easel-painting, painting 'in large', was still associated with interior decorating – some men practised both skills – and portrait-painters and decorators usually belonged not to the Goldsmiths' Company but to the less eminent Painter-Stainers'. As Hilliard puts it, limning 'excelleth all painting whatsoever in sundry points'; '. . . it is sweet and cleanly to use, and it is a thing apart from all other painting or drawing, and tendeth not to common men's use, either for furnishing of houses, or any patterns for tapestries, or building, or any other work whatsoever.'[16] The point is restated in a letter of 1606 to Robert Cecil (who by then had become Lord Salisbury). In this, the artist recalls that he has recently been laying claim to 'trim' the tomb of the late Queen in the Henry VII Chapel of Westminster Abbey; as a Goldsmith, he 'has skill to make more radiant colours like unto enamels than yet is to Painters known'. However, he somewhat ruefully acknowledges that this has prompted a few plain words from the Serjeant-Painter (John de Critz), who has reminded him ('told' him, as Hilliard disingenuously puts it) that the painting of the royal tomb is 'within the Serjeant's patent'.[17] De Critz was probably especially sensitive about his rights as he had only just assumed his office.

Since limning is, in his view, the highest form of visual art, Hilliard insists that its practice is 'fittest for gentlemen'. 'I wish it were so that none should meddle with limning but gentlemen alone.' The art is 'for the service of noble persons very meet, in small volumes, in private manner, for them to have the portraits and pictures of themselves, their peers, or any other foreign persons which are of interest to them'. Here he states his belief, which eventually had to be somewhat modified, mainly because of his chronic insolvency, that the work of the gentlemen limners should be exclusively for those at the apex of society. For 'this is a work which of necessity requireth the party's [the sitter's] own presence for the most part of the time, and so it is convenient that they [the limners] be gentlemen of good parts and ingenuity, either of ability, or made by prince's fee able so to carry themselves as to give such seemly attendance on princes as shall not offend their royal presence.' It is

apparent that Hilliard, from early youth – and probably helped by his upbringing in the Bodley household – was fully able so to carry himself.

The artist does slightly qualify his remarks about his calling being 'fittest for gentlemen' by going on to write of 'true gentility, when God calleth' and conceding that 'though gentlemen be the meetest for this gentle calling or practice, yet not all; but natural aptness is to be chosen and preferred, for not every gentleman is so gentle spirited as some others are. Let us therefore honour and prefer the election of God ['nature's gentlemen', in fact] in all vocations and degrees'. All the same, he has sometimes been criticized in our egalitarian days for his views. But they are not peculiar to him. He recalls that

> the ancient Romans in time past forbade that any should be taught the art of painting, save gentlemen only. I conjecture they did it upon judgment of this ground: as thinking that no man using the same to get his living by, if he was a needy artificer, could have the patience or leisure to perform any exact, true and rare piece of work; but men ingeniously born, and of sufficient means, not subject to those common cares of the world for food and garment . . . would do their uttermost best, not respecting the profit or the length of time; nor permit any unworthy work to be published under their name to common view, but deface it again rather, and never leave till some excellent piece of art were by him or them performed worthy of some commendations.[18]

Hilliard's view was commonly shared in Elizabethan and Jacobean days. The little work on the art of illumination published in 1573, *Limming*, enumerates in its lengthy title-page all the things 'necessary to be known of gentlemen'; and Henry Peacham, in *The Compleat Gentleman*, devotes a whole chapter to the subject of 'drawing, limning and painting'.

Setting out the conduct proper for a limner, Hilliard declares that all those endowed with a natural aptness by God should 'rejoice with humble thankfulness . . . lest it be soon taken from them again by some sudden mischance; or, by their evil customs, their sight or steadiness of hand decay'. They should 'sleep not much, watch not much [not stay up too late], eat not much, sit not long, use not violent exercise in sports . . .', although a little dancing is admissible, or a game of bowls. 'Discreet talk or reading, quiet mirth or music, offendeth not, but shorteneth the time and quickeneth the spirit, both in the drawer and he which is drawn.' And the limner must at all costs 'avoid anger, shut out questioners or busy fingers'.[19]

The *Treatise* – which bears all the signs of being a first draft – exists only in one manuscript copy, now in Edinburgh University Library, transcribed by an unknown hand some five years after Hilliard's death (a page of the manuscript is reproduced in the new edition). It may be that

in the final version the artist would have omitted the personal observations which obtrude from time to time; if so, it would have been to our infinite loss. One of the most entertaining of these is sandwiched between a dissertation on the preparatory technique of applying the 'carnation' or flesh-tint on which the face of the sitter is to be painted, and advice on tempering colours which have dried out in their shell containers. He cannot resist a swipe at difficult sitters: 'I have ever noted that the better and wiser sort will have a great patience, and mark the proceedings of the workman [artist], and never find fault till all be finished. If they find a fault, they do but say "I think it is too much thus, or thus", referring it to better judgment; but the ignoranter and baser sort will not only be bold precisely to say, but vehemently swear that it is thus or so, and swear so contrarily that this volume would not contain the ridiculous, absurd speeches which I have heard upon such occasions.' Adhering – in theory, anyway – to his earlier advice that the limner must always keep his temper, he concludes: 'My counsel is that a man should not be moved to anger for the matter, but proceed with his work in order, and pity their ignorance.' The impulsive Hilliard must sometimes have found it difficult to follow his own counsel.[20]

Another useful piece of advice, again taken from his own experience, is to avoid telling the sitter that the hands are to be drawn, or he will become self-conscious: 'Tell not a body when you draw the hands, but when you spy a good grace in their hand take it quickly, or pray them to stand but still; for commonly when they are told, they give the hand the worse and more unnatural or affected grace.'[21]

The most vehement outbursts in the *Treatise* are on the conventional complaint about the poor rewards for artists in England – although Hilliard goes out of his way to exempt from blame 'the renowned and mighty King Henry the eighth, a prince of exquisite judgment and royal bounty, so that of cunning strangers [talented foreigners] even the best resorted unto him, and removed from other courts to his'. Artists in England are impoverished if they do not receive 'some profit by other trade, or that they be (as in other countries) by pension or reward of princes otherwise upheld and competently maintained', indeed, 'in other countries they are men of great wealth for the most part. Then you to whom it appertaineth to know may perceive the reason in part why they are not so here, the more is the pity'.[22]

Work of high quality is not rewarded as it deserves: 'one botcher nowadays maketh many, and they increase so fast that good workmen give over to use their best skill, for all men carry one price.' He takes up the point again later and at greater length, arguing that the 'excellent

workmen' usually take longer over their work than the 'bunglers' and are therefore poorer: 'for while the good workman taketh pleasure to show his art and cunning above other men in one piece (in what art soever), the botcher dispatches six or seven, and gives it a good word or a boast, keeping his promise within his time, which greatly pleaseth most men, for indeed the time is all in most matters'.[23] This has a familiar ring in our days.

It should not be forgotten, either – although Hilliard does not labour the point – that the limner's materials were often very costly. In writing about blue, for example, he remarks without comment that for limning, 'the darkest and highest blue is ultramarine of Venice.Of the best I have paid three shillings and eight pence a carat, which is but four grains – eleven pounds ten shillings the ounce; and the worst [cheapest], which is but bad, will cost two shillings and six pence the carat – seven pounds ten shillings the ounce'.[24]

All the surviving manuscript records, although inevitably scrappy for a man living four hundred years and more before our own time, combine to show that Hilliard's complaints about the poor rewards for artists were well founded in his own case. Although he received a great deal of royal and noble patronage, its value was very much more in the way of prestige rather than hard cash. Unlike Levina Teerlinc, for example, who enjoyed her annuity of £40 from the Crown throughout the thirty years of her working life in England,[25] Hilliard never received any kind of regular income until 1599 – thirty years after the start of his own brilliant career; and even individual 'rewards' were few and far between, and of dubious worth. Three pounds seems to have been the normal rate for an ordinary Hilliard limning without an elaborate setting; for example, the Household Accounts of the ninth Earl of Northumberland for 1 September 1585 to 27 November 1586, and from 16 June 1587 to 8 July 1588, show that Hilliard was paid sixty shillings each for two 'pictures' of the Earl; the same sum was paid to him for a third portrait-miniature in the 1590s, as shown in the accounts for 2 March 1594/5 to 21 February 1595/6 – by which time the Earl had inherited the lease of Syon House through his marriage to Dorothy, a sister of the Earl of Essex.[26] Three pounds was not negligible in current money terms, but could not be called lavish.

Three pounds – or less – would have been the fee for one of Hilliard's delectable miniatures of young women, done in 1574. The sitter is Jane Boughton *née* Coningsby, then aged twenty-one (Plate 7). The work remained in the family until 1980, when it was sold at Sotheby's for £75,000, a new auction record for any portrait-miniature.

Jane Coningsby came of a notable family: her great-grandfather Sir Humfrey was Lord Chief Justice, and her maternal grandfather a Judge of the Court of Common Pleas. Her father, Humfrey Coningsby Esquire of Hampton Court near Leominster in Herefordshire, is said to have been employed at Court. He died in 1559, committing his young daughter to the 'rule, order and bringing up' of her mother. She married into a prominent Warwickshire family called Boughton, who had long had estates near Rugby. Several Boughton girls married men with names echoing Shakespearean connexions – Lucy, Catesby, Combe of Stratford. Jane's husband was William Boughton Esquire of Little Lawford within the parish of Newbold-on-Avon, where he asked to be buried near his ancestors; he died in 1596. He and Jane had had four sons and two daughters.[27]

An attractive, although damaged, portrait of Jane's brother Thomas Coningsby, done in 1572 when he too reached the age of twenty-one, is now in the National Portrait Gallery. Thomas is fashionably dressed and holds a green lure with brown feathers in his right hand; round his neck hangs a green hood for his hawk, which flies upward at the top left of the picture. Thomas was a friend of Sir Philip Sidney, and visited Italy with him in the year after his portrait was painted; later he took part in the siege of Rouen under Essex in 1591 and was knighted there by the Earl.[28]

It has recently been argued[29] that Hilliard's career 'got off to a flying start' in the 1570s, but this is not altogether borne out by the evidence. Professionally he went straight to the top; and he did indeed marry his wealthy former master's daughter – but very large numbers of young Elizabethans did that; and in material terms he seems to have been continually in difficulty. On 9 January 1572/3 he received the first of several royal promises of tithes, leases and so on for his 'good, true and loyal service' – perhaps this was for the Queen's miniature done a few months before; but, as so often, it was more of a gesture than anything else. It was a grant of a lease of the rectory and church of Cleeve near Minehead in Somerset; but it was to come to him *in reversion only*, which normally meant on the death of the current holder; so he did not receive it at once and probably never benefited. Later in the year, on 11 October, there is a warrant under the Privy Seal for payment of the large sum of £100 for unspecified work. But it is only a warrant – to the Treasurer and Chamberlains of the Exchequer – to pay Hilliard, the money 'to be taken unto him as of our reward freely to be bestowed upon him'; and he probably never received this either. Long afterwards, an exactly similar warrant (dated 11 December 1591) authorized payment to him of £400; but the reward was to come out of such moneys or goods

as 'were or should be adjudged' (i.e. in the future) forfeited in the Exchequer Court; and after eight years had passed, Hilliard complained bitterly in a letter to Sir Robert Cecil that he had received only £40 of the total.[30]

To 1572, the year of the artist's first two promised but probably unpaid 'rewards' from the Crown, belongs also the first example of his reckless undertakings to help other people, which cannot have done them or himself much good. The evidence is in proceedings which he initiated some years later in the Court of Requests against one William Alcock, brother and executor of a deceased goldsmith Richard Alcock, from whom Hilliard's brother John had borrowed £13. Hilliard pledged his credit for his brother, taking out a bond of £20 with him guaranteeing payment of the debt. He maintained that the debt *was* paid, and that the 'obligation' was returned to him and John. But he had later departed for Paris, 'leaving sundry boxes and chests with many writings in the custody of lewd and negligent servants, amongst the which this obligation was also left', and presumably lost – a telling insight into the contrast between Hilliard the exquisite and meticulous artist and Hilliard the man totally disorganized in worldly matters.[31]

William Alcock, in his 'Answer' to Hilliard's complaint, maintained (in the manner customary on these occasions) that he had approached the artist 'in most gentle manner', but that Hilliard in return had 'used unseemly speeches' and declared at first that there had been no bond, although later he had admitted that there had; Hilliard, in his 'Replication' to the 'Answer', stuck to his original story. It is not known whether the suit went any further.

The Alcock papers of 1580 provide the last known documentary reference to Hilliard's brother John, and as he is not mentioned in their father's will made on 2 November 1586, it would seem that he died within that six-year period. A John Hilliard, citizen of London and goldsmith, became a substantial figure in the affairs of the City of London in the latter half of the sixteenth century, and at first I supposed that he was Nicholas's brother; but he turns out to have been a much older man, and I now think that he was his uncle. The conjunction of his profession – so much a part of the Exeter family – and his far from common surname must surely be more than coincidence. This John was an exact contemporary of Nicholas's future master and father-in-law, Robert Brandon: he was admitted to freedom of the Goldsmiths' Company by redemption on 19 March 1547/8 – a month after Brandon – paying £3 for the privilege plus three shillings for the oath: the Clerk enters his name 'John Hyller'. He had a distinguished career in the

Company, becoming successively Renter Warden (1562), 4th Warden (1569), 3rd (1575), 2nd (1580) and Prime Warden (Master) in 1584 – two years after Brandon. It was while he and two fellow Wardens were presiding at a meeting of the Court on 14 April 1570 that young Nicholas, his freedom by servitude newly granted – and his name entered as 'Helliard' – appeared to pay forty shillings to acquire his own first apprentice, in a transaction which will be set out in detail in the next chapter.

John Hilliard lived in Red Cross Street, in the parish of St Giles Cripplegate; and a minute-book relating to the Manor of Finsbury, recently transferred from Guildhall Library to the Corporation of London Records Office, contains many references to him from 1550 onwards – his surname, and that of members of his family, variously spelt Hillar, Hilliard, Hyllyarde, Hilliar, Hyllar, Hyllard, Hilliarde and Hillyard.[32] John Hilliard of Red Cross Street was one of the principal freeholders, and by 1550 he held from the Lord of the Manor a brewhouse in Golding (now Golden) Lane called the 'Flower-de-Luce', which he let out to other men. His first wife, Joan – he was her third husband – died in about 1584, and Hilliard inherited from her 'certain gardens . . . called new gardens', part of a large property in and near White Cross Street (the street – near the Barbican – still exists) consisting of a great house, tenements and eight-and-a-half acres of land, the whole 'called Glocesters'. A youth called Nicholas Hilliard – his name is surely significant – buried at St Giles Cripplegate, John's parish, on 25 May 1579 was probably a son of John and Joan.

For two years, from September 1580 to September 1582, John Hilliard served as a governor of Christ's Hospital: this charity school, founded in 1552 for orphaned boys and girls in the City, was then housed in the old Greyfriars buildings in Newgate Street close to St Paul's (and Goldsmiths' Hall). Hilliard served with two other leading freemen of the Goldsmiths' Company – Robert Brandon, and Andrew Palmer, later to be an Assay Master of the Mint.[33] In 1576 he sat on the Court of Common Council of the City, as one of the Aldermen's Deputies for the Ward of Cripplegate; and he appears again as a Deputy in 1585, when he pays into the Chamber (now presided over by Robert Brandon) the sum of £4.6s.6d., collected from 'foreigners and the strangers inhabiting the same ward' for the training up of two thousand men in gun-shot in 1578. He is still described as 'Deputy' in his burial entry on 17 May 1591 (where the parish clerk gives him yet another spelling, 'Hillare').[34]

John's son and heir, Robert, gentleman, succeeds him in the records of

the Manor of Finsbury – sometimes signing them, 'Hiller' and later 'Hyllyarde'; John's second wife, Katherine, was buried at St Giles' on 8 December 1602; Robert died in 1622 or 1623 and is succeeded in the records by another John Hilliard, gentleman, probably his son; John still holds the 'Flower-de-Luce', and he signs his name 'Hillyard'. I have not pursued this family further.

If the elder John Hilliard was indeed the uncle of Nicholas and John of Exeter, he may well have had something to do with placing them as apprentices in the City of London in the 1560s – especially as it has now become clear that he was associated with the master chosen for Nicholas, Robert Brandon. Nicholas was soon to be far removed from him, however, in the world of the Court and nobility. It is sometimes assumed – perhaps partly because the letters from him which survive are all addressed to Sir Robert Cecil, son of Lord Burghley and himself the first Lord Salisbury – that his principal patrons were the Cecil family. But during the first part of his career he was more closely connected with the Protestant circle of Robert Dudley, the Queen's 'sweet Robin' whom she had created Earl of Leicester in 1564 while Hilliard was still an apprentice. An early Hilliard miniature of the Earl was done in 1576 (Plate 8).

The significance of an entry in the manuscript records of the Goldsmiths' Company dated 6 April 1571 has not, I think, hitherto been recognized. It is about a dispute between a goldsmith called Edmund Cradock, and Nicholas and John Hilliard, over a jewel and four little gold rings, which Cradock had received of the brothers 'in earnest of a bargain between him and them'. The jewel is described as being a rose of gold enamelled with a diamond in it and a pendant pearl (very like some of the pieces in the Cheapside Hoard); two of the rings have 'ragged staves in them' (my italics). The bear and ragged stave or staff formed the famous cognizance of the Earl of Leicester, so it is clear that this commission was for him. The ragged staff often appeared without the bear: on New Year's Day 1580, for example, the Earl gave the Queen a black velvet cap 'with a band about it with 14 buttons of gold garnished with diamonds, being ragged staves and true-love knots, garnished with rubies and diamonds, and 36 small buttons, being true-love knots and ragged staves'. And in the Beauchamp Chapel at Warwick, where the Earl and Countess and their little son Robert lie buried, their monuments are decorated with ragged staves and cinquefoils.[35]

A few weeks before the dispute between Cradock and the Hilliard brothers – on 23 February 1570/1 – Agnes Rutlinger, the wife of John, a goldsmith and a prominent engraver, had promised to deliver to one Thomas Clerke 'a book of portraitures', whole and perfect, within a

week, the book being at present in the hands of Nicholas Hilliard.[36] This is the earliest known documentary reference to Hilliard's work. Rutlinger, Rutlingen or Rutling – the name of this immigrant family (presumably from Reutlingen in Württemberg, Upper Germany) is spelt in all these ways in contemporary manuscripts – figures in the Goldsmiths' book again on 6 April, the day of the entry about the Hilliard brothers and the jewel and rings. And again it is in connexion with a commission from the Queen's powerful favourite: Rutlinger is promising to finish 'a book of gold' on the following Thursday, or sooner if possible, 'which book he hath to make for Mr Lonnyson to the use of my Lord of Leicester'. Lonnyson, like the former masters of the Hilliard brothers, was a leading goldsmith of Westcheap, living at the sign of 'The Acorn': he was a Warden of the Company in 1574 and 1579, and a master worker of the Mint from 1572 until his death in 1582.[37]

Rutlinger executed a remarkable line-engraving of the Queen in about 1589 or 1590, showing all the characteristics of a craftsman skilled in goldsmith's work. It has been remarked that the ruff is of the same type as the one portrayed in the second Great Seal of the realm – which, as will be explained in Chapter 6, came into use in 1586, and which Hilliard designed and may have helped to engrave – and also as the one in the Armada Jewel containing a (much restored) miniature portrait by Hilliard of the Queen, which she presented to Sir Thomas Heneage after the defeat of the Armada in 1588. Rutlinger was Under-Graver of the Mint for a time, during the Mastership of Sir Richard Martin who has been mentioned several times already. In 1568 he and his wife were living in the precinct of St Martin-le-Grand near Westcheap, a haunt of immigrants; later they moved to the parish of St Anne and St Agnes behind Goldsmiths' Hall, where Rutlinger died intestate in 1608.[38]

Whatever the nature of the 'book of portraitures' and the 'book of gold', the references to them indicate that Hilliard was already designing portraits for engravers as early as 1571 – and perhaps doing some engraving himself. It may be relevant to note that two signed portraits of the Queen by the eminent immigrant engraver Remigius Hogenberg are very near in type, and apparent age, to Hilliard's miniature of her done in 1572. As I have recently established, Hogenberg was living in the parish of St Giles Cripplegate in the 1580s (making him a fellow-parishioner of Hilliard's supposed uncle John): a son and daughter were baptized there in April 1585 and December 1587, and the engraver himself was buried on 16 March 1588/9; a son and namesake was baptized a month later, and three sons and a daughter were buried in October 1592, no doubt victims of the devastating outbreak of plague which began in that

autumn and continued until 1594. Perhaps Hogenberg gave the young Hilliard tuition in engraving at some stage (he is said to have been in England from about 1572). It is interesting that in about 1587 he engraved a bird's-eye plan of Exeter, Hilliard's home town.[39]

Engraving techniques are a major influence on Hilliard's art: his liking for a clear, precise line, and his method of shadowing by hatching, both derive from the training. As we know, he insisted that 'the principal part of painting or drawing after the life consisteth in the truth of the line'; and of shadowing in limning he writes that it 'must not be driven with the flat of the pencil, as in oil work, distemper or washing, but with the point of the pencil [tip of the brush] by little light touches, with colour very thin, and like hatches, as we call it, with the pen'. He especially praises the line engravings of Dürer – 'cunning Albert', who like himself was the son of a master goldsmith: he is 'as exquisite and perfect a painter and master in the art of engraving on copper as ever was since the world began'; and again, 'the most perfect shadower that ever engraved in metal'. Hatching with the pen, in imitation of Dürer's engravings, should be practised by the apprentice limner before ever he begins to limn; his copies should be so exact 'as one shall not know the one from the other, that he may be able to handle the pencil point in like sort'.[40]

An engraved title-page dating from 1574 was almost certainly designed by Hilliard. It is an elaborate affair, with at the top a lamb with its legs bound and a knife at its throat, twisted columns and vine branches at the sides, and at the bottom a vase with the date; near the top are the engraver's or designer's initials, 'NH', and below this a monogram of 'C' and 'T'. The title-page remained in constant use until at least as late as 1641, when the block seems hardly to have deteriorated at all: it must have been engraved on very hard wood, since a print of 1641 is actually better than most of the early ones. The design has been used for the title-page of the new edition of Hilliard's *Treatise*.

A title-page of 1571 has only the initials 'CT' (presumed to have been the cutter of the one of 1574), but it is so close in conception and quality to the other that it seems likely to have been designed by the same hand; and it will be remembered that 1571 was the year in which Hilliard was working with the engraver John Rutlinger on the 'book of portraitures'. Three other title-pages, two of them dated 1575, also have the initials 'CT' – with 'RB', which might conceivably stand for Robert Brandon, although there is no evidence elsewhere that he designed engravings.

It has been suggested that 'CT' might be a Dutch immigrant called Charles Tressell or Tressa who is entered in the aliens' returns as having arrived in England with his father in the late 1560s. He was the elder son

of Adrian, a schoolmaster; in 1571 he is entered as being 'a graver of letters for printers', which may mean a cutter of type-punches, and in 1582–3 (when he had a wife called Agatha) as 'a carver to the printers', which must mean a cutter of wood-blocks. It is probably significant that the family lived in the parish of St Alban Wood Street, a street which is next to Gutter Lane going eastwards: Gutter Lane is where the Hilliards lived after their return from France in 1578, and Nicholas probably lived somewhere near there in the years between 1569 (after the completion of his apprenticeship to Robert Brandon in Westcheap) and 1576, when he and Alice were married and left for France.[41]

4

A Scottish Adventure

An episode which must belong to the early 1570s constitutes the first evidence of the impetuous, over-optimistic and sometimes almost ludicrous efforts which Nicholas Hilliard made to further his prospects. It relates to an attempt to promote the mining of gold, a matter of prime professional importance to him, at Crawford Moor in Lanarkshire. The whole affair, of much intrinsic interest, illustrates Hilliard's eagerness (so characteristic of Elizabethan Englishmen) to join in any likely 'adventure', however dubious its promoters.

It is often stated[1] that the artist became involved in the Scottish project in 1578 or 1579: but he was in France from the latter half of 1576 until almost the end of 1578; and it is very much more likely that his involvement took place *before* he went abroad, probably in 1573 or 1574.

The first stage of the story is told in three letters now among the State Papers at the Public Record Office.[2] On 7 October 1566 Thomas Thurland, Provost of the Mines, writes two letters to London from Keswick, one to the Queen's principal secretary, Sir William Cecil, and the other to the Queen herself. A Dutchman called Cornelius Devosse, a Scot and an English merchant have brought him a sample of gold-bearing sand 'in a napkin' from Crawford Moor, a place which they report to be very rich in gold. 'This secret', says Thurland, 'is as yet unknown to Scotland', and he urges the Queen to secure a lease of the mine from Mary Queen of Scots before foreign merchants and/or rulers find out about it. In a second letter to Cecil, dated 5 December, he casts doubt on the probity of Devosse, and suggests secretly despatching someone else to Crawford Moor to bring back 'one little bag' of earth – 'all Scotland never the wiser'.

Eventually, on 4 March 1567/8, Devosse secured a licence to mine for gold and silver for nineteen years, employing not more than twenty people.[3] (Earlier he seems to have been employing a hundred-and-

twenty people in various valleys and dales, 'both lads and lasses, idle men and women, which before went a-begging'.) When he secured his licence, of course, Hilliard could not have had anything to do with the enterprise, as he had not yet completed his apprenticeship.

The story is taken up by a London goldsmith, Stephen Atkinson, whose little book[4] *The Discoverie and History of the Gold Mynes in Scotland* was published in 1619 – just after Hilliard's death, but partially based on what the artist had told the author. Atkinson's account is muddled and repetitive, but sense can be made of it.

Devosse's licence of 1568 had been granted in the names of King James VI of Scotland, the future James I of England (who was then not two years old), the Regent – the Earl of Moray – and others. Moray was assassinated at Linlithgow in January 1570 – a few months after Hilliard had become a freeman. Devosse is described as 'a most cunning artist, and excellent in art for trial of minerals and mineral stones'; Atkinson states that he sometimes lived in London, where he was 'well acquainted with Mr Hilliard, then principal drawer of small pictures of the late Queen Elizabeth'. He was perhaps the 'Cornelius Devoys' who in 1564 was living in Hosier Lane, in the sprawling Holborn parish of St Sepulchre-without-Newgate – then a haunt of artists – and who was assessed at the high figure of £150.[5]

Devosse 'procured' Nicholas Hilliard to 'adventure with him into Scotland, and to send his servant and friend as an agent thither, by name Arthur Van-Brounckhurst'. This man was 'known to be a good artist, skilful and well seen in all sorts of stones, especially in minerals and mineral stones'. No doubt Devosse believed that Hilliard's already powerful connexions would he helpful; his 'procurement' of the artist means, in the language of the day, that Hilliard agreed to share in a speculative enterprise in Scotland, *not* to go there himself, as has sometimes been supposed. 'Mr Hilliard ceased not, until he had procured patent which was granted unto Cornelius Devosse', and Van Brounckhorst as their agent 'set sundry workmen to work' at Crawford Moor.[6]

After two stopgap appointments, the Earl of Moray was succeeded as Scottish Regent by the Earl of Morton in November 1572, and the conclusion must be that it was very soon after that – and not some years later – that Hilliard used his best endeavours to get Devosse's licence renewed. They would certainly not have wanted any delay.

To begin with, as Atkinson makes clear, Van Brounckhorst had 'a further privilege' not granted to others before him: 'he was admitted to bring with him into England a good quantity of gold unrefined . . . and to

put the same stones, minerals or mineral stones, and the gold that there withall dwelled, safely into a barrel or vessel.' Cornelius Devosse and Mr Hilliard had 'had the like from thence before sundry times'. But eventually Van Brounckhorst was ordered to deposit all gold found at Crawford Moor at the Scottish Mint House, whereas before it had been agreed that he should simply pay in the value of the gold – 'whereas before, it was conditioned, betwixt Mr Hilliard and Cornelius of the one part, and Van Brounckhurst of the other part, that the said Brounckhurst should pay the full valuation for all such natural gold as should be gotten by him in Scotland, unto the King in minority, or unto the Regent, for use of His Majesty'. Finally, Van Brounckhorst was compelled to enter King James's employment, 'to draw all the small and great pictures' for him. It is usually stated that this enforcement dates from 9 September 1580, since that is the date of a precept authorizing payment of the large sum of £64 to the artist. But the payment is being authorized – as one would expect – *for work already done*, so that Van Brounckhorst must have entered the royal service in Scotland at some earlier date, perhaps some considerable time before.[7] In any case, he seems to have been back and forth between Scotland and London: in 1573, for example, he painted a portrait of Lord Burghley and in 1578 one of Oliver St John, first Baron St John of Bletsoe (the man wrongly thought to have sat to Hilliard in 1571), whereas he must have been in Scotland when dated portraits of the boy King James (1574) and James Hamilton, second Earl of Arran (1578) were painted, if these last two are correctly attributed to him; an undated portrait of the Earl of Morton, of c.1575, has also been attributed to Van Brounckhorst.[8]

In the 1580s he was back in London, in the parish of St Nicholas Acons in Lombard Street, where three children of Arthur and Sara 'Brunkhurst' – Sara, Michael and William – were baptized in 1582, 1584 and 1586. This was a parish favoured by goldsmiths, and by immigrants; among them, earlier in the century, had been the leading goldsmith and friend of Holbein known to history as 'Master John of Antwerp'. The burial of 'Cornelis Clewtinge de Vos, Dutchman' is recorded there on 11 December 1586, and I suspect that he was the Cornelius Devosse who had been associated with Hilliard and Van Brounckhorst in the gold-mining project.[9]

There has been some doubt in the past about whether Van Brounckhorst's name was Arthur or Arnold, since he is called 'Arnold' in the Scottish precept: but the London evidence now assembled seems to prove that it was 'Arthur', especially as Atkinson's book of 1619 on the Scottish gold-mining adventure, largely based on information

from Hilliard, who obviously knew the man, consistently calls him 'Arthur'.

Since all the evidence suggests that Hilliard had some instruction in the technique of limning from a painter or painters trained in the Flemish tradition, it seems possible that Cornelius Devosse and/or Arthur van Brounckhorst (both described as good artists, and the latter known to have painted 'small pictures' for King James) provided that instruction – or some of it. That would have led on naturally to the gold-mining adventure as soon as Hilliard had completed his formal apprenticeship with Robert Brandon and become a freeman. Devosse was obviously an older man than his 'servant' Van Brounckhorst, so perhaps the credit belongs to him.[10]

Whatever the exact timetable of the gold-mining adventure, Hilliard was still smarting over it more than forty years later. 'Mr Hilliard and Cornelius Devosse lost all their charges', says Atkinson, 'and never since got any recompense, to Mr Hilliard's great hindrance, as he saith.' Later ventures were to be similarly unsuccessful.

It is inconceivable that he should have gone to Scotland himself in the early 1570s, at a time when he was just making his way at Court and with noble patrons in London, and producing some of his finest work. In addition to that, he was beginning to take apprentices. He acquired the first only a few months after he had become a freeman: this was John Cobbold, who was 'set over' (transferred) to him by the widow of Cobbold's former master on payment by Hilliard of forty shillings for her goodwill, with the promise of a further twenty shillings in a year's time. (The payment was made, as mentioned earlier, at a meeting of the Goldsmiths' Court on 14 April 1570 attended by Warden John Hilliard, the young artist's supposed uncle.) Cobbold went to live with Nicholas Hilliard – wherever he was living at the time, which we do not know. In 1571 a foreign goldsmith called Gualter Reynolds – born in Brunswick and attending the Dutch Church in London – who had come to England 'to increase his knowledge of that art', was also studying under Hilliard. Here is further evidence of the high regard in which he was already held, while still only in his mid-twenties. On 13 March 1572/3 William Smythe was apprenticed to him; and on the following 20 July another immigrant, William Franke – probably a German – who had begun his apprenticeship with Mr Edward Gylbert (the former master of Hilliard's brother John) was 'turned over' to Nicholas and entered his household, replacing John Cobbold, who had been freed the month before. Finally, John Pickering was apprenticed to him on 21 March 1574/5.[11] According to George Vertue, the artist John Bettes the Younger also studied

under Hilliard; if so, it must have been an informal arrangement, for he became a freeman not of the Goldsmiths' but of the Painter-Stainers' Company. He subsequently secured his freedom of the City, his Company paying the Chamberlain (Robert Brandon's predecessor) £3.6s.8d. for the privilege on 10 May 1582.[12]

On 25 June 1576 Hilliard may have ridden out through Aldgate and along the lanes to Stepney to attend the funeral of Levina Teerlinc – if, indeed, she had given him some instruction in the art of limning; three weeks later, on 15 July, at St Vedast Foster Lane close to Goldsmiths' Hall, he married Alice Brandon, who was now twenty years old. The young couple left for France shortly afterwards.

5

The Hilliards in France: 1576–78

As Hilliard departs overseas, at the age of twenty-nine and after some six or seven years of brilliantly successful but poorly rewarded work in London, it is appropriate to quote his 'portrait of the artist':[1]

The good workman . . . dependeth on his own hand, and can hardly find any workmen to work with him to help him to keep promise and work as well as himself, which is a great mischief to him. Neither is he always in humour to employ his spirits on some work, but rather on some other. Also, such men are commonly no misers, but liberal above their little degree, knowing how bountiful God hath endued them with skill above others; also, they are much given to practices to find out new skills, and are ever trying conclusions; which spendeth both their time and money. And oft-times, when they have performed a rare piece of work (which they indeed cannot afford), they will give it away to some worthy personage for very affection, and *to be spoken of*. They are generally given to travel, and to confer with wise men, to fare meetly well, and to serve their fantasies, having commonly many children if they be married. All which are causes of impoverishment if they be not stocked to receive thereupon some profit by other trade, or that they be (as in other countries) by pension or reward of princes otherwise upheld and competently maintained, although they be never so quick nor so cunning in their professions, depending but on their own hands' help.

Thus much I thought need to insert in respect of the common opinion, or common slander rather, which is that cunning men are ever unthrifts, and therefore generally poor. Indeed, when by the causes aforesaid they are fallen poor, they have a more unthrifty show than others, for they will spend still if they can come by it; so that I think they love the liberal sciences, and it is a virtue in them, and becometh them like men of understanding. If a man bring them a rare piece of work, they will give more for it than most men of ten times their ability [to pay]. . . .

This passage comes between the sections on the sapphire and the emerald, and when he launched upon it, Hilliard seems to have had the

jeweller principally in mind; but it soon develops into an apologia for artists of all kinds.

Elsewhere[2] he urges the artist to put his whole heart and soul into his work: 'Then this exhortation give I . . ., that he be diligent, yea ever diligent, and put his whole, uttermost and best endeavours to excel all others . . . the most perfect and cunningest must do the same diligence, or rather more, to effect and perform his work, than he did at the first in learning.' Inborn ability is not enough: 'for it cannot be said that a man, be he never so cunning by teaching or natural inclination, yet it will grow out of him as hair out of the head, or fall from him whether he will or no, but [only] with great labour'. If he is so diligent, 'this comfort shall he have then above others, even an heaven of joy in his heart to behold his own well doings *remaining to his credit forever*. Yea, if men of worth did know what delight it breedeth, how it removeth melancholy, avoideth evil occasions, putteth passions of sorrow or grief away, cureth rage, and shorteneth the times, they would never leave till they had attained in some good measure. Ay, more than comfort may he have, both praise and even honour in the sight of men living, and *fame for ever after*; and princes commonly give them competent means' by which they are *'eternized, and famously remembered* . . .' (my italics throughout).

Here speaks a true Elizabethan, obsessed with the transitoriness of life, a feeling perfectly expressed by Shakespeare in the opening lines of Sonnet 15:

> When I consider every thing that grows
> Holds in perfection but a little moment. . . .

The poet rails constantly against Time – 'Time's scythe', Time's 'injurious hand', Time's 'fell hand'; Time is 'devouring' and 'swift-footed', a 'bloody tyrant'; our minutes 'hasten to their end'. The only defence is, in Hilliard's words, 'to be spoken of', to be 'famously remembered' – to achieve the kind of immortality both claimed by the poet and promised to his young friend:

> So long as men can breathe and eyes can see,
> So long lives this, and this gives life to thee.

In his pursuit of excellence, and so of 'fame for ever after', Hilliard was now, like the artist described in the *Treatise*, 'to travel, and to confer with wise men'. On 17 September 1576, two months after Hilliard's marriage, Nicholas Gorges wrote from North Foreland to Sir Francis Walsingham in London, having that day received instructions from the Privy Council 'concerning the conducting of the Lord Ambassador to France';[3] he

would, he replied, be ready to attend at Dover or the Downs 'as wind and weather shall give leave'. The newly appointed English Ambassador was Sir Amyas Paulet, a prominent Puritan and a faithful servant of the Queen who – like so many Elizabethan Englishmen – incurred much personal expense in the performance of public duties. From 1585 he was to be entrusted with the onerous task of keeping custody of Mary Queen of Scots and her household, and he once wrote despairingly from Tutbury: 'This Queen's servants are always craving, and have no pity at all on English purses.' He was one of the commissioners at her trial at Fotheringhay Castle, was present at her execution and died in the following year, 1588.

Judging from his copious official correspondence, Sir Amyas's term as Ambassador to France, from 1576 to 1579, was similarly burdensome. He landed at Calais on 25 September, *en route* to take up his duties, and one of the members of his train was the fifteen-year-old Francis Bacon, who had just come down from Trinity College, Cambridge. Nicholas and Alice Hilliard were almost certainly of the party also – for within a few weeks (on 8 December) the Ambassador was writing plaintively 'from St Dye besides Bloys' to Mr John Peter, Auditor of the Exchequer, enclosing an expense account supplementing others sent earlier: 'I must pray you to consider', he says, 'that my train hath been great by reason of *divers gentlemen recommended unto me by the Queen's Majesty* as Master Doctor Cesar, Mr Throgmorton and *Mr Helyer* [my italics] besides those of mine own company. . . .'[4]

The letter shows that the Queen's limner had travelled to France with her blessing; and although the point has not, I think, been remarked upon before, it seems more than likely that he went with a specific order to provide her with likenesses of François, Duc d'Alençon, the subject of the last and most prolonged of her marriage projects.

François was the third son of Catherine de' Medici and brother of Henri III of France. Henri himself had been a suitor of Elizabeth, but was now married; in 1570 Catherine had offered her second son, the Duc d'Anjou, as a prospective husband; that came to nothing, and towards the end of 1571 she tried once again, with Alençon. He was more than twenty years younger than the Queen, and was undersized and ugly, with a large nose and a face pitted with smallpox; but he was reputed to be lively, responsive, civilized and a good talker, qualities likely to appeal to Elizabeth's sharp intelligence.

Catherine and Elizabeth at this time both wanted an alliance, even if there were no marriage, and after much negotiation they concluded the Treaty of Blois in April 1572. Time passed, and by 1576, the year of

Hilliard's arrival in France, the first courtship had faded – the prospective bride and groom having still not met.

In the following year, Hilliard was in Alençon's employment, for a list of members of his household between 1562 and 1584 includes the entry: '*Nicolas Béliart, peintre anglois, valet de chambre du duc d'Alençon en 1577 à 200 livres de gages*'.[5]

A tiny and famous prayerbook belonging to Queen Elizabeth, in which she wrote six prayers in as many languages, was decorated by Hilliard with a portrait of Alençon at the beginning and one of herself at the end (Hilliard writes in the *Treatise* of limning being 'fittest for the decking of princes' books'). Its whereabouts are no longer known, but a black-and-white facsimile in the British Library, printed in the 1890s, gives some idea of the original, and from it Erna Auerbach was able to identify a Hilliard miniature, now in the Kunsthistorisches Museum in Vienna (Plate 9), as being of Alençon.[6]

Presumably the Queen was not repelled by Hilliard's limnings of her prospective wooer. A second courtship began, and in January 1579 – shortly after Hilliard's return to London – Alençon sent over a personal envoy, Jean de Simier, Baron de St Marc, 'a most choice courtier, exquisitely skilled in love-toys, pleasant conceits and court-dalliances'.[7] The revived marriage project seems to have caused the English Ambassador much trouble: on the previous 6 December he had written home: 'Simier cometh now unto you, and to be plain with you, I am not sorry that he is among you, where you are at the well-head to receive your instructions to answer directly *ad omne quare*, and now I trust to come to some rest, having been baited here one month and more as a bear at the stake, and had nothing to say but stood still at my defence for fear to take hurt.'[8]

The Queen always loved to bestow nicknames on those about her: Burghley was her *Spirit*, dark Walsingham the *Moor*, Hatton the *Mutton* or *Sheep*, Leicester her *Eyes* (he sometimes signed his letters with two circles with a dot in each). She promptly christened Simier her *Monkey*, and in writing to her he compliantly signed himself '*votre pauvre Singe*'. Discussion of marriage terms went forward, and in August Alençon himself visited England for the first time – at once becoming the Queen's '*petite Grenouille*', her little frog. Hilliard no doubt waited upon his former employer. By this time the Queen was forty-six, and it was clear that hopes that she would produce an heir to the throne must be abandoned; there was growing political and public opposition to the match. Alençon came over once more, during the winter of 1581–82, but by then English interest was at an end, and he returned home in

February – the Queen and her Court, anxious that he should not be offended, escorting him as far as Canterbury, and Elizabeth showing him her great ships at Rochester. Lord Leicester, Lord Hunsdon and others attended him on the crossing to Flushing, in a fleet of fifteen large vessels, and Leicester went on with him as far as Antwerp. Alençon died two years later.

In a despatch to the Doge and Senate written just after the Queen's death, the then Venetian Secretary in England, Giovanni Carlo Scaramelli, said it was accounted one of her most remarkable achievements that, 'although she never had the smallest intention of taking Alençon for a husband, she led the French to that most momentous step of making him Protector of the States', thereby casting France into open war with Spain.[9]

Hilliard's fluent French, acquired during his time in Geneva as a boy, had enabled him to fit easily into the Duc d'Alençon's household while he was in France. And there is considerable evidence of his friendship with other leading French people during his visit of 1576–8. He may well have become acquainted with the small but brilliant Court of Navarre, since Alençon was now on good terms with his sister, Marguerite, Queen of Navarre. Both Alençon and the English Embassy went as far south as Poitiers in the summer of 1577. Hilliard probably went too, and it would have been then that he met the artist Jacques Gaultier, who at one time was closely connected with Navarre and who two years later became official painter to the city of Bordeaux. Among the correspondence – now in Lambeth Palace Library – of Francis Bacon's brother Anthony is a letter from Gaultier written in Bordeaux and dated 12 January 1592/3. In a postscript he begs leave to salute '*les bonnes graces de Monsieur Hyllart paintre et orfeuvre* [goldsmith] *de la Royne sil est pres de vous*'. He sends a sample of paint, and begs Hilliard to let him have a pound of the same colour – a notable tribute to Hilliard's excellence in the practice of his art. Hilliard probably also knew the famous engraver Léonard Gaultier, who is presumed to have been a son of Jacques. A further piece of evidence about Hilliard's renown in France is an anagram of his name, written at the beginning of the seventeenth century and signed: '*Votre meilleur ami, et serviteur à jamais Jehan Durant Parisien*'. It is a rather tortuous affair, based on changing the second 'l' in the artist's name to 'e', producing 'Nicolas Hileyart', and then forming the anagram '*En Christ ay la loi*'. This was written out in gold by a famous English calligrapher, Peter Bales, and is now in the library of the Victoria and Albert Museum.[10]

When Hilliard composed his *Treatise* more than twenty years after

visiting France, he recalled meeting Ronsard: 'I heard Ronsard the great
French poet on a time say that the islands indeed seldom bring forth any
cunning man [talented artist], but when they do, it is in high perfection;
so then I hope there may come out of this our land such a one, this being
the greatest and most famous island of Europe.'[11] His hope was fulfilled
in his own person – a fact which he probably had in mind when he wrote.
Bernard Shaw once remarked that the 'timid cough of the minor poet'
was never heard from William Shakespeare: read 'painter' for 'poet', and
the same might be said of his great contemporary.

Among Hilliard's close friends and admirers in France was Blaise de
Vigenère, philosopher, man of letters and secretary to the Duc de
Nevers; Vigenère wrote a eulogy of Hilliard describing him as '*un peintre
Anglois nommé Oeillarde*'[12] (it is odd that the French should have had
such difficulty with his name, since it differs only in its initial letter from
the common French name Tilliard). In a letter to his employer, Vigenère
reported that Hilliard was an outstanding artist, in works of small size at
any rate: '*Le dit peintre angloys est tenu pour l'un des plus excellents dont on
aye memoire au moins en petit volume*': and he suggested that he should be
employed to do a complete book (presumably of engravings) for Nevers
of leading figures of the day, '*les princes et illustres personnages de ce temps,
hommes et femmes*'. This is a reminder of the 'book of portraitures' with
which Hilliard had been concerned at the start of his career in London a
few years earlier.

Whether or not anything came of the project for a book is not known,
but Hilliard certainly did execute fine wood-engravings of Nevers and
his wife for a small quarto volume containing the constitution of a charity
which they had founded, the *Fondation du duc de Nivernois*, to arrange
marriages for sixty poor maidens. Vigenère got in touch with him about
the commission after earlier attempts by two other men, a Frenchman
and a Fleming, had been found unacceptable and their engravings
removed from the title-page. The pear-wood then used was also to be
removed, and boxwood – a harder wood – substituted; and it was even
suggested that the Duc should travel to Paris to sit for the English artist –
further evidence of his renown and excellence.[13]

Things did not go smoothly, for on 20 February 1577/8 Vigenère
wrote to his master that he was having difficulty in tracking down
Hilliard. He had been staying with '*maistre Herman l'orfèvre*' – presumed
to be Germain Pilon, an eminent goldsmith and sculptor employed by
Henri III – and had been supposed, but wrongly, to have gone on to the
Court; he was eventually discovered taking refuge in the house of '*maistre
Georges, le peintre de la reyne*', the Queen Mother Catherine de' Medici's

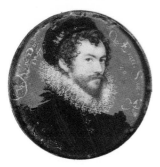

1. Self-portrait miniature
by Nicholas Hilliard, aged 30
in 1577

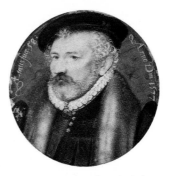

2. Richard Hilliard, father
of the artist, aged 58 in 1577
by Nicholas Hilliard

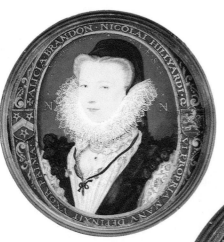

3. Alice Hilliard, *née*
Brandon, wife of the artist,
aged 22 in 1578
by Nicholas Hilliard

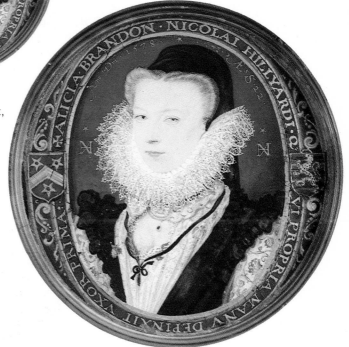

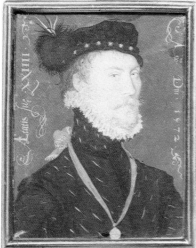

4. Unknown man, aged 24
in 1572
by Nicholas Hilliard

5. Young Man among Roses,
inscribed *'Dat poenas laudata
fides'*
by Nicholas Hilliard

Flemish painter 'George of Ghent'.[14] Hilliard was probably hiding in the house of the hospitable George to escape creditors (it is evident that he was on excellent terms with the artists employed at the brilliant Valois Court).

Some light is thrown on this by a letter written to Sir Francis Walsingham by the English Ambassador on 19 February – the day before Vigenère's letter to his master. Paulet's relevant passage (which has always been misquoted) reads:

> It may please your honour to be advertised that Helyard meaneth nothing less than to leave Her Majesty's service [has absolutely no intention of doing so], being repaired hither for no other intent, as he saith, than to increase his knowledge by this voyage [compare with what he says in the *Treatise* about travelling abroad to consult 'wise men'], and *upon hope to get a piece of money of the lords and ladies here for his better maintenance in England at his return* [my italics]; where he would have been before this time if he had not been disappointed by some misfortunes, intending to repair thither very shortly, and carry his wife with him.[15]

Authors have wrongly assumed that the summary in the printed Calendar of State Papers is a transcription. Paulet is made there to write of Hilliard that 'he would have been back by this time, if he had not been disappointed by some misfortunes. He intends to go shortly, and carry his wife with him'. This is twentieth-century phraseology.

The Ambassador's letter makes it clear that the Queen was becoming restive and demanding to know when her gifted servant was coming home. His attempt to 'get a piece of money of the lords and ladies . . . for his better maintenance in England' underlines the fact that he had not been satisfied with the rewards of his work in London in the years up to 1576, and that he himself certainly did not consider his career to have made a 'flying start'.

He was understandably anxious to return home with his wife at this time, for Alice was in the later stages of her first pregnancy. Their son Daniel was baptized in the City of London, at St Vedast Foster Lane – where they had been married nearly two years before – on 16 May. (Why was the baby called Daniel? It was presumably the name of an unknown godfather.) But a letter from Sir Amyas Paulet to the Earl of Hertford a month later shows that Hilliard was still then detained in France. The Ambassador writes: 'Helyer hath prayed me to signify unto your Lordship that he had finished your jewel long before this time if God had not visited him with sickness, and that he trusteth to end the same within three weeks, and then will not fail either to bring or send it to your Lordship. . . . Paris 16 June 1578.'[16]

Hilliard must have painted his self-portrait miniature (Colour Plate 1) and the one of his father (Colour Plate 2) in France, since both are dated 1577 – as is a miniature of an unknown man aged fifty-two dressed in black and wearing a tall hat.[17] Richard Hilliard must have been visiting his son and daughter-in-law, and it seems reasonable to assume that he escorted Alice home for the birth of the baby. The beautiful miniature of her (Colour Plate 3), now in the Victoria and Albert Museum, is dated 1578, and her husband no doubt did it before she left: childbirth was hazardous (not to mention the Channel crossing), and he would not have risked waiting until his own return to London later in the year.

The self-portrait is only 1⅝ inches in diameter. Yet it is so perfectly executed that it can be greatly enlarged (Plate 10) without losing any of its quality. The method the artist devised for portraying the lace of ruffs, well exemplified here, was to draw the complicated tracery with a very full brush of white lead, virtually dribbling the paint on to the vellum. Under magnification the lacework resembles the decoration piped with icing-sugar by a confectioner.[18]

Much has been written about French influence on Hilliard's work, and in particular about what has been described as 'the exquisite Gallicising miniature of Mrs Hilliard'. Carl Winter, in 1943, noted that the portrait-miniatures of the artist and his father are akin, in medallic shape and design, to Germain Pilon's medals of Charles IX (1572) and Henri III (1575) of France; and Hilliard himself, in the *Treatise*, refers to 'divers excellent persons of Italy, France and the Low Countries' while writing of engraving; he also names 'Rosso', presumed to be the Florentine painter, designer and engraver Giambattista Rossi (1494–1541), a leading figure in the school of Fontainebleau. Roy Strong finds the origins of his famous *Young Man among Roses* (Colour Plate 5) of the 1580s among the frescoes and stucco decoration of the Palace of Fontainebleau, and sees the young man's pose as being lifted direct from work there by the Italian Primaticcio. Examples of French Court painting could also, of course, have been seen at the Scottish and no doubt at the English Court.[19]

The limnings of Hilliard and his father, done in France in 1577, are round, as Holbein's miniatures had been; but the ones of the unknown man (1577) and Mrs Hilliard (1578) are oval – a shape the artist had already experimented with in his first miniature of the Queen in 1572; and after his return from France, the oval was his favoured shape, although he did sometimes revert to the round – as in the *Francis Drake* of 1581 in the National Portrait Gallery (Plate 11), where he probably felt that it was better suited to his sitter's stocky body and round head: as

Stow once described him, he was 'low of stature, of strong limbs, broad-breasted, round headed, brown hair, full bearded; his eyes round, large and clear; well favoured, fair, and of a cheerful countenance'.

Hilliard was still detained in France in August 1578 – for when, in London on the 22nd, his apprentice William Franke applied to be made free of the Goldsmiths' Company, he was told that this was impossible because his master was 'at this present beyond the seas'. He was instructed to wait for six weeks, during which time Master Warden Brandon, Hilliard's father-in-law, would write to him. In fact, the young man had to wait a good deal longer than that: he was eventually freed on 3 November,[20] which indicates that Hilliard had just returned and could present him for freedom in the required way. Hilliard later said [21] that he had been abroad for 'two years', which neatly fits with the present assumption that he left for France in September 1576 and returned probably in October 1578.

Francis Bacon stayed on in France until the following March. Hilliard had done a miniature of him in 1578, at the age of eighteen (strictly speaking, in his eighteenth year – he was born in 1561), which is now at Belvoir Castle, in the collection of the Duke of Rutland (Plate 12). At Gorhambury in Hertfordshire (where Bacon had his country house – 'a large, well-built Gothique house', as John Aubrey calls it) is a copy of this miniature, done in 1805; it is inscribed on the reverse with the information that the original belonged to one James Edwards and that previously it had been in the French royal collection. Edwards (1757–1816), a prominent bookseller and bibliographer, established his reputation by buying up libraries on the continent during the post-revolutionary period, and it was presumably he who brought the miniature to England. He retired to Old Verulam, so that the copyist at Gorhambury was working from a miniature in the hands of a close neighbour.[22]

There is a postscript to be added to the story of the limning of the young Francis Bacon in 1578, from forty years on. By then Bacon had become Lord Chancellor and Baron Verulam, and Nicholas Hilliard was within weeks of his death. In the Public Record Office is a small paper account-book,[23] presumably written by Bacon's steward, setting out receipts and privy-purse expenditure in the period from 24 June to 29 September (Michaelmas Day) 1618. Sometimes the Lord Chancellor was at Gorhambury and sometimes at York House in the Strand (the official residence of the Lord Keeper, where Bacon himself had been born when his father held that office). Among 'Payments' is an entry for 1 September: 'Paid the picturemaker [unnamed] for your Lordship's picture', £33. 'Gifts and Rewards' during the period take up more than

eight folios, and total £302.7s.0d. It is a miscellaneous collection – my Lady Hatton's man who brought garden seeds gets eleven shillings; five shillings goes to Lady Bacon's footman who has brought cherries to London from Gorhambury; £2.4s.0d. is paid to the King's Trumpeters, and £3.6s.0d. to the Prince's; and a poor pilgrim receives £2.4s.0d. A buck is delivered (£1.2s.0d.), and a stag (£3.6s.0d.). Mr Recorder's man brings two salmon (£1.3s.0d.); £2.4s.0d. is paid for five fat wethers, five shillings for partridges, three for apricots, eleven for strawberries from Hackney (one of the principal market-garden centres supplying the capital), and 'one who rid twice to London for beer' receives five shillings. The same is paid 'to the washwoman for sending after the crane that flew into the Thames' (no doubt one of the ornamental birds which the Lord Chancellor liked to keep at York House – 'the aviary at York House was built by his Lordship', says John Aubrey; 'it did cost £300').

The two highest payments in the 'Gifts and Rewards' section of the accounts are of £22 to a Mr Butler in June and £25 to a Mr Guilman in July, and each is entered as having been 'a gift'. On 19 August two shillings is paid 'to the weeders in the garden by your Lordship's order'; the next payment on that day, and the third highest in the section, is of £11 'to old Mr Hillyard'. It is not entered as a 'gift' but was presumably meant as one – if it had been for a commissioned miniature, the entry would have been made under 'Payments', along with the one to the unnamed 'picturemaker'. It is pleasing to think that Hilliard received a substantial payment from the Lord Chancellor in the closing weeks of his life; it would have enabled his faithful servant Elizabeth Deacon to ease the discomfort of his last sickness.

6

Hilliard Back in London: 1578–87

It seems that Hilliard rejoined his wife – and saw his baby son Daniel for the first time – in October 1578, having failed in his hope of getting 'a piece of money' from the lords and ladies in France to further their maintenance in London. A year later, on 4 October 1579, their second child, Elizabeth, was baptized at St Vedast Foster Lane.

Shortly after his return, Hilliard had managed to borrow £70 from his father-in-law – but only on the most stringent terms: the loan was set against a property in the parish of St George's, Exeter, sold to Brandon by the artist's father, and the money was to be repaid at Brandon's house in Westcheap in exactly one year – on May Day 1580. Hilliard had by this time become a citizen of London, for he is described as 'citizen and goldsmith' in the document.[1] The artist's sudden outburst, written years later in the *Treatise*, about the 'common opinion, or common slander rather, which is that cunning men are ever unthrifts', sounds very much like an exasperated memory of criticism from his wealthy father-in-law.

It must have been at about the time of the loan, 1579–80, that Hilliard began to be afflicted by what was probably gout.[2] For, writing to Lord Salisbury on 26 March 1610, he says: 'I have been so visited and tormented this 40 days that I feared death; although but of the grief whereunto I have been subject this 30 years, yet never in so sharp a manner nor so long together, doubling upon me and returning again to the places from whence it was driven out (or in, I cannot tell whether).' This sounds like the 'flying gout', where the pain migrated seemingly without cause from one part of the body to another – an affliction later diagnosed in the case of George III. In Hilliard's case, the gout cannot have affected his painting hand, for he continued to produce work of the highest quality almost to the end of his long life; perhaps, like Falstaff, it tended to play the rogue with his great toe. Two earlier references in letters to Cecil hint at attacks of the same malady. The main purpose of

the first, written on 16 March 1593/4, is to put in a good word for a young engraver, known to Hilliard for nearly five years, who is in trouble for alleged coining: the artist explains that the letter is being delivered by the man's brother-in-law, and that he himself would have accompanied him 'the better to help him to the speech of your honour' – further evidence of Hilliard's good standing with Cecil; however, he is 'not in case [in a fit state] to ride'. The other letter, written on 6 May 1606, is seeking to advance the career of Hilliard's son Laurence: again he apologizes for not presenting himself in person – 'I am as yet not able to go abroad [out and about], which makes me humbly bold to write to your Lordship.'[3]

It seems that there is no full-length history of gout – assuming that Hilliard's complaint was indeed gout and not, say, rheumatism: it was not until about 1600 that French physicians established a satisfactory distinction between the two, and confusion continued for two more centuries. It is known that gout commonly affects men rather than women; that it is a hereditary metabolic disorder characterized by the deposit of sodium urate on the joints; and that the first onset is most commonly in the thirties – which would fit Hilliard's case. The artist would have been in sympathy with Lord Chesterfield's pronouncement, that 'gout is the distemper of a gentleman'.

It was probably in 1579, soon after Hilliard's return from France, that the family moved into their new home at the sign of 'The Maidenhead' in Gutter Lane off Cheapside, which was owned by the Goldsmiths' Company (Hilliard had originally been granted the lease in reversion on 9 June 1573, when it was stated that, on his actually securing it, it should run for twenty-one years).[4] He was to take over on the death of the then tenant, another goldsmith called Nicholas Johnson (the date of whose death I have not so far been able to discover). When Johnson himself moved in in the 1550s, he had had to share the premises with the widow of a third freeman of the Company, he and his family being allowed 'three chambers, whereof two have chimneys, with a privy, and a shop beneath for an entrance into the said rooms. And . . . his wife or maid one day in every week shall have the use and occupying of the kitchen there for their necessary washing' – an arrangement which may well have led to the arguments often arising over shared accommodation. Presumably by the time the Hilliards moved in the widow had died, and they could occupy the whole house.[5]

'The Maidenhead' was on the west side of Gutter Lane – and it could not have been at the Cheapside end, because the Company owned no properties there. It stood somewhere within the few yards between the

point where Carey Lane, running along the south side of Goldsmiths' Hall, meets Gutter Lane, and the point where Goldsmith Street runs into Gutter Lane on the other, east, side.[6] Wherever it was, the house must have had a window providing the north light 'somewhat toward the east' which the artist demanded for his work.

Certainly the Hilliards were parishioners of St Vedast by October 1579, when their daughter Elizabeth was baptized; and Hilliard's name appears as a parishioner in a subsidy roll of 1582,[7] assessed at the modest figure of £5, with five shillings to pay (compared to his father-in-law's £120 with £6 to pay). Five pounds was a very common assessment for people living in the City – Shakespeare's assessment was the same when he was lodging in Bishopsgate in the 1590s. It has hitherto been believed that the Hilliards lived uninterruptedly in Gutter Lane for thirty-five years or so, but, as will emerge later, I do not think that they did.

The date of Isaac Oliver's birth in Rouen is not known. When, in the eighteenth century, George Vertue attempted to find the answer, he reported in a notebook that the 'best computation' he could arrive at was that the artist was sixty-one or sixty-two when he died in 1617; Horace Walpole could do no better, and in his *Anecdotes of Painting* written later in the century, he simply copied Vertue. Obviously neither man had been able to discover any facts. On the evidence of the dating of his first known work, Oliver cannot have been born as early as the mid-fifties; the most likely date is in or about 1565. And indeed, in a later notebook, Vertue says that he was 'between fifty and threescore' at his death.[8] Hilliard would have taken him into the Gutter Lane household on his return from France or very soon after, since fourteen was the customary age for a youth to begin his apprenticeship.

Oliver's was not a formal servitude, for – unlike his master – he was never a practising goldsmith and/or jeweller; he never appears in the records of the Goldsmiths' Company; and, again unlike Hilliard, he is never described as 'goldsmith' in official documents. Rowland Lockey, on the other hand, who began an eight-year term with Hilliard on Michaelmas Day (29 September) 1581, did register formally. It was then the practice of the Goldsmiths' Company to require boys to write their own apprenticeship entries, as a means of ensuring that they were literate. Lockey's entry[9] is in a large, rounded, immature hand, and his spelling is remarkably idiosyncratic even by sixteenth-century standards. 'Memomorrandom', he writes, 'that I Rowland Lockey son of Lenard Lockey of thi paresh of St Brids in Flitstrete crasbomakar have put my self prentice to Nicolas Hiliard for the terme of 8 yiers bigining at the fest of s meghel in anno d'm'i 1581 by me Rouland Lockey.' His father the

crossbow-maker was a freeman of the Armourers' Company; and he was a man of substance, for on 13 December 1576 he and two other freemen of the Company had been able to pay the considerable sum of £5 each to become freemen of the City. Rowland Lockey became a competent miniaturist, and died before his former master – in 1616.[10]

He and his French fellow-pupil Isaac Oliver had known each other from the time when they were little boys, for the Lockey family, like the pewterer Harrison with whom the Olivers lodged when they arrived in London, lived in Fleet Lane. Harrison's house was in the part of the Lane which ran westward from Old Bailey; the Lane turned south just before it reached the Fleet and went on down beside the water, and that is where the Lockey family lived, for it was only that part of the Lane which lay within their parish of St Bride's.[11]

A newly discovered will of 1588 provides interesting information about the two young limners: the testator, a Dutchman from Breda called Pieter Mattheus, bequeaths his 'books of arts' and that which 'concerneth' his art – presumably his brushes, palettes, colours and so on – to his 'two fellows' Isaac Oliver and Rowland Lockey, or 'Isac Olivyer and Rouland Lacq' as he exotically spells their names. This indicates that he had been studying with them under Hilliard: as a foreigner, the arrangement, like Oliver's, would have been an informal one. Pieter was a son of Jacob, perhaps the 'Jacob Mathewe, painter' who twenty years before – when the Olivers arrived in London – was living in the parish of St Sepulchre's where they lodged.

Pieter makes a number of bequests of money, ranging from £10 to £3, to people who have given him help and comfort in his 'sickness and otherwise': all the names are Dutch with the exception of the last two – Isaac Oliver and his mother Epiphane, who are each to receive £3 (this may mean that his father, Pierre, was dead). This at last establishes the Christian name of Mrs Oliver: in five aliens' returns, the best the English writers could manage was 'Typhan' (1571), 'Tyffen' (1571 and 1576), 'Tiffyn' (1582–3) and 'Tiffiny' (1608), 'Tiffany' being an English version of 'Epiphany'. Pieter bequeaths three 'pictures', of his late parents and himself, and also 'the Arte concerning Limming' (this must be the little book on the art of illumination, *Limming*, published in 1573), to his cousin Adrian van Zont, painter to King James of Scotland. He is lodging in Bishopsgate, and leaves to his landlord 'the framed picture of Charity'; he was buried at St Helen's on 6 November, three weeks after making the will.[12]

In later years (1601), Hilliard wrote to Sir Robert Cecil of his various apprentices: 'hoping to bring up others also for Her Majesty's better

service, I have taught divers both strangers [foreigners] and English, which now and of a long time have pleased the common sort exceeding well, so that I am myself unable by my art, any longer to keep house in London, without some further help of Her Majesty' – an echo of his complaint in the *Treatise*, written at about the same time, that 'all men carry one price', regardless of the quality of their work. He cannot have intended to include his brilliant former pupil Isaac Oliver among those who simply 'pleased the common sort'. It has been suggested [13] that relations between the two men were 'perhaps not in later years cordial': there is no evidence for this. Neither can have failed to appreciate the quality of the other as an artist, and probably they were divided by no more than their differences of race and temperament. Oliver, although he spent most of his life in England, never forgot his French origin, and lived determinedly within the closely-knit community of immigrant artists and craftsmen in the City of London.

The third Hilliard child, a boy, was born soon after Isaac Oliver is presumed to have joined the household in Gutter Lane; he was baptized Francis on Christmas Eve 1580. It has been customary to suppose that the baby was named after Sir Francis Knollys.[14] I think it more probable that the godfather was Francis Drake, who had sailed into Plymouth Sound a few weeks before at the end of his voyage round the word. He had been away for nearly three years, and his first anxious question to some passing fishermen was whether the Queen was still alive and well, since his whole future might depend upon the answer. Having received reassurance, he immediately sent his trumpeter, John Brewer, to London to announce his successful return to Elizabeth, whereupon she summoned him to Court to tell his story. The two great men of Devon, Hilliard and Drake, must have known each other well – and they were near to each other in age.

It was in the following spring, on 4 April 1581, that the Queen went down to Deptford where Drake entertained her to a banquet aboard *Golden Hind*. Writing to Philip of Spain two days later, the Ambassador, Bernardino de Mendoza, reported [15] that Marchaumont, a confidential agent of the Duc d'Alençon – the Queen's frog prince, and Hilliard's former employer – had been present, and that Elizabeth had handed him the sword to dub Drake 'Sir Francis'. The Spanish Ambassador further reported that the new knight had presented his sovereign with 'a large silver coffer, and *a frog made of diamonds*' (my italics). He would have taken advice on what would be an acceptable gift, being out of touch with affairs at home after so long an absence abroad, and had surely asked his friend, the Queen's goldsmith and jeweller, to fashion it for him: Hilliard

was probably present at the ceremony. Many little jewels of gold and enamelled frogs were given to Elizabeth during the years of the Alençon courtship: in 1587, for example, 'one little flower of gold with a frog thereon, and therein Monsieur his physiognomy, and a little pearl pendant' (this presumably from Alençon himself, and the 'physiognomy' probably commissioned from Hilliard), and 'one pair of bracelets of gold enamelled, set with letters of sparks of diamonds with this name, *François de Valois*, containing 8 pieces'; and on New Year's Day 1582 Lady Huntingdon gave her 'a green frog, the back of emeralds, small and great, with a pendant emerald, with a small gold chain to hang by'.[16]

Hilliard painted two miniatures of Drake in 1581, and no doubt they were commissioned to commemorate the great day at Deptford: the sitter is not portrayed in the usual martial gear, but is handsomely turned out in the manner of a courtier. The larger of the two, oval in shape, is now in Vienna;[17] the smaller, round, miniature (Plate 11) is the one in the National Portrait Gallery. Five years later, the Queen presented Sir Francis with what is now known as the Drake Pendant or Jewel: it is a superb affair of gold enamelled in white, opaque pale blue, pale green, mid-blue, translucent red, blue and green; the jewel is set with table-cut rubies and diamonds and hung with pearls, and in the centre is a sardonyx cameo of a negro's head. In this it resembles the so-called Gresley Jewel, where the exterior has a cameo of a negress – although she is seen in full-face, whereas the negro is portrayed in profile. Busts of negroes and negresses were among the most common subjects for cameo-cutters in the sixteenth and seventeenth centuries, combining the appeal of the exotic with exploitation of the layers of an onyx. Both these fine pieces were displayed at the *Princely Magnificence* exhibition at the Victoria and Albert Museum. Each opens to reveal the work of Nicholas Hilliard. Within the Drake Pendant is a miniature of the Queen, and the inscription, which has been damaged and over-painted, once read: '*Anno Dm 1586 28*' – the twenty-eighth year of the reign (in the past the jewel has been given wrong dates ranging from about 1575 to 1588). Inside the lid is a parchment lining painted, presumably again by Hilliard, with a phoenix. Drake is wearing the Pendant in a portrait dated 1591 which now hangs in the National Maritime Museum at Greenwich.

The Gresley Jewel contains two miniatures by Hilliard – one of a man and the other, inside the lid, of a woman. They are Catherine Walsingham, a cousin of the Queen's Secretary of State Sir Francis, and her husband, Sir Thomas Gresley, and according to family tradition the jewel was presented to the couple by the Queen on their marriage.

It may well be that Hilliard fashioned the jewelled settings of both

pieces in addition to painting the limnings which they contain. Certainly he could and did make settings for his work, although he would not always have done so.[18]

On 5 March 1581/2 Hilliard's third son and fourth child, Laurence, was baptized at St Vedast Foster Lane; so far as is known, he was the only son to outlive Nicholas, whom he succeeded as royal limner. He was probably named after his paternal grandmother, Laurence Hilliard *née* Wall, but it is possible that John Bodley's son Laurence was his god-father, as Nicholas Hilliard and Laurence Bodley had known each other since they were boys in Exeter and Geneva.

It was later in this year, 1582, that Laurence's maternal grandfather Robert Brandon became Prime Warden (Master) of the Goldsmiths' Company for the ensuing twelve months; and it was on the following 8 January that he was appointed to the office of Chamberlain of the City of London which he would hold for the remaining eight years of his life.[19]

Clearly his artist son-in-law was getting no help from him. But in 1582 the Queen's powerful favourite, Lord Leicester, intervened in Hilliard's tangled affairs. Among uncalendared State Papers at the Public Record Office[20] is a letter written by him from Court on 18 June to the Chancellor of the Exchequer, Sir Walter Mildmay: 'Mr Chancellor', he writes, 'the Queen's Majesty hath given this bearer Nicholas Hilliard (in consideration of some service wherein he hath been employed these two years towards Her Highness) a lease of certain things, late in the tenure of Sir Francis Englefield, to the value of £23.3s.4d. by year. Wherefore I heartily pray your good favour toward him, for his speedy going through therewith, it is now a good while ago since Her Majesty did grant him relief.' The story is all too familiar: the grant was not over-large, and Hilliard had already been waiting 'a good while' to benefit in any way. One can imagine the anxious artist waiting at Leicester House in the Strand while the Earl signed the letter, and then hastening to deliver it to Mildmay. Leicester's intervention seems to have been fairly effective, since four months later a warrant appears in a patent roll, authorizing the lease to 'Nicholas Hilliard, goldsmith, for his good service', of a rabbit-warren at Millbrook, part of the manor of Ampthill in Bedfordshire, for a rent of £7; of tithes in the parish of Lockington (near Beverley in Yorkshire) – rent £3.13s.4d.; and of the manor of Yelvertoft in Nor-thamptonshire (near Rugby). The rent for the manor is put at £10.4s.2d. – but once again there is a snag, for Hilliard is to acquire the lease only 'upon the expiry of a lease to John Bassett'. He must have secured this eventually, but in May 1596 he was involved in litigation over it – as appears in a letter written by him on 20 May to an unknown recipient

and now in the Harold Cohen Library at Liverpool University. Hilliard is entreating 'the continuance of your Lordship's favour in the cause between Thomas Willcox and me and the poor tenants of Yelvertoft', and complains of 'the perverseness of the said Willcox'.[21]

As for the tithes of Lockington, they became, very soon after the granting of the lease, the subject of one of Hilliard's over-optimistic bits of financial juggling. The documents in this case provide further evidence of his easy relationship with the Knollys group at Court. The episode involves Henry Carey, first Lord Hunsdon, Sir Francis Knollys's brother-in-law: Hunsdon was certainly the Queen's first cousin, and he may well have been her half-brother, since his mother, Mary Boleyn, had been Henry VIII's mistress before her sister Anne became his wife – and his name, Henry, suggests a royal father. Lord Hunsdon's main claim to fame is that as Lord Chamberlain in the 1590s he was the first patron of Shakespeare's company of actors, the Chamberlain's Men. But in 1583 he was Master of the Hawks in the Royal Household, and as such he was approached by Hilliard at the request of a man called Thomas Brigham, to secure a place as a royal falconer for Brigham's brother Francis, at a wage of twelve pence a day for life. The case is not especially interesting except insofar as it provides further evidence not only of Hilliard's chaotic finances, but also of the ease with which he evidently moved among the courtiers. A few years after his approach to Hunsdon on behalf of Francis Brigham, he went to law (a popular Elizabethan pastime) against the brothers, in the Court of Requests – Francis then being described as a gentleman of the parish of St Giles-in-the-Fields, and Thomas as 'one of the surveyors of the Queen's stables'. Hilliard maintained that he had 'laboured' on behalf of Francis to good effect, securing a falconer's place for him not at twelve pence a day, but sixteen. In return, he said, Thomas had promised to pay him £40 for the tithes of Lockington. Thomas denied this, saying that at the time he had 'had great occasion to use money in a bigger matter' than Lockington; and he brought a simultaneous action against Hilliard in the same court. Nothing is known of the outcome (if any) of either case.[22] Hilliard later painted a miniature of George Carey, the second Lord Hunsdon, who like his father held the office of Lord Chamberlain.[23]

It was customary for the Queen and members of her Household to exchange presents at the New Year, and the gift roll for 1584 shows that Hilliard gave her 'a fair table [probably a panel inset with miniatures] containing the history of the five wise virgins and the five foolish virgins'[24] – a graceful tribute to her wisdom and chastity. Hilliard did not receive any gift in return, and his gesture was probably intended to

further his attempt to secure exclusive rights as royal limner. A draft patent dating from this year[25] would have given the portrait-painter George Gower, who then held the office of Serjeant-Painter in the Household, the monopoly of 'all manner of portraits and pictures' of the Queen, 'excepting only *one Nicholas Hilliard, to whom it shall or may be lawful to exercise and make portraits, pictures, or proportions of our body and person in small compass in limning only . . .*'. No evidence has been found that this was enrolled; but in the letter to Sir Robert Cecil of 1601, Hilliard does say that he has '*long been one of* Her Majesty's goldsmiths and *drawer* [not '*a* drawer'] *of Her Majesty's pictures*' (my italics). This seems to imply that he had by then enjoyed a virtual monopoly for a number of years.

The New Year gift to the Queen may have smoothed Hilliard's path to securing an important commission in that year: to design the second Great Seal of the realm, the existing one 'by much use and wearing waxing unserviceable'. The engraving was to be done by Derick Anthony. The Anthonys seem to have been originally an immigrant family from Germany: in 1541 denization rights were granted to a John Anthony, who had then been living in England for fifteen years and had an English wife; in 1549 to a Peter; and in 1585 to another John, a goldsmith employed in the royal service, who was living in Whitechapel and had then been in England for forty years. Hilliard's colleague Derick Anthony lived in the parish of St Mary Woolnoth in Lombard Street during part at least of the 1550s, as did Hilliard's future father-in-law; Brandon's first two surviving children were baptized there in 1551 and 1552, and Anthony had three daughters and a son baptized, and another son buried, between 1550 and 1555. By 1563, when Brandon had moved to the parish of St Vedast and Hilliard was serving his apprenticeship there, Anthony had also become a parishioner.[26]

A letter from Sir Francis Walsingham to the Chancellor of the Exchequer, Mildmay (who was his brother-in-law), written from his London house in Seething Lane near the Tower on 8 November 1586, indicates that Hilliard may have had a hand in actually engraving the Great Seal as well as designing it, for Walsingham refers to his 'pains lately employed in the engraving . . .'. The Queen, he says, is pleased to bestow 'upon this bearer Nicholas Hilliard a lease in reversion [the usual story] of forty pounds a year' for his work on the seal, and for 'divers other services for which as yet he never received any recompense or allowance' – the usual story once more. So again the needy artist waited while a powerful minister wrote to the Chancellor on his behalf, and again he delivered the letter to Mildmay himself. Later Hilliard was to

execute a miniature of the Chancellor's son Sir Anthony Mildmay, which is now in the Cleveland Museum of Art. It belongs to a group of large-scale rectangular miniatures all dating to the decade *c.*1585–95, and the full-length figure is within a setting of curtains, table, assorted pieces of armour and a dog. The artist seems not to have been at ease with this formula, and he abandoned it after ten years or so.

The new Great Seal came into use in 1586, while Sir Thomas Bromley was Lord Chancellor. He died in April of the following year, and was succeeded in the office by Sir Christopher Hatton. The lease in reversion mentioned in Walsingham's letter of 8 November related principally to the manor of Poyle in Middlesex – which formed part of Stan*well*, not Stan*more* as has usually been stated.Hilliard could not raise sureties for his bond, and this time a letter was written on his behalf by the Queen's great minister Lord Burghley, no less – the first evidence of the considerable help which he, and subsequently his son Robert Cecil, were to give to the artist. There was clearly no lack of goodwill towards him. Writing from Court on 12 July 1587 to an Exchequer official, Mr John Morley, Burghley asked him to help Mr Hilliard: 'For his bond to stand to the order, use myself and Mr Chancellor, finding him unable to put in two sureties; you may take his own with one other, and to retain the bond privately with you, without certifying or notifying thereof, without my further direction.' The manor of Poyle does seem to have been leased to Hilliard in that year, 1587, but he can have retained it for only a very short time, since by 1591 it was already passing from a second man, William Day, to a third, Thomas Ridley.[27]

In the mid-eighties Hilliard had recklessly undertaken to be a surety himself (three times over): he was trying one of the classic contemporary methods of securing some cash – acting as an orphans' recognitor. There had long been an elaborate system whereby, when a freeman of the City of London died leaving young children, their portions were administered for them by the authorities until they came of age. From the early years of the sixteenth century, orphans' affairs were handled by the Court of Aldermen – the Court of Common Council being by then too large and meeting too infrequently to be able to deal adequately with them; and this made great demands on the aldermen's time. Orphans' moneys were commonly lent out to the sureties or recognitors (generally three or four of them, who had to be freemen of the City), and they were required to guarantee sums larger than those they borrowed, to protect the orphans' interests and guard against default.

The sureties had to go to Guildhall in person on assuming their responsibilities, and Hilliard did this on 4 March 1584/5. The orphans

concerned were: Henry and George, sons of the late George Miller of Fenchurch Street, a freeman of the Girdlers' Company; Winifred, daughter of a deceased painter-stainer, Timothy Cockerell; and the three sons and three daughters – James, William, Thomas, Anne, Mabel and Elizabeth – of the late William Metholde, a freeman of the Mercers', the premier livery company. Hilliard and his fellow-sureties – two other goldsmiths, John Ballet and John Bent, and an innholder, William Freeman – signed the book, thereby qualifying to borrow a total of £96.6s.3d., in return for which they had to guarantee £124. Four other sureties – two painter-stainers, a carpenter and a haberdasher – were also concerned with one of the Miller orphans, Henry. Metholde had been a parishioner of St Lawrence Jewry by Guildhall, where he was buried on 3 May 1580; he was a man of property with a 'mansion house' in Milk Street off Cheapside, then an important residential quarter where, as John Stow says, there were 'many fair houses for wealthy merchants and other'; he also owned houses in Westminster. The other two deceased citizens seem to have died intestate.[28]

These entries about the orphans have been taken as evidence that Hilliard was then 'still on good terms with his father-in-law',[29] who had become Chamberlain of the City. But *all* moneys concerned with orphans went automatically through his office, the Chamber, and there would have been nothing personal about it; in the welter of business, Robert Brandon probably did not even know until later that his son-in-law was involved in the affairs of the deceased girdler, painter-stainer and mercer.

Hilliard being Hilliard, it goes almost without saying that he got into trouble with his guarantees. He and John Marrett, described as one of the Queen's messengers, unsuccessfully besought a freeman of the Grocers' Company, John Mouser, to lend them £100; and on 17 January 1588/9 the two men appeared in the Court of Chancery and acknowledged a debt to the goldsmith John Ballet – one of Hilliard's co-sureties – of £200.[30] This time there seems to have been a satisfactory outcome; but ten years later, in 1599, Hilliard requested that, 'upon very good sureties' (the eternal optimist: how could he have supposed that he was going to find them?), he be permitted to borrow from 'the orphanage money', according to 'the common custom letten to all men'. His petition, now at Hatfield House,[31] is addressed to 'my good Lords' and is presumably to the Privy Council. In the text, the sum asked for is clearly written as £100, but an endorsement in an unknown hand states that Hilliard is seeking £200. Dr Auerbach cast doubt on the dating of this petition (she probably had not seen the original), which she described as a 'letter' to

Lord Burghley or Sir Robert Cecil: she wrongly supposed that a refer-
ence by Hilliard to a time when he had been 'in trouble attending the
Queen's Majesty about the Great Seal 4 years past' referred to his work
on the second Great Seal, and concluded that the petition must date to
*c.*1588–90. (Robert Cecil was, of course, not yet a lord by that date.)
However, the petition is endorsed '1599' in a clearly contemporary hand,
and is also dated 'May 1599', together with some doodlings, on the inside
fold of the document; and, as will be explained in Chapter 9, Hilliard is
referring to work not on the second Great Seal, but on a third – which
never came into use.

 No doubt the artist never got the money asked for in his petition – and
in a letter to Sir Robert Cecil in the following month he was to describe
himself as being 'in great extremes'.[32]

6. Robert Devereux,
2nd Earl of Essex
by Isaac Oliver

7. Unknown man, aged
27 in 1590
by Isaac Oliver

8. Henry Wriothesley,
3rd Earl of Southampton,
aged 20 in 1594
by Nicholas Hilliard

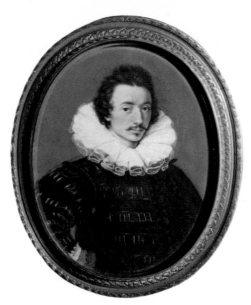

9. Self-portrait miniature by
Isaac Oliver, aged about 30

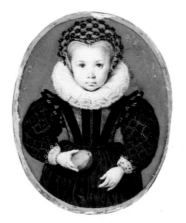

10. Girl holding apple,
aged 4 in 1590
by Isaac Oliver

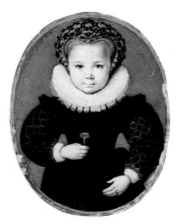

11. Girl holding
carnation, aged 5 in 1590
by Isaac Oliver

7

The Limners, the Poets and the Courtiers: the 1580s

One of Nicholas Hilliard's most attractive miniatures of the 1580s is of Walter Ralegh (Plate 13) – the earliest representation of him. When this 'tall, handsome and bold' man, brilliant but 'damnable proud' as John Aubrey was to describe him, appeared at Court early in the decade, he immediately caught the eye and ear of the Queen. Soon he joined the circle of intimates, and inevitably she nicknamed him *Water*. Hatton, jealous of his own position, promptly sent her a gold bodkin and a little gold charm shaped like a bucket, with a letter saying he knew she would need the latter, since *Water* was sure to be near her. She sent back a verbal message assuring him that she had bounded her banks so that no water could overflow them; she was a shepherd, and her *Sheep* was ever dear to her.

Ralegh was knighted at the end of the Christmas season of 1584–5, on Twelfth Day (6 January) and at Greenwich Palace:[1] he was the only man then knighted – unlike her successor, the Queen was always frugal with honours as with money. It seems most probable that Hilliard's miniature was commissioned to mark the occasion, as Drake's had been in 1581 to mark his knighthood, and that the artist was present at the ceremony –and did the miniature at Greenwich. The sitter wears an enormous ruff, and his bonnet is encircled by a black band entwined with double rows of pearls and with a star-shaped jewel securing a white feather.

Notwithstanding his 'conversation with the learnedest and politest persons', says Aubrey, Ralegh 'spake broad Devonshire to his dying day' – as, no doubt, did his 'intimate friend' Sir Francis Drake and their mutual friend Nicholas Hilliard. One can catch echoes of Hilliard's soft Devon burr in his letters to Robert Cecil: 'farder', for example, he writes for 'farther', 'forder' for 'further', and 'forderance' for 'furtherance'; and 'doone', 'woorthe' and 'woord' for 'done', 'worth' and 'word'.

In the intensely competitive world of the Court, it was soon Ralegh

who had occasion to be jealous: no one doubted that Robert Dudley would always be nearest to the Queen's heart, but he was now growing old by sixteenth-century standards, and had not very much longer to live. In Hilliard's miniature of him done in 1576 (Plate 8), the familiar proud face still looks comparatively young at the age of forty-four, moustache and beard dark although the hair is greying at the temples; but when Hilliard did a large full-length limning of the Earl some nine or ten years later, there was a marked change. Hair, moustache and more straggly beard are now white, and although Leicester still stands erect, his right hand rests on a support.[2]

Leicester's nephew Sir Philip Sidney, on whom so many hopes had rested, died of his wounds at Zutphen in 1586; and the Earl now introduced his stepson, Robert Devereux, Earl of Essex, at Court to counter Ralegh's influence. (Essex had become a ward of Lord Burghley after his father's early death, but he had an apartment at Leicester House in the Strand, known as 'my Lord of Essex' Chamber'.) He was twenty-one in 1587, the Queen fifty-four. She was captivated by the tall, well-set-up young man: he was endowed with some good qualities, but was spoiled and vain, and lacked judgment and discretion to a degree that would ultimately cost him his life.

A manuscript in the British Library, drawn up by an anonymous astrologer,[3] is devoted to the Earl (his date of birth is usually given as 19 November 1566, but this document – the source of the information – states quite clearly that the date was the 9th; he was born at a quarter to ten at night – the astrologer needed such precise details for the horoscope which tops the page). The manuscript provides a fascinating example of 'what would have happened if . . .', for the writer, bringing his original entry up to date, notes at the bottom: '1585: he fell into a ditch & was almost drowned in going a hunting in September.' If the young man had indeed been drowned at the age of nineteen while a-hunting, there would have been no success at Court, no fatal expedition to Ireland in 1599, no attempted rebellion and execution in 1601 – and who would Lord Leicester have chosen to introduce at Court after his nephew's death in 1586? History would have unfolded in a quite different way.

The Earl and his sister Penelope, who was about four years the elder, were the children of the formidable Lettice Knollys, who married three times and lived to a great age. She was the eldest daughter of Sir Francis Knollys, who has figured in the story of Nicholas Hilliard already, and a grand-daughter of the Queen's aunt Mary Boleyn. Her first husband, Walter Devereux, had been created Earl of Essex in 1572 – the year of

Hilliard's first miniature of the Queen; Walter died in 1576 – the year the Hilliards went to France – and on 21 September 1578 (just before Nicholas Hilliard returned home) she was married to Lord Leicester at his country house at Wanstead near London. His nephew Philip Sidney later fell deeply in love with Lettice's daughter Penelope, and she became the 'Stella' of his sonnets; but by then she was the allegedly unwilling wife of Robert Lord Rich, to whom she eventually bore seven children.

In 1587 another attractive young man arrived at Court: Sir Charles Blount, later to succeed to the title Lord Mountjoy and – at the start of the next reign – to be created Earl of Devonshire. At the time of his appearance at Court he was 'brown-haired, of a sweet face, and of a most neat composure, tall in his person'. He had gone to Whitehall Palace to see 'the fashion of the Court', and the Queen, who was at dinner, asked her carver who he was; this enquiry, and the knowledge that she was looking at him, 'stirred the blood of the young gentleman, insomuch as his colour went and came'. The Queen called him to her, gave him her hand to kiss and told him to come to Court. Hilliard's miniature of the young gentleman done at the time (Plate 14) may be presumed to do him full justice.

It was now the turn of Essex to be furiously jealous. One day when Blount had excelled at the tilt, Elizabeth sent him a gold chess-queen, richly enamelled, and he appeared at Court next day with it fastened to his arm with a crimson ribbon: Essex, coming from the Privy Chamber, saw Blount 'with his cloak cast under his arm, the better to command it to the view' (one can see the proud young man standing hand on hip), and on being told what it was, exclaimed: 'Now I perceive, every fool must have a favour.' Enraged at the public insult, Blount challenged the Earl to a duel, which took place 'near Marybone Park' – Regent's Park in our day – 'where my Lord was hurt in the thigh and disarmed'. When the Queen heard about the affair, 'she sware by God's death', her favourite oath, 'it was fit that some one or other should take him [Essex] down, and teach him better manners, otherwise there would be no rule with him.'[4] It was a prophetic remark.

Thereafter the two young men became friends – and Blount became the lover of the Earl's sister Penelope, who bore him five children in addition to her seven by her husband, Lord Rich. After her brother's execution in 1601, she and Blount lived openly together, and her husband left her; a divorce was obtained, and at the end of 1605 the couple were married at Wanstead, where Penelope's mother had been married to Leicester twenty-seven years before. Both died soon afterwards.

In 1587, when Blount first arrived at Court, the principal figures in the Leicester-Essex circle were Robert Dudley, Leicester himself; his second wife, Lettice; his stepdaughter Penelope, Lady Rich; and her brother Robert, Earl of Essex. The last three of the seven surviving children known to have been born to Nicholas and Alice Hilliard were *Lettice* (baptized on 25 May 1583), *Penelope* (31 October 1586) and *Robert* (30 March 1588). Nothing could more strikingly illustrate the patronage of the artist by the most powerful group at Court, and it is not too much to assume that the two women and one of the Roberts consented to act as godparents.[5]

At the end of 1587, on 23 December, the young Earl of Essex succeeded his stepfather in the important office which Leicester had held from just after the beginning of the reign, Master of the Horse. The three departments of the Household, out-of-doors, downstairs and upstairs, were presided over by the Master of the Horse (responsible for all the multifarious transport requirements); the Lord Steward with a Treasurer, Comptroller and Cofferer – his responsibilities included the running of all the catering departments; and for the Chamber, the heart of the Court, the Lord Chamberlain with a Vice-Chamberlain and usually a Treasurer also, although these two posts were sometimes combined. The three great officers heading these departments were members of the Privy Council, which met almost daily at Court.[6]

In the spring of 1588, a few months after becoming Master of the Horse, Essex was created a Knight of the Garter. That momentous year saw the defeat of the Armada – and almost immediately afterwards, on 4 September, the death of the Earl's stepfather. Sir Amyas Paulet, the Ambassador to France during Hilliard's visit, also died in September. Leicester was buried at Warwick, Paulet in St Martin-in-the-Fields.

It is at just about this time that one would expect Isaac Oliver to appear on the scene, since an apprenticeship, whether formal or not, usually lasted for about seven years. And that is exactly what does happen. Until fairly recently, Oliver's first signed and dated miniature was thought to have been done in 1588; but then a work dated 1587, and with the artist's familiar monogram of an 'I' bisecting an 'O', rather like a Greek capital *phi*, was found in a drawer at Drumlanrig Castle, still in its original frame. The subject is a twenty-year-old woman of the middle class, wearing a hat, and she is painted in unusual three-quarter length, with both hands showing, the right on hip, the left holding a glove.[7]

This miniature is not especially remarkable: but one done in the following year shows Oliver already a master of his art, as the young

Hilliard had been when he did his first known adult limning some sixteen years before. And it immediately signals the way in which the careers of the two artists were to diverge. Oliver's miniature exemplifies the realism so characteristic of his work, in total contrast to the stylistic imagery of his former master; and it is fitting, for a man always conscious of his foreign origin, that his sitter is a Dutchman. But at the same time there is a significant link with Lord Leicester, since the Earl and the Dutchman had been closely associated during the recent campaigning in the Low Countries.

John Aubrey once lamented: 'Tis pity that in noblemen's galleries the names are not writ on or behind the pictures.' Very many works of the time, whether then 'in noblemen's galleries' or not, bore no names – and it is not uncommon for wrong names to have been added in later years. Thus the subjects of many miniatures are now perforce described as 'unknown man' or 'unknown woman', and until recent years, Oliver's Dutch sitter of 1588 was among them. But now it has proved possible to identify him.[8]

He was Colonel Diederik Sonoy (1529–97) (Plate 15), who came of an ancient family in the Duchy of Cleves. He was an early adherent of the Prince of Orange in the rising against Philip of Spain, and commanded the troops in North Holland. It was after the assassination of the Prince in 1584 that Queen Elizabeth finally agreed to intervene in the Low Countries in support of the Protestant cause, and Leicester landed at Flushing in command of the English forces in the following year. Sonoy gave him absolute support and was described by a contemporary as 'marvellously well affected' to the Queen and her realm. The States of Holland regarded him as a rebel and traitor, and he appealed to the Queen for help. The Foreign State Papers of 1587 and 1588 in the Public Record Office include many letters to, from and about him: one from Lord Leicester, written 'from the Court at Croydon' on May Day 1587, promises that he will do all he can to ensure the Queen's continued favour. Two letters survive from the Colonel to the Queen and Secretary Walsingham, the former thanking Elizabeth for so promptly and zealously taking his cause in hand. These were written on 9 May of the following year, 1588, from the port of Medemblik. Some weeks later the port was forced to surrender, and the Colonel and his wife were given permission to seek refuge in England.

Isaac Oliver's miniature of Sonoy bears a (slightly inaccurate) inscription in Dutch: '*Sonder erch Verhouue*', in mistake for '*Vertrouwe*': 'To trust without suspicion' (in modern Dutch, '*Vertrouwen zonder erg*'). So long as the sitter remained unidentified, the miniature was taken as evidence

that Oliver probably visited Holland in 1588. But a letter (now in the Public Record Office) from Sir William Russell, the then governor of the port of Flushing, commending the Colonel to Walsingham and dated 17 October, is endorsed with the words 'By Colonel Sonoy'. So he must have brought it to England himself shortly after that date, and it seems much more likely that Oliver painted the miniature here – that is, at some time between 17 October and the end of the year. This is supported by the fact that his sitter is not wearing armour, as he would normally have done in Holland (and as he is in a portrait still in the ownership of the family at a château in Belgium).

Colonel Sonoy was fifty-nine when Isaac Oliver limned him in 1588; the sitter in another miniature by the artist done in the same year (Plate 16), which has recently been acquired by the Ashmolean Museum at Oxford, was then seventy-one. He remains unidentified, but to my eye this equally sober-suited and behatted gentleman also looks Dutch. Perhaps he came to England with the Colonel; the very similar decorative spandrels of the two works suggest that they were done as a pair.

A third Oliver miniature, also dating to 1588, is of a young man of nineteen, with strong features and curly hair, who looks English (Plate 17). It is interesting to study this work in conjunction with three limnings of young men done by Hilliard in the 1580s. One, like Oliver's actually dated 1588, is of a bearded man clasping a hand from a cloud, and wearing a narrow-brimmed hat, black doublet and white falling lace collar (Plate 18); the subject of the second (Plate 19) is arrayed in a jewelled bonnet, huge ruff and gold slashed doublet;[9] the third miniature, probably dating to 1587 or early 1588, is among the earliest of Hilliard's large-scale works belonging to c.1585–95, and its extraordinary elongated shape (its successors are all rectangular) suggests that it was designed for a very special setting – it measures $5^3/8 \times 2^3/4$ inches. The *Young Man among Roses* (Colour Plate 5) is now one of the most famous and familiar of all English miniatures: but it was not publicly known until it entered the Victoria and Albert Museum in 1910, and as recently as 1937 a respected authority could publish his doubts as to whether it was by Hilliard.[10]

Since then there has been much debate about the identity of the tall young man, the significance of his dress, pose and setting, and the meaning of the inscription. At the time, miniatures, and especially miniatures by Hilliard, had become more than straightforward portraits; the miniature was often a kind of fetish, full of ambiguities.[11] The likeness of the sitter was accompanied by allegorical accessories and sometimes, too, by a motto or inscription, the whole constituting a kind

of emblem or device, an *impresa*: literally *multum in parvo*. The historian and herald William Camden provides the classic definition of the *impresa* in his long chapter on the subject in *Remaines of a greater Worke concerning Britaine* published in 1605, which begins:[12]

> An impresa (as the Italians call it) is a device in picture with his motto, or word, borne by noble and learned personages, to notify some particular conceit of their own, as emblems . . . do propound some general instruction to all. . . . There is required in an impresa (that we may reduce them to few heads) a correspondency of the picture, which is as the body, and the motto, which as the soul giveth it life. That is, the body must be of fair representation, and the word in some different language, witty [clever, full of meaning], short, and answerable thereunto [appropriate]; neither too obscure, nor too plain, and most commended when it is an hemistich, or parcel [part] of a verse.

Painting and inscription were to be interpreted together, as conveying a single message – 'a correspondency of the picture . . . and the motto'. *Imprese* often appeared as painted shields of paper, with emblems and mottoes, used at the tilt; when the German Paul Hentzner visited the Palace of Whitehall in 1598, he saw some which had been 'used by the nobility at tilts and tournaments, hung up there for a memorial'.[13] The accounts of the steward to Francis Manners, sixth Earl of Rutland, show that Burbage and Shakespeare were engaged to paint and provide the devices for the Earl when he took part in the tilt of 24 March 1613 marking the tenth anniversary of King James's accession. It was written of this occasion that some of the *imprese* were so obscure that their meaning was not yet understood – 'unless perchance that were their meaning, not to be understood'.[14] The words could equally well be applied to many miniatures, and especially to Hilliard's *Young Man among Roses*.

The strange, enigmatic figure – worlds away from the sober, realistic portraits being limned by Isaac Oliver – is depicted as though seen from below, so that his head and features are disproportionately small. This recalls Hilliard's advice in the *Treatise*, that the artist should try to sit on a level with his subject – 'but if he be a very high [tall] person, let him sit a little above, because generally men be under him, and will so judge of the picture, because they under-view him.'[15]

Some years ago, Sir David Piper suggested that the *Young Man* was Robert Devereux, Earl of Essex, and this has since been restated and developed by Sir Roy Strong.[16] The argument hinges largely on the fact that the young man seems to be the same as the subject of a miniature by

Hilliard which is now in the Metropolitan Museum in New York; in this, the sitter wears a slashed doublet and a falling lace collar. An inscription puts his age at twenty-two in 1588, which fits the Earl; and the miniature came from Warwick Castle, and so very probably from the collection of Fulke Greville, the first Lord Brooke, who was a friend of Essex and had apartments in Essex House in the Strand. So far, so good. A third Hilliard miniature is often held to represent the same young man – although the face looks to me somewhat gentler and rounder; this sitter is in armour and wears an ear-ring in his left ear (his head is half-turned, so that the right ear cannot be seen).[17] This miniature is in the collection of the Duke of Rutland – and the fifth Earl of Rutland was associated with Essex in the abortive rebellion of 1601.

It is not altogether easy to reconcile Hilliard's almost chubby-faced, dreamy *Young Man among Roses* of *c.*1588 with the ambitious, quick-tempered, thrusting young Earl who had just become Master of the Horse. Nor does he seem very like the bearded Earl of some eight years later, dressed all in white, in the famous full-length by Gheeraerts now at Woburn;[18] the face in the Gheeraerts portrait looks markedly longer – as it does in other undoubted portraits of the Earl;[19] and the bridge of the nose has a slight bump not apparent in Hilliard's *Young Man*. Isaac Oliver did a fine miniature of Essex at about the time that the portrait was painted (Colour Plate 6), and in this and in a preliminary sketch,[20] the sitter seems to have a slight widow's peak, whereas the hairline of Hilliard's young man is straight. David Piper acknowledged the differ-ence in shape of face between the subject of Hilliard's miniature and the Earl in the Gheeraerts portrait, and suggested that perhaps, for the rhythmic and idealizing purposes of the miniature, Hilliard softened and rounded the Earl's long face.

If the miniature does represent Essex, it was presumably done before 23 April 1588, the date on which he was created a Knight of the Garter (he was installed on 23 May), since he is not wearing the insignia.[21] And the invaluable astrologer who noted that the young man fell into a ditch in September 1585, added a further note that in March 1588 he was sick of 'a burning ague', so perhaps he sat to the limner before that date also.

The tree trunk in the miniature, it is generally agreed, signi-fies constancy. What, then, of the white roses, on very thorny bushes, which surround the young man? Roy Strong identifies them with eglantine. He quotes from Spenser, who in *The Faerie Queen* describes the Bower of Bliss as 'an arbour green,/Fraséd of wanton ivy, flowering fair',

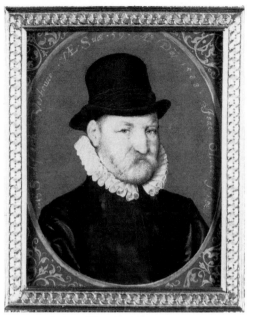

15. Colonel Diederik Sonoy, aged 59 in 1588, inscribed *'Sonder erch Verhouue'* by Isaac Oliver

16. Unknown man, aged 71 in 1588 by Isaac Oliver

17. Youth, aged 19 in 1588 by Isaac Oliver

18. Man clasping a hand from a cloud, 1588, inscribed *'Attici amoris ergo'* by Nicholas Hilliard

19. Unknown youth
by Nicholas Hilliard

20. Leonard Darr, aged 37
in 1591
by Nicholas Hilliard

21. Boy, called 'Henry Prince of Wales': drawing,
pencil and coloured chalk on paper (reduced)
by Isaac Oliver

22. Self-portrait miniature by Isaac Oliver (enlargement, detail:
Colour Plate 9 shows actual size)

23. Unknown man,
called 'Thomas Howard,
2nd Earl of Arundel'
by Isaac Oliver

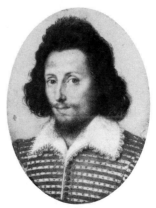

24. Unknown man
by Isaac Oliver

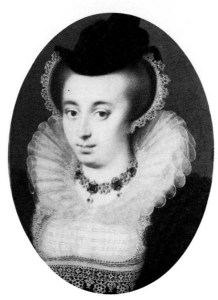

25. Unknown lady
by Isaac Oliver

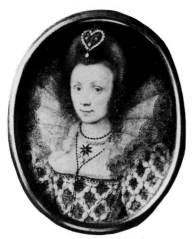

26. Unknown lady,
called 'Frances
Walsingham, Countess of
Essex'
by Isaac Oliver

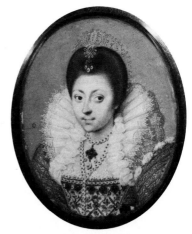

27. Unknown lady
by Isaac Oliver

Through which the fragrant eglantine did spread
His pricking arms, entailed with roses red;

and from Richard Barnfield, who in *The Affectionate Shepherd* (1594) describes other such bowers:

. . . in the sweltering heat of summer-time
I would make cabinets for thee, my love,
Sweet-smelling arbours of eglantine
Should be thy shrine. . . ;

and from Bess of Hardwick, who in an inscription on a table at Hardwick, used the words 'the redolent smell of eglantine'. To these I add the most familiar of all references to eglantine – from *A Midsummer Night's Dream*:

I know a bank where the wild thyme blows,
Where oxlips and the nodding violet grows,
Quite over-canopied with luscious woodbine,
With sweet musk-roses, and with eglantine,

this suggesting a natural bower or arbour.

Roy Strong concludes his argument by identifying the Queen with eglantine – 'Everyone in the court circle and beyond it knew of the Queen's use of eglantine as especially her flower. She *was* the eglantine.' However, I doubt whether the rose in Hilliard's miniature is the eglantine. Eglantine surely is *Rosa eglanteria (rubiginosa)*; and this has a deep pink, not a white flower (Spenser's 'pricking arms with roses red'). And in the quotations cited, it is the fragrance rather than the beauty which is insisted upon – 'fragrant eglantine' (Spenser), 'sweet-smelling arbours of eglantine' (Barnfield), 'the redolent smell of eglantine' (Bess of Hardwick) and 'sweet' musk-roses and eglantine (Shakespeare) – to which must be added the words of Arviragus in *Cymbeline*:

With fairest flowers,
Whilst summer lasts, and I live here, Fidele,
I'll sweeten thy sad grave. Thou shalt not lack
The flower that's like thy face, pale primrose, nor
The azured harebell, like thy veins; no, nor
The leaf of eglantine, whom not to slander,
Out-sweet'ned not thy breath. . . .

In *Rosa eglanteria*, as this last quotation explicitly states, the fragrance is not so much of the flowers as of the leaves. It is this quality – especially noticeable after rain – that everyone who has the rose in the garden, or

who has walked past it in a hedgerow, will know; and it is this which gives it its popular name, Sweet-Briar. It is a native of the British Isles, and, as the quotations remind us, it was very popular in the sixteenth and seventeenth centuries for covering arbours, often with woodbine (honeysuckle). Francis Bacon, in his Essay *Of Gardens*, writes that 'the breath of flowers is far sweeter in the air (where it comes and goes, like the warbling of music) than in the hand', and goes on to list the most fragrant flowers and plants, among them the musk-rose and sweet-briar; in the wild part of his ideal garden he wants 'some thickets, made only of sweet-briar and honeysuckle, and some wild vine amongst'. John Gerard, in his *Herball*, published in 1597 and dedicated to Lord Burghley, devotes a long section of the chapter on roses[22] to 'The wild roses', among which he includes 'the eglantine, or sweet briar'.

I believe that the rose in Hilliard's miniature is the trailing, sweet-smelling white rose of the hedgerows (*Rosa arvensis*) – Shakespeare's, Bacon's and Gerard's sweet musk-rose. As Gerard says (p.1,266), it has 'divers long shoots of a greenish colour . . . armed with very sharp prickles', which is what Hilliard depicts. If his rose is *Rosa arvensis*, and if Queen Elizabeth '*was* the eglantine', then the small white roses in the miniature do not perhaps signify 'Elizabeth'. Writing of the emblems adopted by the Tudor monarchs, Camden[23] recalls that Henry VII used white and red roses to signify the union of York and Lancaster; when Henry VIII succeeded, the English wits began to imitate the French by adding *mots* or mottoes; Queen Mary, after her marriage to Philip II, added a pomegranate to the red and white roses, to signify Spain; but as for Queen Elizabeth, she 'used so many heroical devices as would require a volume'. In this work, published only two years after the Queen's death, Camden does not mention eglantine, or indeed any kind of rose, as being especially associated with her – although of course she retained the red-and-white 'Tudor rose' which is still a royal symbol today.

Geffrey Whitney, in his *Choice of Emblemes* (1586),[24] writes that the rose, the pride of the garden, is surrounded with sharp prickles which will remain when the flower has withered, even as the joys of life are transient. So perhaps Hilliard's roses simply mean pleasure-and-pain, good-and-bad.

It has often been noted that the black and white of the young man's dress were colours especially favoured by the Queen: hence the proposition that, with hand on heart, he is indicating that his love for her will remain constant in good times and bad. But more generally, the colours white and black represented faith and constancy. As for the hand on heart, usually taken as a gesture of devotion, Leslie Hotson has argued

that the young man is not so much a lover as a faithful friend. Certainly he is not at all like Hamlet as described by Ophelia: 'his doublet all unbraced, . . . his stockings fouled,/Ungart'red, and down-gyvéd to his ankle' (which prompts her father's automatic question: 'Mad for thy love?', and her reply: 'My lord, I do not know,/But truly I do fear it.'). Nor does he resemble the indisputable lover of Hilliard's *Man against a background of flames* (Plate 3), the flames signifying the fires of love, the man's hair and shirt disordered, and the miniature itself – a fact presumably then known only to artist, sitter and sitter's beloved – backed by part of an ace of hearts. On the contrary, the *Young Man among Roses* is exceptionally smart, his doublet not at all 'unbraced' and his white stockings, far from being 'fouled and down-gyvéd to his ankle', smooth and immaculate.

So, whether or not he is the Earl of Essex – and because of his exceptional height and splendid garb he well may be – perhaps he is portrayed as someone's faithful friend rather than the devoted lover of the Queen. Two quotations from the 1590s are apposite: 'Friendship *with her hand upon her heart*' and 'The Romans shadowed [Friendship] in the shape of *a young man whose head was bared . . . putting his finger to his heart*' (my italics).[25] This interpretation seems to be supported by the much-debated inscription on the miniature, '*Dat poenas laudata fides*' – roughly 'Loyalty, though praised, brings penalties.' It is taken from Lucan's *De Bello Civili*, and, although it is not familiar to us now, various translations were available in times past, one of them by Ben Jonson – so that Camden's requirement that the motto of an *impresa* should not be 'too obscure' held good in Hilliard's day. Its context would have been well known in miniature-owning circles. The quotation is from a speech by the eunuch Pothinus, who is counselling the assassination of Pompey, and the relevant lines (not often quoted accurately or in full nowadays) read:

> 'Dat poenas laudata fides, dum sustinet', inquit,
> 'Quos fortuna premit',

which may be translated: 'He said, "Fidelity is praised; but it brings penalties when it supports those whom Fortune crushes." ' '*Quos fortuna premit*', 'those whom Fortune crushes': the words are not at all appropriate to Queen Elizabeth, and she would certainly not have thanked anyone who applied them to her. The quotation must surely mean that the young man is no fair-weather friend but will be faithful in bad times as in good.

The debate will continue.

The identity of Hilliard's young man of 1588 (Plate 18), and the meaning of the inscription, will continue to be debated with equal fervour. The sitter lightly clasps with his right hand the fingers of a left hand, apparently female, emerging from clouds; Camden's rule that the motto should not be 'too obscure' is no longer true of its '*Attici amoris ergo*'. Leslie Hotson recently went so far as to maintain that the sitter is the young Shakespeare, who was of course twenty-four in 1588.[26] But even if he had arrived in London by then, there is no reason to suppose that he had yet acquired any kind of reputation that would have made him a likely subject – and a prosperous-looking one – for the celebrated Court miniaturist, then at the height of his fame. Shakespeare must have been in Stratford in 1584, the year of the conception of his twins, Hamnet and Judith, and he was probably at the font in the parish church on the Feast of Candlemas (2 February) 1585 for their christening. The first evidence of his presence in London dates to 1592, when the ill-tempered outburst about the 'upstart crow' by Robert Greene shows that he had begun acting and play-writing in the capital. Millions of words have been written about the 'hidden years' between the two dates: was he 'a schoolmaster in the country'; did he go to sea, or travel in Italy; serve as a soldier; work in a lawyer's office; do several or none of these? One fact is indisputable: his birthplace, a busy market-town in the heart of England, received many visits from touring companies of players; and it is not unreasonable to surmise that a stage-struck young man joined one of them on their return to London. They would have come along the Oxford Road (our Oxford Street), passed through the last village (not yet belying its name of St Giles-in-the-Fields) to Holborn and entered the City of London, the famous little square mile, by way of Newgate.

Judging from Greene's words, Shakespeare is likely to have arrived at the start of his career in the late 1580s, say in 1587 or 1588. Already in the City, and just starting *his* career, was the miniaturist Isaac Oliver. The two men were almost exact contemporaries: probably born within a year of each other, and certainly dying in successive years, 1616 and 1617. The limners Hilliard and Oliver, and Shakespeare the poet and playwright, cannot have failed to meet, since the limners were patronized by Queen and courtiers while the Chamberlain's Men, the company to which Shakespeare belonged from its formation in 1594, enjoyed absolute supremacy and were often commanded to perform at Court and in noble houses. (And London was then so small that 'everyone knew everyone', among people of consequence.) But the limners, as we know, regarded themselves, and were generally regarded by others, as being gentlemen and had to be able, in Hilliard's words, to 'give seemly

attendance on princes', since the nature of their art required the presence of the sitter, however eminent, 'for the most part of the time'. A player, on the other hand, was certainly not a gentleman; he was but one of a company of entertainers. And although in the 1590s Shakespeare was to secure his coat of arms and buy the best house in Stratford, he was conscious of the low status of his profession:

> Alas 'tis true [he writes in Sonnet 110], I have gone here and there,
> And made myself a motley to the view . . . ,

and in the next Sonnet,

> O for my sake do you with Fortune chide,
> The guilty goddess of my harmful deeds,
> That did not better for my life provide,
> Than public means which public manners breeds.
> Thence comes it that my name receives a brand,
> And almost thence my nature is subdued
> To what it works in, like the dyer's hand. . . .

The price of a limning of Shakespeare by Hilliard or Oliver would be far above rubies. In 1590 Oliver did indeed paint a fine miniature of a man – who does not perhaps look quite grand enough to be a courtier – then aged twenty-seven, or in his twenty-seventh year (the inscription '*Aetatis Suae 27*' can be translated either way). The age was Shakespeare's. However, the sitter (Colour Plate 7) bears absolutely no resemblance to the known likenesses of him. The other possibility that springs to mind is: could it be his exact contemporary, Christopher Marlowe? If either artist had thought to limn a man of the theatre, he would have chosen in 1590 not Shakespeare, with a reputation yet to make, but the brilliant graduate of Corpus Christi, Cambridge, admired poet and playwright, and protégé of the Walsinghams and of Sir Walter Ralegh. No known likeness of Marlowe exists – although some claim has been made for a portrait found in 1953 when the Master's Lodge of his old college was being repaired.[27] If an undisputed likeness were ever to be found, this miniature could be compared with it.

Hilliard and the emergent Isaac Oliver were naturally concerned, at the end of the 1580s, not with the players but with the patronage of the principal group at Court – now led, after the death of Lord Leicester, by his stepson the Earl of Essex. We know that Hilliard did at least one limning of Penelope Rich, the Earl's sister – although it is not known to survive – because the poet Henry Constable wrote a sonnet about it, probably in 1589. It is addressed to 'MR HILLIARD, UPON

OCCASION OF A PICTURE HE MADE OF MY LADIE RICH', and
begins:

> If Michael the arch-painter now did live,
> Because that Michael he an angel hight,
> As partial for his fellow-angels, might
> To Raphael's skill much praise and honour give.

There follows a reference to the artist's universally admired way of
portraying jewels:

> But if in secret I his judgment shrive,
> It would confess that no man knew aright,
> To give to stones and pearls true dye and light,
> Till first your art with orient nature strive.

The poet ends, in conventional manner, by apportioning the highest
praise to Lady Rich:

> But think not yet you did that art devise:
> Nay, thank my Lady that such skill you have;
> For often sprinkling her black sparkling eyes,
> Her lips and breast, taught you the
> [*words missing, something like 'form you gave'*]
> To diamonds, rubies, pearls, the worth of which
> Doth make the jewel which you paint seem Rich.[28]

 Penelope became the intermediary in a secret correspondence with
King James of Scotland, the most favoured claimant to the English
throne. Letters went through a young member of the Douglas family in
Edinburgh, and Penelope devised a secret code in which the Queen
became *Pallas*, King James *Victor*, Lord Essex *Ernestus*, Lord Rich
Richardo and Penelope herself *Rialta* – the Exchange. Essex and his
adherents were showing their usual lack of discretion: the code and the
correspondence were not in fact as secret as they intended, for a former
employee of the late Lord Leicester, a man called Thomas Fowler,
writing from Edinburgh, was keeping Lord Burghley fully informed
about what was going on – and in a letter dated 7 October 1589 which
gives the names of the parties, their code-names are written above in the
hand of Burghley himself. Fowler says Douglas has 'a long scroll' of all
the code-names, and a cipher alphabet 'to understand them by'; he
himself does not know them all, but Essex is '*the weary knight*', 'account-
ing it a thrall that he lives now in, and wishes the change' (of sovereign). 'I
trow', Fowler continues, 'some of them went too far in persuading the
poor King to hope for hap shortly, and that Her Majesty could not live

above a year or two [in fact, she lived for over thirteen more], by reason of some imperfection. . . .'[29]

In his next letter, dated 20 October and replying to one from Burghley on the 13th, Fowler writes: 'Roger Dalton is exceeding great with young Constable [the poet], and hath brought him to secret conference sundry times with Victor [the King]. He had commission from Ernestus [the Earl] and from Rialta and Richardo [Penelope and her husband], *and brought with him Rialta's picture*' (my italics).[30] This presumably was the miniature by Hilliard that is the subject of Constable's sonnet.

There is no reason to think that Hilliard had any knowledge of the dubious exchanges in which he was indirectly involved. He was probably a completely a-political man, concerned only with the pursuit of his art and prepared to accept commissions from anyone important if the terms were right – or even if they were not. Similarly, his great successor Samuel Cooper devoted his talents to the service of Cromwellians and Royalists alike.

At about the time of the 'Rialta' correspondence in which his sister played so influential a part, Robert Devereux introduced another handsome young man at Court. This was Henry Wriothesley, third Earl of Southampton, who had been born at Cowdray in Sussex in October 1573. Essex showed him a 'brotherly interest' which, to quote the masterly understatement of *The Dictionary of National Biography*, proved to be 'a doubtful blessing'.

As all the world knows, the younger Earl was the first, indeed the only, patron ever acknowledged by Shakespeare, whose first published works, the long poems *Venus and Adonis* and *The Rape of Lucrece*, appeared in 1593 and 1594 respectively and are dedicated to Southampton. It was in 1594, during the months preceding his twenty-first birthday in October, that Nicholas Hilliard painted the Earl's miniature (Colour Plate 8). The long auburn hair hangs down over his left shoulder in the manner then so much admired; the work is interesting also because it has an early example of the new type of formalized background which Hilliard now introduced to replace the conventional blue.[31] It represents crimson curtains, and Hilliard used the 'wet-in-wet' technique already described in connexion with the carnation flesh-tint. (Some years later he adopted a different and quicker method of achieving the same effect, laying the whole background area with dark, transparent lake and then, while it was still wet, drawing a dry brush over the lines of the folds of the material to produce the highlights.)

If one accepts that Southampton is the young friend of the Sonnets, then Sonnet 16 assumes great significance. It is one of the group in which

the poet urges the young man to marry; to defy the tyrant Time by renewing himself in children while he is in his prime:

> But wherefore do not you a mightier way
> Make war upon this bloody tyrant Time?
> And fortify your self in your decay
> With means more blessèd than my barren rhyme?
> Now stand you on the top of happy hours,
> And many maiden gardens yet unset,
> With virtuous wish would bear you living flowers,
> Much liker than your painted counterfeit:
> So should the lines of life that life repair
> Which this time's pencil or my pupil pen
> Neither in inward worth nor outward fair
> Can make you live your self in eyes of men.
> To give away your self, keeps your self still,
> And you must live drawn by your own sweet skill.

The poet deploys the vocabulary of the artist: 'painted counterfeit', 'lines', 'pencil' (the limner's brush), 'drawn'.

But more than that: 'your painted counterfeit' sounds as though he is referring to a specific limning of his patron just completed, along with his own sonnet; and surely *'this time's pencil'* can mean no other than the supreme limner of the day, famous at home and abroad, Nicholas Hilliard – whose art was to be summed up four years later by Haydocke in the words *'his learned pencil'*. (The sonnet line is often printed: '. . . which this, Time's pencil, or my pupil pen . . . ', which makes no sense.) The poet may have been in attendance at Southampton House in Holborn while the artist limned their patron – a limning commissioned probably to celebrate the Earl's approaching majority in October, and perhaps also his mother's remarriage, for on 2 May of that year she became the wife of Sir Thomas Heneage, Vice-Chamberlain of the Royal Household.

8

Family Matters: the first Mrs Oliver and the first Mrs Hilliard

Isaac Oliver spent the whole of his London life within the community of immigrant artists and craftsmen. And although he had been brought over from Rouen by his parents in 1568, he did not seek and obtain his letters of denization, or residential rights, until thirty-eight years later.[1] His second wife was Flemish, and, as I have recently discovered,[2] his third was of Anglo-French parentage: his first wife was probably of foreign origin also.

All that is known about her is that her name was Elizabeth, and that she was buried in the church of St Peter-upon-Cornhill, aged twenty-eight, on 6 September 1599. St Peter's was reputed to have been the earliest church in the City of London; there were well over a hundred churches there by the time of the Great Fire of 1666, in which St Peter's, like so many others, was destroyed; it was one of those rebuilt by Christopher Wren. Writing while the Olivers were living in the parish, John Stow says of St Peter's that 'it seemeth to be of an ancient building, but not so ancient as fame reporteth, for it hath been lately repaired, if not all new builded, except the steeple, which is ancient'. At the beginning of the fifteenth century, Henry IV had given a licence to the parson and three other members of St Peter's to found a gild and chantry, the former to be known as the Fraternity and Gild of St Peter-upon-Cornhill; and the Gild was chiefly composed, perhaps because St Peter was a fisherman, of freemen of the Fishmongers' Company. During the reign of Henry VI a school was attached to the church – one of four parochial schools directed by Parliament to be maintained in the City. There had also been a fine library, 'of old time builded of stone, and of late repaired with brick by the executors of Sir John Crosby Alderman, as his arms on the south end doth witness', as Stow tells us. 'This library hath been of late time, to wit, within these fifty years [the second half of the sixteenth century] well furnished of books

... but now those books be gone, and the place is occupied by a schoolmaster and his usher, over a number of scholars learning their grammar rules, &c.'[3] It was obviously a very select little parish in which Isaac Oliver chose to live.

In 1538 Thomas Cromwell had ordered that parish registers be kept throughout the kingdom; and the entries for some parishes – including St Peter's – survive from that date. To begin with, records were kept in paper books, but in 1597 it was decreed that the books should be of parchment. Entries were then copied from the one to the other. The first parchment register-book of St Peter's – or the part of it up to 1605 – is of quite exceptional beauty, and it also contains more informative entries than is customary. This is thanks to the then parish clerk, a man called William Averell, who noted that, to conform with the new rule, their book had been purchased on 22 September 1598. He and his wife Gillian had an enormous family in the parish – 'she died of her 17th child', and was buried on 20 February 1595/6, and William on 23 September 1605.[4] The parish also boasted three reputed centenarians – all women – in the sixteenth century: one died in 1575, and the other two, who would have been fellow-parishioners of Isaac Oliver and his wife, in March and September 1597.

The Olivers undoubtedly knew the Averells well, and it is to William Averell that we owe the information that Elizabeth was twenty-eight at her death, and that she was buried in the church, behind the south door. Isaac would have taken particular pleasure in Averell's beautiful penmanship, and in the little decorations with which he embellished the register-book: at the start of the burial entries, for example, he inscribes the words: 'The Lord hath given me wine to comfort my heart and made me flourish like the rose', the decorations including a tun – presumably indicating that he was a freeman of the Vintners' Company – and a rose, with his initials, 'WA', in the centre.

Many immigrants from the Low Countries lived in this parish, and some French people also, so it is understandable that Oliver should have chosen to live there. In addition, it was very close to Threadneedle Street, where members of the 'French congregation' in the City had their church. The 'Dutch congregation' had since 1550 been allowed to use part of the old church of Austin (Augustine) Friars a little to the north.

The marriage of Isaac and Elizabeth Oliver does not appear in the registers of the Dutch Church (which survive from 1571), so it seems likely that it took place at the French Church – for which registers do not survive earlier than 1600. Until the early 1580s at least, Isaac was probably living with his parents in Fleet Lane, where they had lodged

with Harrison the pewterer on their arrival in London, for his father is still entered in Fleet Lane in an aliens' return of 1582.[5] In another return, of 1582–83,[6] Pierre is puzzlingly entered as a 'minister' of the French Church: if this is not simply a mistake, it may mean that he was acting as a temporary or part-time minister or lay reader. This is the last known reference to Pierre, and, as I have suggested earlier, in connexion with Isaac Oliver's young 'fellow' Pieter Mattheus who died in 1588, his father may have died by then; his mother Epiphane moved to the parish of Christchurch Newgate Street at some stage,[7] either on her husband's death or her son's marriage. The Christchurch registers after 1588 were destroyed in the Great Fire, so no information is to be had there.

Isaac Oliver's father provided the name for Isaac's firstborn son, Pierre/Peter, who was also to become a distinguished miniaturist. His date of birth is not known – he was no doubt baptized at the French Church, as was Isaac's first son by his third wife (he had no children by his second). In 1621 someone near Hilliard's studio painted a miniature of a man then aged twenty-seven, adding the inscription '*ARS MEA PATRIMONIA*'. Some years ago[8] it was suggested that the sitter was Peter Oliver, and since then it has been customary to date his birth to *c*.1594. I think it likely, however, that he was born earlier than that. Seventeen was a popular age for brides in the sixteenth century, and as Elizabeth Oliver reached it in 1588, she could well have been married then, and her son Peter could have been born in, or shortly after, 1589.

If the sitter in the miniature of 1621 is not Peter Oliver, it is necessary to suggest someone else of the right age and meriting the inscription '*ARS MEA PATRIMONIA*'. I suggest that he might be John, eldest of the sixteen children of the Serjeant-Painter John de Critz – the man who had to remind Nicholas Hilliard in 1606 that it was not for him to paint the tomb of the late Queen, since that was one of the duties belonging to his own office. De Critz and his first wife would have been married in the early 1590s,[9] so that their son John could well have been born in 1594. And he *was* a painter, although not, it seems, of much quality: he succeeded to the office of Serjeant-Painter on the death of his father in March 1642.

It is possible that a likeness of Peter Oliver as a child survives. A tender drawing by Isaac of a young boy, done in pencil and coloured chalk on paper (Plate 21), and now in the collection of the Duke of Buccleuch, has been called 'Henry Frederick, Prince of Wales', which is not possible. The child (not a 'youth', as it has also been called) is wearing a ruff characteristic of the early 1590s, and Prince Henry (the elder brother of the future Charles I) was not born until 1594; in any case, his

birthplace was Stirling Castle, and he did not come to England until the accession of his father as James I in 1603; nor is there any reason to think that Isaac Oliver ever went to Scotland. I suggest that the drawing is of the artist's firstborn son, the child he is most likely to have drawn. Peter would have 'learnt his grammar rules, &c.' in the fine old library building attached to St Peter-upon-Cornhill, under the excellent parish clerk Mr Averell, who taught at the school there. The register-book testifies that Averell was a Greek and Latin scholar, as well as being a master of calligraphy.

Isaac Oliver clearly had a special talent – not, perhaps, shared by his former master Nicholas Hilliard – for depicting young children. The boy who is the subject of the drawing really does look young and vulnerable, quite unlike the children in so many Elizabethan drawings and paintings who resemble little wooden dolls, or small-scale adults; and in 1590 Oliver painted touching miniatures of two little fair-haired girls then aged four and five (Colour Plates 10 and 11), the younger holding an apple, the older a small carnation – so the season was late summer. They regard the artist with solemn gaze as though conscious of the importance of the occasion. Under magnification it can be seen that the miniatures provide examples of Oliver's occasional use of a dotted stipple to model features.[10]

As the girls are dressed alike, they were presumably sisters. There is no way of positively identifying them. So far as is known, Isaac and Elizabeth Oliver had but one child; so, on the chance that the girls were the children of neighbours, it seemed worth searching William Averell's little register to see if there were any sisters born in the parish of St Peter's in 1585 and 1586 who would fill the bill. Only two babies of either sex were born into one family in those years: Grace Sturman, born on 9 May 1585 and baptized on the 16th, and Margaret, born on 9 August 1586 and baptized on the 14th. Their father, Richard Sturman, was a citizen of London and a freeman of the Fishmongers' – as has been explained, there was a strong link between that Company and the Gild and Fraternity of St Peter. Richard died soon after the birth of his daughters, at the early age of thirty-nine, and Averell noted the interesting fact that he was buried 'in the library' attached to the church,[11] the building where Averell taught his pupils. So Isaac Oliver's two little sitters – if they were indeed Grace and Margaret Sturman, which can be no more than speculation – were orphans when they had their miniatures painted. Their mother subsequently married a gentleman called Anthony Williamson and went to live at the pretty riverside hamlet of Poplar. There is no mention of Williamson's stepdaughters in his will of 1613.

Isaac Oliver, so far as is known, spent his whole life in London, apart from one or more trips to the continent. Hilliard, the west-country Englishman, on the other hand, probably went down to Devon from time to time to see his parents and his brothers Jeremy and Ezekiel, and his brothers probably travelled up to London to see him. One such visit is mentioned in an interrogatory surviving from the Brigham case of the 1580s: this speaks of 'one of the plaintiff's [Hilliard's] brothers that then dwelt in the west country' being in London at Hilliard's house – that would be Jeremy, the Exeter goldsmith; and of 'another brother . . . being a student and then ready to go beyond seas to travel' – Ezekiel, who went into the ministry.[12] (He was presumably the Ezekiel Helliard, rector of Stoke Climsland near Tavistock, whose will of 1614 was lost in the bombing of Exeter in the last war.)

One of Hilliard's trips to Devon may well have been in 1591, for in that year he did a fine miniature of a Devon man, named in its inscription as Leonard Darr, then aged thirty-seven (Plate 20). It is often argued that from the 1570s, the portrait-miniature became 'democratized'[13] – and to some extent that must have been true, since if it had remained within the narrow limits of the Court, that new breed of man, the portrait-miniaturist, could not have made a profession or a living out of his art. But it would seem, from a close study of the men and women who sat to Hilliard and Oliver – even though a good many of them are no longer identifiable – that the great majority were of the upper class, even if not actually of or near the Court. And that is as one would expect, since limnings must always have been commissioned by people of means.

In 1916 it was suggested that Hilliard's sitter of 1591 could be identified with a Leonard Darr who figures in two Domestic State Papers of 1585.[14] In the first he is described as a merchant of Tavistock who on 15 October, with a merchant of Totnes, was licensed by Thomas Edmonds and John Bland, deputies of Sir Francis Walsingham in the port of Plymouth, to depart into France with the *Christopher* of Looe, a barque of forty tons burthen, master William Watts, 'with her full lading' (nature of cargo unspecified); Walsingham had been empowered to license imports and exports. On 22 October Darr – again described as a merchant, but Tavistock not mentioned – secured a licence from William Creed, Deputy Collector of Customs at Fowey, to ship fifty tons of pilchard and conger to St Malo in the *Trudeler* of Fowey, of fifty-four tons burthen. The identification of Darr has been accepted without question, and the miniature has formed the main plank of the 'democratization' argument. Indeed, it has been said[15] that Hilliard 'created an industry which stretched well beyond the confines of the Court circle to

men of "the common sort" such as Leonard Darr, the fish merchant of Tavistock'.

Hilliard's production of exquisite miniatures over a long working life of some fifty years hardly amounted to an 'industry'. And to dismiss 'Leonard Darr of Tavistock' as being of 'the common sort', even if he was Hilliard's man, is to misinterpret the State Paper entries about him. In the sixteenth century, a man described as a 'merchant' was a man of importance and substance: Darr was an entrepreneur, certainly not soiling his own hands with pilchard and conger and whatever the second cargo consisted of; licences such as he secured had to be paid for, and would not have been sought or obtained by 'common' persons; and his cargo for St Malo was a very large one by the standards of the day.

I discover that Hilliard's sitter was (or became) a very wealthy and enlightened gentleman. He could of course have been a merchant when young – although it is possible that the Tavistock man was a relative, since the surname (variously rendered in contemporary manuscripts as Darr, Darre and Dare) was not uncommon in Devon. One, Ananias Dare, was among the very first English settlers in North America in the 1580s, and has the distinction of having fathered a daughter – naturally christened Virginia – who has been described as 'the first American-born child of English descent'.[16] Her mother was Eleanor White, daughter of no less a man than John White, whose attempted settlements were largely promoted by Ralegh, and the baby Virginia was born 'in the city of Ralegh'.

Nicholas Hilliard's sitter Leonard Darr was probably born at Totnes (the registers of Tavistock and Totnes do not survive far enough back to be able to check his baptism). A William Dare of Totnes who figures in Devon subsidy rolls of 1524–7 was probably his father or grandfather.[17]

Whether or not Leonard was born at Totnes, he certainly lived there for a number of years. And he is entered in the parish register as 'Mr Leonard Darre', the 'Mr' of course indicating high social status. He married Joan Bond; and she was a younger daughter of Sir George Bond, who belonged to one of the great families of the City of London. The Bonds had originally, like the Hilliards, come from Cornwall; but Sir George, and his elder brother William, were born at Buckland in Somerset, near Frome. In 1567 William Bond, alderman and sheriff, bought one of the most famous houses in the City – Crosby Place in Bishopsgate, which had been built a century before by Sir John Crosby, the man responsible for repairing the library in the parish of St Peter-upon-Cornhill where young Peter Oliver would have started his lessons. Crosby Place was 'of stone and timber, very large and beautiful', as Stow

tells us; it was the highest house in London in his day, and William Bond was evidently determined that it should remain so, for he added 'a turret on the top thereof'. The Duke of Gloucester, later Richard III, lived in this celebrated house for a time; 'divers ambassadors' lodged there, and the Lord Mayor of 1594–5 used it while he was in office; other famous occupiers were Sir Thomas More and Sir Walter Ralegh.[18] On the other side of Bishopsgate was Gresham House, home of the Queen's financier Sir Thomas; when Shakespeare was lodging in Bishopsgate in the 1590s, he saw the two great houses every day, and he mentions Crosby Place more than once in *Richard III*.

William Bond, the uncle of Joan Darr of Devon, died in 1576 and lies buried in his parish church of St Helen's Bishopsgate, where his wall-monument can be seen today close to Gresham's marble tomb: it proclaims him to have been 'A Merchant Adventurer Most Famous in his Age'. Indeed he was, for he owned ships, exported cloth to Antwerp, imported wine from France, traded probably with Spain and certainly with the Baltic ports, and was a founder-member of the Barbary and Muscovy Companies trading with North Africa and Russia.[19]

William Bond's younger brother Sir George was Lord Mayor in 1587–8, and lived in the parish of St Stephen Walbrook (close to the present Mansion House). He had married Winifride, daughter of Sir Thomas Leigh, the Lord Mayor of 1558–9. Not only did their daughter Joan become the wife of Hilliard's sitter of 1591; another daughter, Anne, was the second wife of Sir Richard Martin, who has figured several times in Nicholas Hilliard's story – as a fellow goldsmith and neighbour in Westcheap, as Master of the Mint from 1581, as yet another Lord Mayor and as father-in-law of Alice Hilliard's sister Mary.[20]

Elizabethan London was the most formidable unit in the kingdom, in size, wealth and power. The great mediaeval monasteries and convents had disappeared, and it had become a purely civic and mercantile community, governed by its own ruling body, under the Lord Mayor, of men drawn from the powerful livery companies: a state within a state. Royal power, the law courts and parliament were upstream at West-minster, and noblemen were leaving their mediaeval mansions in the City and moving further west. By his marriage with Joan Bond, Leonard Darr of Devon established strong links with the rulers of the City of London. The Bonds and Greshams, with others of their kind, were wealthy and powerful men with major overseas trading interests, and among them are forebears of many of the great families of England. Sir George Bond, for example, Darr's father-in-law, is said to be, through

two of his daughters, an ancestor of Lord Melbourne, Queen Victoria's first Prime Minister, and of the Dukes of Marlborough.[21]

Leonard and Joan Darr had five surviving children: Leonard and George, and three daughters, Winifride, Rebecca and Julian or Gillian. Judith (who must have died) was baptized at Totnes on 30 December 1599, Winifride – called after her grandmother the Lady Mayoress, Winifride Bond *née* Leigh – on 22 May 1601, Rebecca on 14 November 1602 and Leonard on 20 November 1603. At some time after that, the family moved to South Pool, south-east of Kingsbridge and at the head of South Pool Creek which runs out into the estuary opposite Salcombe. There the daughter Julian/Gillian was baptized on 24 August 1606, and buried on 25 September 1618 or 1619; George's baptism has not been found. A John Dare, clerk of the parish and no doubt a relative of Leonard, was buried on 27 April 1618 or 1619.[22]

When Leonard Darr, gentleman, made his will[23] in 1611, he described his home in the parish of South Pool as 'my farm or barton known as Hadwill *alias* Hedgwill'; the name is now Halwell, and maps show Halwell House between South Pool and Kingsbridge as being 'On Site of Mansion'; the mansion was presumably Darr's home. He also owned slate quarries at Molescombe in the adjoining parish of Stokenham.

Darr bequeaths to the poor of South Pool, from his profits from the quarries, twenty shillings a year, to be paid quarterly for 'two thousand nine hundred years' – or, as a wooden tablet in South Pool church bearing the Bond arms has it, 'FOR EVER'. The money is to be spent on three score penny loaves of good and wholesome bread made of wheat, to be laid out on Mr Darr's monument and distributed by the churchwardens; if they should default, the money is to be distributed to the poor of Totnes from the church porch. In addition, the handsome sum of £5 is to be given to the poor of each parish on the testator's burial day.

Darr asks his son Leonard to devote 100 marks (£66.13s.4d.) to a 'fair monument' in South Pool church to his late wife and himself; this was duly done, and an inscription on the alabaster monument in the south aisle proclaims that Joan was the daughter of 'Sir George Bond Alderman of London late Mayor of the said City in the memorable year 1588 [Armada year]'. Joan died on 10 December 1608 and Leonard on 28th March 1615. True to his intention, his bequest to the poor of South Pool is still providing help today: the bequest has been combined with others and is administered by the vicar and four trustees.[24]

In his will Darr makes handsome provision for his five surviving children. Leonard is to inherit the farm in South Pool, the lands and quarries at Molescombe, and some woods in the manor of Buckfastleigh;

the other son, George, is to have £1,000 when he comes of age, £40 a year immediately for his 'education and learning', and his father's house and gardens in Totnes. As for the daughters, Winifride is to receive 1,000 marks (£666.13s.4d.) on her marriage, and Rebecca and Julian £500 each, and each daughter is to have £30 a year immediately for her 'education and maintenance' – unusually generous provision for the education of girls. The testator's brother-in-law Mr Thomas Bond is appointed guardian of the motherless children and bequeathed £50; and, as he is not in Devon, Darr entreats his 'best friends' – two gentlemen of Totnes and one of Kingswear – to assist him in his responsibilities.

Here is just the sort of man, wealthy and enlightened, who might be expected to have commissioned a miniature from his fellow man of Devon, Nicholas Hilliard. The 'fish merchant of Tavistock' as a representative of the 'common sort' can be quietly forgotten.

Darr and his London bride may well have met in the west country, since her family came from there; but he probably travelled up to London from time to time. However, the marriage seems not to have taken place in the City. And Hilliard's miniature of 1591, commissioned (to judge from the dates of birth of the Darr children) some years before the marriage, was probably done in Devon.

It was in that year, 1591, that Hilliard's father-in-law, Robert Brandon, died. On the evidence of his remarkable will,[25] it seems unlikely that his son-in-law attended the funeral at St Vedast Foster Lane on 8 June (Brandon had died on 30 May).

In this lengthy document, Brandon works systematically through his family. The five married daughters have already been 'advanced', he says – no doubt in their respective marriage settlements; the youngest and only unmarried daughter, Lucy, is to receive half his goods and chattels. There are bequests of money totalling £300 to the seventeen grandchildren by his son Edward and daughters Rebecca, Sara, Martha and Mary – who are all named, as are the sons-in-law. The only exception in the orderly progression through the family is Alice Hilliard. Not only is her husband totally ignored, but so are their children. Alice and her four married sisters are to share the bequests made to the grandchildren in each of the other families if they should happen to die; and there is one special provision for Alice. Fifty pounds is to go to the Goldsmiths' Company 'for and towards her maintenance', the Company paying out the money by quarterly instalments of £16.13s.4d. (The Company's Court Minute Book for the period was burnt when Goldsmiths' Hall was being rebuilt in 1681 after the Great Fire, so no information survives about the payments.) If Alice should die, her £50 is to revert to her

brother and married sisters. To his only son Edward (another son, Charles, had died at the age of twenty-six) Brandon bequeaths £100; he is also to receive an annuity of £50, again to be administered by the Goldsmiths' Company. If Edward's children die, his five married sisters are to share the £100 bequest; similarly, they are to share the £50 annuity – but once again the Hilliard family is treated differently. For whereas, when Alice's sisters die, the annuity money is to pass to their children, when she dies, her share is to go not to her children but to her nephews and nieces.

The executors of the will are Lucy Brandon and a wealthy freeman of the Merchant Taylors' Company, Mr Robert Smith; the overseer is Peter Osborne Esquire, Brandon's brother-in-law by his second marriage. Osborne was probably the man of that name knighted in 1611, and the eldest son of Sir John Osborne, Treasurer's Remembrancer of the Exchequer.[26]

The conclusion to be drawn from Robert Brandon's will seems to be inescapable: he did not consider that his daughter Alice was being adequately maintained by her husband, and he had no interest whatsoever in their children. Attempts have been made to explain away the will by arguing that Brandon wished the Goldsmiths' to administer Alice's £50 to ensure that the money went to her and not to her husband's creditors – which may well be true. But this does nothing to explain the total exclusion of the Hilliard children.

Hilliard's father Richard died some three years after his father-in-law. The registers of St George's, Exeter, where he expressed the wish to be buried, do not survive so far back, but there is no reason to doubt that he was buried there. In his will, proved on 9 August 1594,[27] Richard bequeaths to Nicholas his property in the parish of St Pancras, Exeter, together with the patronage of the church; also his best gown and 'my gold ring with the cornelian stone in it'. His married daughters, Anne Avery and Mary Beane, are to receive £20 each after the death of their mother, his unmarried daughters, Frances and Parnell, £20 each at once; Nicholas's firstborn son, Daniel, must have died before the will was made (on 2 November 1586), since Richard bequeaths £6.13s.4d. to the next son, Francis; Jeremy's son Richard is to receive the same amount. If Nicholas's sons die, the St Pancras property is to pass to Jeremy and his heirs male, and then to Ezekiel and his. Jeremy and Ezekiel are bequeathed their father's 'gold ring with the greater sapphire stone in it' and the one with the 'lesser sapphire stone' respectively. Everything else goes to the testator's wife Laurence, who is appointed executrix.

Everyone who writes about the miniaturist is strongly tempted to

dwell on his charm. His work has immense charm; he looks charming in the self-portrait miniature; and we get a strong flavour of the attractive side of his character in the *Treatise* and from his six letters to Robert Cecil. But he must have been extremely tough and resilient to survive in that harshly competitive world, constantly short of money and having to execute his small and exquisite works in the cramped, smelly and noisy environment of Elizabethan and Jacobean London (although conditions would have been a bit better when he was commissioned to work at Court or in a nobleman's household). And evidence already mentioned, with more to come, suggests that there was a combative and arrogant side to his nature, together with the self-absorption of the creative artist.

Was he a good husband and father? The evidence of Robert Brandon's will suggests not; and, although one must make due allowance for the impatience of a wealthy and influential citizen with the vagaries of his son-in-law's artistic temperament, it has to be admitted that there is an extraordinary dearth of information about the seven Hilliard children. The only one to figure in the artist's will, made at the end of 1618, is his son and fellow-limner Laurence. We do know, through the chance survival of some legal papers,[28] that his daughter Elizabeth was married, towards the end of the 1590s, to a man described as 'Thomas Richardson of London, gent.', and that they had a daughter, also called Elizabeth. (Thomas is described as the son and heir of Mary Richardson, one of the daughters and coheirs of Anne Leigh, deceased.) But Thomas and Elizabeth were not married at St Vedast Foster Lane, as would have been normal if the Hilliards had been living in the parish at the time; this is one of the reasons why I suspect that the family did not live continuously at the sign of 'The Maidenhead' in Gutter Lane from 1579 on. Even more remarkable, none of the Hilliard children was buried at St Vedast, although it would seem that some at least of them must have died before their father.

Then there is the mystery of Hilliard's wife or wives. The miniature of Alice done in France in 1578 has a later inscription in which she is described as '*VXOR PRIMA*' – which indicates that there was a second wife. But no burial of Alice is recorded at St Vedast. It has been customary to assume that a Nicholas Hilliard who married Susan Gysard on 3 August 1608, at the church of St Mary-at-Hill near London Bridge, was the artist; but even that is not certain, since another Nicholas Hilliard was living in the parish of St Martin-in-the-Fields in the 1620s, and he could be the man. And an Alice Hilliard, who might well be the first wife of the artist, was buried at St Margaret's Westminster on 16 May 1611 – that is, after the date of the marriage at St Mary-at-Hill. The Hilliards

would often have been at Westminster, because of the artist's employ-
ment at Court.

All that seems reasonably certain is that the second wife died before
Hilliard, since there is no mention of her in his will; he names only two
relations, his son Laurence and sister Anne Avery, and leaves £10 worth
of bedding and best household stuff to his trusty servant Elizabeth
Deacon, 'my attendant in this my sickness'.[29]

The Hilliards probably did something to help Alice's half-sister Lucy.
Alice's mother Katherine had died in 1574 (she was buried at St Vedast
on 29 July), and her father Robert soon married again, his second wife
being Elizabeth Chapman *née* Osborne, the widow of John Chapman, a
freeman of the Grocers' Company who had lived in that important
residential area, Milk Street.[30] She was probably the godmother of the
four Brandon grandchildren (including the Hilliards' first daughter) who
were christened 'Elizabeth'. And she was the mother of Brandon's last
child, Lucy, who was baptized at St Vedast on 29 December 1577 (while
the Hilliards were in France). Her daughter Elizabeth Chapman by her
first marriage was buried on 11 August 1579.

The pursuit of Lucy has uncovered interesting links with Devon and
with the Earl of Essex: it is this which prompts the supposition that the
Hilliards helped her for a time (her mother had died in September 1588,
when she was only eleven), and perhaps promoted her marriage.

Lucy became the wife of Sir Richard Reynell, a member of a promi-
nent Devon family living at East Ogwell just west of Newton Abbot. He
was knighted at Theobalds on 23 July 1622, and two of his brothers,
Thomas and George, were among the many men knighted 'in the royal
garden at Whitehall' on 23 July 1603, two days before King James's
coronation.[31] Another brother, Carew, has a modest place in history. In
June 1588 – in the month before the Armada was sighted off the Lizard –
Secretary Walsingham signed a warrant to pay Carew Reynell 100
shillings for bringing letters from the Lord Admiral (Howard of
Effingham) at Plymouth to the Court at Greenwich; and nine years later
he was involved in the so-called Islands Voyage to the Azores under the
command of Essex. On 20 July, at the time when the gathering ships
were dispersed by a storm, the Earl wrote from Plymouth to Secretary
Cecil in London that he was seeking to collect his 'scattered flock': he had
found Ralegh and others at Plymouth 'with some of the Queen's great
ships', and at Falmouth had found some including Carew Reynell in
Foresight. Carew went on to serve under Essex in the campaign in Ireland
in 1599, and was knighted by the Earl at Dublin on 12 July. Soon after
the death of Lord Leicester in 1588, Lettice Knollys had married as her

third husband Sir Christopher Blount, a young kinsman of the Sir Charles limned by Hilliard in 1587, Sir Christopher thus becoming stepfather to Essex. Blount took part in the rising of 1601, and was one of those executed shortly after Essex himself: during his examination on 18 February, he denied that he had 'used persuasions to Sir Carew Reynell to join them, or upon his dissent used bad words, or offered to draw his dagger on him'.[32]

Sir Carew Reynell was buried – like Hilliard, but some five years after him – at St Martin-in-the-Fields, having bequeathed a miniature of Essex to his son, the third Earl, 'as a remembrance for all the favours and benefits which I received from his most noble father'. The very large sum of £30 was to be spent on a jewelled setting before delivery. It must be more than likely that the miniature was Hilliard's work.[33]

The third Earl of Essex was a parliamentary general in the civil wars – as was Sir William Waller, whose first wife was Jane Reynell, Robert Brandon's grand-daughter and the daughter of Sir Richard and Dame Lucy. Jane was married to Waller on 12 August 1622 (a month after her father was knighted) at Wolborough, which formed part of Newton Abbot (not then itself a parish) and is close to East Ogwell; Sir Richard Reynell's seat was Ford House, a former monastic property which still stands, and there he died in January 1633 (he also owned a house in the cathedral close at Exeter, the city of Hilliard's birth). He was buried at Wolborough on the 25th, and his widow – Alice Hilliard's half-sister – on 20 April 1652, having lived a long life and achieved great-grand-children. A marble monument in the church bears their life-size recumbent figures. The Reynells' grand-daughter Margaret Waller married a member of the prominent Devon family of Courtenay – a baronet, Sir William, of Powderham between Exeter and Exmouth. When Nicholas Hilliard's brother Jeremy, the Exeter goldsmith, made his will in 1631, he mentioned a debt of £28 due from Sir William Courtenay and his executors. So it seems that the Hilliards in London and Exeter, and Alice Hilliard's half-sister and her family, remained on friendly terms.[34] Laurence Hilliard, Nicholas's son, called his own eldest son Brandon: this has sometimes been taken as proof that there was no lasting rift between the Hilliards and the main part of the Brandon family: but it seems much more likely that, in choosing the name Brandon for his son, Laurence Hilliard was simply commemorating the maiden name of his mother Alice and her half-sister Lucy.

9

Professional Matters in the 1590s: Oliver rivals Hilliard

To this decade must belong the beautiful self-portrait miniature by Isaac Oliver (Colour Plate 9), which appears to have been done when he was about thirty years old: certainly George Vertue believed that the 'picture of himself in an oval' was done at that age, although he misdated it because he was wrong about the date of the artist's birth. The self-portrait of the young Frenchman, done in London, is therefore directly comparable with the self-portrait of the Englishman Nicholas Hilliard (Colour Plate 1), done at about the same age in France in 1577. And as with Hilliard's, enlargement of Oliver's limning (Plate 22) reveals his mastery of his art. Horace Walpole, who was the proud owner of the work for a time in the eighteenth century, having bought it 'at Mr Barret's sale', makes the point: he describes the artist as 'a genius' and continues: 'This picture alone would justify all I have said of him. The art of the master and the imitation of nature are so great in it, that the largest magnifying glass only calls out new beauties.'[1]

Oliver's professional life seems to conform to the rule that 'no news is good news', in contrast to that of his former master, whose frequent appearances in contemporary records nearly always indicate money troubles: references to Oliver are sparse, so one may assume that the little Huguenot household on Cornhill – with but one child, as against the Hilliards' seven – was conducted in a sober, modest and prudent manner. In a subsidy roll towards the end of the decade, Oliver's assessment is lower than Hilliard's in 1582: he is assessed at only £3, with eight shillings to pay.[2]

This, however, in no way reflects his standing, for he had by now become a very fashionable artist and a formidable rival to Hilliard. To quote George Vertue again, he was 'much esteemed by the courtiers of Queen Elizabeth, and the Queen herself sat to him several times for her picture'.[3] His three surviving miniatures of 1588 – of the Dutchman

Colonel Sonoy (Plate 15), in the collection of Princess Juliana of the Netherlands; of the black-clad seventy-one-year-old man (Plate 16), now in the Ashmolean Museum at Oxford; and of the beruffed youth of nineteen (Plate 17), in private ownership – were followed in 1590 by the man aged twenty-seven (Colour Plate 7), or in his twenty-seventh year, who, it is now suggested, might possibly be Christopher Marlowe, and the two little sisters aged four and five (Colour Plates 10 and 11); and then, during the decade, by fine miniatures of men and women who appear to be of or near the Court. The men include one who has been wrongly called 'Thomas Howard, second Earl of Arundel' (Plate 23), one who has in the past been wrongly described as 'Sir Philip Sidney' (Plate 24) – there is at Penshurst a picture of a man, aged twenty-eight in 1597, resembling the sitter; and the mature Earl of Essex, in the miniature already mentioned, wearing the ribbon of the Garter and the curious transitional combination of a falling collar topped by a small ruff (Colour Plate 6). The miniatures of ladies include one in the Royal Collection, of a sitter wearing a hat (Plate 25) – in the eighteenth century she was wrongly identified as Mary Queen of Scots; and two of very elaborately dressed and bejewelled sitters (Plates 26 and 27) – the latter, whose dark hair is surmounted by a jewelled tire, looking perhaps continental rather than English.

The range of colour is in general much more sombre than Hilliard's: instead of his former master's English springtime freshness – 'proud-pied April in all his trim' – there is an autumnal air about the miniatures of Isaac Oliver. This derives partly from continental influences, but it may not be fanciful to relate it in part to the changing times: the confident springtime of the Elizabethan age was over, the Queen herself was ageing, and the future was dark and uncertain.

In conformity with his style of sober realism, Oliver rarely included the inscriptions which are such a feature of Hilliard's work, and he set no store by guessing-games with intricately worked symbolism and quotations 'in some different language' as Camden had required in his rules for *imprese*. In any case, he was no calligrapher: while each 'Nicholas Hillyarde' signature is a small work of art in itself, as exemplified in the letter to Sir Robert Cecil now reproduced (Plate 28), Oliver's signatures on drawings are modest and unobtrusive; he adopts no standard spelling of his surname, and judging from a note on the back of a miniature of 1596 (Plate 30), his handwriting – again unlike Hilliard's – was unremarkable.

Some of Oliver's most famous portrait-miniatures have been described as 'essays in melancholia'.[4] An outstanding example is a

rectangular work, $4^5/8 \times 3^1/4$ inches, in the Royal Collection, the sitter again wrongly identified in the past as Sir Philip Sidney (Colour Plate 12). The handsomely dressed young man sits beneath a tree, leaning against the trunk, with his sword beside him, his left hand gloved, his right glove lying on the grass. In the background, and at a lower level, is an imaginary palace or great house (once supposed to be Penshurst or Wilton) with a formal garden. The sitter appears to be in deep thought: as Vertue puts it,[5] he is depicted 'at whole length sitting musing in a garden [it is not exactly that, but the turf at the man's feet is starred with flowers] most exactly and curiously [skilfully, exquisitely] done'. With this miniature, although it belongs to a later date, may be compared the recumbent *Lord Herbert of Cherbury* (Plate 31), brother of George Herbert the poet. This rectangular work is even larger than the other: $7^1/8 \times 9$ inches. These fashionable melancholic courtiers are paralleled by 'melancholy Jacques': indeed, when 'First Lord', addressing the exiled Duke in the Forest of Arden, reports

> Today my Lord of Amiens and myself
> Did steal behind him as he lay along
> Under an oak, whose antique root peeps out
> Upon the brook that brawls along this wood,

he might be supposed to have had the miniature in mind, were it not that *As You Like It* was written a few years before the date of Oliver's Lord Herbert; for the subject is indeed 'lying along under an oak' beside a 'brawling brook'.

When Rosalind taxes Jacques with being 'a melancholy fellow', he readily agrees: 'I am so: I do love it better than laughing.' And he sets out the varieties of the species. The scholar's melancholy is emulation; the musician's, fantastical; the courtier's, proud: the soldier's, ambitious; the lawyer's, politic; the lady's, nice; and the lover's, 'all of these'. As for Jacques, his brand of melancholy is different again: 'it is a melancholy of mine own, compounded of many simples'. Melancholy was assumed, like a garment, and Oliver lent his art to its portrayal in paint as did Shakespeare in words.

Towards the end of the decade, Oliver did a limning of Catherine Knyvett of Charlton Park near Malmesbury in Wiltshire (Plate 32), who some years before had become the second wife of one of the members of the great family of Howard. He was Thomas, whose father, the fourth Duke of Norfolk, had been executed in 1572 for intriguing with Mary Queen of Scots. Queen Elizabeth had no doubts about Thomas's loyalty, and she knighted him for his gallantry in the fight against the Armada,

and created him Baron Howard of Walden nine years later; at the beginning of the next reign, he was created Earl of Suffolk and Lord Chamberlain. One of Oliver's most brilliant large-scale miniatures – a round one, with a diameter of five inches (Colour Plate 13) – has been called 'Frances Howard, Countess of Essex and Somerset', who was a daughter of Thomas and Catherine. The work used to be dated *c*.1610–15, but it is now considered that it belongs to the late 1590s, because of the sitter's hair-style and the cut of her sleeves.[6] The lady is in an elaborate form of undress, without ruff, or jewels in her hair, but with a wired cap from which fall gauze draperies. An embroidered mantle is caught up to her corsage with a jewelled brooch.

The sitter certainly cannot – if the new dating is right – be Frances Howard, who was to become the centre of a scandal tremendous even for the far from decorous Jacobean age: there will be more to say about her in Chapter 14, but for the moment it is necessary only to note that she was not born until the spring of 1590. In the British Library is an entry about her by an astrologer, as meticulous as the earlier one about the second Earl of Essex; he says that she was born at six o'clock in the morning of 31 May of that year. Speculation about the identity of this sitter – as of so many others – must continue. But she is obviously a great lady, and I wonder whether she might not be Lettice Knollys. The first husband of Frances Howard was to be the third Earl of Essex – they were married in the chapel of the Palace of Whitehall in January 1606, when both were in their early teens; the first husband of Lettice Knollys was of course the first Earl (grandfather of the third), and her second husband, Lord Leicester. It is possible that a portrait-miniature of Lettice, Countess of Essex and *Leicester*, might later have been supposed to represent Frances, Countess of Essex and *Somerset*. A portrait in the collection of the Marquess of Bath, formerly identified as 'Catherine Parr', is now said to be of Lettice Knollys,[7] and the sitter looks not unlike Isaac Oliver's.

Although it now seems, from the circumstances of Colonel Sonoy's arrival in England towards the end of 1588, that Isaac Oliver did not visit the Low Countries in that year, as had been supposed, he certainly was in Venice in May 1596: George Vertue's remark, that he 'suspected' that the artist had been in Italy 'in his younger days', was well-founded.[8] Here the evidence is in an inscription written by the artist on the back of a miniature of an unknown sitter called 'Sir Arundel Talbot' (Plates 29 and 30). The inscription is dated 13 May 1596 and reads: *'Fecit m. Isacq oliŭiero Francese'*, followed by his monogram of the 'I' bisecting the 'O'; it constitutes further proof that he regarded himself as French, which of

course he was, both legally and in spirit. The note about the name of the sitter is in another hand.

In Abraham van der Doort's celebrated catalogue of Charles I's art collections is an item described as 'a big limning' representing 'our Lady, St Katherine, and many angels and other figures'. Van der Doort says it was a copy of a Veronese, and writes that it was 'first done in Italy and since overdone and touched by Isaac Oliver'; it was 'about a foot in height', and set in an ebony frame with 'a shutting door of ebony', and had been bought by the King. This has now been taken[9] as proof that Oliver was already executing large-scale copies of oil-paintings in the mid-1590s, and thus at a far earlier date than had hitherto been believed. But there is nothing to prove that the 'big limning' was done in 1596, and it is quite possible that Isaac Oliver visited Italy again later on. There was much crossing and re-crossing of the Channel in those times, and it would be surprising if a man with such strong continental ties of birth, marriage and profession did not visit his native France, and perhaps Italy as well, more than once.

There may be a clue to the identity of his sitter of 1596, 'Sir Arundel Talbot', in events of that year. Gilbert Talbot, seventh Earl of Shrews-bury, accompanied by Garter King of Arms and by Somerset Herald (who at the time was the painter William Segar), was in Rouen in the autumn of the year, to convey the Garter to Henri IV of France, who had succeeded the murdered Henri III; and there were family links between the Shrewsburys (family name *Talbot*) and the *Arundels*.[10] The unusual Christian name of Oliver's Talbot sitter strongly suggests that he had an Arundel for a godfather, and he may have been a relative of Lord Shrewsbury who was perhaps making a continental tour with Isaac Oliver in his train; they could have visited Rouen – the artist's birthplace – on the way home from Italy, permitting 'Sir Arundel' to join his noble relative for the Garter ceremony.

Nicholas Hilliard was also involved with the Shrewsburys in the 1590s. In 1592 Bess of Hardwick, who was stepmother (by her fourth and last marriage) of the Earl who went off to Rouen four years later, commissioned Hilliard to do one or two miniatures – for which he seems to have received the customary payment of £3. (He then introduced his former apprentice Rowland Lockey to her service, and established a useful connexion for him.)[11] Three years after the payments to Hilliard, his name appears intriguingly in connexion with Bess's grand-daughter, Lady Arabella Stuart.

Arabella's father was Lord Charles Stuart, Earl of Lennox, the younger brother of Lord Darnley. The brothers were grandsons of

Margaret Tudor, Henry VIII's sister, and thus were close to the English throne. And although in the end it was James VI of Scotland, Darnley's son by Mary Queen of Scots, who succeeded Elizabeth as James I of England, Arabella was regarded by many people as having a stronger claim since – unlike her cousin James – she had been born in England. Inevitably, through the unhappy accident of her birth, she became a tool of Catholic intrigue; and she eventually died (in 1615) in the Tower.

Among the domestic and Venetian State Papers, the accounts of the Treasurer of the Chamber at Court and the Cecil Papers at Hatfield, are a number of documents referring to an English, or possibly Irish,[12] Catholic recusant living on the continent, who was suspected of plotting to kill Queen Elizabeth. The man was usually at Brussels or Antwerp, and his name was Michael Moody – although he also used several aliases. It is necessary to tell something of his complicated story, since Nicholas Hilliard's name is associated with his at one stage.

According to a letter from a secret agent to Sir Robert Cecil in 1592, Moody had once been employed by the English Ambassador to France, Sir Edward Stafford (whom Hilliard had known when they were boys in Geneva in the 1550s). This is borne out by the Chamber accounts, which show that between August 1580 and March 1584, Secretary Walsingham signed several warrants to pay Moody – then described as a 'gentleman' – sums totalling £59.6s.8d. for carrying letters between the Ambassador in France and the Court at Whitehall.[13] (The printed calendar of State Papers omits the important word, that Moody was a '*sometime*' – former – servant of the Ambassador, thus giving the misleading impression that Stafford might somehow have been implicated in Moody's subsequent activities.)

By 1586 Moody was being described as 'an idle, profligate fellow' and was in Newgate gaol, for reasons unknown: at the end of the year William Stafford, Sir Edward's brother, called on the French Ambassador in London at his house in Bishopsgate Street, and told him that he was 'discontented' because Lord Leicester had taken a dislike to him; at this, he alleged, the Ambassador asked him whether he knew of anyone who would be prepared, for money, to kill the Queen, to further the cause of Mary Queen of Scots. Stafford then apparently told Queen Elizabeth what was going on, and a few days later – on 12 January – Burghley summoned a meeting at his house attended by Leicester, Hatton and Secretary Davison; they called in the Ambassador and confronted him with Stafford, but he hotly denied the charges against him. By 13 February the Venetian Ambassador to France, Giovanni Dolfin, was already reporting to the Doge and Senate that certain

English prisoners, including William Stafford and 'Modi', had been asking the French Ambassador in London to give them money to get out of prison and kill the Queen. This despatch was written five days after the execution of Mary Queen of Scots. Thereafter, it seems, Moody and his associates amended their plans and decided to promote a marriage between Arabella Stuart and the son of Alexander Farnese, Duke of Parma (the Spanish commander in the Netherlands), and to put the Catholic couple on the English throne after the assassination of Queen Elizabeth.[14]

Next in order of date is a letter, now at Hatfield, from Moody himself to Sir Thomas Heneage (then Treasurer of the Chamber), dated 18 December 1590.[15] He speaks of having been much disgraced by the false reports of a lewd and bad fellow (presumably William Stafford), notwithstanding divers good services done for the Queen in France; he now seeks employment in France or Spain.

Among the State Papers of 1591 are a number of letters to Robert Cecil from a secret agent called John Ricroft. In the first, dated 7 August, Ricroft reports that he has just been talking to Moody – 'the man your honour knows of', as he puts it – 'and if my Lord [Burghley] in his honourable discretion use him well and seem to cherish him, all will be well. I dare assure your honour he shall not escape the net I will lay for him.' There are cryptic references, in this letter and in others written by Ricroft later in the month, to someone whom he describes as 'Mr V', and to 'my purpose for U' and 'the matter of/at U' (the printed calendar wrongly renders them all as 'U'): in one of the letters Ricroft reports that Moody 'was most part of the day with me yesterday being Sunday . . . *he is busied in getting the picture of Arbella* [as she was often then called] *to carry to the Duke of Parma and told me he had Mr V's letter to aid him therein to Hilliard*' (my italics).[16] 'Mr V' must have been someone whom Nicholas Hilliard knew well.

In two-and-a-half pages of notes in his own hand, summarizing what he had learnt from Ricroft about Moody's 'bad proceedings', Cecil comments that the man may well argue that Ricroft's charges against him, based on conversations at which no one else was present, are without foundation: to that the answer will be 'that if his meaning had been good, he would never have imparted so much of his secrets to Ricroft'; he must have been seeking '*to draw him into the complot*'[17] (the words in my italics are not in the printed calendar).

Next come four letters now at Hatfield. On 27 September Moody is writing from Antwerp to the Earl of Essex that he has secured some hangings, as requested, which he hopes will meet with approval; in a

postscript, he says he has gone to Flushing, 'under the habit and name of a Scottish merchant'. A few days later, on 4 October, he writes to someone unnamed asking for news about *the lady Arabella. I pray you send me her picture, for that there is some one very desirous to see it* (these words are in cipher, marginally deciphered). On the 12th, in a letter to Heneage, Lord Burghley says that at Flushing Moody has been telling Sir Robert Sidney 'how he is used on the Queen's behalf to discover all such practices as are to be had about the Duke of Parma'; he has used Burghley's name to Sidney 'and gotten money of him'. Moody has clearly lost the Queen's trust: he has now written to the Lord Chancellor, the Lord Admiral and Burghley himself, 'so as it cannot be as his service can be secret, which is I think the cause that Her Majesty allows not of his service'; in addition, she has recently learned from a 'very trusty gentleman of Scotland' that Moody has been chattering to many people in Brussels, too, about being in the royal service. Burghley himself is not inclined to reject Moody; but not surprisingly, a despatch is sent to him warning him about his 'lavish tongue', and telling him not to write so many letters and not to visit Flushing so often.[18]

Some six months later, in April 1592, Moody and his associates on the continent are reported to be still negotiating with Arabella or some of her friends about the projected marriage to Parma's son; an agent reporting to Cecil on the 7th, on his return from the continent, says Moody arrived in Antwerp from England just as he left: *he was once before sent for her picture, and at the least within this year he hath been thrice in England* (my italics). By 1594 things have become much more serious. It was a time of great anxiety about the Queen's safety, reflected in the trial and execution – in June – of her Portuguese physician Dr Roderigo Lopez, who was charged (probably quite unjustly) with attempting to poison her. On 13 August a priest called Richard Williams (whose signature becomes alarmingly shaky as the month progresses) is examined at the Tower by Lords Essex and Cobham and Attorney-General Coke, and confesses that 'there was speech at Brussels at the table about the killing of Her Majesty'; and on the 20th Edmund Yorke, examined by Francis Bacon and others, says that Moody has arrived in England, or will soon do so, to carry out the assassination: the plotters had considered using 'a little crossbow of steel' to shoot a poisoned arrow at her from a distance, or stabbing her with a 'little dagger . . . as she walked in the garden'; but in the end it had been thought better to use 'a rapier poisoned in the point which is least suspected' (it sounds just like Hamlet and Laertes).[19]

On 19 September Moody himself writes dolefully to Robert Cecil, as he had done to Heneage some four years earlier: notwithstanding all his

endeavours in the past three years to do Her Majesty service, and his desire to continue, he is still 'disgraced by a malicious means'. This time he signs 'John Bristowe', one of his aliases.[20]

Almost the last word comes in a report to Lord Burghley in June 1595: Moody has been 'taken in bed' at Brussels, 'carried to the castle, and thence to a secret prison'. He is said to have died in the following year.[21]

On the strength of the possible involvement of Nicholas Hilliard in all this, there has been speculation that he was himself a crypto-Catholic. This does not seem at all probable: his family background was strongly Protestant; and, as has been suggested earlier in connexion with the 'Rialta' correspondence between the Essex faction and the young King James of Scotland (which also includes references to Arabella Stuart), the likelihood is that Hilliard, a totally dedicated artist, had no strong political or religious convictions. Any sensible agent wishing to secure a miniature of the prospective bride for her prospective father-in-law, to further a marriage of political importance, would naturally turn to the most accomplished miniaturist of the day; and as for the miniaturist, he would accept a commission from anyone. In fact, Hilliard is not known to have limned Arabella at this period – although one or two miniatures of young girls (she was sixteen in 1591 when Michael Moody's efforts to secure her 'picture' began) have been tentatively said to represent her.

Even if Hilliard did limn her, it is clear that Lord Burghley and Sir Robert Cecil had absolutely no suspicions about his motives. There is an intriguing postscript to the story in the despatch, already mentioned, sent home by the Venetian Secretary in England in May 1603, just after the Queen's death. Having praised Elizabeth's manipulation of the Alençon marriage project, Scaramelli goes on: 'Her second and not less remarkable action now comes to light, for at the very height of the Spanish preparations against England in 1588, she . . . despatched into Flanders Robert Cecil, a little hunchback, and then in private life, but very wise; and he, in simple traveller's garb, but with credentials from her, whispered to the ear of Alexander Farnese [Parma] that the Queen would give Arabella as wife to his son Ranuccio, and with her the succession to the throne; the whole world has seen the results of that step.'[22] (Cecil was a member of Lord Derby's mission of 1588 to discuss peace terms with Spain.) Perhaps Hilliard was being used, with or without his knowledge, by the Cecils to lure Michael Moody into their net.

Whether or not he limned Arabella in the 1590s, there is evidence that he may have given instruction to young English ladies being 'finished' in elegant households. It comes in a letter from a girl called Rebecca Pake,

written from London to her parents at Broomfield in Essex, just north of Chelmsford. Dating her letter 'Friday night, 1595', Rebecca says:

Dear mother, My humble duty remembered unto my father and you, &c. I received upon Wednesday last a letter from my father and you, whereby I understand it is your pleasures that I should certify you, what times I do take for my lute, and the rest of my exercises. I do for the most part play of my lute after supper, for then commonly my lady heareth me; and in the mornings, after I am ready, I play an hour; and my writing and ciphering [arithmetic], after I have done my lute. For my drawing, I take an hour in the afternoon; and my French at night before supper. My lady [her identity is unknown] hath not been well these two or three days; she telleth me, when she is well, that *she will see if Hilliard will come and teach me; if she can by any means, she will* [my italics]. Good mother, I do know that my learning hath been a great charge both to my father and you, and a great pain to myself . . . Your obedient daughter, Rebecca Pake.

This delightful letter testifies both to the immense demands upon Hilliard – Rebecca's lady seems very uncertain whether she will be able to secure his services; and to his great renown – Rebecca can toss the name 'Hilliard' into a letter to her parents down in the country in the certainty that they will know who she is talking about.

She would not have had much opportunity to take lessons from the artist even if he found time to give them, for in the following year she was married – at Broomfield, on 22 July – to Mr Nicholas Crisp, a freeman of the Skinners' Company (which dealt, among other things, with rich imported furs, so important for lining the gowns of those living in the cold English climate), and a merchant venturer. He belonged to a notable City family: his brother Ellis became a Sheriff, and Ellis's son Sir Nicholas (?1599–1666) was a leading Royalist who was limned by Cornelius Johnson. Rebecca and Nicholas Crisp lived in the parish of Allhallows Lombard Street, and between 1597 and 1612 they had ten children, of whom five daughters survived, three died, and both sons also died. Rebecca was buried in the north chapel of Allhallows on 2 May 1616 and her husband on 28 November 1637. One of their daughters, Mary, became the wife of Sir Thomas Cullum, Royalist, alderman and sheriff, who in the 1650s bought the estates of Hawstead and Hardwick near Bury St Edmunds in Suffolk; another daughter, Abigail, was married to a Lord Mayor of London, Sir Abraham Reynardson,[23] who was also a leading Royalist.

The Cullums were a Suffolk family, and the fact that Sir Thomas (Rebecca Pake's son-in-law) acquired Hawstead hints at a link with the Drurys of Hawstead – the family who gave their name to Drury Lane,

and whose large town house was at its southern end. Robert Drury, like young Thomas Coningsby whose sister Jane was limned by Hilliard in 1574 (Plate 7), was among those knighted by the Earl of Essex during the siege of Rouen in 1591. Sir Robert married Anne Bacon, a daughter of Sir Nicholas, half-brother of Sir Francis whom Hilliard knew; and in 1611 he became the patron of John Donne, who had a profound admiration for Hilliard's work.[24] All these are but half-clues, if that: but it would be pleasing to think that young Rebecca acquired her 'learning' at Drury House, and that her 'lady' was Lady Drury, *née* Anne Bacon.

Three of Hilliard's most delightful miniatures of ladies were done at this period. One is in the Victoria and Albert Museum (Plate 33); a second, of a sitter with ringlets and very dark eyebrows, is in the Fitzwilliam Museum at Cambridge (Colour Plate 16); the third, also in the Victoria and Albert, was twenty-six years old when the artist limned her in 1593 (Colour Plate 17). All are unidentified, although the third has been called 'Mrs Holland' – the 'Mrs', of course, meaning 'Mistress', which in those days indicated social standing and could be applied equally to a married or unmarried woman. 'Mrs Holland', who has been said to have been one of the Queen's Maids of Honour, is perhaps the most beautiful and elegantly dressed of all Hilliard's women sitters. All three works merit Vertue's verdict in the eighteenth century,[25] that the artist was 'very exact and curious [accurate, skilled]' in portraying contemporary dress, and 'especially in the gold works, jewels, laces and embroideries that adorned them [the sitters], which now is very enter-taining to the curious who admire [marvel at] the different and various habits of those times'.

Hilliard was of the opinion that 'rare beauties' were, 'even as the diamonds are found among the savage Indians, more commonly found in this isle of England than elsewhere' – and 'not for the face only, but every part'; and he writes with ecstasy of the 'lovely graces, witty smilings, and . . . stolen glances which suddenly like lightning pass' across the human face. To see exceptional beauty is to be 'moved . . . with amorous joy and contentment', and it is 'with an affectionate good judgment' that the limner portrays such graces.[26]

However, not all working time was so delightfully spent. One of Hilliard's most time-consuming (and ultimately fruitless) tasks of the 1590s – which continued until the end of the reign – was work on the projected third Great Seal of the realm.[27] The Queen seems never to have been satisfied with the second seal, the one Hilliard and Derick Anthony were responsible for and which came into use in 1586. And apparently it was as early as 1591 that Hilliard was 'making models' for a

28. Letter from Nicholas Hilliard to Sir Robert Cecil, dated 2 June 1599 (slightly reduced)

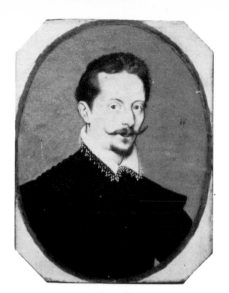
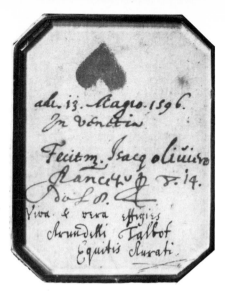

ad. 13. Magio. 1596.
In venetia.

Fecit m. Isacq oliuiero
Aancello y v. 14.
dio L P.
viva & vera effigies
Arundelli Talbot
Equitis Aurati.

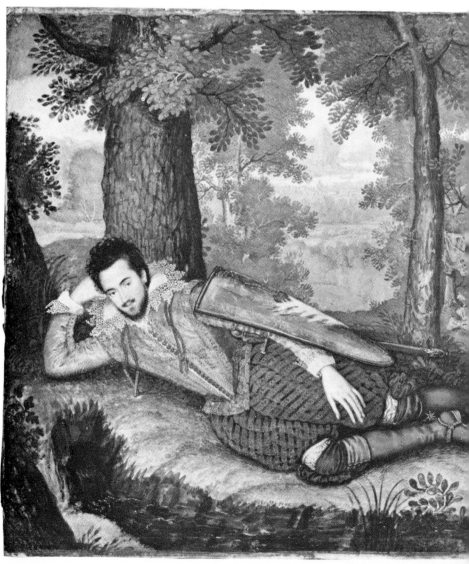

29, 30. 'Sir Arundell
'albot', and endorsement
ted Venice, 13 May 1596
 by Isaac Oliver

32. Catherine Knyvett,
Countess of Suffolk,
inscribed '*Infelix Spectator*'
 by Isaac Oliver

31. Edward Herbert,
1st Baron Herbert of
Cherbury (slightly
reduced)
by Isaac Oliver

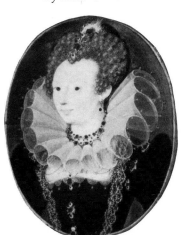

33. Unknown lady
by Nicholas Hilliard

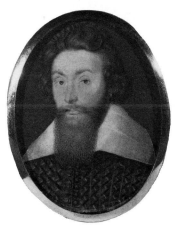

34. Sir Richard Leveson
by Isaac Oliver

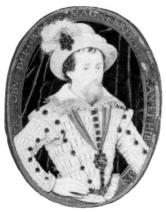

35. King James I,
inscribed '*IACOBVS.
DEI. GR. MAGNAE.
BRITANIAE. FRAN ET.
HIBE REX*'
by Nicholas Hilliard

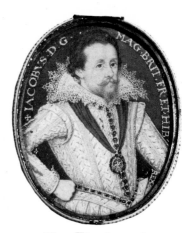

36. King James I,
inscribed '*IACOBVS.
D.G. MAG. BRIT. FR.
ET. HIB. REX*'
by Nicholas Hilliard

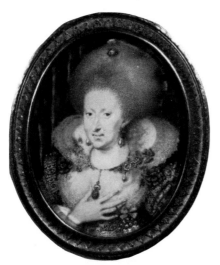

37. Queen Anne of
Denmark
by Isaac Oliver

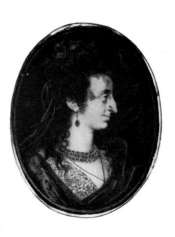

38. Queen Anne in
masque costume,
inscribed '*Seruo per
regnare*'
by Isaac Oliver

third. The evidence for this date is in some rather curious papers at Hatfield reporting the questioning of a man called Thomas Harrison – or 'Herrisson' as he signs himself.

This story can be most clearly told by first quoting from a letter written on 3 October 1601 to Sir Robert Cecil by William Waad,[28] a man always active in seeking out treasonable practices and examining Jesuits and recusants – with Francis Bacon, he had been involved in 1594 in some of the enquiries into the activities of Michael Moody and his friends. Waad was knighted in 1603, and in 1605 became Lieutenant of the Tower, and he was one of the chief examiners of the Gunpowder Plot conspirators. The letter of 1601 reports that his 'cousin Leveson' had warned him about the impending arrival from France of a suspicious chest belonging to Harrison. This William Leveson was a forebear of the Leveson-Gower Dukes of Sutherland, and belonged to the circle of influential City men who included the Bonds and Greshams: his mother was a Gresham, and he was a freeman of the premier livery company, the Mercers', and a merchant venturer with overseas trading interests. His brother Sir John was Lord Mayor at the time of the Essex rebellion of 1601 (and of Waad's letter to Cecil), and helped to put it down; their relative Sir Richard commanded the home fleet during Elizabeth's last illness to prevent foreign intervention in the succession, and was appointed Vice-Admiral of England in 1604. Isaac Oliver limned him during the 1590s, and one of three known versions of the work is now in the Wallace Collection in London (Plate 34).

William Waad and William Leveson awaited the arrival at the Custom House (near the Tower) of Thomas Harrison's chest. Inside was a little box, which, says Waad, 'my cousin Leveson took forth and advised me not to open the same, because he opening the box . . . fell on sneezing very extraordinarily'. Exercising understandable caution, Waad 'caused the box to be opened holding it afar off, where I found Her Majesty's picture [representation] in metal, and a kind of mercury sublimate which had eaten in the metal'. So he sent the box to an apothecary, where it was found to contain 'a very strong poison'. 'I cannot conceive', he concludes, 'he can have a good meaning, that will place the picture of Her Majesty's sacred person with such poison as hath endangered the pothecary's man that did but put it to his tongue.'

Waad and Lancelot Browne (a royal physician) forthwith examined Thomas Harrison, and they both sign the reports of the questioning, as does Harrison himself. They obviously suspected him of papist sympathies, and he admitted that the Bishop of Boulogne had 'made much of him because he delivered unto the Bishop certain secrets in alchemy'.

Asked about the 'picture' in the box, he had replied at first that it was 'of a woman, but of whom he doth not know'; the metal was of mercury congealed with vinegar and verdigris, '*and was made by Mr Hilliard about eight or nine years sithence*'. With aqua fortis the metal would be dissolved again into quicksilver; '*and he says that the said picture was made about the time that Mr Hilliard did make models for the great seal in the time of Sir Christopher Hatton*' (my italics). Thus (if Harrison was right) it seems that Hilliard began work on the projected third Great Seal at least as early as 1591, for Hatton, the then Lord Chancellor, died in November of that year.

Harrison was pressed again at a second examination as to whether the 'picture' in the box was of the Queen; he replied that he 'thought' Hilliard had made it 'amongst the models that he made for the seal for the Queen's picture'. Asked further if he had actually seen Hilliard making it, he said he had not: 'but Hilliard telling him how he did congeal the same, he required the said Hilliard to give him one piece, and so Hilliard gave him that picture, and after[wards] he saw the said Hilliard make the metal. . . .'[29]

Once again, if anything dubious was going on – which is far from being established – it is obvious that no one suspected Hilliard of being implicated. But Harrison's examinations do show that, as one would expect, the artist – that man of enquiring mind and many talents – engaged in alchemy, the chemistry of the Middle Ages and the sixteenth century.

In designing the second Great Seal, Hilliard had collaborated with Derick Anthony. Now, for work on the third, his colleague was Charles Anthony, Graver of the Mint (and probably Derick's son). Charles Anthony's account-roll testifies to the great and prolonged amount of work involved. Two patterns were drawn and embossed in 1592; six more in 1594 and 1596; a pattern in white wax for the 'foreside' of the seal was embossed in 1597; another was embossed in white wax 'after a pattern which Mr Hilliard did limn in parchment in the year 1599'; a greater pattern in white wax was embossed 'which after many mendings [alterations] was liked by Her Majesty' – one senses the exasperation of the designers at the Queen's continued indecision; and 'sundry patterns for the horseback side of the said great seal' were made in 1600. All this cost £37. In addition, the accountant was to receive a total of £26.13s.4d. for his attendance on the Queen at Oatlands, Hampton Court, Nonsuch, Richmond, Greenwich and other places 'by the space of ten years' (which indicates that work began in 1590 rather than 1591). The workmanship was adjudged by sundry workmen chosen by Sir Richard Martin as Master of the Mint.

At last the Queen's mind was made up, and on 17 May 1600 a warrant was drafted for making a new Great Seal. 'Forasmuch as we have thought meet . . . that a new great seal shall be made according to a pattern which we have ready and remaineth with Nicholas Hilliard our servant, we will and command you to give order to Charles Anthony, graver of our Mint, by himself and the help of other skilful workmen to work, engrave, sink, finish and bring to perfection ready to be used with all sufficient speed a great seal in silver. . . .' Three days later a Privy Seal was issued, and money advanced for the work of engraving. But although the work went on, probably until the end of the reign, the third Great Seal never came into use. When the Queen died and James I came to the throne, in March 1603, he used the (second) Elizabethan seal for a short while; on 19 July it was defaced, and a seal for the new reign approved and delivered to the Lord Keeper.[30]

One of the engravers employed by Hilliard is the subject of the first of his six surviving letters to Sir Robert Cecil. In 1594 he and Richard Martin (then an alderman, and not yet knighted) both wrote to Cecil, Hilliard in March and Martin in May, on behalf of the young man, an immigrant called Abel Feckman. He had been found guilty of coining, but the petitioners explain that he had been drawn into this by a man called Webb and 'one Morgan, Webb's man'. 'He is an excellent work-man', Hilliard writes, whom he has known 'almost this five years, and never heard but very well of him'.[31] Martin, for his part, writes that Abel is 'very penitent', and became involved in coining only 'for want of maintenance in the time of the last great infection [the outbreak of plague of 1592–4], being then newly married, and not having work to keep himself and his family'. He is 'young and able to do Her Majesty good service, in graving under Mr Hilliard, who set him on work'.[32] Hilliard explains that the Earl of Cumberland (one of his frequent sitters) had urged him to accompany Abel's brother-in-law with the petition, 'the better to help him to the speech of your honour'; but he is not well enough to ride. With all this powerful backing, the penitent young engraver was probably allowed to continue his good work.

Five years later, Hilliard's colleague on the Great Seal, the Graver of the Mint, Charles Anthony, himself delivered a letter from the artist to Sir Robert Cecil (Plate 28).[33] It merits quotation in full, and I give it with Hilliard's spelling and punctuation:

Right hono͏ͬable/ This bearer Mͬ Charlles Antony graver of her Maͭͭˢ Minte, sheweth me that yoͬ honoͬ hathe su[me] opinion that I am a Competitoͬ wͭͪ him in sute for that office wherin he hathe long served and sued to haue a

pattent of the same, I most humbly yelde yo[r] hono[r] dutifull thancks for yo[r] loving rememberance of me, assuring yo[r] hon[r] y[t] I nev[er] spake woord for that office, but once to Sir Tho' Henage [Vice-Chamberlain of the Household] w[ch] motioned it to her Ma[tie], and my L: yo[r] Father [Burghley] stayed it (and as I afterwards vnderstood) the reason was for that his L: had geven his woord to this bringer w[ch] as him selfe telleth me hathe his L: hand [written promise] also for it/

Wherefore right hono'able I will not hinder him in any degree but forder [further] him rather if I maye (as I haue ev[er] tolde him and thinck him woorthie) as for my owne p[ar]t, I hope yo[r] hono[r] will stand my hono'able good freind to her Ma[tie] in su[me] oth[e]r matter, w[ch] am nowe brought into great extremes, throughe missing of so many sutes as I haue had w[th]in this 8. yeres. and nev[er] received but 40[li] in all this tyme for all that I haue doone, and for that I thank yo[r] hono[r], I thinck it cam[e] p[ar]tly by yo[r] hono[rs] meanes, at yo[r] going ov[er] Ambasado[r] into Fraunce last I am ashamed I am not better hable to deserve yo[r] hono[rs] goodnes. but I hope still to be, & in this hope I humbly Com[m]end my hartiest and best service to yo[r] Hono[rs] Com[m]aund/this second of ['May' crossed out] June, 1599.

Yo[r] hono[rs] most humbly bounde
Nicholas Hillyarde

Here is a characteristic performance by Hilliard: full of confidence in his own abilities, and impetuously trying to teach other men their business – just as, in 1606, he was to try to assume the Serjeant-Painter's responsibility for painting the tomb of the late Queen – but now seeking to make amends (or excuses). The letter also serves as a reminder of how much lobbying Court servants had to do on their own behalf. Hilliard confesses that he had indeed once sought to have the office of Graver of the Mint, by way of a word with the Vice-Chamberlain of the Household, Sir Thomas Heneage; but Charles Anthony had already secured a promise from the Lord Treasurer, Lord Burghley. Hilliard then seizes the opportunity to seek help from Cecil on 'some other matter': the fact that he has so far received only £40 of the £400 granted to him by warrant eight years before.

The reference to Cecil's 'going over Ambassador into France' refers to the fact that in 1598 Philip of Spain had been making overtures of peace to Henri IV: to avert a Franco-Spanish alliance, Cecil was sent over on an extraordinary embassy with his brother-in-law Lord Brooke, the Earl of Southampton, Sir Walter Ralegh and others, arriving in Paris on 3 March. Cecil returned home on 29 April; his father's health was failing, and he died in August. (Philip of Spain died in the following month.)

Hilliard reverts to the difference with Charles Anthony in the letter to

Cecil of 1606[34] in which he recalls the contretemps over the Queen's tomb. Having noted the Serjeant-Painter's insistence that the responsibility is his – 'otherwise', as Hilliard rather unconvincingly adds, he 'had not been so bold' as to seek to do the work – he is immediately reminded of the clash over the post of Graver of the Mint, and continues: 'For I had once envy enough about a great seal, for my doing well in other men's offices.' His over-confidence must often have got him into difficulties.

Evidence from wills suggests that there was no lasting rift between Hilliard and the Anthonys. His colleague Charles died in 1615, being then described as 'Chief Graver of the King's Majesty's Mint and of his Seals'. He was a parishioner of St John Zachary in Aldersgate Ward, and left six young sons and a daughter; the eldest son, Thomas, was to have 'all my goldsmith's tools, work presses, patterns and prints of seals, and all my books and papers thereunto belonging, also my seal ring of arms . . .'. Thomas died three years later, having bequeathed 'my father's picture' to his eldest brother, Richard, and 'my grandfather's picture' to his uncle Francis Anthony, a doctor of physic: these were surely miniatures by his father's and grandfather's old colleague, Nicholas Hilliard.[35]

In the petition to the Privy Council of 1599 in which he tried to borrow from the 'orphanage money', Hilliard speaks of having been 'in trouble' four years before through attending on the Queen about the projected third Great Seal – meaning, no doubt, as he says in the letter of 2 June which has been quoted in full, that he had 'missed many suits' because he was so preoccupied with this royal commission.

His despairing outburst in the letter about being 'in great extremes' produced a result: the letter was followed on 17 August by the grant of an annuity of £40, to be paid quarterly: Hilliard is described as 'goldsmith and our limner'.[36] True to form, within three years he had mortgaged the annuity and handed over the patent – but that story belongs to the next decade.

At just this time Shakespeare was writing *Hamlet*. If Hilliard was a playgoer, which one suspects he was not, he would have smiled wryly at the Prince's bitter remark to Rosencrantz and Guildenstern: 'My uncle is king of Denmark, and those that would make mows [grimaces] at him while my father lived, give twenty, forty, fifty, a hundred ducats apiece for his picture in little.' Hilliard never seems to have received many 'ducats' for his royal limnings.

10

Hilliard's Home

It is generally assumed[1] that the Hilliard family lived continuously at the sign of 'The Maidenhead' in Gutter Lane off Cheapside for thirty-five years – from 1578 until 1613. This needs re-examination.

The family probably moved in in 1579, shortly after the artist's return from France. The appalling outbreak of plague in the 1590s began in the autumn of 1592 and continued until the spring of 1594 – driving many Londoners away for part at least of that time, the Hilliards possibly among them. The invaluable William Averell, clerk of Isaac Oliver's parish, notes in his register that the number of deaths in the capital in 1593 alone (including the so-called suburbs and liberties) totalled 25,886, of whom 15,003 died of the plague – and that out of a population which may have been well under 200,000.

Since the Goldsmiths' Court Minute Book of 1579 to 1592 was destroyed by fire, the first reference to Hilliard's house – after the original one about the lease in reversion dated June 1573 – appears in the next book, and is dated 27 May 1593. This records that he had had to mortgage his lease to the wealthy goldsmith John Ballet, one of his co-sureties for the orphans in the 1580s – perhaps because Ballet had helped him over his guarantees.[2] 'Licence was granted', the entry states, 'to Master Warden Ballet to alien, sell or set over the lease of a tenement in Gutter Lane, late in the tenure of Nicholas Hilliard and now in the possession of the said Mr Ballet.' It is possible that the Earl of Essex helped Hilliard to redeem the mortgage, for in the Devereux accounts at Longleat,[3] under the heading 'Gifts', is an entry for 1595 recording that £20 had been paid to Mr Dean Wood 'for Mr Hilliard's house'; this is said to be 'in part of 140', which may mean that the Earl was completing a gift totalling £140. On the other hand, it could equally well mean that there was a promise to pay £140 but that Hilliard actually received only £20 in all. 'Mr Dean Wood' was Owen Wood, Dean of Armagh, Queen's

chaplain, and private chaplain to the Earl, which made him a suitable intermediary: that autumn he married the widow of John Ballet the goldsmith – 'rich Ballet of Cheapside'. Indeed, he wasted no time about it, for Ballet was not buried (at St Vedast) until 30 September, and by 16 November Rowland Whyte was writing to his master, Sir Robert Sidney, at Penshurst that the Dean and the widow were already married: 'he hath by her £300 a year jointure, and she is besides worth £4,000.'

Clearly the Earl's gift of £20 in 1595, whether or not Hilliard ever received the remaining £120, did not solve his problems, for in the years that followed, a great deal of protracted bargaining went on between the artist and his Company. He applied for a renewal of the lease of 'The Maidenhead' in February 1596, and in May and again in July 1597. Then, on 19 March 1598/9, he offered a 'fine' or down-payment of £20, plus 'a picture [presumably a miniature] which shall be worth twenty nobles [£6.13s.4d.]'. No subject for the miniature is specified. On the 21st his suit was 'respited' until some other time.[4]

The faintest hint of a clue to Hilliard's possible whereabouts at this time exists in a Latin fragment surviving from the Middlesex Sessions Records. It refers to one Christopher Robinson, a hosteler (innholder) of the parish of St Leonard Shoreditch, and a note at the bottom in English records that he was alleged to have enticed away 'a servant of Nicholas Hilliard'. But is this the artist Hilliard? It is just possible that he was lodging temporarily in Shoreditch, since it was outside the City limits, cheaper than living within the walls and further away from creditors, yet at the same time within easy riding or walking distance of the centre of London. The fragment is dated 3 March 1597/8. The name of Hilliard does not appear in a subsidy roll of 1598–9 covering the parish of St Vedast, which again suggests that he was not living in Gutter Lane at the time.[5]

On 30 June 1600 the Privy Council intervened on his behalf.[6]

We understand [they wrote to the Goldsmiths] that Nicholas Hilliard, Her Majesty's servant, being one of your Company, is also one of your tenants of a small tenement of three pounds' rent in Gutter Lane, which because he hath been at great charges to repair (to the sum at least of £200), by reason that it was much decayed and the lights thereof darkened with the annoyance of one of the next neighbours' building, his suit unto you is that his lease being near expiration may be favourably renewed for some longer term of years and for some small fine [cash payment], the rather for the consideration above-mentioned of his charges and for he is one of your own Company.

It is very unlikely that Hilliard really spent the enormous sum of £200 on 'repairing' his house, even if he did receive help from the Earl of Essex or some other source: it sounds like a tall story on his part, intended to arouse as much sympathy as possible – indeed, the whole passage sounds rather as though it had been dictated by the artist.

The communication from the Privy Council goes on to bring the ultimate influence to bear.

> Of which suit Her Majesty having taken notice, and wishing that the same should take effect, is pleased that we shall signify the same unto you by these our letters, and let you know that the favour you show unto her servant Hilliard will be acceptable unto herself, because with the more conveniency of his house he shall be the better able to do Her Majesty service in the skill and workmanship wherein he is employed. We doubt not but it will suffice that we have signified Her Majesty's pleasure in his behalf, wherein we need not add any word of request from our selves, and yet nevertheless to show our own desire also that he may speed, we do earnestly commend his suit unto you, and pray you to afford him all the favour that you may.

Probably it was the artist's staunch friend Sir Robert Cecil who had spoken the necessary word in the Queen's ear.

The Goldsmiths' could not ignore this approach; and four days later, on 4 July, it was minuted that a lease of the house would be granted to Hilliard for twenty-one years. But not on Hilliard's proposed terms. The Company now stipulated that he must make a down-payment not of £20 but of £30, describing this disingenuously as 'his own voluntary offer'.[7] And the miniature (subject unspecified) which he had offered had now become 'a fair picture in great of Her Majesty' – the only positive piece of evidence that Hilliard painted large portraits as well as limnings, although it is considered probable that he did the 'Pelican' portrait of the Queen in the Walker Art Gallery, Liverpool, and the 'Phoenix' portrait in the National Portrait Gallery in London. The picture 'in great' of the Queen was 'to remain in the House [Goldsmiths' Hall] for an ornament and remembrance as well of their humble duties as of her princely favour towards him and of his gratefulness to the Company'. On 28 November of that year he told them that 'the winter time is very unseasonable time to work, he will make it in the summer'; and he had still not paid his £30.[8]

The then Goldsmiths' Hall, a brick building completed by Nicholas Stone in the late 1630s, was badly damaged, and most of its contents destroyed, in the Great Fire of 1666, so there is no way of knowing whether Hilliard ever did paint the portrait of the Queen demanded in 1600. Sir Charles Doe drove to the Hall when he realized the fire danger in 1666, and saved all the Company's silver and the records – but as Miss

Hare, the Librarian, suggests, the portrait (if portrait there was) may have been too large for his coach, or just forgotten in the panic.

The next relevant document in the saga of Hilliard's house in Gutter Lane is his letter to Sir Robert Cecil of 28 July 1601.[9] This is the one in which he says that his former pupils 'now and of a long time have pleased the common sort exceeding well', so that he himself can no longer, by the practice of his art, afford to live in London without some further help from the Queen. 'Although I have long been one of Her Majesty's goldsmiths and drawer of Her Majesty's pictures (to my credit and great comfort), and have upon suits made obtained some rewards [he means that they were not volunteered, but had to be asked for], yet if the common works for other persons had not been more profitable unto me, I had not been able to have continued it [the royal service] thus long.' He realizes that he cannot expect further royal help, '(though a very small matter would help me)', considering how recently the Queen, largely thanks to Cecil – 'the rather for your honour's sake' – granted him the annuity of £40. He therefore wishes to inform Cecil 'what I shall be suddenly [immediately] enforced to do'.

Sufficient weight has not been given to what follows. Hilliard writes that the annuity *'will be a good stay and comfort unto me sojourning with my friends in the country, at house rent and table free'* (my italics); but he is afraid that he will 'not long be safe among them, by reason of some debts' which he owes; and he begs Cecil to seek the Queen's permission (which was undoubtedly not granted) for him to go abroad 'for a year or two at the most'. This is what he will be 'suddenly enforced to do'. He continues: 'I trust in God, and doubt it not, but within that time to take order with all my creditors very easily [the eternal optimist] . . . so, right honourable, I may afterwards return again with credit to Her Highness' better service, quieted and furnished with divers things for my needful use, which are not here for any money to be had.'

The words now put in italics surely mean that Hilliard was already, at the time of writing, staying with his hospitable friends: the annuity, he means, 'will be a good stay and comfort to me *while I am* staying with my friends in the country'. If only he had put a dateline on his letter.

Some months later, on 9 March 1601/2, Hilliard approached his Company again, bearing a letter from Sir John Fortescue (who had become Chancellor of the Exchequer on the death of Sir Walter Mildmay in 1589), and hopefully asked that his fine of £30 be remitted. Two months after that, on 17 May, eight goldsmiths, Hilliard among them, were warned 'to amend and repair their houses' (which must surely prove that he had not already spent £200 on repairs, as he

claimed). On 18 June the Wardens reported that they had had a meeting with Fortescue, who had asked that Hilliard have his lease 'from the expiration of the three years yet to come in his old lease'. This must mean that the original twenty-one-year lease granted in about 1579 had been renewed in 1584, a fact no doubt recorded in the missing Court Minute Book.[10]

On 13 July, over five years after his first known application, the new lease was sealed.[11] The terms remained as demanded by the Company: a down-payment of £30, an annual rent of £3 'and a picture'. This was an unusual transaction. But I have discovered that on 16 April 1607 a freeman of the Painter-Stainers' Company called John Cobbold – presumably a son of the youth of that name who had been apprenticed to Hilliard in 1570 – was given permission to purchase his freedom of the City, in return for the gift of 'the King's Majesty's picture in a fair table, to remain with the Lord Mayor for the time being [i.e., of the day]';[12] so such a payment in kind by an artist was not unique.

According to a Goldsmiths' rent-book, which includes details of all the Company's properties in the City in 1610, Hilliard's tenure of 'The Maidenhead' was dated as from Lady Day (25 March) 1602, and he is entered as being in 1610 the 'present occupier'. In the Court Minute Book for the period, it is noted that on 10 February 1612/13 there was a conference with Laurence Hilliard, Nicholas's son, about 'renewing' *his* lease of the tenement (which perhaps implies that he held it already): he offered to pay a 'fine' of £40, 'but it is agreed that he shall pay three score pounds without any abatement'. So just as in 1602 his father had been required to pay £30 instead of the £20 he had offered, Laurence was now required to pay £60 instead of his offer of £40 – the total having doubled in eleven years. On 7 May 1613 it was agreed that Laurence should have a twenty-one-year lease of the tenement from midsummer; the corresponding entry in the rent-book states that his lease is to date from Michaelmas (29 September), and it now describes him as 'present occupier'. The references of 1610 and 1613 are the only ones to the Hilliards in this rent-book (in which entries are made only at irregular intervals). A few months later, Laurence assigned his lease to a Mr Humfrey Westwood, presumably a fellow-goldsmith.[13]

It is not safe to put too much trust in the evidence of rent- and lease-books. Laurence Hilliard married in December 1611, and he and his wife became parishioners of St Bride's Fleet Street: their four children were baptized there, in 1612, 1614, 1615 and 1617, and Hilliard was buried there in 1648. So he may not have been the 'occupier' of the tenement in Gutter Lane at any time, and he certainly was not so in 1613

as stated in his Company's rent-book. Similarly, it should not be assumed on the evidence of the rent-book alone that his father was the 'present occupier' in 1610. Thus neither the rent-book nor the Court Minute Book can be taken as proving that it was in 1613 – as is sometimes supposed – that Nicholas Hilliard left the parish of St Vedast Foster Lane for that of St Martin-in-the-Fields, where he died in 1619.

It seems that those who wrote up rent- and lease-books in the sixteenth and seventeenth centuries were not in the habit of making regular entries, and that they were slow to catch up with the facts of life (and death). For example, I have closely studied the lease-books of New College, Oxford, belonging to this period: there, after one man had signed the lease of the principal wine-tavern in the city (which belonged to the college) in July 1592, the place is not mentioned again for over ten years; and the adjoining tenement is described in 1616 as being 'now' in the tenure or occupation of someone who had then been dead for twenty-one years. In 1613 the tavern is still called after a tenant who had been dead for thirty-two years; a woman who in the mid-seventeenth century was the tenant for forty years is nowhere named at all; and in the latter part of the century, the lease-book fails to acknowledge the current name of the tavern itself until seventeen years after it had come into general use.

11

The End of the Elizabethan Age

The old order had rapidly changed in the last years of the sixteenth century. In July 1589 Henri III of France, the last Valois king – at whose Court Nicholas Hilliard had been welcomed at the end of the 1570s – was assassinated by a fanatical monk. In England, the Chancellor of the Exchequer, Sir Walter Mildmay, died in the same year, his brother-in-law Secretary Walsingham in 1590 and Lord Chancellor Hatton – and John Bodley, who had taken Hilliard to the continent as a boy – in 1591. Sir Francis Knollys and Lord Chamberlain Hunsdon died in July 1596; in August 1598 came the death of the greatest of them all, William Cecil, Lord Burghley, the Lord Treasurer, followed in Spain in September by England's old adversary, Philip II.

The Queen had been only twenty-five years old at her accession, but she was in no doubt about the ability, and the steadfast loyalty, of William Cecil, whom she immediately appointed her chief minister – with the celebrated words: 'This judgment I have of you, that you will not be corrupted by any manner of gift and that you will be faithful to the state and that, without respect of my private will, you will give me the counsel which you think best.' Although Cecil was sometimes driven almost to distraction by her caprices and her explosive Tudor temper, the relationship held firm until his death. 'No prince in Europe hath such a counsellor as I have in mine', she once declared.

When Burghley grew old, the Queen treated him with great kindness. She would even give him permission to sit in her presence: 'My lord, we are mindful of you', she once said smilingly, 'not for your bad legs but for your good head'; and after his death, tears came into her eyes whenever she heard his name spoken. A miniature of the old, tired man surviving from near the end of his life has been attributed to both Oliver and Hilliard.[1]

Burghley was thirteen years older than the Queen, and although ever

mindful that she was his sovereign, he had been able to advise her with firmness; his son Robert, however, thirty-two years her junior, had a more delicate task, and – to quote Lord David Cecil – 'gave her the full Gloriana treatment'.[2] Burghley had trained his son from early youth to succeed him in the counsels of state. In the words of Sir Robert Naunton: 'He was his father's own son . . . a courtier from his cradle'; and although by the late 1580s the Queen was captivated by the young Earl of Essex, as she had been in earlier days by Leicester, she was well aware of the superior abilities of the young Robert Cecil. He was a very small man, and, perhaps because he had been dropped by his nurse as a baby, he had a crooked back and an awkward way of walking, with splayed-out feet. To his mortification, he could never excel as a sportsman or swordsman – although he could manage partridge-netting and hawking. One of his servants was heard to say of him: 'It is an unwholesome thing to meet a man in the morning who hath a wry neck, a crooked back and a splay foot'. But, to quote Naunton again, 'his little, crooked person . . . carried thereon a head, and a head-piece, of a vast content'; and although he was 'not much beholden to nature for his appearance', he was somewhat beholden 'for his face, which was the best part of his outside'.[3]

He was sensitive, diligent and highly intelligent, but at the same time acutely aware of his lack of physical attraction. When he fell in love with Lord Cobham's daughter, Elizabeth Brooke, he besought a sister-in-law of his to find out whether 'the mislike of my person' would make him unacceptable as a suitor: all was well, and in 1589 the couple were married, and enjoyed a happy although short-lived marriage, Elizabeth dying shortly before her father-in-law.

When his father first introduced Robert Cecil at Court, the Queen predictably nicknamed him her *Pygmy*. He naturally did not care much for this; but his abilities carried him forward, and soon she was calling him by the more affectionate and attractive nickname of her *Elf*. At Walsingham's death in 1590, Robert was too young and inexperienced to take over his post of Chief Secretary – which ranked second only to that of Lord Treasurer held by his father. The Secretary supervised all the main areas of government, including the then very efficient secret service, and he was the chief intermediary between the Queen and the principal council of state, the Privy Council.

For the time being, Burghley persuaded the Queen to allow him to take over the secretaryship himself; but he delegated much of the work to his son – who successfully withstood the efforts of Essex, Ralegh and his own first cousin Francis Bacon to replace him in the Queen's counsels. In 1596 Essex and Ralegh led the successful attack on Cadiz – Gheeraerts'

great portrait of the Earl at Woburn is assumed to have been painted on his return, and the miniature by the artist's future brother-in-law, Isaac Oliver (Colour Plate 6), was probably done at the same time – but while they were away, Robert Cecil achieved his ambition of being officially appointed Chief Secretary. When his father died in 1598 he was the Queen's undisputed first minister.

This was the man to whom Nicholas Hilliard turned in times of trouble, and the man to whom all his surviving letters – five of them at Hatfield and one in the Public Record Office – are addressed. Making allowance for the manners and language of the day, they are in no way obsequious or servile in tone. So far as one can judge from reading only one side of the exchanges – and, in any case, Cecil's responses would have been made verbally, when the expectant Hilliard 'waited upon' him – there was a genuine respect and liking between the powerful minister and the gifted artist.

Apart from the brief appeal in 1594 on behalf of the errant young engraver Abel Feckman, the letters all belong to the period 1599–1610 – the years of Cecil's supremacy. The ambitious courtiers who resented the ascendancy of the Cecils had become adherents of the Earl of Essex; and, as has been seen, at the beginning of the 1590s Hilliard and Oliver were patronized by this faction. But by 1590 Essex had already infuriated the Queen by marrying the widow of Sir Philip Sidney, Walsingham's daughter Frances; and as his fortunes, and so the fortunes of his adherents, began to decline, one suspects that the artists saw the way things were going and sought Cecil rather than Essex patronage.

The attack on Cadiz in 1596 was followed a year later by the Islands Voyage to the Azores, which had a very different outcome. John Donne took part in both – although he was probably not attached to the staff of the Earl of Essex as is often stated. It was on 10 July 1597 that the fleet of over a hundred ships set sail for the Azores from Plymouth – and was almost immediately scattered by the appalling weather commemorated by Donne in his poem 'The Storme', probably written at Plymouth. It includes what is perhaps the most celebrated of the contemporary tributes to Nicholas Hilliard:

> . . . a hand, or eye
> By *Hilliard* drawn, is worth an history
> By a worse painter made. . . .

(The earliest portrait of Donne, dated 1591, is known only from an engraving: it is supposed that the original was done by Hilliard.)[4]

The fleet set sail again from Plymouth in mid-August 1597, but the

Islands Voyage ended in failure. Within two years came the campaign in Ireland, then Essex's dash home in defiance of the Queen's orders, his bizarre irruption into her bedchamber at Nonsuch before she was dressed and ready to face the world, his imprisonment, the abortive rebellion of 1601 and his execution.

One of the most touching of all representations of the Queen, limned by Isaac Oliver, belongs to this period, when she was in her late sixties. It is done with uncompromising and unsentimental realism (Colour Plate 14) – which may explain why it is unfinished, since it can hardly have been to the sitter's liking. It is perfectly complemented by the famous description written by the German traveller Paul Hentzner, who watched with the keenest interest at Greenwich Palace one Sunday morning as the Queen appeared from her private apartments. Hentzner and his friends had been admitted by the Lord Chamberlain to the Presence Chamber, through which Elizabeth usually passed on her way to chapel – Sunday being the day when there was 'generally the greatest attendance of nobility'. Hentzner's description is always quoted as translated from the Latin in the eighteenth century by Richard Bentley (not by Horace Walpole, as is usually stated – he acted as editor) and printed at Strawberry Hill in 1757. It illumines with startling clarity a moment of time in 1598. The Queen was 'very majestic', says Hentzner, 'her face fair [*candida*] but wrinkled; her eyes small, yet black and pleasant; her nose a little hooked; her lips narrow [*labiis compressis* – Oliver's miniature conveys Hentzner's meaning better than Bentley's translation] . . . she had in her ears two pearls, with very rich drops; she wore false hair, and that red [*fulvum* – 'red-gold', 'sandy', 'tawny']; upon her head she had a small crown; her bosom was uncovered, as all the English ladies have it, till they marry; and she had on a necklace of exceeding fine jewels.' The observant visitor did not fail to notice the beautiful hands which figure so prominently in all full-length portraits of the Queen – 'small [*graciles*: 'slender' would perhaps be a better translation], her fingers long, and her stature neither tall nor low [*statura corporis mediocris*, of medium height]; her air [bearing] was stately [*magnifica*], her manner of speaking mild and obliging [*blanda & humanissima* – 'pleasant and very gracious', as we might say].' On this day the Queen was wearing a gown of white silk bordered with large pearls, and a mantle of black silk intermingled with silver threads, and her very long train was borne by a peeress. The Sword of State was carried before her, and she was followed by her ladies and by the fifty Gentlemen Pensioners. There was 'excellent music' at the service, says Hentzner, which lasted just over half an hour.[5]

The Queen as she appears in Isaac Oliver's miniature contrasts sharply with the glittering figure so often portrayed by Nicholas Hilliard, the approved royal limner. Yet even he did not indulge in excessive flattery: as the Queen aged, he portrayed – and the Queen evidently permitted him to portray – the tiredness of the face and the thickening of the jawline. One splendid example (Colour Plate 15) was formerly in Horace Walpole's collection at Strawberry Hill. The flesh-tints, and the crimson of the curtain in the background, have faded, and the silver highlights on the pearls and the silver ornaments on the ruff have turned black, but the work remains a magnificent costume-piece.[6]

Walpole himself, writing in the eighteenth century when tastes had changed, took an austere view. Of portraits of Queen Elizabeth both large and small, he declares: 'The profusion of ornaments with which they are loaded are marks of her continual fondness for dress [he does not acknowledge that her 'dress' was a deliberate part of her presentation of majesty], while they entirely exclude all grace, and leave no more room for a painter's genius than if he had been employed to copy an Indian idol, totally composed of hands and necklaces. A pale Roman nose, a head of hair loaded with crowns and powdered with diamonds, a vast ruff, a vaster farthingale, and a bushel of pearls, are the features by which every body knows at once the pictures of Queen Elizabeth.'[7]

It was in the year of Hentzner's visit to England that Dr Richard Haydocke published at Oxford his translation of the first five books of Giovanni Paolo Lomazzo's *Trattato dell' arte de la Pittura* (Milan, 1584). If we are to believe his introduction, we have him to thank for the appearance of Hilliard's *Treatise*. Having praised the artist's fame among foreigners – 'so much admired amongst strangers' – compared him to 'the late world's-wonder', Raphael, and described his painting as 'extraordinary', Haydocke says he decided that the only way of securing an adequate description of Hilliard's art was to persuade him to write it himself – 'which in the end he assented unto; and by me promiseth you [the reader] a treatise of his own practice that way, with all convenient speed'.[8] Haydocke was writing in the year in which Hilliard's old friend Thomas Bodley began planning the foundation of his library at Oxford; the year, too, in which he sat to Hilliard (Plate 4). Haydocke dedicated his translation of Lomazzo to Bodley from New College, of which he was a fellow; it seems likely that Bodley formed a link between Haydocke and Hilliard and thus played a part in the genesis of the *Treatise*.

Somehow, in the midst of all his other preoccupations, Hilliard did contrive to get the *Treatise* written, or at least drafted: we do not know with quite how much 'convenient speed', but it must have been

completed before the death of the Queen on 24 March 1603, and *c.*1600 is a likely date for its appearance. Lomazzo's work has been called the 'bible of mannerist art theory', and Hilliard was obviously familiar with Haydocke's translation. Indeed, he begins his *Treatise* with the words: 'Of precepts and directions for the art of painting I will say little, inasmuch as Paolo Lomazzo and others have excellently and learnedly spoken thereof, as is well known to the learned and better sort who are conversant with those authors'; he himself will concentrate on the art of limning – 'I intend my whole discourse that way'[9] – an intention which, as has been shown, he did not adhere to.

It was at about this time, on 25 February 1601, that the Earl of Essex, the former patron of Hilliard and Oliver, was executed at the Tower after the attempted rebellion. He was thirty-four years old. Among those executed soon after him was Sir Christopher Blount, the third husband of Lettice Knollys. She never married again during her very long life; when she was ninety, it was said, she could still take a brisk morning walk at her country house at Chartley in Staffordshire.

The number of men executed in 1601 was not large, and among those reprieved was the Earl of Southampton, whom Hilliard had limned seven years before (Colour Plate 8). Robert Cecil's influence had been on the side of mercy, but this did not enhance his popularity with the public, who had idolized Essex. Crowds in the streets shouted after him 'Robin with the bloody breast', and taverns were loud with a new song:

> Little Cecil trips up and down,
> He rules both Court and Crown –

which was quite untrue: the Queen still reigned supreme. Cecil was resigned to unpopularity – and, with his father and wife dead, he immersed himself in his work: 'God knows I labour like a pack-horse', he once said. He devoted his major efforts to securing the peaceful accession of James of Scotland when the old Queen should die.

As though to underline Hilliard's adherence to the Cecil faction, it was in 1601 – the year of disaster for Essex and his followers – that he limned Sir Robert: he says so in his letter to Cecil of 6 May 1606.[10] And the important letter of 28 July, in which he says he can no longer afford to remain in the royal service and wishes to go abroad for a year or two, belongs to this year, 1601.

Soon comes the sad but not surprising news that he has mortgaged his annuity and handed over his patent. An Exchequer document in the Public Record Office shows that at Michaelmas, 29 September 1602, the quarterly instalment was paid to Nicholas's son Laurence, then twenty

years old; and that in the following quarter, by deed dated 9 December, the annuity was assigned to two men called Richard Cannon and Richard Orrell. Cannon has not been traced, but Orrell was probably a minor official of that name in the department of the Clerk of the Hanaper, an office dealing with patents, commissions and grants passing the Great Seal, and also with the purchase of stores for the Court of Chancery, including parchment, and wax for sealing. Hilliard would have had dealings with this office during his work on the preparation of a new Great Seal, and might well have borrowed money from a member of its staff. Orrell continued to receive the quarterly payments until Christmas 1607, and there will be more to say about this later.[11]

While Hilliard was complaining that he could no longer afford to remain in the Queen's service, Oliver had as yet no Court appointment – although he was of course being employed at Court. This is explained by the fact that, since the sovereign was unmarried and childless, there was but one Household, her own. With the death of his first wife Elizabeth in 1599, Oliver was left a widower with one son, Peter, who was probably about ten years old. On 9 February 1601/2, at the Dutch Church in Austin Friars, he married for the second time,[12] thereby allying himself even more closely with the tightly-knit community of immigrant artists from France and the Low Countries. His bride, then twenty-six years old, was Sara Gheeraerts, and she was the first surviving daughter, by a second marriage, of the painter Marcus Gheeraerts the Elder from Bruges. Gheeraerts had arrived in London, with two young children by his first marriage, Marcus and Hester, in 1567 or 1568 – at just about the time that Pierre and Epiphane Olivier arrived from Rouen with their young son Isaac. The importance of Isaac's second marriage will be discussed in Chapter 13.

It was probably at the time of the marriage to Sara Gheeraerts that he moved to the little riverside parish of St Anne Blackfriars, where he was to spend the rest of his life. My recent research[13] has established that in the sixteenth and seventeenth centuries there were several clearly defined artists' colonies in the City of London. Mostly they were outside the wall, notably in the Holborn parishes of St Sepulchre-without-Newgate and St Andrew's; the parish of St Giles Cripplegate; and the parish of St Bride Fleet Street, just across the Fleet River to the west from Blackfriars, and thus a little nearer to the Court where all the leading artists were employed. Parishes outside the City wall had a special appeal for immigrant artists, since they offered greater independence from the authorities. Similarly, the players favoured Shoreditch and Cripplegate,

just outside the City wall to the north – the first two commercial theatres, 'The Theatre' and 'The Curtain', arose in Shoreditch in the 1570s – and, on the other side of the river, Southwark.

The parish of St Anne Blackfriars was an exception to the other artists' quarters in that it was extremely small, and not outside but just inside the City wall. But it enjoyed special privileges because it was on the site of a former monastic foundation, and thus ranked among the 'precincts' or 'liberties'. A petition to the Queen dated 1580, from the inhabitants of the Precincts of St Anne Blackfriars and of Whitefriars a little to the west, is of great importance and interest in the history of the practice of the arts in London at the time. It includes this sentence:[14] 'Item that all artificers [the word covered 'artist' in our sense] and craftsmen [this covered such people as goldsmiths and silversmiths] whatsoever (although they be no free men of the City) lawfully to exercise their trades, mysteries [*métiers*, professions] and occupations without controlment of the Mayor or other officers of the City.'

Then, as now, only a small minority of people were full citizens of London, 'free men of the City'. It was not normally possible to become a citizen without first being a freeman of a Company; and citizenship was debarred to any foreign immigrants. It is clear that the privileges claimed by the parishioners of St Anne Blackfriars made the Precinct especially attractive to the large numbers of artists and craftsmen coming to London as Protestant refugees from France and the Spanish Netherlands.[15] Isaac Oliver was able 'lawfully to exercise his mystery' while being neither a freeman of the Goldsmiths' Company or the Company of Painter-Stainers, nor a freeman of the City; Nicholas Hilliard the Englishman, on the other hand, was free both of the Goldsmiths' and of the City.

The parish of St Anne Blackfriars, where Oliver decided to make his home, proves to have been the main haunt of miniaturists at the time, and other skilled artists and craftsmen of various kinds, many of them of foreign origin, also lived there. It was in this parish, at a somewhat later date – after the death of Isaac Oliver but within the lifetime of his son Peter – that the Crown would grant Sir Anthony van Dyck a house: his was on the waterside, and had a garden.[16] Oliver's home seems to have been at the other – northern – end of the little parish, nearer to St Paul's and away from the riverside.[17]

So at the end of the reign, Isaac Oliver had acquired a second wife and a new home in Blackfriars, while Nicholas Hilliard had had to mortgage his so recently won annuity, and was perhaps living with hospitable friends 'in the country, at house rent and table free'.

The City of London, and the City of Westminster two miles upstream, were both still exceedingly small: London occupied an irregular semicircle, of about a square mile, on the north side of the river, lying within the perimeter of the Roman and mediaeval wall, with a few 'suburbs' and 'liberties' beyond, and then meadows. London Bridge, the only river bridge, linked the City to Southwark on the south bank; similarly, Westminster, the centre of Court, government and the law, with the great buildings of the Palace of Whitehall, Westminster Hall and the Abbey, had open country just beyond, while Lambeth Palace on the south side, the official headquarters of the Archbishop of Canterbury, also had fields round about. On the south side of Fleet Street and the Strand, which linked the two little Cities, were the town mansions of noblemen, with gardens sloping down to the water, and on the north side a narrow fringe of houses and a few more mansions. The church of St Martin-in-the-Fields, close to Whitehall, was still almost true to its name.

Because of the professional demands upon him, Hilliard could not have risked being far away, but he need have gone only a very short distance to be 'in the country'. As late as 1646, Mistress Grace de Critz, the widow of the old Serjeant-Painter, was bequeathed two cows, a mare and a colt although she was a parishioner of St Martin's:[18] it is a reminder of how close the meadows still were to the small built-up areas.

The Queen died at Richmond Palace in the early hours of the morning of 24 March 1603 – the eve of the Annunciation of the Virgin Mary, and the last day of the old year as dates were then calculated: she was in her seventieth year. Sir Robert Cecil, who had worked so diligently to ensure a smooth and peaceful succession, received the news in another room of the Palace and summoned the Privy Council; and at half past ten that morning, on a green at Whitehall, he read aloud a proclamation declaring James VI of Scotland to be James I of England. He then rode north, and met the new sovereign at York on his way to London. He became chief minister of the new King as he had been of the old Queen, and held the office until his death in 1612.

The Lord Chamberlain's Book, a paper book with a parchment cover setting out in immense detail the expenditure on the Queen's funeral at Westminster Abbey on 28 April, is a moving and evocative document: here is the entire Royal Household as it was at the end of the long reign, with hundreds of names, some famous, many totally obscure, and notes of the lengths of mourning cloth allowed for their livery.[19] Under the heading 'Officers and artificers of the Robes' are eighteen names, including Baptist Hicks, the leading freeman of the Mercers' who was knighted

by James I soon after his accession and created Viscount Campden by Charles I in 1628; he comes sixth, followed by John Parr, the principal Court embroiderer; the Queen's famous silkwoman, Mrs Speckart, comes fourteenth, and fifteenth is Nicholas Hilliard, 'picturedrawer'; he and most of the others receive an allowance of four yards of black cloth. A list of fifteen Queen's chaplains, headed by the Dean of Canterbury, includes a Mr Hilliard – could he be the artist's brother Ezekiel?

Isaac Oliver did not, of course, attend the funeral, since he was not a member of the Household; but among the Court musicians, with an allocation of seven yards of cloth for himself and six for his servant or apprentice, is a man who was soon to become Oliver's father-in-law by his third marriage.

12

The Jacobean Age Begins: 1603–12

'After the accession of King James to the throne of Great Britain', wrote
George Vertue in the eighteenth century, Hilliard 'was in great favour in
that Court', and 'of his several scholars, none became so eminent as Isaac
Oliver'. Both artists were renowned on the continent as well as at home:
'so much admired amongst strangers', in Richard Haydocke's words
about Hilliard, and as Vertue wrote of Oliver, 'in Europe he was much
esteemed'.[1]

Both were now required to turn out numerous presentation portraits:
and Hilliard, as His Majesty's limner, no doubt figures anonymously in a
contemporary account of the reception at Court, during accession year,
of the Earl of Rutland. The Earl had been sent to represent King James at
the christening of the son of Christian IV of Denmark – Queen Anne's
brother – and to present the Danish King with the Order of the Garter.
Philip Gawdy, of the prominent East Anglian family, wrote to his
brother Sir Bassingbourne in August: 'My Lord of Rutland came to the
Court last week, and some knights, and other gentlemen of the King's
servants to the number of sixteen [Gawdy's punctuation – written as
here reproduced – seems to mean that the whole party totalled well over
sixteen] had chains given them by the King with his picture hanging by,
to the value of some thirty or forty pound. All the rest had his picture
only.'[2] Bearing in mind the wide meaning of the word 'picture', some at
least of these may have been medals rather than miniatures, but which-
ever they were, Hilliard would have been among those kept busy on this
lavish commission. Elsewhere Gawdy writes of the 'multitude of knights'
created in accession year by King James, a subject for much mirth then
and since. It had become immediately clear that times were to be very
different from those of the late Queen.

Hilliard's surviving miniatures of the King – for example, one now in
the Victoria and Albert Museum (Plate 35), bought from a French owner

in whose family, with one of the King's daughter Princess Elizabeth, it had been for a long time, and one now in the Scottish National Portrait Gallery in Edinburgh (Plate 36) – naturally never fall below the level of great competence, but they indicate that the artist was not stimulated by his sitter as he had been by Queen Elizabeth. It is, however, surely going too far to say that his art 'tended to go rather raggedly to seed' in the new reign, or that it sharply declined in quality;[3] he could still produce a work of distinction when the subject pleased him. One of considerable charm shows Charles as Duke of York, done in about 1611 when the Prince was eleven years old. He wears a hat, and the lesser George suspended from the Garter ribbon; he had been installed as a Knight of the Garter on 13 May 1611 (Plate 39).[4]

At the end of the previous reign, Hilliard had been much exercised over the career of his son Laurence, and in the letter of July 1601 to Sir Robert Cecil in which he seeks permission to go abroad, he continues: 'In the mean time, I hope your honour (in remembrance of your loving kindness promised), will take my son into your service to place him with one of your secretaries, or otherwise; he hath the Spanish tongue [how had he learnt that?], and an entrance into well writing and drawing. The loss of whose time under me (by reason I cannot keep him continually to it as I have done others when I was better able) doth more grieve me, than all my other wants besides.' Hilliard's lament that he has not been able to keep Laurence 'to it', or 'at it' as we would say, is perhaps a further indication that he had been away from home with friends 'in the country'.

Laurence was nineteen years old when this letter was written. On 7 June 1605, when he was twenty-three, he became a freeman of the Goldsmiths' Company by patrimony – by virtue of his father's freedom; and a week later, Nicholas took his last known apprentice, Richard Osbaldeston.[5] His son and his former apprentice, Rowland Lockey, would have helped him with the numerous commissions from the royal family.

In the Goldsmiths' records a few months after Laurence's freedom is a cryptic entry which must refer to him, the Company presumably not yet being familiar with his Christian name, as he had not served a formal apprenticeship with them. It reads: '[blank] Hilliarde and [blank] Arteys were complained of by Mr Berblocke for a great abuse by them offered in arresting him at his stall without licence against the ordinances of the Company, to answer which abuse they are referred to Master Wardens' discretion to be dealt with at their private Court. . . .'[6] There is no further explanation.

Nicholas Hilliard's letter to Robert Cecil of 6 May 1606[7] shows that the earlier letter of 1601 must have arisen out of a conversation while Hilliard was painting Cecil's miniature – for he now writes:

About five years ago when I drew your honour's picture, I found that favour with your honour that your Lordship [Cecil had been created Earl of Salisbury in 1605] accepted my humble offer of my son Laurence his service to your honour, and your honour willed me to retain him still to perfect him more in drawing, which I have done. And he doth His Majesty now good service, both in limned pictures, and in the medalling [or 'medals' – the letter is torn at the edge] of gold. And my hope and humble request is that your Lordship *upon this honourable good occasion* [my italics] will let him wait on your Lordship in your Lordship's livery at the feast solemp [nising – the paper is torn again] of St George.

The words 'upon this honourable good occasion' are omitted from the printed summary of the letter. The cult of St George, and the ceremonies connected with it and with the Order of the Garter, took place in April and May each year, new Knights of the Order being created on 23 April, St George's Day.

According to a letter to the Doge and Senate from the Venetian Ambassador in London, Zorzi Giustinian, dated 4 May 1606 – two days before Hilliard's letter to Salisbury – St George's Day was celebrated on 3 May that year; but he probably really meant the holding of the Chapter of the Knights of the Garter, which may have been arranged on different dates in different years, although always quite close to 23 April. Hilliard's request on behalf of his son presumably means that Laurence should wait upon Lord Salisbury in the same livery as he had worn for the feast of St George; the 'good occasion' is obviously Salisbury's impending installation as a Garter Knight – which took place at Windsor on 20 May. In a despatch dated the 18th, the Venetian Ambassador reports that the Earl is 'entirely occupied in preparations for his installation with extraordinary pomp, and with the many affairs of state incident upon the close of parliament'; and on the 31st he writes: 'The pomp was such that the like of it is not in the memory of man: indeed, all confess that it surpassed the ceremony of the King's coronation; so great is the power of this minister. All envy of him is now dead; no one seeks aught but to win his favour; it is thought that his power will last, for it is based not so much on the grace of His Majesty, as on an excellent prudence and ability which secure for him the universal opinion that he is worthy of his great authority and good fortune.'[8]

His power did indeed 'last' until his death six years later. It is to be hoped that Laurence Hilliard was permitted to wait upon the great man

at Windsor on that spring day in 1606. His father was probably present as well.

In Hilliard's other letter of 1606 to Lord Salisbury,[9] he makes a further attempt to get the size of his £40 annuity increased, no doubt thinking that he may do better with a more open-handed sovereign. He ends the letter thus: 'But I humbly presume your Lordship will stand my good Lord in a greater matter to His Majesty, for the increase of my small annuity, as of your Lordship's own noble kindness and good consideration your Lordship once honourably offered.' Needless to say, nothing came of this request.

At the time of writing, he was not even receiving the £40: it will be remembered that at the end of 1602 it had been assigned to Richard Orrell and Richard Cannon, and Orrell was still receiving the quarterly payment at Christmas 1607. The next payment, on 25 March 1608, was made to a man called John Burges.[10] Thereafter the series of records containing details about the mortgaging of the annuity and the transfer of Hilliard's letters patent comes to an end. But I have now found some references in records of the Court of Requests which complete the story. They cover 1609 and 1610: Richard Cannon has died, and Hilliard is suing his executor, Richard Sling. The Court is told that the annuity had been transferred to Cannon and Orrell in 1602 'in trust only', in return for a loan of £120, the letters patent to be returned to Hilliard as soon as the loan had been repaid. However, he had received only £100 instead of £120; and Cannon had wrongfully assigned his share of the annuity to his executor, Sling. On 26 April 1610 the Court ordered Sling to return the letters patent to Hilliard, and arrearages of the annuity to be paid. On 5 November of that year the artist was paid ten shillings, indicating that his right to the annuity was being re-established; and on 26 April 1611 – a year to the day after the Court order – the full annuity of £40 was restored.[11]

The last of the quarterly payments was made to Hilliard at Lady Day (25 March) 1618 (this is borne out by the fact that, in his will made in the following December, he notes that £30 is owing to him).[12]

The following occasional payments (or proposed payments) to Hilliard for work done, up to the death of Henry Prince of Wales in November 1612, are listed in various documents: (1) warrant dated 7 July 1604, to the Treasurer, Chamberlains and Barons of the Exchequer, to pay him £147.12s.0d. 'as of our free gift and reward'; the money was a forfeiture in the Court of Exchequer and was on deposit in the hands of the King's Remembrancer. (2) Warrant dated 28 December 1603, accounts of the Treasurer of the Chamber dated Michaelmas 1604: to

pay Hilliard, His Majesty's limner, 'for his pains and travel [travail] being appointed by direction to make certain pictures of His Majesty's which were by His Highness given unto the Duke of Denmark's ambassador', £19.10s.0d. (3) Warrant under the Privy Seal, dated 24 December 1604, to the Treasurer and Chamberlains of the Exchequer, to pay Hilliard, gentleman, £64.10s.0d. for twelve 'medallias' in gold (£45 for the gold at £3 the ounce, and £19.10s.0d. for the making and workmanship). Perhaps these were for some members of the Earl of Rutland's party back from Denmark.(4) Accounts dated Michaelmas 1608: to Hilliard, His Majesty's limner, for work by him done for His Majesty's service, viz. for His Majesty's picture given to Sir Robert Carr (the King's Scottish favourite), £4; for the King's and Prince's (Prince Henry's) pictures given 'to the Launcegrave of Hessen', and for one other of His Majesty given to Mrs Roper, with crystal glasses covering them, £15. In all, by warrant of the Lord Chamberlain, £19.0s.0d. (5) Accounts of the Treasurer of the Chamber, 10 July 1609: £9.5s.0d. for two pictures, of the King and the Duke of York (Prince Charles), made and delivered for the King's service – on the same date, Marcus Gheeraerts the Younger (Oliver's brother-in-law) was paid £13.6s.8d., on the Lord Chamberlain's warrant, 'for making the picture [portrait] of Philip late King of Spain'. (6) Warrant dated 5 June 1611, accounts dated Michaelmas 1612: for making two pictures and two tablets of gold for His Majesty's service, £24.12s.0d.[13] It seems that Hilliard really was paid for the specified pieces of work, the money totalling £136.17s.0d. over a period of eight years. But in the case of the warrant under the Privy Seal dated 7 July 1604, for work not specified, there must be considerable doubt whether he ever received the large sum of £147.12s.0d.: as much doubt, indeed, as with the similar Privy Council warrants of 11 October 1573 and 11 December 1591 to pay him £100 and £400 respectively (in the last case, we know that by 1599 he had received only £40, and there is no reason to think that the remainder was ever made up).

The royal limner does not seem to have been doing much better under King James than he had done under Queen Elizabeth. Hilliard's rewards are in marked contrast to those of his great successor Samuel Cooper – who was probably born in 1608.[14] Samuel Pepys, for example, who is always complaining in the *Diary* about his expenses, saw Cooper's miniature of his wife Elizabeth completed at the artist's studio in Henrietta Street on 10 August 1668, and sent round the money with no demur that same night: £30 for the miniature itself, plus £8.3s.4d. for the crystal cover and gold case.[15] Cooper was able to live in princely style in the newly-developed Covent Garden area, whereas Hilliard, as we know,

was always in acute difficulties over maintaining a home. Admittedly, Cooper had no family to support, unlike Hilliard and Alice with their seven children (however long they survived), exemplifying his remark in the *Treatise* that artists have 'commonly many children if they be married'.[16] In addition, Cooper was probably a much better businessman than Hilliard.

In 1610 Hilliard tried to promote his last known 'adventure' – a scheme to mend the highways. This is the subject of his last surviving letter to Lord Salisbury, and he was collaborating with a fellow-gold-smith called William Laborer[17] (wrongly indexed once in the printed calendar of State Papers as 'Goldsmith, labourer'). In the 1590s Laborer had been living in Foster Lane, adjoining Gutter Lane, and there are references to him in two of the Chancery papers in which Hilliard's son-in-law Thomas Richardson is also named.[18] Laborer specialized as a 'latten goldsmith', latten being a kind of brass which was often ham-mered into thin sheets. (It recalls the little seventeenth-century anecdote about Shakespeare, playing on the words 'latten' and 'Latin': the story goes that he stood godfather to one of Ben Jonson's children, and that Ben asked him after the service why he was so preoccupied – at which he replied that he had been trying to think of an appropriate gift for the baby: 'I'll e'en give him a dozen good latten spoons, and thou shalt translate them.')

In 1594 and 1595 Laborer was in trouble with his Company, the Goldsmiths', for allegedly not treating his two apprentices properly.[19] Then in 1596 he brought a suit against a Warden of the Company called John Broad, who was also a governor of a metalworks which had been established at Isleworth in 1568; he alleged that the company running the concern were trying to exploit his knowledge and skill, while Broad in a counter-suit accused him of trying to find out their manufacturing secrets. At one stage, Hilliard and his son-in-law agreed to act as sureties for Laborer – Hilliard having earlier signed two depositions taken in reply to interrogatories issued on behalf of both parties. In the first, *Broad v. Laborer*, he signs on 18 October 1599 – describing himself as being then fifty-two 'or thereabouts' (the customary words in such documents); this constitutes another piece of evidence that he was born in 1547. He is unable or unwilling to contribute anything material to the enquiry. In the second set of Chancery papers, *Laborer v. Broad*, Hilliard signs his deposition on 26 February 1601/2, being now fifty-four 'or thereabouts'; and this time he is more forthcoming.[20] John Broad is described in the records as being 'a tall, black [dark] man', a goldfiner (refiner) by trade, who lived 'at a great corner house next

without Cripplegate, London, as you go out of the gate on the right hand'.

As so often, there is no definite outcome of these proceedings – or, if there was, the records do not survive. But they are interesting because of Hilliard's involvement, and doubly so because his colleague in the earlier goldmining 'adventure' in Scotland, Cornelius Devosse, had himself been concerned with the metalworks at Isleworth.[21]

In 1601 William Laborer was in trouble again with the Goldsmiths' Company. On 17 July some latten spoons were taken from him, and on 15 August – after Sir Richard Martin had investigated – he was accused of having treated them with tin to make them look like silver and silver-gilt; he had also stamped marks upon the handle and in the bowl of each spoon 'resembling very nearly the touch of Goldsmiths' Hall', a very serious offence then as it would be now. He was ordered to undertake to work no more copper or latten; this he had declined to do, whereupon it was agreed that the Lord Chief Justice should be informed, and Laborer's offending spoons shown to him. On 24 August 1602 the Company made search at Bartholomew Fair – the great fair held every year in West Smithfield – 'touching the abuses of Laborer and his complices', and removed from their booth three basins, one dish, eleven trencher plates, a great and a small salt with pillars, and one French bowl – also from another booth, kept by Henry Cowley, a basin, a round salt and a candlestick; this last, it was agreed, should be shown to the Attorney-General in the morning. No doubt worn out by their exertions, 'the Company then resorted to their common garden to recreate themselves.'[22]

The matter dragged on, and by 11 February 1602/3 proceedings had been initiated against Laborer and Cowley in the Court of Star Chamber; on 22 June 1604 the prosecution of the suit 'was well liked of' by the Company. Once again, no outcome is known.[23]

In March of 1604 William Laborer had been among the hundreds of people taking part in the progress of King James, Queen Anne and Prince Henry through the City of London; the coronation had been on 25 July 1603 – St James's Day – but the customary ceremonial entry of the new sovereign into the City had had to be postponed until the following 15 March because of another outbreak of plague. In the Lord Chamberlain's Book detailing expenditure, Sir Richard Martin and his son and namesake are entered under 'The Chamber' as Officers of the Mint, each allowed five yards of cloth for his livery; also with five yards is Andrew Palmer, one of the two Assay Masters – probably he was the man who had been associated with Robert Brandon and Hilliard's

supposed uncle John as a governor of Christ's Hospital in the 1580s. William Laborer appears in a much more humble capacity, among those employed under the Lord Steward in the catering department of the Household: he is entered as 'latten goldsmith', receiving four yards of 'scarlet red cloth' for his livery, and was probably engaged in supplying cutlery and/or cooking-pots for the royal kitchens.[24]

By the time that Hilliard wrote to Lord Salisbury in 1610, Laborer had turned his attention to road-mending. It is probably relevant that a bill on the subject was before the Commons in that year – although it did not get beyond the Committee stage; in Stratford-upon-Avon, Shakespeare made a contribution towards the expenses of promoting the bill.[25]

The artist's letter to Salisbury begins with his complaint about the attack of gout – the most prolonged and severe, he says, that he has ever had. He goes on: 'In this extremity, my good Lord, I vowed, if ever I were able to write again, to supplicate your honour (all my own necessities concealed) [a characteristic Hilliard remark] to favour the honest and commendable suit of William Laborer, goldsmith, for the repairing of the highways.' He does not seem to be at all perturbed about Laborer's previous record.

Hilliard reports that Laborer can do the work at half the previous cost – adding, with his customary self-confidence, 'I have been a great furtherance and light unto him, and had a care that he should first make very good proofs, or ever he should speak of it.' It may seem strange to Lord Salisbury, the artist continues, that he should 'trouble his head with such a matter'; but it is very much a matter for goldsmiths. They can mould sands and clays, and make them firmer than they are by nature; also, they can with their small tools invent larger ones for road-mending; 'and although some pregnant wit may perceive and imitate our way, yet the plain country folk and common labouring men must not only see it done, but often do it themselves, ere they will understand it.' And it is unlikely that anyone 'without skill in drawing' will be able to instruct the smith and the carpenter to make the necessary tools; whereas, once they are well made and in common use, the whole thing will be 'as easy as the plough'.

Hilliard had extolled the superior abilities of goldsmiths in just the same way four years earlier, when he wrote to Salisbury explaining why he had asked to 'trim' the late Queen's tomb: it was 'because as a Goldsmith I understand how to set forth and garnish a piece of stone-work, not with much gilding to hide the beauty of the stone, but where it may grace the same and no more. And having skill to make more radiant colours like unto enamels than yet is to Painters [Painter-Stainers]

known, I would have taught some one which would not have made it common. . . .'[26] (This letter was endorsed by a secretary: 'Mr Hyllyard the Picturer to my Lord.')

Hilliard ends the letter of 1610 about the road-mending: 'Sweet Lord, I have been over tedious; but as your honour hath been a great beautifier of this City, so vouchsafe, my good Lord, to be of the highways also, that the remembrance of your honour may be as the brightness of the diamond [the jeweller speaks], above all other precious stones. And look not, my Lord, on the meanness of our estates or imperfections of nature, but on our affections and true knowledge of your honour, for even Moses had his fault in speech, but his heart was with God (most faithful). To whom I commit your honour. . . .'

Not until he adds a postscript to this effusion does Hilliard mention that for four years he has been hoping for 'some profit' out of the road-mending. (Laborer persisted, and after Hilliard's death – probably in 1623 – he petitioned the Privy Council, claiming to have found ways of repairing 'all the great thirteen ways of England' in three years at comparatively small cost, after which they would need little repair 'to the world's end'. On 17 June the Council commended him to the Justices of the Peace for Middlesex, and asked them to provide him with the necessaries – saying that he would be punished if he did not fulfil his promises.)[27]

In February 1612 Lord Salisbury was taken seriously ill. He travelled down to Bath to see if the waters would do him any good, but soon decided to return home; however, by the time the cavalcade reached Marlborough, he was too ill to go any further, and he died on 24 May. Hilliard's faithful patron lies buried in the Salisbury Chapel of Hatfield parish church, and his recumbent tomb effigy is the work of Maximilian Colt, Isaac Oliver's brother-in-law.

For Oliver himself, things seem to have been going well during these years. In 1605, by patent dated 22 June,[28] he received his first formal Court appointment, when he was made 'Painter for the art of limning' to Queen Anne – at the customary salary of £40 a year. One of his characteristic miniatures of the Queen (Plate 37) was bought by James Sotheby in 1691 for £1.16s.0d., and remained in the family until it was acquired by the National Portrait Gallery. A jewelled locket, presumably containing a miniature, is fastened to the Queen's corsage with a pink bow, and is half-visible at the lower right hand.

Dr Auerbach writes of Oliver's appointment:[29] 'Payments to Oliver are only recorded during the reign of James I. Hilliard remained the

King's limner and Laurence was to follow him after his death. As a way out and to please the fancy of the Court, Isaac was attached . . . to Queen Anne's household . . . [he] was moreover a member of Prince Henry's household and enjoyed the patronage of the art-loving prince.' This is to misunderstand the organization of the Court. During the reign of the unmarried Queen Elizabeth, there had been but one Household; now there were three, the King's, the Queen's and that of the heir to the throne, and thus much more scope for royal appointments. It was not a matter of pleasing a whim of the Court.

No doubt Oliver's style, with its Italian and Netherlandish origins, particularly appealed to the art-loving Danish Queen; in addition, Oliver was in the prime of life at the accession, while Hilliard was approaching old age by contemporary standards, and was closely associated with the old reign, while Oliver was the artist of the avant-garde. John Murdoch has recently written[30] of the 'Englishness' of Oliver and his son Peter, and again of their being 'settled Englishmen', but in their choice of wives, friends and places to live, and above all in their professional relation-ships, they adhered to the immigrant and not to the native English community. Isaac's last surviving son, Isaac junior, who lived on into the 1670s, continued to sign his name 'Olivier'[31] and not 'Oliver', indicating that he felt himself to be French rather than English.

The accounts of Queen Anne's Household show that in the year of his appointment to it, 1605, Isaac Oliver received £100 on 22 March and £50 on 17 June in part-payment of the very large sum of £200 due to him 'for his great charges in attending Her Highness' service and for certain portraitures made for Her Majesty in divers places as well here at London as in progress'. This entry about Oliver records the first, and by far the largest, of special payments under the general heading 'Gifts and Rewards by Warrant'.[32] There is nothing to indicate that he ever received the remaining £50. So far as one can tell from surviving accounts, his £40 annuity was paid regularly until his death in 1617.[33]

The ceremonial progress of the King, Queen and Prince through the City in March 1604 had been a very grandiose affair – much more lavish than that of Queen Elizabeth – with seven huge arches erected along the processional route, and the entertainments devised by Thomas Dekker and Ben Jonson. This was a spectacle for the populace – and at once revealed the inability of the early Stuart monarchs to respond to public acclaim. Instead of expressing appreciation, as Elizabeth had always done at public progresses, King James did not attend closely to the pageants, did not speak to the people, showed no pleasure. As a seventeenth-century historian recorded: 'He endured this day's brunt

with patience, being assured he should never have such another ...
afterward in his public appearances (especially in his sports) the accesses
of the people made him impatient, that he often dispersed them with
frowns.'[34] The principal spectacles of the reign were the Court masques
– of which Queen Anne was the prime mover. And these, of course, were
private affairs, presented by and for the Court: the Queen led her ladies
in the dancing, after the manner of the French *Ballet de Cour*, and the
King and courtiers formed the audience. Ben Jonson was chosen to write
the words, and Inigo Jones to design the sets and costumes. Jonson lived
in the parish of St Anne Blackfriars for a time, thus being a close
neighbour of the Queen's limner, Isaac Oliver.[35] Two of Oliver's best-
known miniatures represent the Queen and one of her ladies in masque
costume (Plate 38 and Colour Plate 18).

Whereas in Elizabethan days it had been the miniature that was
replete with symbolism and hidden meanings, and Hilliard the principal
exponent, now it was the masque that fulfilled that role, and Oliver was
its artist. Jonson made extensive use of emblematic figures, and the
performances presented idealized images of the King, the royal family
and the courtiers. The King underwrote the great cost of the masques
because they exhibited the quality of magnificence, *'maiestas'*, which was
felt to be the essential attribute of monarchy – a quality powerfully
conveyed by Queen Elizabeth in her own person, but not embodied in
King James. In the justification which prefaces his account of Queen
Anne's first masque, *The Masque of Blackness*, in 1605 – the year in which
Isaac Oliver joined her Household – Jonson informs the reader that his
intention is 'the study of magnificence', and on the title-page Anne is
described as 'the most magnificent of Queens'. Oliver excels, in his
Jacobean miniatures, in conveying the sense of magnificence.

Two small paper account-books with parchment covers survive to
provide some details of Isaac Oliver's work for the heir to the throne,
Prince Henry: they list disbursements by Sir David Murray, Keeper of
the Privy Purse to the Prince. The first covers the period 24 June 1608 to
29 September (Michaelmas Day) 1609, and shows that on 26 February
1608/9 'Isaac the painter' was paid £5.10s.0d. for a miniature of the
Prince, a larger sum – £7 – being paid on the same day 'for a gold
enamelled box to it'. Two more payments of £5.10s.0d. were made for
miniatures of Henry on 27 June, the artist now entered as 'Mr Isaac'.
There are also two entries about Robert Peake ('Mr Peck'), the English-
man who was the Prince's official large-scale portrait-painter or 'picture-
maker': he was paid £7 on 14 October 1608 for 'pictures made by His
Highness' command', and £3 on 14 July 1609 'for a picture of His

12. Unknown man, called 'Sir Philip Sidney'
by Isaac Oliver

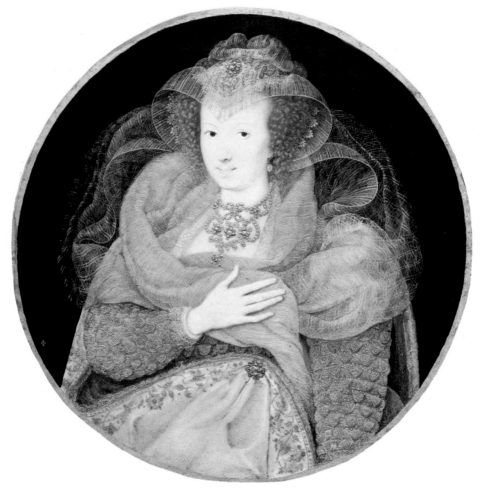

13. Lady, called 'Frances Howard, Countess of
Essex and Somerset'
by Isaac Oliver

14. Queen Elizabeth I,
 unfinished
 by Isaac Oliver

15. Queen Elizabeth I
 by Nicholas Hilliard

16. Unknown lady
by Nicholas Hilliard

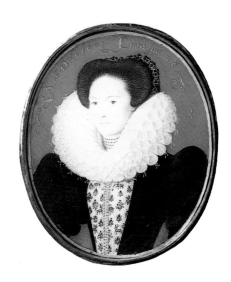

17. Lady, called 'Mrs
Holland', aged 26 in 1593
by Nicholas Hilliard

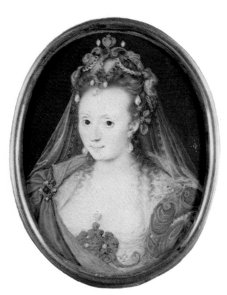

18. Lady in masque costume
by Isaac Oliver

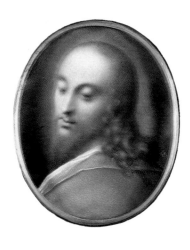

19. Head of Christ
by Isaac Oliver

Highness which was given in exchange of the King's picture'. The prices no doubt reflect the higher quality of Oliver's work, and the general belief that limning was the highest form of pictorial art. Murray's accounts naturally cover a wide variety of items, including such things as losses at cards; and it is noticeable that much more was paid for the young Prince's tennis balls, for example, than for any 'picture', whether large or small: in April 1609 the total was £8, in May £7.10s.0d. and in June £8.14s.0d.[36]

Robert Peake and his son William, both portrait-painters, were freemen of the Goldsmiths' Company. Robert was a slightly younger man than Nicholas Hilliard, having been born in about 1551; but the apprenticeships of the two overlapped, and as the masters of both had their establishments in Goldsmiths' Row in Westcheap, the youths must have known each other well. Robert Peake's master was Laurence Woodham, living at the sign of 'The Key'. Whereas Hilliard's apprenticeship began in 1562, Peake's began on 30 April 1565, and he became a freeman of the Company on 21 May 1576 – nearly seven years after Hilliard. From 1607 he was Serjeant-Painter jointly with John de Critz – concentrating on his duties as royal portrait-painter, while de Critz was in charge of the large department responsible for all the painting-and-decorating of the royal palaces and other residences. De Critz's activities are regularly recorded in great detail in the huge annual parchment rolls of the Office of the Works, now in the Public Record Office; Peake, of course, does not figure there.[37]

There is a gap of a year in the surviving privy-purse accounts of Sir David Murray: Prince Henry was created Prince of Wales on 4 June 1610 – after which his principal residence was St James's Palace – and the second account-book covers the period from 1 October of that year to 6 November 1612, the day of the young Prince's death from typhoid fever. Here, one important section is headed 'Pictures', and it gives details of expenditure of the very large sum, totalling £1,264.11s.4d., spent on works for the Prince's gallery at the Palace. The details are as follows:

To Philip Jacob for divers pictures £130; two other pictures £130;
To *Mr Isaac* for three pictures £32; one great picture £34; three other pictures £30; one great and two little pictures £40;
To Vandellwell Dutchman for the pictures of twelve Emperors £10;
To one Clase a Dutchman for pictures £70;
For two pictures bought of a Dutchman £12;
To a little Dutchman for pictures £260;
To Burlimach for the hundred pictures that came from Venice £408.17s.4d.;

To Philip Jacob aforesaid for pictures £10, and thirty 'alablaster pictures' £15.10s.0d.;

To *Mr Peake* for pictures and frames £12; two great pictures of the Prince in arms at length sent beyond the seas £50; and to him for washing, scouring and dressing of pictures and making of frames £20.4s.0d. [my italics].[38]

Dr Auerbach argues that the use of the word 'great' as it appears in Isaac Oliver's contribution 'either refers to limnings of a large size or perhaps even to oil pictures. The sums he received would seem to confirm the latter suggestion . . . the word "great" surely means what it says and refers to an oil portrait . . . Vertue was convinced that Oliver had painted oil portraits' Certainly Vertue does write that Oliver 'far surpassed all his competitors in limning and in oil painting', but later in the same notebook he says of the artist that he did 'oil colours *in small* [my italics] as well as limnings'. There is no conclusive evidence that Oliver ever did large-scale portraits – although a splendid painting, ninety by eighty-six inches, oil on canvas, done between 1610 and 1612 of the Prince on horseback, is very often attributed to him.[39]

What he certainly did do was – to quote Abraham van der Doort – 'the biggest limned picture that was made of Prince Henry', a very fine miniature $5^{1}/4 \times 4$ inches, formerly in the collection of Charles I and in the Royal Collection today (Plate 40).

Sir Roy Strong believes that Dr Auerbach misread the entry about 'pictures' provided by Isaac Oliver for the Prince's gallery, and that – taking into account the context of the entry – it means that he had been acting as a royal picture-dealer, and that none of the works listed was by him.[40] It is clear that the various Dutchmen in the list were indeed dealers; but the entry about Robert Peake is rather more ambiguous. He is the only practising artist in the list, apart from Oliver himself; and, since he was the Prince's official portraitist, it would seem possible that the 'two great pictures of the Prince in arms at length' (the only works in the whole of Murray's entry of which the subjects are specified, apart from the 'twelve Emperors') were done by him. The payments would be rather high, but as the sitter was in armour, the artist might have had to use expensive gold and/or silver. All this opens up the possibility that some at least of the works in the Oliver list were actually by him; but if so, they may well have been the 'little' pictures only.

John Murdoch develops further the idea that Isaac Oliver was a dealer:[41] he describes him as 'a painter-dealer-historian, an expert agent of the royal connoisseurs' and speaks of his and his son Peter's 'familiarity with the European art market', and again of Isaac's role as 'dealer and agent'. The account-book entry is surely too fragile to support a

theory about art-dealing; as for the 'royal connoisseurs', Prince Henry was only eighteen when he died, and his younger brother Charles, who was of course to become the pre-eminent connoisseur among English sovereigns, was not quite seventeen when Oliver himself died.

The Lord Chamberlain's Book detailing expenditure on Prince Henry's funeral, on 7 December 1612, lists Isaac Oliver under the heading 'Artificers and officers of the Works'.[42] There are thirty-one names in all: first comes Sir John Spelman, jeweller, with an allotment of seven yards of black mourning cloth, with another eight for two servants (apprentices); second is the Scottish Court jeweller Mr Heriot, third 'Mr Isaac painter' and fifth 'Mr Hardret jeweller'. 'Mr Peake the elder painter' (Robert, the Prince's portrait-painter) comes eleventh. Heriot, Oliver, Hardret and Robert Peake are allotted seven yards of cloth each, plus four for a 'servant': Oliver's attendant was no doubt his son Peter. Peake's son William, 'Mr Peake the younger painter', comes fifteenth in the list, with four yards of mourning cloth for himself only. Nicholas Hilliard's name, of course, does not appear, for he had not been attached to the Prince of Wales's Household.

The Hardrets were, like the Olivers, a successful family of French immigrants. They were fellow-parishioners of the Olivers at Blackfriars, and Martin Hardret was one of the witnesses at the baptism at St Anne's, on 18 December 1608, of Isaac's son James, his eldest son by his third wife. Martin describes himself in his will as a 'merchant dwelling in London' but still with property in France, and he sets out in detail the 'merchandize' in which he trades – gold and silver, pearls and precious stones, jewellery, buttons, carcanets, rings, chains and the like. One of his sons, Abraham, secured an appointment as a Court jeweller at King James's accession. No doubt Isaac Oliver and the Hardrets worked closely together professionally, and father and son would have provided jewelled cases for Oliver's limnings, including probably the 'gold enamelled box' costing £7 for the first one of the Prince of Wales listed in Murray's account-book. It was Abraham Hardret who attended the Prince's funeral in December 1612; his father Martin had died earlier in the year.[43]

Two remarkable miniatures of great ladies, one by Hilliard and the other by Oliver, probably belong to the first decade of King James's reign. Oliver's, round, and five inches in diameter (Plate 41) – the same size as the earlier one which, I have suggested, might be of Lettice Knollys (Colour Plate 13) – is called 'Lucy Harington, Countess of Bedford', the patroness of poets and wife of the third Earl, and it is now in the Fitzwilliam Museum at Cambridge. The lady is portrayed at

three-quarter length and wears a beautifully embroidered gown. Oliver paints hands much more often than does Hilliard in his miniatures: usually there is only one, but in this work both hands are shown, the left placed on the sitter's breast over folds of the gauze drapery falling from her head-dress, the right below her waist, with fingertips again touching the drapery. (Oliver's hands, with their long fingers, all look rather alike in his miniatures, whoever the sitter and whichever the sex.) The artist would have gone to Bedford House, on the north side of the Strand (it straddled the site of the present Southampton Street leading up to Covent Garden), to paint the lady now considered, if she is indeed Lucy Harington: it is significant that the work is thought to date to *c*.1605, the year of the first great Jacobean Court masque, *The Masque of Blackness*, for the Countess was one of the principal participants in these spectacles.

The other miniature of a great lady, Hilliard's (Plate 42), is executed almost entirely in white and silver, and set in one of his celebrated borders of simulated jewels. The lady wears a cape lined with ermine and a widow's cap and veil of lace and lawn, and she holds a small white book, probably a prayerbook. There have been many differences of opinion over the years about the dating of the work. At one time it was thought that it showed Mary Queen of Scots as she was when recovering from illness after the birth of her son James – but when he was born, in 1566, she was only twenty-four, and the sitter is obviously an older woman. Later the sitter was still supposed to be the Queen of Scots, but the miniature was thought to have been painted as a memorial portrait done after her execution in 1587. It was oddly stated that the inscription, '*VIRTVTIS AMORE*', was an anagram of 'MARIE STOUART,' although even the numbers of letters are not the same.[44]

The latest proposed date for the miniature is *c*.1615,[45] which may be loosely translated 'early seventeenth century'. Looking at paintings is a notoriously subjective affair, but to my eye, Hilliard's sitter bears some resemblance to one of the indisputably great ladies of the realm, Elizabeth Cooke – if one may assume the portrait of her at Bisham Abbey, done at a much earlier date by an unknown artist, to be a good likeness. The woman in the portrait at Bisham shows Elizabeth as she was after the death of her first husband, Sir Thomas Hoby. She has a rather long chin, whereas in Hilliard's miniature the lady's chin is tucked into her ruff, so that it is not possible to make an exact comparison.

If Hilliard's sitter were indeed Elizabeth *née* Cooke (who died in 1609), there would be a poignant link with the subject of Oliver's miniature, since Elizabeth herself, and not Lucy Harington, would have become Countess of Bedford if her second husband, John Lord Russell, had not

predeceased his father. The eldest son of Francis, second Earl of Bedford, had died in about 1572; the next son, John, Elizabeth's husband, died in July 1584; and the Earl and his third son, also Francis, in July 1585, the son a few hours before the father. July was a fatal month for the family – and fatal, too, for Elizabeth's hopes of becoming Countess of Bedford. Lucy Harington's husband, Edward, who succeeded to the title as the third Earl, was born in 1572 and was the only son of the Francis who died in 1585 – having been mortally wounded in an affray on the Scottish border. The third Earl took part in the Essex rebellion of 1601, and was fined £10,000 and imprisoned, but soon released. He and his Countess, whom he had married in 1594, both died in May 1627.[46]

Elizabeth *née* Cooke, who so nearly became Countess of Bedford, was one of the remarkable daughters of Sir Anthony Cooke of Gidea Park, at Romford in Essex. Her first husband, Sir Thomas Hoby, died on 13 July 1566, while he was English Ambassador to France, at the early age of thirty-six – 'leaving his wife great with child in a strange country', as the inscription declares on the splendid monument which his widow caused to be erected in Bisham church; the child born after his father's death was appropriately called Thomas Posthumus. His elder brother, Sir Edward Hoby, married Margaret Carey, daughter of the Queen's cousin Lord Hunsdon, the Lord Chamberlain. (One of Elizabeth's daughters by her second marriage, Elizabeth Russell, became a Maid of Honour at Court; and Hilliard's beautiful sitter of 1593, 'Mrs Holland' (Colour Plate 17), was once said to have been a Maid of Honour of the same name; but Lady Russell's daughter was several years younger than Hilliard's sitter.)

Of Lady Russell's sisters, Anne became the second wife of the Lord Keeper, Sir Nicholas Bacon, and Mildred the second wife of William Cecil, Lord Burghley. Through them, Elizabeth was the aunt of two great men who played a part in the life of Nicholas Hilliard: Francis Bacon, whom he knew from the time when they were in France in the 1570s, and who when Lord Chancellor made him the payment of £11 at the end of his life; and, much more important, Robert Cecil, chief minister of Queen Elizabeth and King James, and Hilliard's staunch patron. It would be surprising if Hilliard had *not* limned his patron's formidable aunt at some time.

Lady Russell and Isaac Oliver were fellow-parishioners for a time of St Anne Blackfriars, where Elizabeth had her London home. In a petition sent to the Queen in 1596[47] seeking to have the projected Blackfriars Theatre disallowed, the names of 'Elizabeth Russell Dowager' and Lord Hunsdon head the list of thirty-one. 'One Burbage [James, builder of the

first commercial theatre in England, and father of Richard, the star of Shakespeare's company] hath lately bought certain rooms' near the Lord Chamberlain's house, they say; Burbage intends to convert the same 'into a common playhouse', which will be a very great annoyance and trouble to the noblemen and gentlemen living in the Precinct, and a general inconvenience to all the inhabitants, because of the great resort of 'vagrant and lewd persons' who, under cover of resort to the plays, will cause all manner of mischief. The playhouse will be so near St Anne's church 'that the noise of the drums and trumpets will greatly disturb and hinder both the ministers and parishioners in time of divine service and sermons'. The petitioners ask that the said rooms be converted to some other use. If their petition had succeeded, the history of the English stage would have been much altered.

Isaac Oliver probably did not arrive in the parish until 1602: had he been there in 1596, one suspects that he would have signed the petition. All the evidence suggests that he was an assiduous churchgoer; and we may take it that he was in agreement with Hilliard's remark in the *Treatise*, that the 'good painter hath tender senses, quiet and apt' and is temperate in all things.[48] Admittedly the Blackfriars Theatre (which was eventually leased by Shakespeare's company, the King's Men, from 1608, when the Oliver family were certainly living in Blackfriars) was an indoor one, catering for a better-off and higher-class public than the 'Globe' over on the south bank. But it is hard to imagine that Isaac and Peter Oliver would have cared for its presence.

13

More Family Matters: Isaac Oliver and the Court Musicians, Laurence Hilliard and the City Merchants

By his marriage to Sara Gheeraerts in 1602, a year before the death of the old Queen, Isaac Oliver had allied himself in a most intricate way with the two principal immigrant Protestant families of painters from the Low Countries – Gheeraerts from Bruges and de Critz from Antwerp. A miniature by Oliver of one of his three wives survives (Plate 43); this used to be tentatively dated to the 1590s, but Miss Janet Arnold, with her expert knowledge of costume, considers that it belongs to the early years of the seventeenth century, c.1600–15. She sees the sitter as a Dutch or Flemish woman wearing an English embroidered jacket: the coif resembles those in Dutch portraits after 1600, while the embroidery on the jacket is similar to that in several dated English portraits in the first years of the century. The sitter is wearing her smock in a similar way to a man's shirt, with the flat turn-down collar open at the neck – thus she is dressed informally, in a manner not often seen in portraits, but one quite normal for the artist's wife. All this indicates that the woman is Isaac Oliver's second wife, Sara Gheeraerts, and not his third, who we now know to have been French or Anglo-French.

Sara Gheeraerts' mother was Susanna de Critz, a sister of the painter John; and on 19 May 1590, at the Dutch Church in London, Sara's half-brother Marcus Gheeraerts the Younger, the most fashionable portrait-painter of the day, had married Susanna de Critz's younger sister Magdalen, thus converting his stepmother into his sister-in-law. Their son Marcus III, who was also to become a painter, was baptized on 22 August 1602 – six months after Isaac Oliver's marriage. On 31 January 1603/4 the family involvements became even more complicated when Oliver's sister-in-law Susanna Gheeraerts was married – again at the Dutch Church – to Maximilian Colt, an immigrant sculptor from Arras in northern France.[1]

For many centuries, effigies were made for the funerals of kings and

queens of England, and occasionally for other prominent people. Maximilian Colt's elder brother John is often said to have fashioned the effigy for the state funeral in Peterborough Cathedral of Mary Queen of Scots in 1587. In fact, no name is given in the relevant accounts of the man responsible: but John Colt undoubtedly did fashion the effigy of Queen Elizabeth (which does not survive, although a few survivors from other funerals can still be seen in the Norman Undercroft of Westminster Abbey). For the Queen's funeral, on 28 April 1603, Colt was paid £10 for the effigy 'and also for a chest to carry the same'. It was his younger brother Maximilian who subsequently carved the monument of the late Queen for the Henry VII Chapel, and John de Critz who painted it – having headed off Nicholas Hilliard from carrying out a task which belonged to the Court office of Serjeant-Painter which he had himself assumed in 1605. Maximilian Colt – who secured the Court office of Master Sculptor three years later – was also responsible for the small tombs in the Chapel of James I's infant daughters Sophia and Mary. Colt and de Critz continued to collaborate on subsequent royal funerals, and among the best of the surviving effigies is the one made by Colt for Queen Anne's funeral, which took place on 13 May 1619.[2]

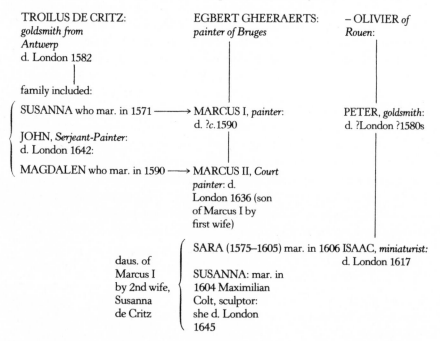

TROILUS DE CRITZ: *goldsmith from Antwerp* d. London 1582

family included:

SUSANNA who mar. in 1571 ⟶ MARCUS I, *painter*: d. ?c.1590

JOHN, *Serjeant-Painter*: d. London 1642:

MAGDALEN who mar. in 1590 ⟶ MARCUS II, *Court painter*: d. London 1636 (son of Marcus I by first wife)

EGBERT GHEERAERTS: *painter of Bruges*

– OLIVIER *of Rouen*:

PETER, *goldsmith*: d. ?London ?1580s

daus. of Marcus I by 2nd wife, Susanna de Critz

SARA (1575–1605) mar. in 1606 ISAAC, *miniaturist*: d. London 1617

SUSANNA: mar. in 1604 Maximilian Colt, sculptor: she d. London 1645

Isaac Oliver would have been constantly in and out of the homes, studios and workshops of the families of painters and sculptors with

whom he was so closely connected. Marcus Gheeraerts the Younger lived in the parish of Christchurch Newgate Street – the parish to which Isaac's mother moved, perhaps after her husband's death, which may have taken place in the 1580s. Gheeraerts' home and studio were in Warwick Lane, which still runs south from Newgate Street into Ave Maria Lane which then meets Ludgate Hill: perhaps Mrs Oliver also lived in Warwick Lane during her later years. John de Critz, at the time of his first marriage in the early 1590s, probably lived in the Holborn parish of St Sepulchre-without-Newgate – the parish where Isaac Oliver and his parents lodged when they settled in London; but in 1607 the de Critz family moved to another part of Holborn, to the parish of St Andrew's. There they lived for thirty years at the top end of Shoe Lane, which runs down from High Holborn to Fleet Street. The Colts lived in the parish of St Bartholomew-the-Great in West Smithfield, which adjoins St Sepulchre's; in the 1590s they had been parishioners of St Martin-in-the-Fields.

One more marriage is relevant: in 1609 John de Critz married, as the second of his three wives, Sara *née* Pookes (Poux), whose immigrant father had come to London from Valenciennes and her mother from Bruges: her first husband, Cornelius de Neve, and their son of the same name, were also painters.

Isaac and Sara Oliver had no children, and on 27 July 1605 Sara was buried at their parish church of St Anne Blackfriars.[3]

In the eighteenth century Horace Walpole wrote: 'Of the family of Isaac Oliver I find no certain account'; and in our own century Graham Reynolds was to declare: 'The life of Isaac Oliver is even more obscure to us than Hilliard's.' It is now possible to add a good deal of information about his later years.[4]

Having involved himself with Court painters and sculptors by his second marriage, Oliver now, by his third, became linked with the Court musicians. Ever since the days of Henry VIII, there had been a preponderance of these from France and Italy. Among them was an immigrant 'from the dominion of the King of France' who secured his right of denization on 5 March 1584/5, and was granted leases of property in reversion in Essex, Surrey and Middlesex on 23 May 1590.[5] His name was Jacques Harden, promptly anglicized to James Harding.

Harding was a leading flautist, and at the funeral of Queen Elizabeth, he is listed third of the seven players of the instrument, who also include a member of the principal Italian family, the Bassanos from Bassano near Venice, and two from the principal French family, the Laniers: one of the Laniers, Nicholas, was grandfather of the man of the same name who

was to become Charles I's Master of the King's Musick, and one of those who assembled artists and works of art for the King on the continent.

James Harding was also a composer of some distinction. He wrote one of the most famous and popular of all Elizabethan galliards, which is found in a number of sources: since the Queen was renowned for her love of dancing and prized good dancers among her courtiers, they all undoubtedly knew it well and danced to it often. In addition, two 'fancies' or fantasias by Harding, written out for keyboard by Thomas Weelkes but surely arrangements of part-music, are in the British Library, in collections also including works by men of such eminence as Byrd, Tallis and Bull; and an incomplete series of five more of his compositions has recently come to light at the Yale School of Music in the United States.

There is plenty of evidence that Harding was highly regarded by his French and Italian colleagues at the English Court; and compositions of his are to be found in a collection of English dance-music compiled by Zacharias Füllsack and published in Hamburg in 1607. He may well have travelled on the continent – perhaps with his French son-in-law, who like him was 'much esteemed' in Europe.[6]

In common with many other immigrant musicians, James Harding had elected to become a parishioner of Holy Trinity Minories near the Tower of London. On 20 January 1577/8 he secured a licence to marry Jane Cotton, spinster, of St Clement Danes, being described in the document as 'gentleman'; the couple were married at the bride's church on the 24th.[7]

James Harding and his wife Jane – who was presumably English – had eight children baptized at the Minories between 1579 amd 1591, most of them dying at a very early age.[8] The second child, Edward, baptized on 24 February 1581/2, survived – and he also became a Court musician. The seventh, Elizabeth, was baptized on 5 March 1588/9. And in the summer of 1606, at the age of seventeen, she became the third wife of Isaac Oliver. The marriage took place at the parish church of the little riverside village of Isleworth, a few miles upstream from London and Westminster – a place with which the Olivers and their friends and relations were to be much associated.

The registers of All Saints Isleworth (now in Hounslow Public Library) were badly damaged in the early hours of 28 May 1943 – in a fire started not during an air raid, as might be supposed, but by two boys aged twelve and thirteen; this gutted the church, leaving only the tower and part of the walls. Towards the end of the first volume, the bottom parts of the parchment folios are very badly charred; but the last entry on

folio 31 can be seen to record the marriage of Isaac Oliver and Elizabeth Harding on 23, or it may be 29, July 1606. It was at the end of that year that Oliver secured his denization rights.

The Harding family probably had a country house at Isleworth, and it was there that their last child, Anne, was baptized, on 11 April 1593. The latter part of 1592, when Mrs Harding became pregnant for the ninth time, saw the start of the severe outbreak of plague which continued until 1594, and James Harding no doubt decided that it would be best to move his family from the Minories to the country. Peter Oliver, Isaac's only son by his first marriage, eventually married Anne Harding, thus converting his father's sister-in-law and his own step-aunt into his wife (as intricate a result as when, in 1590, Marcus Gheeraerts the Younger converted his stepmother into his sister-in-law by marrying Magdalen de Critz). Peter Oliver's marriage probably took place at Isleworth, in a year for which the register entries have been destroyed: the couple were certainly married before 1 May 1626.[9]

To quote from the *Victoria County History* for Middlesex, 'during the sixteenth century an increasing number of the upper and middle classes were attracted to the village [of Isleworth] . . . and to the riverside nearby'; the Olivers and Hardings followed this fashion, in common with other people who like them were employed at Court. Isleworth was one of the regular landing-stages on the journey upstream to the palaces of Richmond, Hampton Court and Windsor, and no doubt Court servants often travelled by water since the roads were so bad. In the mid-sixteenth century it was possible to hire a wherry (light rowing-boat) with oars from London to 'Thistleworth' (Isleworth) 'to and fro' for eighteen pence (more than a day's pay for an ordinary workingman in London), or a tilt-boat (a large boat with an awning) with oars and a steersman for 6s.8d. for one day.[10] The fares would have gone up by the time of the Olivers and Hardings, but they must often have embarked and disembarked at Blackfriars Stairs (a walk of a couple of minutes from the Olivers' home), which was one of the regular staging-points in the City.

The miniaturists and the musicians had to spend much of their time in London, for professional reasons, but they would have relished the soft airs of Isleworth. The place still feels like a village, although it is now part of Greater London; the sturdy church tower still stands; Isleworth Eyot still lies in midstream, although somewhat silted up since the seventeenth century when there were four islets; the smooth stretch of river downstream is fringed with trees and a haunt of water-birds now as it must have been then; and Syon House and Park, the seat now as then of the Northumberlands, adjoin the village on the London side.

(Nicholas Hilliard was probably there in the mid-1590s when he limned the Earl for the third time.) The little river Crane flows through Cranford to enter the Thames at Isleworth, and the Brent comes out at neighbouring Brentford; perhaps this delightful part of the Thames valley inspired the sylvan setting for Isaac Oliver's miniature of Lord Herbert of Cherbury (Plate 31), with its glimpse of a river in the background, and tall trees in the foreground beside a stream. Hilliard, in the *Treatise*, recommends 'quiet mirth or music' as being beneficial to the limner and his sitter:[11] it is pleasing to think of the Olivers quietly limning – both at Isleworth and Blackfriars – to the soft notes of their father-in-law's and brother-in-law's playing.

Isaac and Elizabeth Oliver had six children, all baptized at St Anne Blackfriars. The first, Mary, was baptized on 19 January 1607/8, and buried on the 25th; the second, James, was always thought to have been born in 1609, because he was then baptized (on 8 January) at the French Church in Threadneedle Street;[12] but he was first baptized at St Anne's, on the preceding 18 December. One of the three witnesses at the service at the French Church was 'Jacques Hardan' – James Harding – the baby's grandfather, who no doubt acted as godfather and provided the Christian name. Isaac junior, baptized on 11 December 1610, seems to have been the only one of the family to live very long – although a James who was probably the son of Isaac and Elizabeth was married at St Anne's in 1634;[13] Joseph was baptized on 29 November 1612, Benjamin was baptized on 22 January 1614/15 and buried on 29 March; and Elizabeth was baptized on 23 February 1616/17 – a few months before her father's death – and buried on 24 January 1617/18 – less than four months after it. Isaac Oliver's mother must have spent the end of her life with him, since she was buried at St Anne's – on 6 March 1609/10.

Isaac and Elizabeth Oliver acted as witnesses and/or godparents several times when children of immigrant families were baptized at the French or Dutch Church (they may well have obliged at their own parish church of St Anne Blackfriars also, but there the registers – in common with most others at the time – do not give such details). Isaac Oliver was no doubt the godfather of Isaac Tyse who was buried at St Anne's on 20 March 1603/4, for this baby was a son of Hester *née* Gheeraerts, the half-sister of Oliver's then wife Sara; and, with Susanna Colt, Sara's sister and the wife of the sculptor Maximilian, he was a witness at the baptism at the Dutch Church, on 2 June 1611, of Susanna the daughter of Marcus Gheeraerts the Younger, the portrait-painter. On 24 July 1614, at the French Church, he was a witness when Benjamin, son of Gérard Portier, was baptized; and on 19 May 1616, at the Dutch Church, he acted as

godfather to Isaac Russell, son of Nicasius. Another witness on this occasion was Henry Archer, who was a clockmaker, and the second husband of Hester *née* Gheeraerts, the half-sister of his late wife.[14]

Elizabeth, Oliver's third wife, and Marcus Gheeraerts the Younger witnessed the baptism at the Dutch Church of Elizabeth Russell, another of the children of Nicasius, on 26 July 1612, Elizabeth no doubt being the godmother; and she and Monsieur Marie, Minister of the French Church, acted as witnesses when Nathanael, son of Pierre Chamberlen the younger, was baptized at the church a month later, on 23 August. The Chamberlens, like the Olivers, were a notable family of French immigrants, and they produced eminent physicians and obstetricians in London during several generations. The Portiers, Archers, Russells and Chamberlens were all fellow-parishioners of the Olivers in Blackfriars.

On 28 February 1612/13 Elizabeth Oliver and the widowed mother of her husband's colleague Abraham Hardret the jeweller witnessed the baptism at the French Church of Madeleine Sampson, daughter of Etienne and Madeleine; and on 16 January 1613/14 Elizabeth was at the baptism of John Wheeler at St Mary Colechurch at the eastern end of Cheapside, a little English church of which the register does, unusually, give details of godparents and witnesses at baptisms. The English family of Wheeler was closely connected by marriage with the de Critzes and Gheeraertses.[15] On 26 November 1615 Elizabeth Oliver and Monsieur Marie were witnesses again at a baptism at the French Church.

The last recorded baptism at which Elizabeth Oliver was a witness was at the Dutch Church on 17 January 1618/19 – after her husband's death – when she and the eminent portrait-painter Cornelius Johnson, who had just returned to London from the continent, were at the service for Nicasius Russell junior.

The Russell and Johnson families seem to have been among the closest friends of the Olivers, and they all had strong ties with Isleworth.[16] Nicasius Russell had come to England in about 1573 (not long after the Olivers) from Bruges, and he was a goldsmith and jeweller employed at the Courts of James I and Charles I; he was also something of an artist. His grandson Anthony, a portrait-painter, supplied much information (not all of it accurate) to George Vertue when he was pursuing his inquiries into the history of art and artists in the next century. Anthony Russell told Vertue that his family and the Olivers were actually related, but this seems not to have been strictly so.[17] The second wife of Nicasius, and the mother of nine of his thirteen children, was Clara Johnson, sister of the painter Cornelius: Nicasius was also a friend and near neighbour of Van Dyck, and attended his funeral at St

Paul's on 11 December 1641 – the burial-place, as he noted, being near the tomb of John of Gaunt in the choir.[18] Grave and monument were destroyed in the Fire.

All these foreign involvements were a world away from the English life of Isaac Oliver's former master, and fellow Court limner, Nicholas Hilliard, the west-countryman from Devon; and from the world in which his son Laurence now found himself.

It will be remembered that Laurence had become a freeman by patrimony of the Goldsmiths' Company in 1605. A fragmentary reference in the Middlesex Sessions Records for 1608–9 indicates that he was then still living in the Hilliard family home in Gutter Lane, for he is described as a gentleman of the parish of St Vedast Foster Lane. He and several others were standing surety for certain people accused of 'committing a notorious outrage in Mutton Lane' and beating down doors and windows; one of Laurence's fellow-sureties was Sir Henry Sackford, and another was John Martin of St John of Jerusalem (Clerkenwell) – a place where Laurence would later own or lease property; Martin was presumably the son of Sir Richard and brother-in-law of Laurence's mother.[19]

Anyone doing extensive research into these times cannot fail to notice how often the death of an unmarried man's mother is swiftly followed by his own marriage – he has lost one home-maker and needs to find another. Thus it seems reasonable to suppose that the Alice Hilliard who was buried at St Margaret's Westminster on 16 May 1611 was indeed the wife of Nicholas and mother of Laurence – for it was in December of that year that Laurence married.

By so doing he allied himself closely with the City merchant class – not at such a high level as his father's sitter of 1591, Mr Leonard Darr of Devon, but with a substantial family group nevertheless. The father of his bride – he had died intestate in 1607 – was Mr George Cullymore, a parishioner of St Mary-le-Bow in Cheapside, just across the road from Gutter Lane; he was a merchant venturer and a freeman of the Drapers' Company.[20]

The Drapers' rank third among the Great Twelve livery companies. An association of merchants of the City of London trading in woollen cloth had existed as far back as the twelfth century. Dealings in cloth, and especially its export to Europe, became more and more important, and Edward III granted a royal charter, which still exists, in 1364; the Company also boasts the earliest surviving grant of arms to a corporate body. In the sixteenth and seventeenth centuries a number of Cully-

mores were freemen of the Company, whose Hall was then (and still is) in Throgmorton Street. Among them, and also living in the parish of St Mary-le-Bow, was a James who was probably a brother of George; James was also one of the 215 founder-members of the East India Company. Also a freeman of the Drapers' was George's son and namesake, Laurence Hilliard's brother-in-law; he became a prosperous resident of Poplar, which was then a fashionable part of the parish of Stepney, and he too had links with the East India Company.[21]

George Cullymore senior had married Ellen Buckfoulde at the little church of St Mary Colechurch on 12 June 1570; and they had a large family of children baptized at St Mary-le-Bow. One of the daughters, Jane, was baptized on 28 May 1579; and on 21 November 1605, at St Mary Aldermanbury near Guildhall, Jane was married to a widower called George Farmer, who was a freeman of the Haberdashers' Company. She thereby acquired three stepsons and a stepdaughter, Mary; and she and George had a daughter of their own, Thomasin, baptized at St Mary-le-Bow on 16 July 1609. George died in 1611, between 22 June when he made his will and 3 August when it was proved; he was a man of property, and bequeathed a total of several hundred pounds to his wife and children.[22]

The Farmers could hardly have been closer neighbours of the Hilliards, for their house – where George had presumably lived with his first wife also – was in Huggen Lane (described by John Stow as having become at this time 'very narrow by means of late encroachments');[23] it ran from the east side of Gutter Lane, the opposite side from where the Hilliards lived, to Wood Street. The Hall of George Farmer's Company, the Haberdashers', was close by. It all serves as a reminder that the patterns of most people's lives were largely determined by how far they could walk.

It was on 4 December 1611, four or five months after George Farmer's death, that Laurence Hilliard married his widow – by licence, usually an indication of social standing: the marriage took place (for reasons unknown) across the river at the church of St Saviour's Southwark. Laurence and Jane settled in the parish of St Bride Fleet Street, where their four children were born. Brandon was baptized on 6 October 1612, taking his name, as I have suggested, from the surname of his grand-mother Alice and her half-sister Lucy; Thomas on 29 April 1614; Charles on 28 May 1615; and Laurence – given the Christian name of her father and great-grandmother – on 28 April 1617.[24]

The stepdaughter of Laurence's wife Jane, Mary Farmer, was married to Samuel Thompson, a freeman of the Painter-Stainers' Company;

George Farmer had been godfather to Thompson's daughter Elizabeth, and he appointed Thompson to be one of the two overseers of his will. This provides interesting links with Nicholas Hilliard, and with the Gheeraerts family of painters to whom Isaac Oliver was so closely connected by marriage.

Thompson was the man to whom Marcus Gheeraerts the Younger, the husband of Magdalen de Critz and half-brother of Oliver's second wife, chose to apprentice their son Marcus III: the young man himself was to become a freeman of the Painter-Stainers' on 9 July 1628.[25]

Among the Cecil Papers at Hatfield is a petition submitted in 1593 to Lord Burghley by Samuel Thompson and a fellow Painter-Stainer, Hugh Bennett; they were seeking the sole right to do heraldic works 'upon coaches and otherwise' at royal and other funerals, under Clarenceux King of Arms; 'divers unskilful', they complained, had been intruding upon their monopoly. (It is worth remarking here that this work almost certainly brought them into contact with the family of John Webster the dramatist: for, as I have recently established, the Websters lived in the Holborn parish of St Sepulchre-without-Newgate where they were closely linked with the family of Robert Peake, official portrait-painter to Henry Prince of Wales – and John Webster's father and brother ran a big and profitable coach- and cart-making business in Hosier Lane, West Smithfield.) Lord Burghley forwarded the petition of Samuel Thompson and Hugh Bennett to Clarenceux for an opinion, after which nothing happened; in the following year, 1594, the two men tried again, this time approaching Burghley's son – and Hilliard's patron – Sir Robert Cecil. They begged him to persuade Clarenceux to take action, and said they were 'content that there may also be joined with them to perform such works, Mr Nicholas Hilliard, Her Majesty's servant, so well known for his sufficiency and care in his works'.[26] Whether or not Hilliard did any such heraldic work is open to question: Thompson and Bennett would naturally be 'content' that the great man should co-operate with them, but the petition does not in itself prove that he did, as is sometimes supposed.

14

The Last Years: 1612–19

'Inferior to none in Christendom for the countenance in small': so wrote Henry Peacham in *The Gentlemans Exercise*, published in 1612, of Nicholas Hilliard and Isaac Oliver. His 'good friend Mr Peake' (Robert, the Prince of Wales's portrait-painter) and 'Mr Marcus' – Marcus Gheeraerts, Oliver's brother-in-law – were similarly outstanding 'for oil colours'.

There was much public and private grief at the premature death in November that year of Prince Henry, the heir to the throne; but the bridegroom of his sister Princess Elizabeth, Frederick Elector Palatine, was already in England – he and Prince Charles were the chief mourners at the funeral on 7 December – and preparations for the wedding continued during the winter. The ceremony took place on 14 February, St Valentine's Day. No doubt many of the great ones of the realm commissioned portraits of themselves to mark the occasion, and the Blackfriars studio of the official limner to the bride's mother would have been especially busy. The town house of the Sackvilles of Knole was in Salisbury Court, in the adjoining parish of St Bride Fleet Street, and in the Victoria and Albert Museum is Oliver's full-length – 9¹/₄ × 5 inches – of a splendidly dressed Richard Sackville, third Earl of Dorset (Plate 44), who was twenty-seven years old when the miniature was painted in 1616; the Fitzwilliam Museum at Cambridge has a small head-and-shoulders of him, also by Oliver. A full-length portrait of him 'in large', now in the Greater London Council gallery at Ranger's House, Black-heath, was done in 1613, the year of the royal wedding, and here the young Earl is so magnificently dressed that he is probably portrayed as he appeared on that great social occasion. The artist is presumed to have been the Englishman William Larkin, who is known to have enjoyed the patronage of the Earl and his wife, Lady Anne Clifford. I have recently discovered that, although Larkin's family home was in that haunt of

painters, the sprawling Holborn parish of St Sepulchre-without-Newgate, he was actually lodging in Blackfriars in the years immediately preceding and following the wedding, no doubt for the convenience of his principal patrons, his fellow artists and himself. One of those artists was of course the Queen's limner, Isaac Oliver; and Oliver is known to have been commissioned to copy 'in little' a portrait by Larkin of Lord Herbert of Cherbury (the man whom Oliver limned reclining beside a brook (Plate 31)).[1] It seems likely, therefore, that Oliver's portrayals of the Earl of Dorset 'in small' were similarly preceded by Larkin's portrayal of him 'in large'.

William Larkin was a freeman of the Painter-Stainers' Company and a citizen of London: he owed his citizenship to Lady Arabella Stuart and the Earl of Hertford, the man to whom Hilliard had had to apologize in 1578 – while he was in France – because he had fallen behind in completing a commissioned 'jewel'. Arabella and the Earl's grandson William Seymour (later the 2nd Earl) became acquainted in about 1606, and on 17 July an entry of an unusual kind appears in the records of the Court of Aldermen of the City of London: 'Item at the request of the right honourable the Lady Arbella Steward and of the right honourable the Earl of Hertford and others, signified by their several letters written to this Court on the behalf of William Larkin for his freedom of this City by redemption, it is ordered that the said William Larkin shall be made free of this City by redemption in the Company of Painter-Stainers, paying to Mr Chamberlain to the City's use 6s. 8d.'[2] William and Arabella were secretly married at Greenwich on 22 June 1610.

Larkin had a short life: he died in April or May 1619 – about a year and a half after Isaac Oliver, a month or two after Oliver's patron Queen Anne (she died on 2 March), three or four months after Nicholas Hilliard, and about six months before Robert Peake. Larkin's and Peake's dates of burial are unknown because the registers of their parish church of St Sepulchre's were destroyed in the Great Fire: one has to arrive at approximate dates of death from when their wills were made and proved.[3] Larkin had a stillborn baby and a son William buried at St Anne Blackfriars in 1612 and 1613, and a daughter Mary baptized there on 21 January 1614/15 (the day before Isaac Oliver's son Benjamin) and buried two days later; a second Mary, born after the Larkins' return to Holborn, was still living when the artist made his will.

The royal bride of 1613 – who was born at Falkland Castle in August 1596 – had been entrusted as a young girl to the care of Lord Harington of Exton, a cousin of Sir John the writer and godson of Queen Elizabeth who so much admired Hilliard's work; Lord Harington was the father of

Lucy, Lady Bedford. His account-book survives for privy-purse expenditure for the young Princess during the months preceding her marriage. Along with some clothing, and such items as five shillings for a pair of black roses for her shoes, are entries recording paper, pricking, ruling and binding of a book of her lessons for the virginals, 48s.0d.; 'milk for Her Grace's monkeys, little pans to put their meat in, and other necessaries', 4s.8d.; 'to a joiner for mending Her Grace's parrot cages and other works', 3s.10d.; 'two dishes to put Her Grace's parrots' meat in', 4d.; and to shearing her dog, 12d. Probably towards the end of 1612 (individual entries are undated), two shillings are spent on boat-hire for Thomas Duckworth, one of the Princess's pages, to go 'two several times' to fetch 'Mr Isaac and Mr Hardret': this was no doubt to collect the artist and his friend and colleague, Abraham Hardret the jeweller, from Blackfriars and take them to Kew, where the Princess had been granted a separate establishment in 1608. Later 'Mr Isaac' is paid the handsome fee of £10 for a limning of the Princess for Lady Chichester – Lord Harington's other daughter, Frances, sister of the Countess of Bedford, was the wife of Sir Robert Chichester. Hardret, described as 'Her Highness' jeweller', is paid £38 for trimming a cup of gold and a spoon of gold 'for Her Highness' breakfast' – the size of the payment no doubt accounted for by the price of the gold. There is also a payment of £20 to 'Mr Marcus', Oliver's brother-in-law Gheeraerts the portrait-painter, 'for a picture of Her Grace made at the whole length which was given to Mr John Murray of the King's bedchamber'.[4]

After the wedding, Lord Harington and his wife escorted the couple to the continent: in August, on his way home, Harington died at Worms of a fever. Elizabeth's husband was crowned King of Bohemia in 1619, but the couple were soon driven out by force of arms, Elizabeth to become known to posterity as 'the Winter Queen'. Her sons, the Princes Rupert and Maurice, have their secure places in history: and our present Royal Family traces its direct descent from her daughter Sophia, who married Ernest Elector of Hanover. A miniature of Elizabeth as a young girl by Isaac Oliver (perhaps the one mentioned in Harington's accounts) was once in the collection of her brother Charles I, and is in the Royal Collection today: it portrays her (Plate 45), in the words of Abraham van der Doort, 'in her high time-past-fashioned hair'.[5]

The last known payments for work done by Isaac Oliver are in 1617 and 1618. The new heir to the throne, Prince Charles, had been created Prince of Wales on 3 (or 4) November 1616: by warrant dated 4 April 1617, Oliver, 'picturedrawer', was paid £40 for 'four several pictures drawn for the Prince before his creation'; and by warrant dated

25 February 1618/19, some time after the artist's death, his widow received £40 for a further three works 'made and delivered to the Prince'.[6]

Isaac Oliver's original will survives, in addition to the contemporary registered copy. The original is written on three large sheets of good paper, and the document is dated 4 June 1617: the artist signs 'Isaac Olliuer' at the bottom of each page in a rather shaky hand. The will has been described as a 'formidably premeditated legal document', but the original shows that it was not wholly 'premeditated': there are a number of alterations and insertions. As for its being 'formidable', its terms are not unusual for the period: and, as we now know, Oliver was leaving four children still under the age of ten, in addition to his eldest son Peter in his twenties and a wife who was still only twenty-eight, so it was very important that he should dispose of his valuable property to the best advantage. If the lease of his house in Blackfriars is sold to raise money, his wife – if she wishes to acquire it – is to have it for £40 less than any other buyer. To his eldest son Peter the miniaturist, Oliver bequeaths 'all my drawings already finished and unfinished; and [all my] limning pictures, be they histories, stories or any thing of limning whatsoever of my own hand work as yet unfinished'. This clearly excludes *finished* 'limning pictures'. If Peter should die without issue – as he did – the drawings only are to go to such other son as will practise 'the art or science' of limning: so far as we know, none did. The next provision is that Peter shall have 'the first proffer of the sale of my pictures that shall be sold, and five shillings in a pound cheaper than any [one else] will give for them'. Erna Auerbach misinterprets this part of the will and writes: 'Though Oliver did not classify the pictures as by his own hand, he assumed that they were of special interest to his eldest son and he clearly distinguished them from his miniatures.' But he *does* classify them as by his own hand: they are just as much 'his' as the drawings and the unfinished limnings mentioned in the previous sentence. The distinction is not between his 'pictures' and his 'limnings' – the two words mean the same thing – but between his limnings 'as yet unfinished' and his 'pictures that shall be sold' – that is, completed limnings. He would not have wished unfinished ones to be put up for sale.[7]

The artist appoints his wife to be executrix of the will, in the customary way, and the overseers to assist her are her father and brother, James and Edward Harding the Court musicians, and her stepson Peter Oliver. The Hardings and Oliver's lawyer, Raphe Fetherstone, sign the will as witnesses (the Hardings still spelling themselves 'Harden'); James's wife Jane also acts as a witness, making her mark. Peter Oliver

neither signs nor witnesses the document, so he must have been away from home at the time of his father's death.

Since burial normally followed about three or four days after death, it would seem that Isaac Oliver died at the end of September 1617: he was buried at St Anne Blackfriars on 2 October. George Vertue reports that Peter had a monument put up to him in the church, 'with his bust cut in marble', and in the eighteenth century he himself saw 'a busto-model . . . in baked clay of Isaac Oliver . . . only the head with the ruff under it', supposed to be the 'model' for the completed work; I presume that this was executed by the artist's brother-in-law, the Court Master Sculptor and fellow-Frenchman Maximilian Colt. (Vertue also saw 'several leaves of tablets belonging to books of I. Oliver, that he carried in his pocket to sketch in with a silver pen'.[8] He was wildly wrong about the date of the artist's death, saying that it took place 'in Charles I's time' – whereas Charles was not to become King until eight years later.)

The provisions of Oliver's will underline the essential difference between his career and Hilliard's. Vertue wrote of Oliver that 'he designed not only heads, but various compositions of histories'; as for 'stories', Hilliard makes his view of them plain in the *Treatise*:

'Now know that all painting imitateth nature, or the life; in everything, it resembleth so far forth as the painter's memory or skill can serve him to express, in all or any manner of story work, emblem, *impresa*, or other device whatsoever. But of all things, the perfection is to imitate the face of mankind – or the hardest part of it, and which carrieth most praise and commendations, and which indeed one should not attempt until he were meetly good in story work – so near and so well after the life as that not only the party, in all likeness for favour and complexion, is or may be very well resembled, but even his best graces and countenance notably expressed; for there is no person but hath variety of looks and countenance, as well ill-becoming as pleasing or delighting'.[9]

Hilliard's absolute conviction, that the highest form of art is 'to imitate the face of mankind . . . after the life', means that he probably had few, if any, 'drawings', 'histories' or 'stories' to bequeath to his own son Laurence. Oliver, on the other hand, was inspired by his visit or visits to Italy to limn histories as well as portraits: in Venice he saw the small cabinet pictures of Elsheimer, Rottenhammer and Brill and copied the drawings of Parmigianino. A few of his histories and subject pieces have survived, among them a half-length of *The Prodigal Son*, which was once in Charles I's collection, and a *Head of Christ* (Colour Plate 19), now in the Victoria and Albert Museum. But his most ambitious works, to which there are many seventeenth- and eighteenth-century references,

have disappeared. The most admired of all was a large limning of *The Entombment of Christ*, which is said to have been almost finished at Isaac's death and which was completed by his son (it must have been among the 'limning pictures as yet unfinished' bequeathed to Peter in the will). Signet Office docquets dated March 1636–7 include one noting that a pension of £200 a year was to be paid in quarterly instalments, from Christmas 1636, to 'Peter Olivier Esq' for his presentation of the completed work to King Charles, and for all other limnings to be done in the future. A preliminary full-scale drawing for this work came to light during the last war, when it was acquired by the British Museum.[10] It is very unlikely that Peter Oliver received much of the very large pension, especially as the outbreak of the civil wars was not far off.

More payments to Nicholas Hilliard than to Isaac Oliver are recorded in the royal accounts in the period after the death of Henry Prince of Wales at the end of 1612 – partly because Hilliard lived a little longer than his former pupil, and partly because he was King James's official limner; but it is clear that for any unadorned miniature he received considerably less than did Oliver for commissioned limnings of Princess Elizabeth and Prince Charles. The last known payments to Hilliard are: (1) Warrant dated 3 November 1613, accounts dated Michaelmas 1614: to Hilliard, His Majesty's picturemaker, 'for one tablet of gold, graven and enamelled blue, containing the picture of the Prince's [Charles's] Highness, with a crystal by His Majesty's command to be done', £12. (2) Lord Chamberlain's warrant dated 31 January 1614/15, accounts dated Michaelmas 1615; 'for a picture of the Prince in linen drawn to the waist with a rich crystal thereon, and delivered to Mr [Thomas] Murray his tutor', £8. (3) Lord Chamberlain's warrant dated 18 October 1615, accounts dated Michaelmas 1616: for work done by Hilliard, His Majesty's picturedrawer, 'about a table of His Majesty's picture garnished with diamonds, given by His Majesty to John Barclay', £35 – the much increased price accounted for by the rich setting; next comes an entry about a warrant signed by the Lord Chamberlain on 15 May 1616 for 'three several pictures of His Highness' (Prince Charles) by Robert Peake, described as the Prince's painter, also £35. (4) Accounts dated Michaelmas 1618: to Hilliard, picturedrawer, for 'a small picture of His Majesty's delivered to Mr Heriot, His Majesty's jeweller', £4.[11]

In addition to these royal commissions, the Salisbury private accounts at Hatfield for 1619–20 include an entry about the large payment 'to Mr Hilliard in full of his bill' for £104; the payment must have been made to Laurence, and probably it was for work done by his father before his death some months earlier.[12]

Once again, during the last few years of his life, Hilliard's name appears in connexion with a suspected popish recusant on the continent: the story is as obscure and difficult to disentangle as the one of the 1590s concerning Michael Moody, Lady Arabella Stuart and the Duke of Parma's son. And again there is no suggestion that Hilliard himself was under any kind of suspicion.

This time the man concerned was called Abraham Savery, and relevant manuscripts are among the State Papers, the Cecil Papers and the Downshire manuscripts.[13] An entry in the printed calendar of State Papers has Savery being accused of spreading popish books 'beyond the seas', and this has sometimes been accepted: but it would be irrelevant as a charge at home, and what the original manuscript says is that Savery is accused of being 'a receiver and forwarder of popish books *which are sent from beyond the seas*' (my italics): that is, he has been distributing them *in England*. The reference is in a letter written by George Abbot, Archbishop of Canterbury, from Lambeth Palace to Lord Chief Justice Coke.[14]

Two years before, on 20 May 1613, William Trumbull, the Resident at Brussels, and a man much concerned with investigating the activities of popish recusants, had written to the Archbishop[15] about an allegation that Savery and his father-in-law had had 'secret conferences' with 'the Archduke' (the Spanish ruler in the Netherlands), in the previous summer (1612) and that they had delivered to him a 'picture' of the then Prince of Wales (Henry) 'for some bad purpose'. The painter of the 'picture' is not named, nor is the 'bad purpose' enlarged upon. The accusation was denied; but Trumbull goes on to say – if his very ambiguously worded letter is interpreted rightly – that Savery has confessed that his mother-in-law *'brought over for her daughter, now his wife, a portrait of her husband* [presumably Savery himself] *by Hilliard the painter'*. This, *'for the fame of the workman* [artist] *and curiosity of the science* [skill of the art], *was much admired by this people, things of that nature being here in great estimation,* and by himself showed to some of the Archduke's pages, and other of his acquaintance' (my italics). Whatever all this means, it constitutes further evidence of how much Hilliard was 'admired amongst strangers'. According to a letter (now among the State Papers) written to the Lord Chief Justice by Sir William Waad – the man who in the 1590s had investigated the affair of Thomas Harrison and his box containing the metal 'picture' of Queen Elizabeth – Savery usually lived in Middelburgh, but sometimes visited Flushing, where his father-in-law, a man called Clifton, kept an inn.[16]

Savery's name comes up again in connexion with the murder of Sir

Thomas Overbury. The notorious Frances Howard, who has been mentioned earlier, had been married in January 1606, at the end of the Christmas season, to Robert Devereux, third Earl of Essex and son of Queen Elizabeth's favourite; the couple were in their early teens, and the marriage took place in the chapel of the Palace of Whitehall. The masque on the wedding night, *Hymenaei*, was as usual a Jonson/Jones production, and no doubt Queen Anne's limner Isaac Oliver and his future father-in-law the Court musician were present. While the young Earl was away on a continental tour, Frances fell in love with King James's Scottish favourite, Robert Carr; and she and her confidante, Mrs Anne Turner, sought the help of the quack doctor and astrologer Simon Forman to render her husband 'frigid' towards her on his return home, and Carr 'callid'. In January 1613 Frances took the almost unprecedented step of seeking a bill of divorcement, on the ground of her husband's impotence. One of the most outspoken and dangerous of her opponents was Overbury, and she and her family contrived to get him consigned to the Tower, where on 15 September he died a painful and lingering death from poisoning. Ten days later Frances secured her decree of nullity – Archbishop Abbot being among the courageous minority who were outvoted seven to five on the preceding commission of enquiry. On 3 November Carr was created Earl of Somerset, and on 26 December he and Frances were married at Court.

Soon the young George Villiers, the future Duke of Buckingham, began to supplant the Earl in the King's affections; and slowly but inevitably the story of the poisoning of Overbury came out. Mrs Turner and the other agents of Frances Howard's plot were arrested and examined during the latter part of 1615; Mrs Turner was tried before the Court of King's Bench on 7 November. She said that she and the Countess had often resorted to Forman at his house at Lambeth, and that after his death in 1611 they had employed Dr Savery (Hilliard's sitter), who had 'practised many sorceries upon the Earl of Essex's person'. In the letter from Archbishop Abbot to the Lord Chief Justice already mentioned, written while the enquiries into Overbury's murder were in full swing, the Archbishop says of Savery: 'He hath no honest trade to maintain himself, but goeth by the name of Dr Savery, and maketh show of profession of physic, whereas upon the examination taken before me, he confesseth himself never to have been of any University, or to have more skill than out of English manuscripts. . . .' The College of Physicians had made a very similar accusation against Forman in the 1590s.

Anne Turner was one of those executed – she was taken to Tyburn a

week after her trial; 'many men and women of fashion came in coaches to see her die', to whom she made the expected speech, at which all were moved to pity and grief. The churchwardens' accounts of St Martin-in-the-Fields note the burial fee 'for Mrs Anne Turner who was executed at Tyburn for poisoning of Sir Thomas Overbury knight'.

Finally the Somersets themselves were arrested and imprisoned in the Tower: they were tried in Westminster Hall and found guilty, on successive days (24 and 25 May) 1616, and remained in the Tower for six years. We hear no more of Savery, so obviously no charge was pressed against him.[17]

The events leading up to the trial of the Earl and Countess, and their conviction and imprisonment, naturally caused an immense stir at the time: Nicholas Hilliard must have taken an especially close interest.

He himself was briefly imprisoned during these years – but neither 'in 1617' nor 'for debt', as is often stated, but before – and probably well before – 1617, and for someone else's debt. The evidence for all this is in papers of the Courts of Common Pleas and Requests, and the man involved with Hilliard in litigation was William Pereman, a yeoman usher of the Chamber at Court. Proceedings dated back to 1612; later Pereman alleged that at Hilliard's request he had lent £20 to a Mr John Longford 'upon the joint bond and assurance' of Longford and Hilliard, and that it was only when the debt remained unpaid 'a long time after' the promised date that he went to court and had the artist committed to Ludgate prison. Hilliard then apparently proceeded against Pereman in the Court of Requests, for a fragmentary 'answer' by him, dated January 1617, survives.[18] Eventually, says Pereman, he had been 'content for quietness . . . to take commiseration of Hilliard for his enlargement out of prison', on his promising to repay the remainder of the debt. As this document is dated January 1617, and making allowances for the law's delays, it is obvious that Hilliard's imprisonment cannot have been later than 1616, and was probably earlier than that.

This story has sometimes been presented as amounting to the 'degradation' of the artist in the evening of his life: but the evening was not so far advanced as has been supposed, and from Pereman's remarks it does not seem that the imprisonment was long. In any case, in those days all sorts of people were constantly in and out of the several City gaols, for an enormous variety of alleged offences great and small, and there was no particular disgrace about it. The policing system was rudimentary, and it was a rough-and-ready way of attempting to keep order and investigate complaints, many of them altogether frivolous. Sir Richard Martin, who has been mentioned so often, really did – unlike

Hilliard – suffer 'degradation': this former Sheriff and Lord Mayor was removed from the aldermanry in 1602 for 'unfitting demeanour and carriage' – because of poverty and imprisonment for debt.[19]

In spite of all his ups and downs, Hilliard went on working almost to the end of his life, and he continued to produce miniatures of excellence when the subjects pleased him: a good example is a work dated 1616 – when he became sixty-nine – representing a young man who has been identified as Henry Carey, later second Earl of Monmouth (Plate 46). The sitter is twenty years old, which fits young Carey. He was a grandson and namesake of Lord Chamberlain Hunsdon, Queen Elizabeth's cousin and probable half-brother, and also a great-nephew by marriage of the late Lady Russell, who, as I have suggested, may have sat to Hilliard some years before (Plate 42); her son Sir Edward Hoby had married Hunsdon's daughter Margaret.

In this miniature, instead of painting a background representing crimson satin or velvet curtains, as he had commonly done since the 1590s, the limner reverts to the traditional blue: he also reverts to a calligraphic inscription. It reads: '*Encore Vn* [star sign for '*astre*'] *Luit pour moy*', 'Still a star shines for me'. The young man holds the strings of his collar with the tips of the fingers of the left hand – a hand much more true to life than those so often portrayed by Isaac Oliver. The sitter has been oddly described as looking 'lovesick',[20] but surely appears to be altogether neat, composed and thoughtful, as befitting a scholarly young man who apparently had little taste for Court life. It has been suggested that the inscription refers in some way to the creation of Prince Charles as Prince of Wales at the beginning of November 1616.[21] Henry Carey's father, created Earl of Monmouth soon after Charles's accession in 1625, had for some years been in charge of the young Prince's Household, so that his son would have known the Prince well: indeed, he was among twenty-six men who were created Knights of the Bath at Whitehall on the day that Charles, then nearly sixteen years old, became Prince of Wales,[22] and he may have commissioned his miniature to mark the occasion.

In the following year, 1617, King James, by patent dated Westminster 5 May, granted 'our well-beloved servant Nicholas Hilliard, gentleman, our principal drawer for the small portraits and embosser of our medallions of gold', a monopoly for twelve years to make, engrave and imprint royal representations. This was in recognition of his 'extraordinary art and skill in drawing, graving and imprinting of pictures and representations of us and others'. The King was meeting a request from the artist, who had said that he 'durst not show and publish' such works, for fear

they might be copied, to his own 'loss and discredit'. Hilliard was to pay 13s.4d. a year at Michaelmas for the monopoly. The grant came within two years of his death; during that time he is known to have authorized an engraving by the immigrant artist Francis Delaram of a portrait of Queen Elizabeth.[23]

Nicholas Hilliard is often said to have died on 7 January 1618/19, but that is the date of his burial at St Martin-in-the-Fields. It is just possible that he died at the end of 1618, but more likely that his death was on about 3 or 4 January, since death usually preceded burial by three or four days. He is very unlikely to have reached the age of seventy-two, as is also often stated, but he was undoubtedly in his seventy-second year. His brief will[24] was made on 24 December, and he was by then too ill to execute his beautiful signature, and could only make his mark. He leaves twenty shillings to the poor of the parish, and £10 to his sister Anne Avery from the £30 due from the Crown for his annuity; there is a reference to £15 owing by 'Mrs Anne Langford', probably the widow of the man mentioned in Pereman's Court of Requests 'answer' of January 1617; apart from £10 worth of bedding and household stuff for Elizabeth Deacon, who has been caring for him during his last illness, everything else is bequeathed to his well-beloved son Laurence, who is appointed executor. This would have included all his works of art finished and unfinished and his painting gear, but in contrast to the will of Isaac Oliver, nothing is mentioned specifically.

Laurence could not rise to a marble monument for his father, as Peter Oliver had done for his father in 1617; but 52 shillings was spent on the funeral, an exceptionally large figure.[25]

Some words of George Vertue make a fitting epitaph: 'Being inclined to the study of drawing and limning, he became very excellent in several branches of the art, as his works do well testify; great numbers are still the ornaments of royal collections and noble cabinets of curiosities in England.'[26] That is as true today as when it was written in the eighteenth century.

Within the space of some fifteen months, England had lost the two great limners who between them portrayed most of the leading figures of Elizabethan and Jacobean society, in their habits as they lived.

The self-portraits (Colour Plates 1 and 9) unmistakably reveal the essential Englishness of the one artist and the essential Frenchness of the other. Yet Hilliard from Devon had had the experience of time spent in Geneva as a boy and in France as a young man – and probably, when Oliver studied under him in the 1580s, they conversed in French.

Hilliard was a freeman of a leading City company and of the City itself, took a number of apprentices and lived – for some years at any rate – in the heart of the City, just off Cheapside; but Oliver, as a foreigner, remained outside the formalized structure of London society, and settled in a little precinct on the edge of the City which offered a certain freedom from the authorities to its residents; he did not seek denization papers until late in life; and almost all his personal and professional relationships were with fellow immigrants. Notable among these were the portrait-painters Marcus Gheeraerts the Younger, John de Critz and Cornelius Johnson, Johnson's brother-in-law Nicasius Russell the jeweller, the Hardrets – also jewellers, the sculptors John and Maximilian Colt and the Court musicians James and Edward Harding and their French and Italian colleagues. Hilliard, by contrast, seems to have had no close relationships with fellow artists.

Both men eventually secured Court appointments – although for Hilliard it was later rather than sooner – and they were granted the same salary, £40 a year, Hilliard as limner to the English Queen Elizabeth and the Scottish King James, Oliver as limner to the Danish Queen Anne. Each trained one of his sons to follow him into royal service; Hilliard's son Laurence married into the City merchant class, while Peter Oliver – a much more distinguished artist – maintained the French connexion by marrying his stepmother's sister.

It would be rash to draw firm conclusions about the characters of Nicholas Hilliard and Isaac Oliver from such manuscript records as have survived through the intervening centuries, and there is nothing written by Oliver to set beside Hilliard's *Treatise* and his letters to Robert Cecil. But the impression conveyed is of a romantic, impulsive, self-confident and perhaps somewhat arrogant Englishman as against a prudent, well-organized and circumspect Frenchman. Hilliard was easily persuaded to involve himself in such precarious projects as the Scottish gold-mining adventure and William Laborer's road-mending scheme; and his name crops up intriguingly, although probably quite innocently, in connexion with the affair of Arabella Stuart, Parma's son and the Catholic recusant Michael Moody; with the 'Rialta' correspondence between the Essex faction and the young Scottish king; and with the inquiries into the Overbury murder. It would be as surprising to find the name of Oliver associated with such matters as to learn that he had ever shared Hilliard's experience of being committed to prison.

The works offer striking contrasts. Hilliard's portrait-miniatures have a springtime brightness and freshness, the features unshadowed with an emphasis on line, and a brilliant representation of dress and accessories

matching the exuberance of contemporary fashion; Oliver's miniatures are executed in more autumnal colours, and the dress of the sitters with less dash, and the features are shadowed to convey an impression of three-dimensional realism. Hilliard's Elizabethan works in particular, with their calligraphic inscriptions and elaborate symbolism, match the 'conceits', the verbal gymnastics of the poets and playwrights; Oliver portrays the symbolic qualities of the Jacobean masque costumes, but generally forswears inscriptions and guessing-games in the interests of realism.

In later years Alexander Pope was to declare that 'the proper study of mankind is man', and it was Hilliard's declared belief that for the artist, 'the perfection is to imitate the face of mankind'. Oliver, unlike Hilliard, did 'histories', 'stories' and allegorical drawings as well as portrait-miniatures, and often chose religious themes. Hilliard, unlike Oliver, practised not only as a limner but as goldsmith, jeweller, calligrapher, engraver and medallist. Court and society were fortunate in being able to employ two artists with such a wide range of talents.

15

The Lines Extinguished

Most of the leading families of immigrant Tudor Court musicians – Laniers, Bassanos and Galliardellos prominent among them – settled in parishes near the Tower of London: Holy Trinity Minories, St Olave Hart Street and Allhallows Barking. The head of the Lanier clan, Nicholas, had eleven children, and all six sons became Court musicians in their turn. In 1585 John, the eldest, was married at the Minories to Frances Galliardello, who was then in her nineteenth year; her late father Mark Anthony had served all the Tudor sovereigns from the days of Henry VIII. The French-born Court musician James Harding, who like John Lanier was a flautist, no doubt attended the wedding at his parish church.

Harding's first surviving child, Edward, who was also to become a Court musician, was then three years old. John and Frances Lanier settled in the parish after their marriage: their second child – Nicholas, art connoisseur and Master of the King's Musick under Charles I – was baptized in September 1588; Harding's daughter Elizabeth – the future third wife of Isaac Oliver – in March 1589; and Nicholas Lanier's sister Judith in December 1590. More children were born to both families, and they must all have spent much time together.

Judith Lanier became the first wife of Edward Norgate, whose *Miniatura or The Art of Limning* constitutes the next main source of information on the art after Hilliard's *Treatise*.[1] A miniature of Judith is inscribed on the support (part of an ace of hearts) by her husband – at the top, with the words *'Juditha Norgate. 1617. aet: 25'*, and at the bottom with *'Non obijt sed abijt. Pudicitiae, Pietatis, et Venustatis rarissimum decus. Suauissimae Coniugis, Ed: Norgate'* – 'She has not died, but departed. Rarest ornament of modesty, affection and beauty. To his most sweet wife, Ed: Norgate.' (Judith was in fact not twenty-five but twenty-seven at her death: she was buried at St Martin-in-the-Fields on

16 February 1617/18.) The inscription has led some people to attribute the miniature to Norgate himself, but this always seemed unconvincing; he does not write *'Ed: Norgate fecit'*, which would have been customary; and – far more important – the quality of the work is surely much too high for a man who was never a professional limner. The son of Robert Norgate, Master of Corpus Christi College, Cambridge, Edward made his reputation as an art connoisseur (like his brother-in-law), as an illuminator of the initial letters of official documents and as a Clerk of the Signet and Herald – he died at the College of Heralds in 1650. He also had some musical talent, which explains how he came into contact with the Court musicians: in 1611 he received a joint grant, with one of the Bassanos, of the office of tuner of the King's 'virginals, organs and other instruments'. Thomas Fuller, in his *Worthies of England* – published only twelve years after Norgate's death – writes of him that he was 'employed generally to make the initial letters in the patents of peers and commissions of ambassadors . . . he was an excellent Herald . . . and, which was the crown of all, a right honest man'. Not a word about his being a limner in the sense of a portrait-miniaturist. Indeed, Norgate himself, in the opening paragraph of *Miniatura*, recalls that he had originally drafted his discourse at the request of the royal physician Sir Théodore Mayerne, composing 'such observations as from the best masters and examples here and beyond the mountains I had learned and for my recreation practised, as my better employment gave me leave' – he clearly regarded limning as very much of a sideline, and himself as a complete amateur. 'Never was it my meaning', he writes later, 'that the time spent in this art should become a hindrance to better studies . . . for all painting in general I look upon but as lace and ornament.' He concedes that limning exceeds other forms of art 'as a curious watch doth a town clock'; but his grudging tone is far removed from the declaration by Hilliard, the dedicated professional artist, that limning is 'a thing apart' which 'excelleth all other painting whatsoever'.[2]

Now that we know of the close involvement of the Olivers with the world of the musicians, it seems reasonable to attribute the miniature of Judith Norgate to Peter Oliver.[3] In style it closely resembles his signed *Sir Francis Nethersole*, done two years later. Both works can be seen at the Victoria and Albert Museum, and colour plates are juxtaposed in Carl Winter's *Elizabethan Miniatures* (1943) and in *The English Miniature* (1981). The distinction between Edward Norgate and Peter Oliver is neatly emphasized in a Lord Chamberlain's book covering the period 1628–34: after a long list of Court musicians, Norgate is entered as 'Keeper of the Organs' and Peter Oliver as 'Limner'.[4]

In *Miniatura*, Norgate writes of Isaac Oliver as his 'dear cousin', and of Peter as his 'cousinell'. The modern editor of the work argues[5] that these are no more than terms of affection and friendship: Norgate had ornamented so many letters to and from kings, princes and emperors, who commonly addressed each other as 'cousin', that he had caught the habit. This is not very persuasive: in manuscripts of the period, the word 'cousin' as used by people outside Court circles *does* almost without exception indicate a relationship, whether of blood or by marriage. The first Laniers, like the Olivers, had arrived in London as Protestant refugees *from Rouen* in the 1560s: they may well have travelled together, and I suspect that the two families were related. Thus Norgate, through his marriage with a Lanier, would have established a relationship with Isaac and Peter Oliver.

Although Vertue describes Peter Oliver as 'an excellent artist' who became so eminent in limning that 'he outdid his father in portraits', most of his original portrait-miniatures seem to belong to the years up to the end of the 1620s: thereafter a great deal of his time was spent copying, 'in little', oil-paintings in Charles I's collection. At least seven were of works by, or then thought to be by, Titian: as Norgate writes in *Miniatura*: 'Histories in limning were strangers in England till of late years [he is forgetting Isaac's 'histories'] it pleased a most excellent King to command the copying of some of his own pieces, of Titian, to be translated into English limning, which indeed were admirably performed by his servant, Mr Peter Olivier.'[6] It is debatable whether it was royal orders or a failure of creative talent which caused Peter to do so much copying work.

He is known to have given instruction in limning to the miniaturist Alexander Cooper, who – as I have recently discovered – was born in 1609,[7] and who was the younger brother of the greatest of mid-seventeenth-century practitioners of the art, Samuel. Alexander would presumably have begun studying under Oliver in his mid-teens, say in about 1624: Sandrart, in his *Academia Nobilissimae Artis Pictoriae* (1683), describes him as '*Olivierii hujus discipulus longe celeberrimus*', 'far-and-away Oliver's most famous pupil' – which implies that he took others as well. 'John Galymor from Mr Olivers', buried at St Anne Blackfriars in October 1641, may have been one of them.

Peter Oliver attended the funeral of Queen Anne in 1619, and also that of King James in 1625[8] – at this he is entered in the accounts as a member of the Household of the new King, Charles: his father- and brother-in-law, James and Edward Harding, head the list of twenty-one 'musicians for windy instruments'. A few months later James, Edward

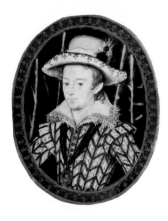

39. Prince Charles
by Nicholas Hilliard

40. Henry Prince of
Wales
by Isaac Oliver

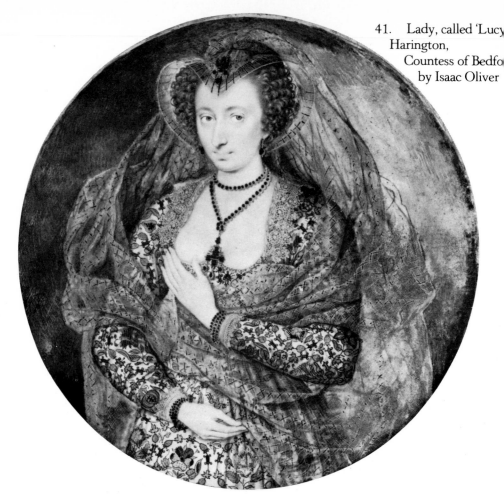

41. Lady, called 'Lucy
 Harington,
 Countess of Bedford'
 by Isaac Oliver

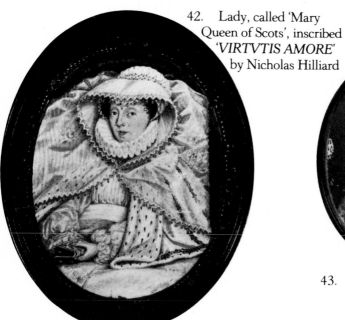

42. Lady, called 'Mary
 Queen of Scots', inscribed
 'VIRTVTIS AMORE'
 by Nicholas Hilliard

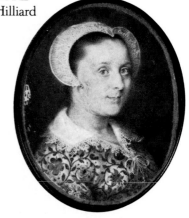

43. Mrs Oliver, wife of the
 artist
 by Isaac Oliver

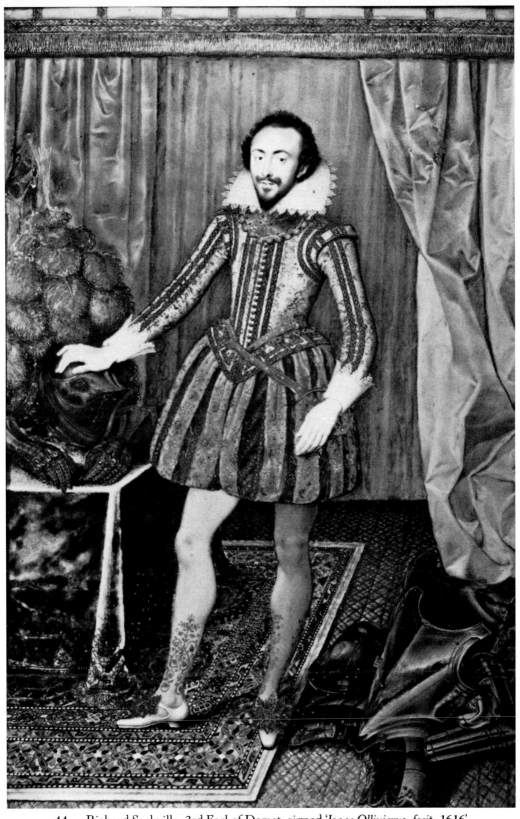

44. Richard Sackville, 3rd Earl of Dorset, signed '*Isaac Olliuierus. fecit. 1616*'
(slightly reduced); by Isaac Oliver

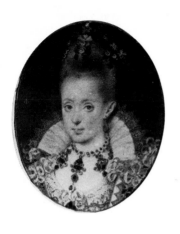

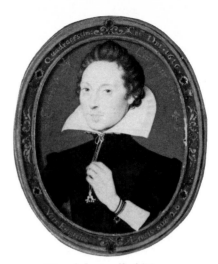

45. Princess Elizabeth,
later Queen of Bohemia
by Isaac Oliver

46. Man, called 'Henry
Carey', later 2nd Earl of
Monmouth, aged 20 in 1616,
inscribed 'Encores Vn * Luit
pour moy'
by Nicholas Hilliard

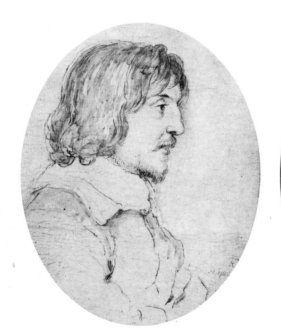

47, 48. Peter and Anne Oliver: drawings by Peter of himself and
his wife

and Edward's wife Mary were all dead, probably victims of the latest outbreak of plague; James was buried at Isleworth, as his wife Jane had been in 1622, and Edward was probably buried there too. James and his son both died intestate, but Mary Harding's will survives: she remembers her sisters-in-law Elizabeth, Isaac Oliver's widow, and Anne, Peter Oliver's wife – Elizabeth is to have a ring that had belonged to Mary's husband (Elizabeth's brother) and 'my bees at Thistleworth', and Anne 'my best tiffany ruff and one pair of tiffany cuffs'.[9] One gets the impression of a close and affectionate family circle, an impression reinforced by later records.

Soon after Isaac Oliver's death, his widow had become the second wife of Mr Pierce Morgan, a wealthy freeman of the premier livery company, the Mercers', who had two houses in Blackfriars, a house and shop in Cheapside, two tenements at Southampton – indicating that he engaged in foreign trade – and several properties at Isleworth. Elizabeth, who died before him, was probably buried at the village, but Pierce Morgan was buried at St Anne Blackfriars, on 9 April 1640. His bequests to Jane, his daughter by Elizabeth, include two miniatures of her grandparents – presumably the Harding grandparents, and presumably done by Isaac Oliver; to Peter Oliver he leaves 'my watch with the silver case for a remembrance', and to twenty-nine-year-old Isaac Oliver, Peter's half-brother and apparently the only surviving son of Isaac senior by his third wife, 'his father's picture in lieu of a silver cup he had given him by his godfather or one of his witnesses [at his baptism in 1610] . . . this being his desire'.[10] Probably this was the self-portrait miniature which is now in the National Portrait Gallery (Colour Plate 9).

Close relations continued between the Olivers and the Morgans; with the family of Nicasius Russell and his wife Clara, sister of the painter Cornelius Johnson; and with various other English and Dutch families who had homes in the City and/or in the pretty Thames-side villages upstream from London and Westminster including Isleworth, Mortlake and Twickenham. Among the families of Dutch origin were Vandeputs, Coles, Desmaistres and Hostes, all of them people of some distinction (one of the Hostes acquired property in north Norfolk, where his descendants had close ties with Lord Nelson and his family).[11]

Nicholas Hilliard's son Laurence attended King James's funeral in 1625: his name, with that of his fellow-limner Peter Oliver, appears among those of nearly sixty 'artificers' and others in the Household of the new King, Charles I; among four jewellers of the late King's Household is Isaac Oliver's old colleague Abraham Hardret. The office of His Majesty's limner held by Nicholas Hilliard had been granted to Laurence

in reversion on 13th October 1608,[12] and it was confirmed on the same date – 13 October – 1619, a few months after Nicholas's death. The patent recalls the original one of 17 August 1599 granting Nicholas an annuity of £40, and states that Laurence is to receive the same for life. It speaks of his having 'attained to good perfection and skill' in the art of limning thanks to his father's instruction, and declares that 'we have had sufficient experience of his work for ourself and for our dearest wife the Queen'.[13]

Not long after this, Laurence petitioned the King in the Court of Star Chamber, alleging that he had been the victim of an unprovoked attack on 18 June 1621 which would prevent his performing the royal service and making his living by his art: he had 'received a wound and mayhem upon his right hand' and had lost the use of one of the forefingers. Four 'turbulent and mutinous men', whom he names, with others – more than a dozen in all – had set upon him in Field Lane in the parish of St Andrew's Holborn (the lower end of our Saffron Hill), at about nine or ten in the evening, as he was walking home from Clerkenwell to Fleet Street, and had left him unconscious and 'bleeding in great abundance'. One of his alleged assailants, a Clerk of the Court of Star Chamber called Abel Gresham, promptly accused the miniaturist of perjury, and a series of charges and counter-charges ensued – during which Hilliard toned down his original complaint and said no more about his painting hand being irreparably damaged. The whole thing seems to have petered out in 1624.[14]

In September 1631 Laurence and his wife, with their fourteen-year-old daughter, were in Suffolk, and on 14 September the artist wrote to his son Brandon – then nearly nineteen – who was keeping an eye on the business: he said that they would be visiting 'my sister Parker' at Bury St Edmunds on the following day, and would be home shortly. Mrs Parker was probably not one of Laurence's own sisters – there is no evidence that they were still alive – but a sister-in-law.[15]

Laurence Hilliard and Peter Oliver, limner sons of famous fathers, died within a few weeks of each other. Oliver died at Isleworth, and was buried at St Anne Blackfriars on 22 December 1647 – we learn from his widow's will that he was buried 'in the vault with a stone laid over him'; Hilliard was buried in his parish church of St Bride Fleet Street on the following 23 February. Oliver's will is brief, and he is only able to make his mark; he leaves everything to his wife. Hilliard's will, on the other hand, is quite long and informative; it had been made on 21 February 1640/1, seven years almost to the day before his burial (perhaps he was ill at the time and thought he might die). George Vertue, very hazy about

dates as so often, says that Oliver was buried 'about the year 1664' – seventeen years out. (He also says that he 'lived to near threescore', which, if anywhere near the truth, would put his birth in the late 1580s, the date I have suggested.)[16]

Laurence seems to have had an especial affection for his only daughter and namesake, and he charges his 'most loving wife . . . by all love and kindness that hath ever been betwixt us, that she show the more love and kindness to mine and her daughter Laurence'. Erna Auerbach slightly misreads this passage, and has the artist charging his wife 'that she sheweth more love and kindness' to their daughter, implying that she had not been showing enough. What he is really doing is picking up and re-emphasizing the words 'love and kindness': there has always been love and kindness between him and Jane, and he urges her to show even more to their daughter. (Laurence was twenty-three, and unmarried, when her father made his will.) The first bequest is to her: 'an excellent limned piece of a gentleman done in mourning, one Mr Hearne by name', which he values at £30. As I have recently suggested, the sitter was perhaps William Herne, who, as the late Queen's Serjeant-Painter from 1572 to 1580, had been a professional colleague of the testator's father Nicholas.[17]

To his eldest son Brandon, Laurence leaves 'my book of drawings of several masters' hands', 'the Earl of Leicester's picture in a great box [case], drawn in his cloak with a cap and feather', papers relating to his property in Clerkenwell, 'a picture of Queen Elizabeth drawn from head to foot in a small volume and in a great box' and 'my own picture drawn when I was a young man it an ivory box'. His second son Thomas (who witnesses the will) is to have 'my grandfather Hilliard his picture [this was presumably the miniature done in France in 1577 (Colour Plate 2) which is now in the Victoria and Albert Museum] in an ivory box with a crystal upon it' and 'a book of portraiture [engravings by Nicholas, perhaps?] in a russet forrel [cover] with strings'. There is no reference to the third son, Charles, who was perhaps away or abroad when the will was made in 1641; nor does Laurence mention his Farmer stepchildren – perhaps they were dead.

None of the works of art bequeathed to his children seems to have been by Laurence – his own miniatures would have been owned by the sitters; the bequests would have been valued family possessions done by his father. There is no mention of Nicholas's limnings of himself and his wife Alice, done in France in the 1570s (Colour Plates 1 and 3) – in the will, Laurence began to write 'my father's pic', but altered it to 'my grandfather Hilliard his picture'. In the customary way, he leaves a third

of his personal estate to his wife, and this no doubt included the miniatures of his parents: similarly, Isaac Oliver's miniatures of his in-laws would have gone to his widow, and on her death to her second husband, who at his death bequeathed them to their daughter Jane.

Laurence's sons Brandon and Charles took out freedom of the Goldsmiths' Company by patrimony on 16 September 1653. At the Restoration in 1660, Charles II was immediately bombarded with petitions by people seeking recompense for past royal service and consequent hardship. The petitions are now among the State Papers, and one of them is from Brandon Hilliard.[18] His father and grandfather, Laurence and Nicholas, he says, had for eighty years 'faithfully served your Majesty's father, grandfather and ancestors' as limners; £600 is owing of his late father's annuity, and during the civil war Laurence had 'sustained many losses, imprisonments and troubles' for his loyalty, to the undoing of himself, his wife and children. The petitioner had borne arms for the King, being a 'menial servant' to Lord John Stuart and in actual service with him when he was killed, and had then been a 'menial servant' to the Queen Mother, Henrietta Maria, and her family at Exeter. Upon the surrender of Exeter he had 'suffered a double persecution', from the public enemy and from incurring debts on behalf of the Queen; he had narrowly escaped imprisonment and had been 'forced to fly into France and the West Indies for shelter'. He now sought employment at the Custom House in London (as did many another petitioner). He would have had to sell some family possessions, for Vertue writes[19] of an account-book kept by him containing entries about limnings, medals, drawings, prints and coins, 'the prices they cost him and some what he sold them for'.

Upon his return to London, Brandon had settled in the parish of St Clement Danes in the Strand, where he was buried on 2 March 1671/2, and his widow Elizabeth on 23 January 1676/7. Their daughter Jane had been married to a Mr Owen Price of Gray's Inn at St Martin-in-the-Fields on 10 May 1671; her parents evidently thought poorly of him. Laurence's second son, Thomas, is wrongly identified by Erna Auerbach with a Thomas Hilliard, Painter-Stainer, of St Bride's parish; Laurence's son may have been a Thomas who in the 1670s was living in Long Acre. The third son, Charles, was buried at St Benet Fink behind the Royal Exchange on 9 February 1675/6; his wife had died earlier, but he makes handsome provision for their daughter Frances, the wife of Mr Jacob Croone, to whom she had been married at St Clement Danes on 7 July 1668; Croone was probably a wine merchant and commissioner for the Wine Act.[20] Charles Hilliard mentions his sister Laurence – Mrs Rich –

in his will; when she made her will, on 24 August 1687, she was living as a widow in the parish of St Dunstan-in-the-West, Fleet Street. She calls herself 'Laurentia', and makes provision for one young grand-daughter, Laurentia the daughter of Dr Charles Trumball; other bequests are to her 'cousin' (niece) and god-daughter Frances Croone and her husband, and to their 'children' (unnamed). Laurence appoints as her executors Sir Peter Rich, alderman – no doubt a relative of her late husband, whose name seems to have been Samuel – and Mr Richard Bayley Esquire of Gray's Inn. (Sir Peter, a freeman of the Saddlers' Company, was a Sheriff in 1682–3 and City Chamberlain in 1684–87, 1683–89 and 1691, and was also a Tory MP for a time.)[21]

Laurence *née* Hilliard apparently had no sons, and unless her brother Thomas had a son or sons, there seem to have been no direct male descendants of Nicholas Hilliard to carry on the name after his grandsons.

As for Isaac Oliver, it seems that the male line ended with his son and namesake: this emerges from my discovery of the will of Peter's widow, Anne. After Peter's death, Anne retired to Isleworth, her birthplace. At the Restoration, King Charles asked about the fate of the Oliver miniatures, which he well remembered from his boyhood, and on being told that Mrs Oliver had a great many of them, he visited her incognito, picked the ones he wanted and subsequently offered her £1,000 down or a £300 annuity – she chose the latter. Some years later, the King gave some of the miniatures to his mistresses, and when Anne Oliver heard about it, she declared that he would never have had them if she had known that he was going to give them to such 'whores, bastards and strumpets'. At this her annuity was stopped.[22]

Drawings by Peter Oliver of his wife and himself, once in the possession of Vertue and then of Walpole (Plates 47 and 48) are now in the National Portrait Gallery. The one of Anne is doubly interesting: it shows a woman of suitably uncompromising aspect, and it may provide a clue as to what her elder sister Elizabeth, Isaac Oliver's third wife, looked like.

Mrs Oliver died, at the age of seventy-nine, between 27 July 1672, when her will was made, and 14 August, when it was proved. There is also an inventory, which shows that she had two houses at Isleworth, with a total of fourteen rooms. Isaac Oliver junior, now aged sixty-two, is living with her, and she entrusts him to the care of Mistress Elizabeth Grantham, 'whom I have always found loving, careful and tender both of myself and of my nephew' – perhaps Isaac was an invalid. Elizabeth Grantham was a grand-daughter of Nicasius Russell and his wife Clara,

the sister of the portrait-painter Cornelius Johnson. Mrs Oliver makes a number of bequests to members of the Morgan family; and an interesting provision in her will is that '*all the paintings and pictures remaining*' are to be sold. According to George Vertue, 'the remaining part of the limnings [which the King had not selected], some finished and some unfinished, fell into the hands . . . of Mr Russell's father, and an old gentlewoman some ways related to them [the Russell family] still living'. Anne Oliver's will at last clears this up: 'Mr Russell' was Vertue's informant Anthony, a son of Theodore the painter and grandson of Nicasius, and the 'old gentlewoman' was obviously Elizabeth Grantham, a daughter of Theodore's sister Mary Russell by her husband, Jeffery Grantham.[23]

Isaac Oliver signs Anne's will as one of the three witnesses, and the inventory is taken by John Symcocks of Isleworth – the husband of Nicasius Russell's daughter Elizabeth – and another man.

The bones of Isaac Oliver and Nicholas Hilliard are now unmarked. St Anne Blackfriars was destroyed in the Great Fire of 1666, Oliver's marble monument with it, and the church was not rebuilt; however, some feeling of the little parish still lingers in the small lanes and alleys between Ludgate Hill and the river. Old St Martin-in-the-Fields, Hilliard's burial-place, was pulled down in 1721 and replaced by the church we know today. Horace Walpole, lamenting the dearth of anecdotes on the life of Samuel Cooper, remarked that it was unimportant: 'his works are his history'.[24] So it is with Hilliard and Oliver: they live in their works.

Abbreviations

B.L.	The British Library, London
Burl. Mag.	*The Burlington Magazine*
C.L.R.O.	Corporation of London Records Office, City of London
C.P.	Cecil Papers, Hatfield House
C.S.P.	*Calendar of State Papers*
C.S.P.D.	*Calendar of State Papers Domestic*
D.N.B.	*The Dictionary of National Biography*
G.L.	Guildhall Library, City of London
G.L.C.R.O.	Greater London Council Record Office, 40 Northampton Road, EC1
Harl. Soc.	The Harleian Society, publications of
H.M.C.	The Historical Manuscripts Commission, publications of
Hug. Soc.	The Huguenot Society of London, publications of
L. & P.	*Letters and Papers, Foreign and Domestic, of the Reign of Henry VIII*
N. & Q.	*Notes and Queries*
N.P.G.	The National Portrait Gallery, London
P.C.C.	Prerogative Court of Canterbury (wills)
P.R.O.	The Public Record Office, London
S.P.	MS State Papers, P.R.O.
T.L.S.	*The Times Literary Supplement*
V. & A.	The Victoria and Albert Museum, London
V.C.H.	*The Victoria County History* series
Wal. Soc.	The Walpole Society, publications of

Notes

1: The Miniature

1 Graham Reynolds, *Wallace Collection: Catalogue of Miniatures* (1980), pp. 7, 8.

2 All quotations from Hilliard's *Treatise* are taken from the edition of R. K. R. Thornton and T. G. S. Cain (1981): this one is on pp. 68–9.

3 Roy Strong, *The English Miniature* (1981), pp. 26–9.

4 W. H. J. Weale, 'Simon Binnink, Miniaturist', *Burl. Mag.*, VIII (1906), pp. 355–6.

5 *L. & P.*, XXI, part 2, p. 227: bills stamped in 1546 include: 'Mrs Levyna Terling, paintrix, to have a fee of £40 a year from the Annunciation of Our Lady [25 March] last past during your Majesty's pleasure.'

6 Hugh Paget, 'Gerard and Lucas Hornebolt in England', *Burl. Mag.*, CI (1959), pp. 396–402.

7 MS Egerton 2604, B.L.

8 Jim Murrell and Roy Strong, *English Miniature*, pp. 3–4, 31–2.

9 Strong, *ibid.*, p. 31; for Hornebolte's last payment, *L. & P.*, XVII, no. 880, p. 476 and Erna Auerbach, *Tudor Artists* (1954), p. 171.

10 Paget, *op. cit.*, p. 401, n.17, sets out details of Susanna Hornebolte's career and marriages but gives no sources for his statements; John Guylmyn's will, P.C.C. F.29 Noodes, Prob.11/40/29, P.R.O., proved by relict on 18 June 1558.

11 Hilliard's *Treatise*, pp. 68–9, 94–7.

12 *Ibid.*, pp. 72–3; and Louis Dimier on the history of portrait-painting in France in the sixteenth century, quoted by Carl Winter, 'Hilliard and Elizabethan Miniatures', *Burl. Mag.*, LXXXIX (1947), p. 179 and n.25.

13.*Treatise*, pp. 72–5.

14 *Ibid.*, pp. 64–5.

15 *Memoirs of Sir James Melville of Halhill 1535–1617*, ed. A. Francis Steuart (1929), p. 94; *A Journey into England by Paul Hentzner 1598*, as translated by Richard Bentley, edited by Horace Walpole and printed at Strawberry Hill (1757), with Latin and English texts: p. 31 for the 'little chest'.

16 *Treatise*, pp. 74–5.

2: Young Hilliard

1 Erna Auerbach, *Nicholas Hilliard* (1961), p. 1.

2 *Visitation of London 1633–5*, I, *Harl. Soc.*, XV, p. 386; Hilliard pedigree supplied by Nicholas's son and heir, Laurence.

3 Auerbach, pp. 173–8 and plates 169–171.

4 *Livre des Habitants de Genève 1549–1560*, ed. P.-F. Geisendorf (Geneva, 1957), p. 84; *Livre des Anglois à Genève*, ed. J. S. Burn (1831), a transcription of the registers of the English church; the Bodley entry is on p. 10.

5 In one inscription, reproduced by Carl Winter, *Elizabethan Miniatures* (1943), and Graham Reynolds, *Nicholas Hilliard and Isaac Oliver* (1971 ed., plate 119A), the artist describes himself as being seventy-one in 1617 – but he probably means that in 1617 he was *in his seventy-first year*, then a common usage; all other evidence so far discovered makes his year of birth 1547.

6 J. E. Neale, *The Elizabethan House of Commons* (1949), p. 313.

7 *Livre des Habitants*, p. 96.

8 Intro. to *Treatise* (1981 ed.), pp. 21–2.

9 *Notebooks*, VI, *Wal. Soc.*, XXX, p. 47.

10 *Treatise*, pp. 68–9; Murrell and Strong, *English Miniature*, pp. 5–6, 48–9.

11 Original register of St Dunstan's Stepney, at G.L.C.R.O.; Levina's son George was buried on the following 11 September, and her husband died a year or so later, leaving a will, P.C.C. 21 Langley, Prob.11/60/21, in which he bequeathed all his property in England and beyond the seas to a grandson George, son of Marcus. Strong on Levina's birth-date, *English Miniature*, pp. 41, 45, 48: the original mistake was made by Auerbach, *Tudor Artists*, who gives the year of birth of Levina's father and herself, pp. 153 and 187, as '1483/4' and '?1483'.

12 *Treatise*, pp. 90–1.

13 For Bettes father and son, my 'Limners and Picturemakers', pp. 67, 97–8, 178.

14 *Treatise*, 64–5.

15 John Stow, *A Survey of London*, ed. C. L. Kingsford (2 vols, 1908), I, pp. 295–6, 345–6, 314.

16 A. B. Beaven, *The Aldermen of the City of London* (2 vols, 1913), II, p. 40.

17 Stow, II, pp. 351–2.

18 Catalogue (1980), pp. 87–9.

19 C.P.87/25, Hatfield House.

20 *Notebooks*, VI, p. 48.

21 *Treatise*, pp. 62–3, 86–7.

22 *Ibid.*, pp. 100–101.

23 *Ibid.*, pp. 102–3.

24 Subsidy roll entries for St Vedast Foster Lane show that Brandon was one of the wealthiest of the parishioners, assessed at £100 in 1563 (E179/145/219), and at £120 in 1577 (E179/145/252) and 1582 (E179/251/16); Hilliard appears in the last, assessed at £5. Details of the tenants of the Goldsmiths' Company in Cheapside are in their MS records, in particular full lists of names for 1558, 1566 and 1569; see also T.F. Reddaway, *Goldsmiths' Row in Cheapside 1558–1645*. For the office of Chamberlain of the City, Charles Carlton, *The Court of Orphans* (Leicester University Press, 1976), and especially pp. 37–8.

25 For St Mary Woolnoth, G.L. MS 7635/1, and transcripts, ed. J. M. S. Brooke and A. W. C. Hallen (1886); for St Peter Westcheap, G.L. MS 6502 (badly damaged by enemy action in 1940); for these and all subsequent entries in registers of St Vedast Foster Lane, *Harl. Soc.*, XXIX and XXX (originals damaged beyond repair in 1940).

26 Beaven's *Aldermen*.

3: Hilliard's Early Career: 1570–76

1 *Complete Peerage*, XI, pp. 333–6; will of Oliver St John Esq., P.C.C. 18 Holney, Prob.11/53/18.

2 See my 'Limners and Picturemakers', *Wal. Soc.*, XLVII (1978–80), pp. 126–9.

3 Graham Reynolds, *English Portrait Miniatures* (1952), pp. 17–18.

4 Murrell, *English Miniature*, pp. 3, 8.

5 For 'young Sir Francis', *D.N.B.*, and will, P.C.C. 90 Essex, Prob.11/204/90. He names his daughter Elizabeth Hammond and her son Robert, and an inscription on the back of Hilliard's miniature confirms that she was 'Mother to Colonel Hamond'; see Reynolds catalogue (1971), no. 22.

6 Murrell, *English Miniature*, pp. 7–8 and black-and-white plates 10, 11, also Reynolds cat. plate 4. This miniature used to be dated *c*.1560–70 but is now considered to be a historicizing work of *c*.1590, copied by Hilliard from an earlier painting by another hand.

7 Van der Doort catalogue, ed. Oliver Millar, *Wal. Soc.*, XXXVII (1960), p. 112.

8 Murrell, *English Miniature*, pp. 4–6.

9 *Treatise*, pp. 98–9.

10 *Ibid.*, pp. 90–1, intro. p. 43, and n.54 (p. 133).

11 *Ibid.*, pp. 86–7.

12 *Ibid.*, pp. 84–7, 114–5.

13 Harington quoted *Treatise*, note 47, p. 132; also *Treatise*, pp. 84–5.

14 *Ibid.*, pp. 82–3, 80–1.

15 *Ibid.*, pp. 68–71.

16 *Ibid.*, pp. 62–3.

17 C.P.119/8, Hatfield House. The letter is undated but endorsed '1606 Mr Hyllyard the Picturer to my Lord' in a contemporary hand. The opening words ('My essinguler good Lord'), the formation of the initial 'M', and the whole style and hand, are almost identical to those of another letter to Lord Salisbury, C.P.115/130, dated 6 May 1606.

18 *Treatise*, pp. 62–5.

19 *Ibid.*, pp. 64–5, 72–5.

20 *Ibid.*, pp. 96–9.

21 *Ibid.*, pp. 114–5.

22 *Ibid.*, pp. 68–9, 108–9.

23 *Ibid.*, pp. 62–3, 106–7.

24 *Ibid.*, pp. 92–3.

25 Auerbach, *Tudor Artists*, pp. 187–8.

26 Auerbach, *Nicholas Hilliard*, pp. 24, 124; Syon House MSS, U.I. 1s; U.I. 1b b; and U.I. 2 y; also *Household Papers of Henry Percy, 9th Earl of Northumberland (1564–1632)*, ed. G.R. Batho (1962); and I am indebted to the Duke of Northumberland's Archivist, Dr Shrimpton, and Secretary, Mrs M. F. Longmuir, for information.

27 *D.N.B.; Visitation of Worcestershire 1569, Harl. Soc.*, XXIX, pp. 43–4; will of Jane's father, P.C.C. 45 Chaynay, Prob.11/42B/45; will of Jane's husband, P.C.C. 36 Drake, Prob.11/87/36; *V.C.H., Warwickshire*, VI (1951), pp. 30–2, 187–9; *Visitation of Warwickshire 1682–3, Harl. Soc.*, LXII, *Boughton of Lawford*, pp. 161, 163–4; *V.C.H., Hertfordshire*, II, p. 153 for a manor at Aldenham owned by the Coningsbys.

28 *D.N.B.*; for Thomas's portrait, Roy Strong, *Tudor and Jacobean Portraits, N.P.G.* (1969), I, pp. 49–50, and plate, II, 89.

29 Strong, *English Miniature*, p. 49.

30 Auerbach, *Nicholas Hilliard*, p. 9 and ns. 1, 2; Noel Blakiston, 'Nicholas Hilliard: Some Unpublished Documents', *Burl. Mag.*, LXXXIX (1947), p. 188; C.P.70/76, Hatfield House. In addition to the formal warrant of 1591 about the £400 for Hilliard, there is a note about it at Hatfield, written by one of Burghley's secretaries, in a memorandum book kept by the Lord Treasurer (C.P.229, f.105): I am grateful to Mr Harcourt Williams, Lord Salisbury's Librarian and Archivist, for information on this.

31 Req.2/219/55, P.R.O.

32 For John Hilliard's freedom, Goldsmiths' *Accounts and Court Minutes, I*, p. 34; I am greatly indebted to Miss Susan Hare, Librarian of the Company, for information about him; for the meeting on 14 April 1570, *Book K–L*, p. 24. *Minute book for the Court Baron*, Manor of Finsbury, C.L.R.O., ref. 39. B.1.: see in particular pp. 1, 5, 11, 13, 19–21, 35–6, 55, 63–5, 72–4, 92–4: I am very grateful to Miss Betty Masters, Deputy Keeper of the Records, for telling me about this acquisition.

33 John Hilliard appears in a subsidy roll for 1577, E179/145/252, mem. 54, P.R.O., assessed at the high figure of £100; for the burial of Nicholas and subsequent Hilliards of this family at St Giles Cripplegate, burial register for 1561–1607, G.L. MS 6419/1; for Christ's Hospital, Aldermen's *Repertories*, 20, C.L.R.O., ff.114, and 235v where Hilliard is identified as 'John'; and school *Court Minute Book*, 2, G.L. MS 12,806/2, ff. 275–275v, 296v, also entries for the whole two years for Hilliard's attendance at meetings of the governors.

34 For the Deputies, who were appointed personally by Aldermen, see Frank Freeman Foster, *The Politics of Stability: A Portrait of the Rulers of Elizabethan London* (1966); for Hilliard paying money into the Chamber, *Chamber Accounts, 16th Century*, 2, C.L.R.O., ff. 72v–73 – I am grateful to Miss Masters for this reference. John Hilliard's will, G.L. MS 25,626/2, ff. 345v–348; his widow Katherine's will, G.L. MS 25/626/3, ff. 138–9.

35 For the dispute, Goldsmiths' *Court Minute Book K–L*, p. 62; Auerbach, *Nicholas Hilliard*, p. 7 and n.3, quotes the passage inaccurately, and wrongly says that in the language of the goldsmith, 'ragged staves' meant a setting pierced with holes. For the New Year's Day gift, Janet Arnold, *Princely Magnificence* cat., p. 40.

36 Goldsmiths' *Court Minute Book K–L*, p. 57.

37 For the 'book of gold', *Book K–L*, p. 62; for Lonnyson, Reddaway, *op. cit.*

38 A. M. Hind, *Engraving in England in the Sixteenth and Seventeenth Centuries*, I, *The Tudor Period* (1952), pp. 236–8; for Rutlinger at the Mint, S.P.38/7 (docquet), f.321, 26 December 1604; see also Auerbach, 'More Light on Nicholas Hilliard', *Burl. Mag.*, XCI (1949), p. 167 and n.20; for Rutlinger at St Martin-le-Grand, *Hug. Soc.*, 10.3.437 (where he is described as 'goldsmith'), and for his death, Archdeaconry Court of London admons., G.L. MS Reg. 4, f.350, 30 November 1608 (where he is described as 'engraver').

39 Hind, *op. cit.*, pp. 64–7, 77; for the Hogenbergs in St Giles' parish, my 'Limners and Picturemakers', pp. 183–4.

40 *Treatise*, pp. 84–5, 100–1, 68–9, 70–1, 100–1.

41 R. B. McKerrow and F. S. Ferguson, *Title-Page Borders Used in England and Scotland 1485–1640* (1932), facsimiles 133, 143, 144, 148 and 152, and pp. 116–8, 122–3, 127–130; see also intro. p. xxxvii. For Charles Tressell/Tressa, *Hug. Soc.*, 10.1.405, 10.2.18. and 10.2.269.

4: A Scottish Adventure

1 *Cf.* Auerbach, *Nicholas Hilliard*, p. 17; Strong, *English Miniature*, p. 49.

2 S.P.12/40/79, S.P.12/40/80 and S.P.12/41/38, P.R.O.

3 *Register of the Privy Council of Scotland*, I (1545–69), pp. 612–4.

4 Ed. G. L. Meason (1825): see especially pp. 18, 21, 33, 35.

5 Aliens' returns, *Hug. Soc.*, 10.1.298. A Cornelius Devosse described as a merchant, who four years later was living in the parish of St Michael Crooked Lane near Eastcheap, see *Hug. Soc.*, 10.3.396, was probably another man, since he attended not the Dutch but the French Church; he is probably also the man who figures in two Court of Requests suits, Req.2/113/52 and Req.2/134/4, for which see also Auerbach, *Tudor Artists*, p. 117 n.15 and pp. 142–3, 152. There is no ground for Dr Auerbach's assumption that the 'cousin Arnold' mentioned in the second suit is Van Brounckhorst.

6 Auerbach, *Nicholas Hilliard*, p. 17, quotes the relevant passage inaccurately.

7 For the precept of 1580, see Meason's editorial notes preceding Atkinson's text, p. 110. Van Brounckhorst is referred to in the precept as 'our lovit servitour Arnold Brounckhurst, our painter'.

8 Roy Strong, *The English Icon* (1969), pp. 135–8 and plates 90–4.

9 Register of St Nicholas Acons, G.L. MS 17,621. A Sara Brunkhurst, widow, probably the widow of the artist, was living in the parish of St Andrew Undershaft – one of those favoured by immigrants – in 1625, *Hug. Soc.*, 10.3.289.

10 Carl Winter, *Burl. Mag.*, LXXXIX (1947), p. 180, strangely suggested that Van Brounckhorst and Devosse were apprentices of Hilliard.

11 Details of Hilliard's apprentices are in the Goldsmiths' MS records; for Gualter Reynolds, see also *Hug. Soc.*, 10.2.50.

12 Vertue, *Notebooks*, V, *Wal. Soc.*, XXVI, p. 72; see also my 'Limners and Picturemakers', pp. 97–8; for Bettes' freedom of the City, Aldermen's *Repertories*, 20 (1579–83), f. 321, C.L.R.O.

5: The Hilliards in France: 1576–8

1 *Treatise*, pp. 106–9.

2 *Ibid.*, pp. 64–7.

3 S.P.12/109/7, P.R.O.

4 E.407/73, P.R.O.

5 E. P. Goldschmidt, 'Nicholas Hilliard as Wood Engraver', letter to *T.L.S.*, 9 August 1947, p. 403; Auerbach, *Nicholas Hilliard*, p. 11 and n.1.

6 Auerbach, *op. cit.*, pp. 77–9 and plates 39–41.

7 Quoted by J.E. Neale, *Queen Elizabeth* (1934), p. 239.

8 S.P. Foreign (France), 78/2/ff. 213–213v, P.R.O.

9 *C.S.P. Venetian 1603–7*, no. 66, pp. 39–42.

10 Auerbach, *Nicholas Hilliard*, pp. 13–14; Noel Blakiston, 'Nicholas Hilliard and Bordeaux', letter to *T.L.S.*, 28 July 1950, p. 469; for the anagram, Auerbach, pp. 45–6, and Reynolds catalogue (1971), no. 119B.

11 *Treatise*, pp. 68–9.

12 Auerbach, p. 16; Horace Walpole, *Anecdotes of Painting*, ed. R. N. Wornum (3 vols, 1888), I, p. 173; Auerbach, 'More Light', p. 166.

13 Auerbach, 'More Light', p. 166, and *Nicholas Hilliard*, p. 73 and plates 34, 35; Goldschmidt, *T.L.S.* letter.

14 Auerbach, *Nicholas Hilliard*, p. 15 and n.4, and 'More Light', p. 167; Roy Strong, *Nicholas Hilliard* (1975), p. 6.

15 S.P. (France), 78/2/16, P.R.O.

16 MS Addl. c.82, f.136, Bodleian Library, Oxford: in a volume of copies of letters home from the Ambassador.

17 Auerbach, *Nicholas Hilliard*, p. 72, plate 32.

18 Murrell, *English Miniature*, p. 8.
19 John Pope-Hennessy, *A Lecture on Nicholas Hilliard* (1949), p. 27; Winter, *Elizabethan Miniatures*, p. 23; Strong, *English Miniature*, p. 54 and *The Cult of Elizabeth* (1977), p. 57 and plates 31–2; Reynolds, *English Portrait Miniatures*, p. 18; intro. to *Treatise*, p. 29.
20 Goldsmiths' *Court Minute Book L, part 2*, pp. 412, 420.
21 Req.2/219/55, P.R.O.
22 Roy Strong, 'Nicholas Hilliard's Miniature of Francis Bacon rediscovered and other Minutiae', *Burl. Mag.*, CVI (1964), p. 337.
23 S.P.14/99, no. 86, P.R.O.

6: Hilliard Back in London: 1578–87

1 Parchment roll of indentures, C.54/1055, mems. 33, 34, P.R.O.: dated 14 July 1579 at bottom, Hilliard acknowledging himself satisfied and paid.
2 An interrogatory in a Court of Requests suit, Req.2/224/38, P.R.O., includes a question about the plaintiff, Hilliard, lying 'sick of the gout'.
3 Letters to Robert Cecil, S.P.14/53/43, P.R.O. and C.P.22/74 and C.P.115/130, Hatfield House; Pat Rogers, 'The rise and fall of gout', *T.L.S.*, 20 March 1981, pp. 315–6.
4 Goldsmiths' *Court Minute Book K–L, part 2*, p. 150; the grant was copied on 21 February 1574/5, *Book L*, p. 224.
5 *Book L, part 2*, p. 157; Auerbach, *Nicholas Hilliard*, p. 10.
6 I am much indebted to Miss Susan Hare for this information.
7 E179/251/16, mems. 106, 107, P.R.O.
8 Vertue, *Notebooks*, I, *Wal. Soc.*, XVIII, p. 142, and II, *Wal. Soc.*, XX, p. 136; Walpole, *Anecdotes*, I, p. 182.
9 Goldsmiths' *Apprentice Book 1578–1648*, p. 30.
10 For Leonard Lockey's freedom of the City, Aldermen's *Repertories*, 19 (1575–9), f. 152v, C.L.R.O.; for the Lockey family in general, my 'Limners and Picturemakers', pp. 95–7.
11 'Limners and Picturemakers', p. 72.
12 Pieter Mattheus' will, P.C.C. 15 Leicester, Prob.11/73/15, P.R.O.: I am very grateful to Mr Beric Lloyd, who found it, for telling me of its existence. For Jacob Mathewe, aliens' returns (1568), *Hug. Soc.*, 10.3.340; for Mrs Oliver in aliens' returns, *Hug. Soc.*, 10.1.425, 10.2.8, 10.2.172, 10.2.301 and 10.3.127. The last two have not, I think, been noticed before, perhaps because in one Mrs Oliver's

husband is entered as 'Oliver Peter' instead of 'Peter Oliver', and in the other because Mrs Oliver's surname comes out as 'Olyters'. For Pieter Mattheus' burial, *Harl. Soc.*, XXXI, p. 256; for his cousin, *Register of the Privy Council of Scotland*, 5 (1592–9), p. 622, where in entries dated Edinburgh 24 and 27 May 1594 he appears as 'Hadrian Vanson' and 'Adrian Vashon'.

13 Hilliard letter, C.P.87/25, 28 July 1601; Hilliard/Oliver relations, Winter, *Burl. Mag.*, LXXXIX, p. 180.

14 First suggested by Noel Blakiston, 'Nicholas Hilliard at Court', *Burl. Mag.*, XCVI (1954), p. 17.

15 *C.S.P. Spanish* (1580–86), p. 95.

16 Janet Arnold, *Princely Magnificence* cat., p. 40; Elizabeth Jenkins, *Elizabeth and Leicester* (paperback ed., 1972), p. 311.

17 Auerbach, *Nicholas Hilliard*, plate 47, p. 84.

18 Reynolds cat. (1971 ed.), no. 102 for black-and-white plate of Drake Pendant; *Princely Magnificence* cat., colour plates of both pieces, p. 61, no. 40 and pp. 62–3, no. 46; Strong, *English Miniature*, pp. 76–7, colour plates 9b, 10 and n.99, p. 216.

19 For Brandon, Reddaway, *op. cit.*; he held the office of Chamberlain from 8 January 1582/3 until his death on 30 May 1591.

20 Blakiston, 'Nicholas Hilliard at Court', p. 17.

21 For patent roll C.66/1214, see Blakiston, 'Unpublished Documents', p. 188; letter of 1596 quoted by Strong, 'Hilliard's miniature of Francis Bacon', *Burl. Mag.*, CVI.

22 Req.2/146/27 and Req.2/224/38, P.R.O.; Blakiston, 'Nicholas Hilliard at Court', pp. 17–18 and ns. 5–7 also mentions Req.1/14 and Req.1/15.

23 See Auerbach, *Nicholas Hilliard*, plate 119, p. 138; and colour plate, Leslie Hotson, 'Queen Elizabeth's Master Painter', *Sunday Times Colour Supplement*, 22 March 1970.

24 MS Egerton 3052, B.L.

25 Quoted by Auerbach, *Tudor Artists*, p. 109.

26 For the John Anthonys, *Hug Soc.*, VIII (Denizations 1509–1603), p. 7, and for Peter Anthony, Aldermen's *Repertories*, 12(1), p. 97, C.L.R.O.

27 Walsingham and Burghley letters quoted by Noel Blakiston, 'Queen Elizabeth's Third Great Seal', *Burl. Mag.*, XC (1948), pp. 103, 104; Mildmay miniature, *English Miniature*, pp. 54–5 and plate 65, and Auerbach, *Nicholas Hilliard*, plate 93, p. 117; plates of second Great Seal, Auerbach, plates 175 (a) and (b), pp. 182–3; for manor of Poyle, *V.C.H.*, *Middlesex*, III, pp. 36, 39.

28 Aldermen's *Repertories*, 21 (1583–7), ff. 123, 145v, 146, 147v, 148v, 153; Court of Common Council *Journal*, 21, ff. 416, 416v, 417, 421; and *Letter Book* (1584–90), ff. 22v, 23, 23v, 25 – all at C.L.R.O.; see also Auerbach, *Nicholas Hilliard*, plate on p. 22 showing signatures of Hilliard and his three fellow-sureties. Registers of St Lawrence Jewry for Metholde's burial, *Harl. Soc.*, LXX, p. 121; Metholde's will, P.C.C. 27 Arundell, Prob.11/62/27; Stow on Milk Street, *Survey*, I, p. 295 and II, p. 338.

29 Auerbach, *op. cit.*, p. 22.

30 For Hilliard and Marrett, Req.2/240/17, P.R.O.; some obscure Haberdashers' Company papers, now G.L. MS 15/860/1, also link the two men, Marrett being described as a tailor of the parish of St Bartholomew-the-Less, West Smithfield, see ff. 16, 21, 59v, 73v; for Ballet, Auerbach, *op. cit.*, pp. 22–3.

31 No. 782.

32 C.P.70/76.

7: The Limners, the Poets and the Courtiers: the 1580s

1 W. A. Shaw, *The Knights of England* (2 vols, 1906), II, p. 83.

2 Reynolds cat. (1971), no. 23; Auerbach, *Nicholas Hilliard*, p. 111, plate 87.

3 MS Sloane 1697, f. 54, B.L.

4 From *Fragmenta Regalia, or Observations on the late Queen Elizabeth, her Times and her Favourites*, written in 1641 by Sir Robert Naunton, then Master of the Court of Wards: p. 141 for description of Blount, p. 135 for the quarrel (1797 ed., bound up with Hentzner's *Journey into England 1598*).

5 First suggested by Blakiston, 'Nicholas Hilliard at Court', p. 17.

6 E. K. Chambers, chapter on 'The Court' in *Shakespeare's England* (2 vols, 1917).

7 Auerbach, *Nicholas Hilliard*, pp. 236–7 and plate 195; *English Miniature*, p. 62, plate 76.

8 See my 'An Isaac Oliver Sitter Identified', *Burl. Mag.* CXXIV (1982), pp. 496–501.

9 *English Miniature*, colour plate 5b, p. 42.

10 Winter, *Burl. Mag.*, LXXXIX, p. 176 and n.4.

11 Graham Reynolds, 'The Painter Plays the Spider', *Apollo* (April 1964), pp. 282–4.

12 Pages 158–76; see also Leslie Hotson, *Shakespeare by Hilliard* (1977), chapter 2.

13 *Journey into England, ed. cit.*, pp. 32–3, para. VIII.

14 *H.M.C. Rutland*, IV, p. 494 and E. K. Chambers, *William Shake-speare* (2 vols, 1930), II, p. 153.

15 *Treatise*, pp. 114–15.

16 David Piper, 'The 1590 Lumley Inventory: Hilliard, Segar and the Earl of Essex', Part II, *Burl. Mag.*, XCIX (1957), pp. 299–303; Strong, *Cult of Elizabeth*, chapter II, pp. 56–83, and *English Miniature*, pp. 68–9.

17 Reynolds cat. (1971), plates 36–8; Strong, *Cult*, plates 36–7; Auerbach, *Nicholas Hilliard*, pp. 104–6, plates 80–82.

18 Strong, *Cult*, plate 38.

19 *Ibid.*, plates 39–43.

20 Reynolds cat., plates 150, 151.

21 Shaw, *Knights*, I, p. 28.

22 *Herball*, pp. 1269–71.

23 *Remaines*, pp. 163–4.

24 Facsimile ed., ed. H. Green (1866), p. 140.

25 Leslie Hotson, *Mr. W.H.* (1964), p. 209.

26 *Shakespeare by Hilliard, passim.*

27 A. D. Wraight and Virginia F. Stern, *In Search of Christopher Marlowe: A Pictorial Biography* (1965), pp. 63–71.

28 *The Poems and Sonnets of Henry Constable*, ed. John Gray (1897), p. lx.

29 C.P.18/51, Hatfield House. The version in *H.M.C. Salisbury*, III, no. 929, p. 435 is not quite accurate.

30 C.P.18/55; *H.M.C. Salisbury*, III, p. 438.

31 Murrell and Strong, *English Miniature*, pp. 8–9 and 56–7.

8: Family Matters: The First Mrs Oliver and the First Mrs Hilliard

1 *Hug. Soc.*, XVIII, p. 11, grant made 6 December 1606.

2 See 'Limners and Picturemakers', pp. 75–6.

3 *H.M.C., 6th Report* (1877), pp. 407–18; Stow, *Survey*, I, pp. 194–5 and II, p. 304.

4 St Peter's original register, G.L. MS 8820.

5 *Hug. Soc.*, 10.2.250.

6 *Ibid.*, 10.2.301.

7 *Ibid.*, 10.3.127: the widowed Epiphane, 'Tiffiny' as she appears, is entered under Christchurch in January 1607/8, among aliens 'either dead, decayed, or gone out of the ward' – Farringdon Ward Within.

8 Graham Reynolds, 'Portrait Miniatures from Holbein to Augustin', *Apollo* (October 1976), p. 276, and fig. 2, p. 274.

9 See my 'Limners and Picturemakers', Part III, for much new material on the de Critz family.

10 Murrell, *English Miniature*, p. 10, black-and-white plate 13.

11 Sturman's burial 25 March 1589; his will, P.C.C. 38 Leicester, Prob.11/73/38, P.R.O.

12 Quoted by Auerbach, *Nicholas Hilliard*, p. 8.

13 *Cf.* Strong, *English Miniature*, p. 52.

14 R. W. Goulding, 'The Welbeck Abbey Miniatures', *Wal. Soc.*, IV (1916), p. 64, no. 16; *C.S.P.D. Elizabeth and James I Add1., 1580–1625*, p. 156, does not adequately summarize the original papers, S.P.15/29, 49. I and II.

15 Reynolds, 'Spider', p. 280.

16 C. W. Bracken, *A History of Plymouth* (1931), p. 166.

17 I am greatly indebted to Mr O. P. Moss of Exmouth for help with research on Leonard Darr.

18 Bond pedigree, *Visitation of London 1633–5*, I, *Harl. Soc.*, XV, p. 86; Stow on Crosby Place, *Survey*, I, pp. 172–3 and II, pp. 186, 299–300.

19 T. S. Willan, *The Muscovy Merchants of 1555* (1953), *The Early History of the Russia Company, 1553–1603* (1956) and *Studies in Elizabethan Foreign Trade* (1959).

20 Martin secured a marriage licence on 30 April 1584, *Harl. Soc.*, XXV, p. 130, and the marriage took place at St Stephen Walbrook on 4 May, *Harl. Soc.*, XL, p. 54.

21 Beaven, *Aldermen*, II, p. 174; his will, P.C.C. 30 Harrington, Prob.11/79/30, P.R.O.

22 Totnes original registers at Devon Record Office, Exeter; incomplete diocesan transcripts for South Pool.

23 P.C.C. 103 Rudd, Prob.11/126/103.

24 B. N. Adams, *South Pool, Its Church and Village* (1935), pp. 12–13; and I am grateful to Mr J.F. Bowman of South Pool, secretary to the trustees, for information.

25 P.C.C. 43 Sainberbe, Prob.11/77/43.

26 Sir John Osborne's will, P.C.C. 25 Ridley, Prob.11/155/25 (proved 1629); Peter Osborne Esquire of the parish of St Faith-under-St-Paul's appears in subsidy rolls of 1577 and 1582 assessed at £70 (E179/145/252, mem. 80 and E179/251/16, mem. 108); a Peter Osborne, picturemaker, of Beech Lane in the parish of St Giles Cripplegate, assessed at only £3 in 1598/9 (E179/146/390) would have been much too humble a man to be Brandon's overseer.

27 P.C.C. 58 Dixy, Prob.11/84/58.
28 C.54/1703 and C.54/1854.
29 P.C.C. 2 Parker, Prob.11/133/2; for the burial of an Alice Hilliard in 1611, *Memorials of St Margaret's Westminster 1539–1660*, ed. A. M. Burke (1914), p. 495.
30 Will of John Chapman, P.C.C. 2 Martyn, Prob.11/56/2, proved on 25 November 1574.
31 Shaw, *Knights*, 11, pp. 179, 116–7.
32 Accounts of Treasurer of the Chamber, E351/542, m. 112, P.R.O.; Essex letter, *C.S.P.D. 1595–7*, p. 467; Shaw, *Knights*, II, p. 96; examination of Blount, *C.S.P.D. 1598–1601*, p. 579.
33 Burial of Sir Carew on 14 September 1624 (he had died on the 7th), *Harl. Soc.*, LXVI, p. 190; will, P.C.C. 91 Byrde, Prob.11/144/91.
34 For Reynells of East Ogwell, *Visitations of Devon 1531, 1564, 1620*, ed. J.L. Vivian (1895), pp. 643–5, and *Visitation of Devon 1620, Harl. Soc.*, VI, pp. 234–6, 238–9; *D.N.B.* for third Earl of Essex and Sir William Waller; Sir Richard Reynell's will, P.C.C. 27 Seager, Prob.11/165/27; Dame Lucy's will, P.C.C. 90 Bowyer, Prob.11/221/90; Jeremy Hilliard's will, P.C.C. 2 Audley, Prob.11/161/2. Jeremy mentions a Nicholas Hilliard with a wife and two children – perhaps he was the Nicholas who appears in the parish of St Martin-in-the-Fields in the 1620s.

9: Professional Matters in the 1590s: Oliver Rivals Hilliard

1 Vertue, *Notebooks*, VI, p. 54; Walpole, *Anecdotes*, I, p. 178.
2 E179/146/372, 40 Eliz.
3 *Notebooks*, VI, p. 53.
4 Strong, *English Miniature*, pp. 70–1.
5 *Notebooks*, VI, p. 53.
6 Strong, *op. cit.*, pp. 66–7.
7 For Frances Howard's date and time of birth, MS Sloane 1683, f. 176, B.L. – also in MS Ashmole 243, f. 162, Bodleian Library, Oxford; for supposed portrait of Lettice Knollys, Roy Strong, *The Elizabethan Image: Painting in England 1540–1620* (Tate Gallery cat., 1969), p. 55 and colour plate 102. It was Horace Walpole, in the eighteenth century, who endorsed the Oliver miniature with the name 'Frances Howard, Countess of Essex and Somerset', and the suggested mistake would be characteristic of him.
8 *Notebooks*, VI, p. 55.
9 *Wal. Soc.*, XXXVII, p. 123, no. 1; Strong, *English Miniature*, p. 63.

10 See my 'Limners and Picturemakers', p. 73.

11 Hardwick MS 7, f. 30, and Auerbach, *Nicholas Hilliard*, pp. 24, 254–6.

12 *H.M.C. Salisbury*, IV, p. 486.

13 S.P.12/241/118 and E351/542, ff. 10v, 20v, 22, 55v, 56v, P.R.O.

14 *C.S.P.D. 1581–90*, pp. 199–203 and *C.S.P. Venetian 1581–91*, no. 468, pp. 243–6. It has been wrongly stated that the plan was to marry Arabella to Parma himself, see Graham Reynolds, *Burl. Mag.*, CIV (1962), p. 357 and *English Portrait Miniatures*, p. 12.

15 *H.M.C. Salisbury*, IV, p. 77.

16 S.P.12/239/128 and S.P.12/239/164, P.R.O.

17 S.P.12/239/148, P.R.O.

18 *H.M.C. Salisbury*, IV, pp. 138, 144, 147, 156.

19 S.P.12/241/118, S.P.12/249/68 and S.P.12/249/98, P.R.O.

20 *H.M.C. Salisbury*, IV, p. 617.

21 *C.S.P.D. 1595–7*, pp. 54, 324.

22 *C.S.P. Venetian 1603–7*, no. 66, p. 41.

23 See Rev. Sir John Cullum, Bart., *The History and Antiquities of Hawsted . . . Suffolk* (1784), also in *Bibliotheca Topographica Britannica*, V (1790), reprinted New York (1968), pp. 152–247 for Rebecca's letter and material on Cullums and Crisps; the author owned some of Rebecca's letters, and says she wrote in 'a very beautiful hand'. I am grateful to Leslie Hotson for the reference. For Cullums and Crisps, see also *D.N.B.* – where Rebecca's husband is wrongly called an alderman, confusing him with his nephew and namesake Sir Nicholas the Royalist – for whose miniature by Cornelius Johnson see Reynolds, *Apollo* (1976), fig. 4, p. 276. *Miscellanea Genealogica et Heraldica*, 2nd series, 5, pp. 369–71 for the Pakes of Broomfield; registers of Allhallows Lombard Street, G.L. MS 17,613; Beaven, *Aldermen*, II, p. 179 for Ellis Crisp; *Visitation of London 1633–5*, I, *Harl. Soc.*, XV, p. 202 for Crisp; will of Ellis Crisp, P.C.C. 120 Clarke, Prob.11/147/120 (1625); will of Nicholas Crisp (Rebecca's husband), P.C.C. 164 Goare, Prob.11/175/164. Ellis and Nicholas Crisp were among the 215 founder-members of the East India Company (charter of incorporation 31 December 1600), see *C.S.P. Colonial* (E.I.C., China and Japan, 1513–1616), pub. 1862, nos. 281, 288.

24 R. C. Bald, *John Donne: A Life* (1970), p. 236.

25 *Notebooks*, VI, p. 48.

26 *Treatise*, pp. 72–3, 76–7.

27 For this section, Blakiston, 'Third Great Seal', pp. 101–7.

28 C.P.88/86.
29 C.P.88/89 recto and verso, and 88/89/2.
30 See Reynolds cat. (1971), no. 107, for a design for the obverse of a Great Seal of Ireland, done in pen-and-ink and wash over pencil, now in the British Museum. The Irish emblems (the harp and the three crowns) in the cartouches are only lightly drawn in, and such a seal never came into use for Ireland. It has been suggested that this drawing may be identical with one of Hilliard's drawings for the third Great Seal of England listed in Charles Anthony's account-roll: see Blakiston, p. 107, and Auerbach, p. 186 and plate 177.
31 C.P.22/74.
32 C.P.26/96.
33 C.P.70/76.
34 C.P.119/8. See chapter 3, n.17, for the dating of this letter.
35 Will of Charles Anthony, P.C.C. 105 Rudd, Prob.11/126/105; will of Thomas Anthony, P.C.C. 42 Meade, Prob.11/131/42.
36 Blakiston, 'Unpublished Documents', p. 189.

10: Hilliard's Home

1 *Cf.* Auerbach, *Nicholas Hilliard*, p. 9 and Roy Strong, *Nicholas Hilliard* (1975), p. 6.
2 Auerbach, p. 23.
3 Roy Strong, 'Queen Elizabeth, the Earl of Essex and Nicholas Hilliard', *Burl. Mag.*, CI (1959), p. 146.
4 Goldsmiths' *Court Minute Book 0, part 1*, pp. 160, 161; and, for 1596 and 1597, Auerbach, p. 28. The details in Auerbach, 'More Light', p. 168, are not accurate.
5 *Middlesex Sessions Records*, MS MJ/SR 353/79, G.L.C.R.O.: subsidy roll E179/146/390.
6 *Acts of the Privy Council 1599–1600*, p. 432.
7 Goldsmiths' *Book 0, part 2*, p. 125.
8 *Ibid.*, p. 157.
9 C.P.87/25.
10 Goldsmiths' *Book 0, part 2*, pp. 228, 237, 243; Auerbach references, *Nicholas Hilliard*, pp. 29–30, are not accurate.
11 Goldsmiths' book, p. 247.
12 Aldermen's *Repertories*, 28 (1607–8), f.8v, C.L.R.O.
13 *Rent-book*, 1913/B.393; *Court Minute Book P, part 1*, pp. 112, 118, 153; Auerbach, pp. 224–5. In one or two instances, the records refer to Laurence's 'tenements' (plural), but the definitive entry

in the Court Minute Book dated 7 May 1613 (p.118) states 'tenement'.

11: The End of the Elizabethan Age

1 Reynolds cat. (1971), no. 125; Strong, *Tudor and Jacobean Portraits*, II, p. 58.
2 David Cecil, *The Cecils of Hatfield House* (1973), p. 119.
3 *Fragmenta Regalia*, pp. 144–5.
4 Bald, *John Donne*, pp. 80 and n.1, 87 and n.1, 89, 54 and n.1, and plate 1.
5 *Journey into England* (1757 ed.), pp. 47–51.
6 Winter, *Elizabethan Miniatures*, p. 25.
7 *Anecdotes*, I, p. 151.
8 Richard Haydocke, *A Tracte containing the Artes of curious Paintinge, carvinge & buildinge* (Oxford, 1598).
9 *Treatise*, pp. 62–3.
10 C.P.115/130.
11 E403/2287, P.R.O.; Blakiston, 'Third Great Seal', p. 104 and ns. 19, 20; Auerbach, *Nicholas Hilliard*, p. 31.
12 Dutch Church register, G.L. MS 7382; 'Limners and Picturemakers', p. 73.
13 'Limners and Picturemakers', *passim*.
14 S.P.12/137, no. 74 and 'Limners and Picturemakers', p. 64 and ns. 1, 2.
15 *Ibid.*, p. 65.
16 *Ibid.*, p. 125, and n. 295.
17 *Ibid.*, p. 84, and n. 99.
18 *Ibid.*, p. 151 and n. 391.
19 L.C.2/4(4).

12: The Jacobean Age Begins: 1603–12

1 Vertue, *Notebooks*, VI, pp. 48, 53.
2 MS Egerton 2804, B.L.
3 Winter, *Burl. Mag.*, LXXXIX, p. 176; Pope-Hennessy, *Lecture*, p. 24.
4 Shaw, *Knights*, I, p. 30.
5 Goldsmiths' *Court Minute Book O, part 3*, pp. 397, 398.
6 *Ibid.*, p. 433, 15 January 1605/6.
7 C.P.115/130.

8 *C.S.P. Venetian 1603–7*, no. 517, p. 344; no. 522, pp. 349–50; no. 527, pp. 354–5. I am indebted to Mr Harcourt Williams for advice on this section.

9 C.P.119/8.

10 Blakiston, 'Third Great Seal', p. 104 and n.20.

11 *Court of Requests: Orders and Decrees*, Req.1/24, pp. 876, 895, 904; Req.1/25, pp. 6, 21, 34, 117, 177–8, P.R.O. The notes about the restoration of Hilliard's annuity are in a collection of Exchequer books recording Jacobean *Fees and Annuities*, also at P.R.O.: entries are made under the names of four tellers, Hilliard's under one called Egiok. The first, about the ten shillings, is in the book for Michaelmas 1610, and the second in that for Easter 1611, ref. for both E403/2367. Auerbach, *Nicholas Hilliard*, p. 31, notes only the second, and gives the wrong overall reference.

12 Blakiston, 'Unpublished Documents', pp. 188, 189 for the last payment; in an Exchequer document after Hilliard's death, quoted by Blakiston, it was apparently stated that he was owed only £20.

13 Blakiston, same refs.; Auerbach, *op. cit.*, p. 39; for no. (5), E351/543 – entries about Hilliard and Gheeraerts on mem. 217.

14 My 'Limners and Picturemakers', pp. 98–100.

15 *Diary*, ed. Robert Latham and William Matthews (1970–83), vol 9, pp. 276–7.

16 *Treatise*, pp. 108–9.

17 Letter to Salisbury, dated 26 March 1610, is S.P.14/53/43, P.R.O.; Auerbach's section on Laborer, *Nicholas Hilliard*, pp. 33–7, is not very accurate, and some of the references are wrong.

18 C.54/1703, C.54/1676, P.R.O.

19 Goldsmiths' *Court Minute Book N–O, part 1*, pp. 33, 37, 59, 60, 61, 63.

20 For the metalworks at Isleworth and Hilliard's depositions, 'Limners and Picturemakers', pp. 75–6, n.56 and plate 22; refs. for the depositions, C.24/294, part 2/43 and C.24/283, part 1/4 (Town Depositions series), P.R.O.

21 Auerbach, *Nicholas Hilliard*, p. 35.

22 Goldsmiths' *Court Minute Book O, part 2*, pp. 192, 194–5, 258.

23 *Ibid.*, pp. 260, 261, 263, 282, 348.

24 L.C.2/4(5), pp. 73, 54, P.R.O.

25 Chambers, *William Shakespeare*, I, p. 88 and II, pp. 152–3.

26 C.P.119/8.

27 Laborer's petition, S.P.14/188, no. 57, among *Undated Letters Jas. I*, P.R.O.; *Acts of the Privy Council June 1623 to March 1625*, pp. 2–3.

28 *Ministers' and Receivers' Accounts*, S.C.6/Jas.I/1646, accounts for Michaelmas 1604 to Michaelmas 1605, P.R.O.: entry on f.15 notes that Oliver is to receive £20 for half a year, under the Queen's letters patent dated 22 June 1605, proving that his annuity began in 1605 and that the first money he received covered the six months from Lady Day (25 March) to Michaelmas Day (29 September); see my 'New Light', p. 74 and n.20. Dr Auerbach (*Tudor Artists*, p. 179 and *Nicholas Hilliard*, p. 233), finding a reference to a payment to Isaac Oliver of £40 for the full year 1614–15 (E101/437/8, f. 25) was misled by the reference back to 'Jas.2' into thinking that the annuity dated from 1604: the regnal year Jas.2 is of course 1604–5, not 1604.

29 *Nicholas Hilliard*, p. 233.

30 *English Miniature*, p. 94.

31 My 'Limners and Picturemakers', pp. 83, 95.

32 *Ministers' and Receivers' Accounts*, S.C.6/Jas.I/1646/f.18v, P.R.O.; my 'New Light', pp. 74, 77 and n.18.

33 *Ibid.*, S.C.6/Jas.I/1650; 1653, f.17; and 1655, f.18v, P.R.O.; 'New Light', p. 77 and n.20.

34 Arthur Wilson, *The Life and Reign of James I* (1653), p. 13, quoted by Graham Parry, *The Golden Age Restor'd* (1981); see also Parry's Chapters 2 and 3, on 'The Jacobean Masque' and 'The Court of Henry Prince of Wales'.

35 'Limners and Picturemakers', p. 125.

36 E101/433/8, ff. 6, 10, 13v, 14, 12, 12v, 13v, P.R.O.

37 For the Peake family, see my 'New Light', pp. 74–83, and 'Limners and Picturemakers', Part II.

38 E351/2794, P.R.O.

39 Auerbach, *Nicholas Hilliard*, p. 234; Vertue, VI, pp. 48, 53; Strong, *Elizabethan Image*, p. 81 and plate 180 and *Icon*, p. 338, plate 364 for the Prince on horseback.

40 *English Miniature*, p. 64.

41 *Ibid.*, pp. 93, 94.

42 L.C.2/4(6), P.R.O.

43 'Mr Martin Hardret' was buried at St Anne Blackfriars on 22 April 1612; in his will, P.C.C. 26 Fenner, Prob.11/119/26, P.R.O., he sets out in detail the 'merchandises' in which he trades, and describes himself as a 'merchant dwelling in London' but still with property in France. For Martin and Abraham Hardret, see my 'Limners and Picturemakers', pp. 79, 85, 167.

44 See Goulding, *Wal. Soc.*, IV, p. 58, no.8.

45 Strong, *English Miniature*, p. 59.

46 *D.N.B.* for Elizabeth Cooke; *Complete Peerage*, vol 2, pp. 76–8 for the Earls of Bedford.

47 S.P.12/260/no. 116, P.R.O.

48 *Treatise*, pp. 72–5.

13: More Family Matters: Isaac Oliver and the Court Musicians, Laurence Hilliard and the City Merchants

1 See my 'Limners and Picturemakers', Part III, for much new material on the Gheeraerts, de Critz and Colt families. For the Dutch Church registers, G.L. MSS 7380–2; also edited version by W. J. C. Moens (1884) – to be treated with caution.

2 For royal funeral details, 'Limners and Picturemakers', pp. 165–7.

3 This and all subsequent entries from the St Anne's registers taken from G.L. MSS 4508/1 (baptisms), 4509/1 (marriages) and 4510/1 (burials).

4 Walpole, *Anecdotes*, I, p. 178; Reynolds cat. (1971), p. 17; 'Limners and Picturemakers', Part I.

5 *Hug. Soc.*, VIII, p. 116 and *C.S.P.D. 1581–90*, p. 667.

6 For Harding's dance-music in B.L., Addl. MSS 30,826, f.8, 30,828, f.7 and 30,485, ff. 47–8, 50–1; for information on Filmer MS 2 at Yale I am indebted to Drs Andrew Ashbee and Peter Holman; see also *Grove's Dictionary of Music and Musicians*, 5th edition, ed. Eric Blom (9 vols, 1954), II, pp. 949–50 and IV, p. 69, and *New Grove*, ed. Stanley Sadie (1981) – where the Harding family details, VIII, p. 159, are not quite accurate.

7 *Harl. Soc.*, XXV, p. 78 for the licence; St Clement Danes MS register at Westminster City Library, Buckingham Palace Road, for the marriage (which is wrongly entered as having been on 24 December 1577 instead of 24 January 1577/8 – it was the first marriage in January, following one on 21 December).

8 Holy Trinity Minories register, G.L. MS 9238; see also 'Limners and Picturemakers', pp. 76–7 for Harding entries, and possible members of Isaac Oliver's family.

9 'Limners and Picturemakers', p. 78. John Murdoch, *English Miniature*, p. 89, argues that Peter Oliver would not have been younger than Anne Harding, but this does not follow at all – and certainly not in their day, when marriages were more often than not matters of convenience and deliberate arrangement.

10 *V.C.H., Middlesex*, III (1962), p. 91; for fares for hire of Thames boats, *Journal*, 17, Court of Common Council (1555–60), f. 323v, C.L.R.O.

11 *Treatise*, pp. 74–5.

12 This and all subsequent references to the French Church register are taken from *Hug. Soc.*, IX.

13 'Limners and Picturemakers', p. 79.

14 For Hester Gheeraerts and her marriages, 'Limners and Picture-makers', pp. 136–7.

15 For the Wheeler family, 'Limners and Picturemakers', pp. 140–3; register of St Mary Colechurch, G.L. MS 4438.

16 'Limners and Picturemakers', pp. 83–9 for the Russells, John-sons and other members of the Olivers' circle in London and at Isle-worth.

17 Vertue, *Notebooks*, II, *Wal. Soc.*, XX, p. 73.

18 Lionel Cust, *Anthony Van Dyck: An Historical Study of his Life and Works* (1900), p. 145.

19 *Calendar of Middlesex Sessions Records 1608–9*, p. 49, entry for 22 March 1608/9.

20 Hilliard pedigree, *Visitation of London 1633–5*, I, *Harl. Soc.*, XV, p. 386; Cullymore was buried at St Mary-le-Bow on 16 January 1606/7, admon. dated 27 January, P.C.C. Prob.6/7, f. 64. For St Mary-le-Bow register entries, *Harl. Soc.*, XLIV and XLV. Cullymore appears in three subsidy rolls, E179/145/252 (1577), mem. 125 and E179/251/16 (1582), mem. 46, assessed at £50; and E179/146/369 (1598), mem. 19, assessed at £10.

21 *Roll of the Drapers' Company of London*, ed. Percival Boyd (1934), p. 50; and for the younger George Cullymore, G. W. Hill and W. H. Frere, *Memorials of Stepney Parish* (1891), compiled from vestry minutes 1579–1662.

22 Jane Cullymore's baptism, *Harl. Soc.*, XLIV, p. 10; her marriage to George Farmer, *Harl. Soc.*, LXI, p. 77; baptism of Thomasin, *Harl. Soc.*, XLIV p. 17; George Farmer's will, P.C.C. 71 Wood, Prob.11/118/71, P.R.O.

23 Stow, *Survey*, I, pp. 291, 297.

24 Microfilm of St Saviour's registers at G.L.C.R.O.; for St Bride's, G.L. MS 6536 for baptisms.

25 'Limners and Picturemakers', pp. 139–40 for Marcus Gheeraerts III; for his freedom, Painter-Stainers' *Court Minute Book I*, G.L. MS 5667/1, p. 39.

26 *H.M.C. Salisbury*, IV, pp. 459–60 and V, p. 63; and see my 'In Search of John Webster', *T.L.S.*, 24 December 1976.

14: The Last Years: 1612–19

1 James Lees-Milne, 'Two Portraits at Charlecote Park by William Larkin', *Burl. Mag.*, XCIV (1952), pp. 352–6.

2 *D.N.B.* for Hertford; Aldermen's *Repertories*, 27 (1605–6), f.244v, C.L.R.O. for Larkin's freedom of the City.

3 For Larkin, see my 'New Light', pp. 74–83 and plates 18–23, and 'Limners and Picturemakers', pp. 101, 126–9; Larkin's and Peake's wills in Commissary Court of London, G.L. MS 9171/23, ff. 271, 320 – Larkin's made on 10 April and proved on 14 May, Peake's made on 10 October and proved on the 16th.

4 The account-book, E407/57/2, P.R.O., covers the period 29 September 1612 to 25 March 1613: for the entries about Oliver, Hardret and Gheeraerts, pp. 5, 6, 7, 10.

5 Van der Doort catalogue, *Wal. Soc.*, XXXVII, p. 117, no. 54.

6 Shaw, *Knights*, pp. 159–60 for date of Prince of Wales' creation; E351/544, mems. 76v, 101v for payments to Oliver, and Auerbach, *Tudor Artists*, p. 180 gives parallel reference in E101/435/9 for the first. E351/544, mem. 14 also notes a payment of £20 to Robert Peake, by Privy Council warrant dated 3 October 1612, for 'three several pictures drawn by him at the commandment of the officers of the Duke of York' – Prince Charles – in the month before Prince Henry's death.

7 Oliver's will, registered copy P.C.C. 93 Weldon, Prob.11/130/93, original Prob.10/346, P.R.O.; 'Limners and Picturemakers', plate 24c for one of the signatures; Winter, *Elizabethan Miniatures*, p. 20; Auerbach, *Nicholas Hilliard*, p. 235.

8 *Notebooks*, I, p. 68; II, p. 136; V, p. 60; VI, p. 55: *Wal. Soc.*, XVIII, XX, XXVI, XXX.

9 Vertue, *Notebooks*, VI, p. 53; *Treatise*, pp. 74–5.

10 Reynolds, *English Portrait Miniatures*, pp. 23, 26, and cat. (1971), no. 202 for plate; docquet, S.O.3/11, P.R.O.; Van der Doort catalogue, *Wal. Soc.*, XXXVII, p. 103; Vertue, *Notebooks*, IV, p. 31; 'Limners and Picturemakers', p. 81 and n.82.

11 E351/544, mems. 32v, 47v, 65v, 89; Auerbach, *Nicholas Hilliard*, p. 39, ns. 7–10, gives parallel entries in A.O.1/389/51, A.O.1/390/52, A.O.1/390/53 and A.O.1/390/55.

12 Private Accounts 123/7; Auerbach, *Nicholas Hilliard*, p. 42.

13 I am very grateful to Mr Reynolds for directing me towards the *Downshire MSS* – see *H.M.C.*, LXXV.

14 S.P.14/82/no. 51, P.R.O.: Letter dated 16 October 1615.

15 *H.M.C. Downshire*, IV, p. 109: the editor suggests that the letter is addressed to the Bishop of London, but in the context I think this must be wrong.

16 S.P.14/82/no. 50, P.R.O.: letter written on the same day as the one above (n.14).

17 List of questions to be put to Savery, S.P.14/82/no. 52, P.R.O., attached to the Archbishop's letter; for Anne Turner's trial, *A Compleat Collection of State-Tryals* (1719), pp. 228–30 and *H.M.C. Salisbury*, XXII, p. 21 – in the index, Savery's name is wrongly given as 'Arthur'; for Simon Forman, my 'Simon Forman's Vade-Mecum', *The Book Collector* (Spring 1977), p. 44–60; for the Somersets, *Complete Peerage*, XII, Part I, pp. 67–8, and for their trials, *Compleat Collection*, pp. 244–64; Anne Turner's burial, *Harl. Soc.*, XXV, p. 171, and churchwardens' accounts of St Martin's at Westminster City Library, F.2.

18 For Court of Common Pleas, Auerbach, *Nicholas Hilliard*, p. 41; for Pereman's 'answer', Blakiston, 'Unpublished Documents', p. 189 and *N. & Q.*, CXCII (1947), pp. 123–4.

19 Beaven, *Aldermen*, II, pp. 40, 174 and *D.N.B.*

20 Strong, *English Miniature*, p. 59.

21 Goulding, *Wal. Soc.*, IV, pp. 62–3; *Complete Peerage*, IX, pp. 58–60 for the Monmouths.

22 Shaw, *Knights*, I, pp. 159–60.

23 For the patent, Thomas Rymer, *Foedera* (2nd ed., 1727), pp. 15–16; for Delaram, Auerbach, *Nicholas Hilliard*, pp. 196–7 and plate 186.

24 P.C.C. 2 Parker, Prob.11/133/2.

25 St Martin's churchwardens' accounts, F.2., vol 2.

26 *Notebooks*, VI, p. 47.

15: The Lines Extinguished

1 Edited by Martin Hardie (1919): in his *Introduction*, p. vii, he misdates the final version of *Miniatura* through supposing that Peter Oliver's death was in December 1648 instead of 1647.

2 For Norgate, *D.N.B.* and Fuller's *Worthies*, ed. John Freeman (1952), p. 60; *Miniatura*, pp. 5–6, 65; *Treatise*, pp. 62–3.

3 First suggested in my 'Limners and Picturemakers', pp. 77–8.

4 L.C.5/132, p. 37, P.R.O.

5 *Introduction*, p. xvii.

6 Vertue, *Notebooks*, II, p. 136 and VI, p. 55; *Miniatura*, p. 54; see also,

for Peter Oliver's career, Reynolds, *English Portrait Miniatures*, pp. 31–3, and Murdoch, *English Miniature*, pp. 88–95.

7 'Limners and Picturemakers', p. 99.

8 L.C.2/5 and 2/6, P.R.O.

9 P.C.C. Prob.6/12, ff. 47v, 77 for Harding admons.; Mary Harding's will, P.C.C. 96 Hele, Prob.11/149/96; James Harding was buried on 28 January 1625/6, Jane on 10 May 1622 – the Isleworth parish clerk, who would not have known Jane very well as she was not a full-time resident, inserts the Christian name 'An' above the line before her surname. For fuller details on the Hardings, 'Limners and Picturemakers', pp. 75–9.

10 Pierce Morgan's will, P.C.C. 65 Coventry, Prob.11/183/65; for more on the Morgan family, 'Limners and Picturemakers', pp. 81–3.

11 For the Olivers' circle, *op. cit.*, pp. 83–93; for the Hostes and Nelsons, Winifred Gérin, *Horatia Nelson* (paperback ed., 1981), pp. 227, 255–6, 274.

12 Auerbach, *Tudor Artists*, p. 133.

13 E403/2699/no. 9, P.R.O.

14 Stac.8/33/11 and Stac.8/155/17, P.R.O.; for a fuller account of the mugging, 'Limners and Picturemakers', pp. 69–70. Auerbach, *Nicholas Hilliard*, p. 225, misdates the incident.

15 Laurence's letter, S.P.16/199/no. 42, and see 'Limners and Picturemakers', p. 68; Auerbach, *op. cit.*, p. 226, supposes that the 'sister' was Lettice or Penelope Hilliard, but at the time the word could mean 'sister' or 'sister-in-law'.

16 Will of Peter Oliver 'of Isleworth, gent.', P.C.C. 184 Essex, Prob.11/206/184, and original, Prob.10/700; Laurence Hilliard's will, P.C.C. 45 Essex, Prob.11/203/45, and original, Prob.10/673; Vertue, *Notebooks*, II, p. 136.

17 'Limners and Picturemakers', pp. 70, 179–80; Auerbach on the will, *Nicholas Hilliard*, pp. 227–30. She suggests that Laurence may be referring to his father's miniature of 1616 now known as 'Henry Carey, Earl of Monmouth' (Plate 46), but the sitter is surely not in mourning but in an ordinary smart black doublet with white collar.

18 S.P.29/9/no.79, P.R.O.

19 *Notebooks*, IV, p. 125.

20 MS registers of St Clement Danes and St Martin-in-the Fields at Westminster City Library; Brandon Hilliard's will, P.C.C. 30 Eure, Prob.11/338/30, and his widow's, 5 Hale, Prob.11/353/5; Auerbach's wrong identification of Thomas, *Nicholas Hilliard*, p. 228, and see 'Limners and Picturemakers', p. 71; burial of Charles,

G.L. MS 4098, and will, P.C.C. 17 Bench, Prob.11/350/17 (Auerbach, p. 228, gives wrong reference); for Jacob Croone, *Calendar of Treasury Books*, III, part 2; IV; and V, part 2; for Laurence Hilliard and family in general, 'Limners and Picturemakers', pp. 68–72.

21 Laurence Rich *née* Hilliard's will, P.C.C. 155 Foot, Prob.11/389/155; the will of Robert Rich, gentleman of the parish of St Edmund Lombard Street, P.C.C. 166 King, Prob.11/361/166 (1679), speaks of his brother Samuel and sister-in-law Laurentia. There is no trace of her burial at St Dunstan's between the making of her will on 24 August 1687 and its proving on 14 December, so she was probably the woman entered as 'Ann Rich' who was buried on 31 October. For Sir Peter Rich, Beaven's *Aldermen*.

22 Vertue on Charles II and Anne Oliver, MS Addl. 21,111, ff. 49–49v, B.L., and transcription (not quite accurate), *Wal. Soc.*, XVIII.

23 Anne Oliver's original will, MS AM/PW/1672/38, and inventory, MS AM/PI/1673/40, both at G.L.C.R.O.; for fuller details on Mrs Oliver, 'Limners and Picturemakers', pp. 93–5.

24 *Anecdotes*, II, p. 146.

Select List of Sources

Place of publication London except where otherwise indicated.

Adams, B. N.: *South Pool, its Church and Village* (South Pool, 1935)
Aldermen's *Repertories*: MSS, C.L.R.O.
Aliens' returns and denizations: Huguenot Society publications
Anne of Denmark, Queen: see *Ministers' and Receivers' Accounts*
Arnold, Janet: see *Princely Magnificence*
Atkinson, Stephen: *The Discoverie and History of the Gold Mynes in Scotland* (1619), ed. G. L. Meason (Edinburgh, 1825)
Auerbach, Erna: *Tudor Artists* (1954)
—— 'More Light on Nicholas Hilliard', *Burl. Mag.*, XCI (1949)
—— *Nicholas Hilliard* (1961)
Bald, R. C.: *John Donne: A Life* (Oxford, 1970)
Batho, G. R.: *Household Papers of Henry Percy, 9th Earl of Northumberland (1564–1632)* (1962)
Beaven, A. B.: *The Aldermen of the City of London* (2 vols, 1913)
Blakiston, Noel: 'Nicholas Hilliard: Some Unpublished Documents', *Burl. Mag.*, LXXXIX (1947)
—— 'Nicholas Hilliard and Queen Elizabeth's Third Great Seal', *Burl. Mag.*, XC (1948)
—— 'Nicholas Hilliard and Bordeaux', *T.L.S.* letter, 28 July 1950
—— 'Nicholas Hilliard at Court', *Burl. Mag.*, XCVI (1954)
Boyd, Stephen: *Roll of the Drapers' Company of London* (1934)
Bracken, C. W.: *A History of Plymouth* (Plymouth, 1931)
British Library, Department of Manuscripts: MSS, various
Burke, A. M.: *Memorials of St Margaret's Westminster 1539–1660* (1914)
Camden, William: *Remaines of a greater Worke concerning Britaine* (1605)
Carlton, Charles: *The Court of Orphans* (Leicester, 1976)
Cecil, David: *The Cecils of Hatfield House* (1973)

Cecil Papers: MS records, Hatfield House

Chamber Accounts, Sixteenth Century: C.L.R.O.

Chambers, E.K.: Chapter 3, 'The Court' in *Shakespeare's England* (2 vols, Oxford, 1917)

—— *William Shakespeare* (2 vols, Oxford, 1930)

Chancery, Court of: MS records, P.R.O.

Christ's Hospital: MS records, Guildhall Library

Complete Peerage, The (new edition, revised, 12 vols, 1910–40)

Constable, Henry: *The Poems and Sonnets of*, ed. John Gray (1897)

Court of Common Council, *Journals* of: MSS, C.L.R.O.

Cullum, John: *The History and Antiquities of Hawsted . . . Suffolk* (1784); also in *Bibliotheca Topographica Britannica*, V (1790), reprinted New York (1968)

Cust, Lionel: *Anthony Van Dyck: An Historical Study of his Life and Works* (1900)

Devon MSS and printed records, at County Record Office and City Library, Exeter

Dictionary of National Biography, The

Dutch Church, Austin Friars: MS records at Guildhall Library, and see Moens, W. J. C.

Edmond, Mary: 'New Light on Jacobean Painters', *Burl. Mag.*, CXVIII (1976)

—— 'In Search of John Webster', *T.L.S.*, 24 December 1976

—— 'Simon Forman's Vade-Mecum', *The Book Collector* (Spring 1977)

—— 'Limners and Picturemakers: New light on the lives of miniaturists and large-scale portrait-painters working in London in the sixteenth and seventeenth centuries', *Wal. Soc.*, XLVII (1980)

—— 'An Isaac Oliver Sitter Identified', *Burl. Mag.*, CXXIV (1982)

Elizabeth, Princess: MS Household accounts of, P.R.O.

Exchequer accounts, various: MSS, P.R.O.

Finsbury, Manor of: MS *Minute Book for Court Baron*, C.L.R.O.

Foskett, Daphne: *A Dictionary of British Miniature Painters* (2 vols, 1972)

Foster, Frank Freeman: *The Politics of Stability: A Portrait of the Rulers of Elizabethan London* (1966)

French Church, Threadneedle Street: registers, Huguenot Society publications

Frere, W. H.: *Memorials of Stepney Parish* (1891)

Fuller, Thomas: *The Worthies of England*, ed. John Freeman (1952)

Gerard, John: *The Herball* (1597)

Gérin, Winifred: *Horatia Nelson* (paperback, Oxford, 1981)

Goldschmidt, E. P.: 'Nicholas Hilliard as Wood Engraver', *T.L.S.* letter, 9 August 1947

Goldsmiths' Company: MS records, Goldsmiths' Hall, City of London

Goulding, R. W.: 'The Welbeck Abbey Miniatures', *Wal. Soc.*, IV (1916)

Grove's Dictionary of Music and Musicians, 5th ed., ed. Eric Blom (9 vols, 1954) and *New Grove*, ed. Stanley Sadie (1981)

Haberdashers' Company: MS records, Guildhall Library

Harben, H. A.: *A Dictionary of London* (1918)

Harleian Society publications: in particular for parish registers, marriage licences, Visitations and grantees of arms

Haydocke, Richard: *A Tracte containing the Artes of curious Paintinge, carvinge & buildinge* (Oxford, 1598)

Henry Prince of Wales: MS Household accounts of, P.R.O.

Hentzner, Paul: *A Journey into England 1598* (Strawberry Hill, 1757 ed.)

Hilliard, Nicholas: *A Treatise concerning the Arte of Limning*, ed. R. K. R. Thornton and T. G. S. Cain (Mid Northumberland Arts Group in association with Carcanet New Press, Manchester, 1981)

Hind, A. M.: *Engraving in England in the Sixteenth and Seventeenth Centuries*, Part I: *The Tudor Period* (Cambridge, 1952)

Historical Manuscripts Commission: publications, various

Hotson, Leslie: *Mr W. H.* (1964)

—— 'Queen Elizabeth's Master Painter', *Sunday Times Colour Supplement*, 22 March 1970

—— *Shakespeare by Hilliard* (1977)

Huguenot Society of London: publications, various

Isleworth parish registers: MSS, Hounslow Public Library

Jenkins, Elizabeth: *Elizabeth and Leicester* (paperback, 1972)

Lees-Milne, James: 'Two Portraits at Charlecote Park by William Larkin', *Burl. Mag.*, XCIV (1952)

Letters and Papers, Foreign and Domestic, of the Reign of Henry VIII

Limming: A very proper treatise, wherein is briefly sett forthe the arte (1573)

Livre des Anglois à Genève: ed. J. S. Burn (1831)

Livre des Habitants de Genève 1549–1560: ed. P.–F. Geisendorf (Geneva, 1957)

Long, Basil: *British Miniaturists 1520–1860* (1929)

Lord Chamberlains' Books: MSS, various, P.R.O.

McIntyre, James: *The Story of the Rose* (1970)

McKerrow, R. B. and Ferguson, F. S.: *Title-Page Borders Used in England and Scotland 1485–1640* (1932)

Melville of Halhill 1535–1617, Sir James, Memoirs of, ed. A. Francis Steuart (1929)

Middlesex Sessions Records: MSS and printed series, G.L.C.R.O.

Ministers' and Receivers' Accounts: MS records of Queen Anne of Denmark's Household expenditure, P.R.O.

Miscellanea Genealogica et Heraldica, 2nd series, 5: for Pake family of Broomfield, Essex

Moens, W. J. C.: printed ed. of some Dutch Church registers (1884)

Murdoch, John (with Jim Murrell, Patrick J. Noon and Roy Strong): *The English Miniature* (New Haven and London, 1981)

Murrell, Jim: see Murdoch, John

Naunton, Robert: *Fragmenta Regalia, or Observations on the late Queen Elizabeth, her Times and her Favourites* (1641)

Neale, J. E.: *Queen Elizabeth* (1934)

—— *The Elizabethan House of Commons* (1949)

Norgate, Edward: *Miniatura or The Art of Limning*, ed. Martin Hardie (Oxford, 1919)

Paget, Hugh: 'Gerard and Lucas Hornebolt in England', *Burl. Mag.*, CI (1959)

Painter-Stainers' Company: MS records, Guildhall Library

Parish registers and churchwardens' accounts, London and Westminster: MSS and printed series at Guildhall Library, G.L.C.R.O. and Westminster City Library (Buckingham Palace Road)

Parry, Graham: *The Golden Age Restor'd* (Manchester, 1981)

Paulet, Amyas: MS copies of letters from, while Ambassador to France, Bodleian Library, Oxford

Peacham, Henry: *The Gentlemans Exercise* (1612)

Pepys, Samuel: *Diary*, ed. Robert Latham and William Matthews (1970–83)

Piper, David: 'The 1590 Lumley Inventory: Hilliard, Segar and the Earl of Essex', Part II, *Burl. Mag.*, XCIX (1957)

Pope-Hennessy, John: *A Lecture on Nicholas Hilliard* (1949)

Prerogative Court of Canterbury: MSS of wills (registered copies and originals) proved in, P.R.O.

Princely Magnificence: Court Jewels of the Renaissance 1500–1630: V. & A. exhibition catalogue (1980)

Privy Council, Acts of

Privy Council of Scotland, Registers of

Reddaway, T. F.: *Goldsmiths' Row in Cheapside 1558–1645* (1963)

Requests, Court of: MS records, P.R.O.

Reynolds, Graham: *English Portrait Miniatures* (1952)

Reynolds, Graham: 'The Painter Plays the Spider', *Apollo* (April 1964)

—— *Nicholas Hilliard and Isaac Oliver* (1947 V. & A. exhibition catalogue, as revised and expanded 1971)

—— 'Portrait Miniatures from Holbein to Augustin', *Apollo* (October 1976)

—— *Wallace Collection: Catalogue of Miniatures* (1980)

Rogers, Pat: 'The rise and fall of gout', *T.L.S.*, 20 March 1981

Rymer, Thomas: *Foedera* (2nd ed., 1727)

Sandrart, Joachim von: *Academia Nobilissimae Artis Pictoriae* (Nuremberg, 1683)

Shaw, W. A.: *The Knights of England* (2 vols, 1906)

Star Chamber, Court of: MS records, P.R.O.

State Papers, domestic, colonial and foreign: MSS and printed series, P.R.O.

State-Tryals, A Compleat Collection of (1719)

Stow, John: *A Survey of London*, ed. C.L. Kingsford (Oxford, 2 vols, 1908)

Strong, Roy: 'Queen Elizabeth, the Earl of Essex and Nicholas Hilliard', *Burl. Mag.*, CI (1959)

—— 'Nicholas Hilliard's Miniature of Francis Bacon rediscovered and other Minutiae', *Burl. Mag.*, CVI (1964)

—— *The English Icon: Elizabethan and Jacobean Portraiture* (London and New York, 1969)

—— *Tudor and Jacobean Portraits*: catalogue of portraits in the N.P.G. (2 vols, 1969)

—— *The Elizabethan Image: Painting in England 1540–1620*: Tate Gallery exhibition catalogue (1969)

—— *Nicholas Hilliard* (1975)

—— *The Cult of Elizabeth* (1977)

—— *The English Miniature* (1981): see Murdoch, John

Subsidy rolls: MSS, P.R.O.

Syon House MSS, various

Totnes parish registers: MSS, Devon County Record Office

Treasurers of the Chamber at Court: MS account rolls, P.R.O.

Treasury Books, Calendar of

Van der Doort, Abraham: catalogue of Charles I's art collections, ed. Oliver Millar, *Wal. Soc.*, XXXVII (1960)

Vertue, George: *Notebooks*, original MSS in B.L., and transcripts, *Wal. Soc.*, XVIII, XX, XXII, XXIV, XXVI, XXIX (index), XXX

Victoria County History, The

Vivian, J. L.: *Visitations of Devon 1531, 1564, 1620* (1895)

Walpole, Horace: *Anecdotes of Painting*, ed. R. N. Wornum (3 vols, 1888)

Walpole Society: publications, various

Weale, W. H. J.: 'Simon Binnink, Miniaturist', *Burl. Mag.*, VIII (1906)

Whitney, Geffrey: *Choice of Emblemes* (Leyden, 1586): facsimile ed., ed. H. Green (London and Manchester, 1866)

Willan, T. S.: *The Muscovy Merchants of 1555* (Manchester, 1953)

—— *The Early History of the Russia Company 1553–1603* (Manchester, 1956)

—— *Studies in Elizabethan Foreign Trade* (Manchester, 1959)

Wills and letters of administration: MSS, registered copies and originals, at Guildhall Library, G.L.C.R.O. and Westminster City Library

Winter, Carl: *Elizabethan Miniatures* (London and New York, 1943)

——'Hilliard and Elizabethan Miniatures', *Burl. Mag.*, LXXXIX (1947)

Wraight, A. D. and Stern, Virginia F.: *In Search of Christopher Marlowe: A Pictorial Biography* (1965)

Index

Page numbers in bold type indicate substantial references

Abbot, Archbishop George, 175, 176, 213(n.15)
alchemy, 121, 122
Alcock brothers, 48
Aldermen, Court of, 34, 78, 170
Alençon, François de Valois, Duke of, **61–3,** 73–4, 118
Anne of Cleves, Queen, 21, 24
Anne of Denmark, Queen, 142, 148, 151; and Isaac Oliver, **150–2,** 169–70, 176, 180; and Laurence Hilliard, 186; death and funeral, 160, 170, 184
Anthony, Charles (engraver) and family, **122–5;** *and see* Great Seals
Anthony, Derick (engraver) and family, 77, 120, 122, 125; *and see* Great Seals
Antwerp, 20, 38, 56, 63, 103, 115–17, 159–60
Armada, Spanish, and Armada Jewel, 51, 84, 104, 108, 112
Arnold, Janet, 9, 159
Arran, James Hamilton, 2nd Earl of, 56
Arundel, Thomas Howard, 2nd Earl of, 111
Ashmolean Museum, Oxford, 86, 111
Atkinson, Stephen, **55–7**
Aubrey, John, 67, 68, 81, 85
Auerbach, Erna, 7, 62, 79–80, 150–1, 154, 172, 187, 188, 193(n.11), 196(n.35), 197(ns.5, 6), 208(ns. 11, 17), 214(ns.15, 17)
Averell, William, 98, 100, 126
Avery, Anne (Hilliard's sister), 106, 108, 179

Bacon, Sir Francis, later Baron Verulam, and Hilliard, 61, 63, **67–8,** 120, 157; and Michael Moody, 117, 121; and Robert Cecil, 133; *Essays* of, 42, 90
Bacon, Sir Nicholas, 67, 157; *and see second wife,* Cooke, Anne
Bales, Peter (calligrapher), 63
Ballet, John (goldsmith), 79, 126–7
Barber, Katherine (Hilliard's mother-in-law), 34–5, 108; *and see husband,* Brandon, Robert
Barnfield, Richard, 89
Bassano family, 161–2, 182, 183
Beane, Mary (Hilliard's sister), 106
Bedford, Countess of, *see* Harington, Lucy
Bennett, Hugh (painter-stainer), 168
Benninck family (painters), 20, 22, 30
Benninck, Levina (limner), *see* Teerlinc, Levina
Bent, John (goldsmith), 79
Bess of Hardwick, 89, 114
Bettes, John the Elder (painter), 30–1

Bettes, John the Younger (painter-stainer), 30–1, 57–8

bice (pigment), 38

Bisham Abbey and church, 156–7

Blackfriars, *see* St Anne Blackfriars *under* Parishes (City of London)

Blakiston, Noel, 7, 205(n.27)

Blount, Sir Charles, later Earl of Devonshire, **83–4,** 108–9

Blount, Sir Christopher, 108–9, 137; *and see wife,* Knollys, Lettice

Bodley, John and family, 25–30 *passim,* 43–4, 75, 132

Bodley, Sir Thomas, 25–8, 136

Boleyn family, 20, 27, 76, 82

Bond family, 102–5 *passim,* 121; *and see* Darr, Leonard *and* Martin, Sir Richard

Boughton, Jane, **46–7,** 120

Brandon, Alice, *see* Hilliard, Alice

Brandon, Lucy, 105–6, **108–9,** 167; *and see husband,* Reynell, Sir Richard

Brandon, Robert (goldsmith, Hilliard's master and father-in-law), 48, 52, 194(n.24); City Chamberlain, 8, 34, 49, 75, 79, Master of the Goldsmiths', 34, 49, 75, governor of Christ's Hospital, 49, 148–9; and Hilliard, 34–5, 38, 48, 50, 57, 67, 69, 75, 79, 105–6, 109; family and will, **34–5,** 77, **105–7,** 108, 109

Brigham brothers, 76, 101

Broad, John (goldsmith), 147–8

Bromley, Sir Thomas, 78

Bruges, painters of, 19–20, 30; and Gheeraerts and de Critz families, 138, 159–61; and Nicasius Russell, 165

Brussels, 115, 117, 118, 175

Buccleuch, Duke of, 9, 84, 99

Buddle, Anne, 9

Burbage, James and Richard, 24, 87, 157–8

Burghley, Lord, *see* Cecil, Sir William

Cadiz, attack on, 133–4

Calvin, John, 27–8

Camden, William, 87, 90–2, 111

Cannon, Richard, 138, 145

Carey, Catherine, *see husband,* Knollys, Sir Francis

Carey, Henry, *see* Monmouth, 2nd Earl of

'carnation', 21, 23, 45, 95

Carr, Robert, *see* Somerset, Earl of

Catherine de' Medici, Queen, 61–2, 64–5

Cecil, Lord David, 133

Cecil, Sir Robert, later 1st Earl of Salisbury, 80, 108, 121, 150, 157; career, character, relations with Queen Elizabeth, 118, 124, **133–4,** 137, 140, and with King James, 137, 140, **144–5;** and Michael Moody, 115–18; patronage of Hilliard, 8, 50, 78, 128, 134, 137, 150, 157, 168, 174; *and see letters to, under* HILLIARD, NICHOLAS

Cecil, Sir William, later 1st Baron Burghley, 23, 54, 56, 80, 82, 90, 94–5, 124, 132, 157, 168; relations with Queen Elizabeth, 62, **132–4;** and Michael Moody, 115–18 *passim;* and Hilliard and Oliver, 50, 78, 132. *See also wife,* Cooke, Mildred

Chamberlain of the City, office of, 34

Chamberlen family, 165

Chapman family, 108

Charles I, King, 39, 141, 169, 173; created Prince of Wales, 171, 178; art collections of, 40, 114, 154–5, 161–2, 171, 173–4, 182, 184; and Nicholas and Laurence Hilliard, 143, 146, 185, 188; and Isaac and Peter Oliver, 171–2, 174, 184; and Nicasius Russell, 165

Charles II, King, 188, 189–90

Charles IX of France, King, 66

Cheapside Hoard, 32, 50; *and see* Cheapside *under* Streets (City of London)

Chichester, Sir Robert, 171

Christian IV of Denmark, King, 142

Christ's Hospital, 49, 148–9

Cleeve, Somerset, 47

Cleveland Museum of Art, 78

Clifford, Lady Anne, 169

Clouet, Jean, 19

Cobbold, John (Hilliard's apprentice), 49, 57; ?son of, 130

Cockerell, Timothy (painter-stainer), 79

Colt, John (sculptor), 160–1, 180

Colt, Maximilian (Master Sculptor), 150, 159–61, 164, 173, 180

Common Council, Court of, 49, 78

Companies, 34, 103, 139; Armourers, 72; Barbary, 103; Carpenters, 79; Drapers, **166–7;** East India, 167; Fishmongers, 97, 100; Girdlers, 79; Goldsmiths, *see under* 'G'; Grocers, 35, 79, 108; Haberdashers, 79, 167, 201(n.30); Innholders, 79; Mercers, 79, 121, 140–1, 185; Merchant Taylors, 106; Muscovy, 103; Painter-Stainers, 43, 57–8, 79, 130, 139, 149–50, 167–8, 170, 188; Saddlers, 189; Skinners, 119; Vintners, 98

Coningsby, Jane, *see* Boughton, Jane

Coningsby, Sir Thomas, 47, 120

Constable, Henry, 93–5

Cooke, Anne (mother of Francis Bacon), 157

Cooke, Elizabeth (wife of Sir Thomas Hoby and John Lord Russell), **156–8,** 178

Cooke, Mildred (mother of Robert Cecil), 157

Cooper, Alexander (limner), 184

Cooper, Samuel (limner), 95, 146–7, 184, 190

Cornwallis, Mary, 24; *and see* Plate 1

Cotton, Jane (Oliver's mother-in-law), 162, 172–3, 185, 210(n.7), 214(n.9); Oliver ?miniature of, 185, 188. *See also husband*, Harding, James

Courtenay family, 109

Cradock, Edmund (goldsmith), 50–1

Crawford Moor, Lanarkshire, *see* gold-mining, Scottish

Crisp family, 119; *and see* Pake, Rebecca

Croone, Jacob, 188–9

Crosby, Sir John, 97, 102; Crosby Place, 102–3

Cullum family, 119; *and see* Pake, Rebecca

Cullymore, Jane and family, **166–8,** 186–8; *and see husbands*, Farmer, George, *and* Hilliard, Laurence

Cumberland, Earl of, 123

Dalton, Roger, 95

Darr, Leonard and family, **101–5,** 166; *and see* Bond family

Deacon, Elizabeth (Hilliard's servant), 68, 108, 179

De Critz, John (Serjeant-Painter), 43, 99, 140, 153, 159–61, 165, 180; *for dispute with Hilliard over Queen's tomb, see letters to Robert Cecil under* HILLIARD, NICHOLAS

De Critz, John (son), 99

Delaram, Francis (engraver), 179

Devereux, Penelope, *see* Rich, Lady

Devereux, Robert, *see* Essex, 2nd *and* 3rd Earls of

Devereux, Walter, *see* Essex, 1st Earl of

Devonshire, Earl of, *see* Blount, Sir Charles

Devosse, Cornelius (painter and lapidary), **54–7,** 148, 197(n.5), 198(n.10)

Dolfin, Giovanni, 115–16

Donne, John, 120, 134

Dorset, Richard Sackville, 3rd Earl of, 169–70

Drake, Sir Francis, 66–7, 73–4, 81; Drake Jewel, 74–5

Drury family, 119–20

Dudley, Robert, *see* Leicester, Earl of

Dürer, Albrecht, 20, 42–3, 52

Edward VI, King, 25, 26, 29

Edwards, James, 67

eglantine, **88–90**

Elizabeth I, Queen, 25, 29, 32, 54, 61, 85, 94–5, 111, 112–13, 139, 157; character and appearance, 23–4, 39, 41, 61, 81–3 *passim*, 90, 91, 122–3, 132, **135–6,** 152, 162; bestows nicknames, 62, 81, 133; Alençon marriage project, **61–3,** 73–4, 118; plots to kill, 115–18 *passim*; death and funeral, 136–7, **140–1,** 160, 161–2; *and, for tomb, see letters to Robert Cecil under* HILLIARD, NICHOLAS. *For relations with courtiers, see their entries Patronage of artists*: her collection of miniatures, 23–4; engravings of, 51, 179; 'models' of, *see* Great Seals; employment of Hilliard, 32–3, 38–41 *passim*, 47–8, 55, 61, 63, 65, 72–8 *passim*, 92, 123–5 *passim*, 127–30 *passim*, 136, 138, 141, 143, 146, 168, 180, 188, *and see* HILLIARD, NICHOLAS; employment of Oliver, *see* OLIVER, ISAAC

Elizabeth, Princess, later Queen of Bohemia, 143, 169, **170–1,** 174

Ernest Elector of Hanover, 171

Essex and Leicester, Countess of, *see* Knollys, Lettice

Essex and Somerset, Countess of, *see* Howard, Frances

Essex, Walter Devereux, 1st Earl of, 82–3, 113

Essex, Robert Devereux, 2nd Earl of, 38, 93–5, 116–17, 118, 180; character, and relations with Queen Elizabeth, **82–4,** 133–4; siege of Rouen, 47, 120; attack on Cadiz, and Islands Voyage, 108, 134–5; campaign in Ireland, rebellion, trial and execution, 37, 82, 88, 108–9, 135, 137, 157; and Hilliard, 38, 84, 87–91 *passim*, 93–5, 108–9, 126–8, 134, 137; and Oliver and Gheeraerts, 88, 111, 133–4

Essex, Robert Devereux, 3rd Earl of, 109, 113, 176; *and see wife,* Howard, Frances

Exeter, 25–6, 28, 29, 31, 48, 52, 69, 75, 101, 106, 109, 188

Farmer, George and family, 167–8, 187

Feckman, Abel (engraver), 70, 123, 134

Fetherstone, Raphe (Oliver's lawyer), 172

Finsbury, manor of, 49–50

Fitton, Mary, 24; *and see* Plate 2

Fitzwilliam Museum, Cambridge, 21, 120, 155, 169

Flushing, 63, 85–6, 116–17, 175

Fontainebleau, school of, 66

Ford House, Newton Abbot, 109

Forman, Simon, 176

Fortescue, Sir John, 129–30

Fowler, Thomas, 94–5

Franke, William (Hilliard's apprentice), 57, 67

Frederick Elector Palatine, 169, 171

Freeman, William, 79

Fuller, Thomas, 183

Gaultier, Jacques and Léonard, 63

Gawdy, Philip, 142

Geneva, **26–9,** 35, 38, 63, 75, 115, 179

'George of Ghent', 64–5

Gerard, John (herbalist), 90

Gheeraerts, Marcus the Elder (portrait-painter), 138, 160

Gheeraerts, Marcus the Younger (portrait-painter) and family, 138, 146, 159–61, 163, 164–5, 168, 169, 171, 180; Essex portrait by, 88, 133–4

Gheeraerts, Marcus III (painter-stainer), 159, 168

Gheeraerts, Sara (Oliver's 2nd wife), 97, 138–9, 159–61, 164–5; *and see* OLIVER, ISAAC

Ghent, painters of, 19–20, 30; 'George of Ghent', 64–5

Giustinian, Zorzi, 144

goldmining, Scottish, **54–8,** 148, 180

Goldsmiths' Company, 43, 56, 71, 105–6, 126, 128–30, 139; Goldsmiths' Hall,

31, 49, 51, 58, 71, 105, 128–9, 148; Goldsmiths' Row, **31–2**, 34–5, 51, 153, *and see* Cheapside and Westcheap *under* Streets (City of London); 'picture' commissioned from Hilliard, 127, 128, 130. *For supremacy of goldsmiths, see letters to Robert Cecil under* HILLIARD, NICHOLAS; *and for his house leased from the Company,* 'Maidenhead, The'. *See also individual freemen* Richard Alcock, John Ballet, John Bent, Robert Brandon, John Broad, Edmund Cradock, William Franke, Edward Gylbert, Hilliards (Brandon, Charles, John – ?uncle and brother of the artist – NICHOLAS and Laurence), Nicholas Johnson, William Laborer, Rowland Lockey, John Lonnyson, Sir Richard Martin, Andrew Palmer, Robert and William Peake and Thomas Wood

gout, 69–70, 149

Gower, George (Serjeant-Painter), 24, 77 *and see* Plate 1

Grantham, Elizabeth, 189–90

Great Seals of the realm: second, 51, 77–8, 80, 120, 122, 123; third, 79–80, **120–5**, 138, 206(n.30)

Gresham, Abel, 186

Gresley Jewel, 74–5

Guylmyn, John, 21–2; *and see wife,* Hornebolte, Susanna

Gylbert, Edward (goldsmith), 35, 57

Gysard, Susan, 107

Hammond, Colonel Robert *and* Hampden, John, 39

Harcourt Williams, Robin, 8, 196(n.30), 208(n.8)

Harding, Anne (Plate 48), 163, 185, **189–90;** *and see husband,* Oliver, Peter

Harding, Edward (Court musician), 162, 164, 172, 180, 182, 184–5

Harding, Elizabeth (Isaac Oliver's 3rd wife), 97, 141, 155, 159, 162–5 *passim,* 172–3, 182, 185, 189; *and see* OLIVER, ISAAC *and 2nd husband,* Morgan, Pierce

Harding, James (Court musician, Oliver's father-in-law), 141, **161–4,** 172–3, 176, 180, 182, 184–5, 210(n.7), 214(n.9)

Harding, Jane (James's wife), *see* Cotton, Jane

Harding, Mary (Edward's wife), 184–5

Hardret, Abraham (jeweller), 155, 165, 180, 185; and Princess Elizabeth, 171

Hardret, Martin (jeweller), 155, 180

Hare, Susan, 8, 128–9, 196(n.32), 199(n.6)

Harington, Lucy, Countess of Bedford, 155–7, 171

Harington of Exton, Lord, 170–1

Harington, Sir John, 41–2, 170–1

Harrison (pewterer), 35, 72, 98–9

Harrison, Thomas, **121–2,** 175

Hatton, Sir Christopher, 42, 62, 78, 81, 115, 122, 132

Haydocke, Dr Richard, 35–6, 96, 136, 142

Heneage, Sir Thomas, 51, 96, 116–17, 124

Henri III of France, King, 61, 66, 114, 132

Henri IV of France, King, 114, 124

Henrietta Maria, Queen, 188

Henry VII, King, 19, 20, 39, 90; Chapel, 43, 160

Henry VIII, King, 19, 20, 21, 22, 26, 28, 39, 45, 76, 90, 115, 161, 182

Henry Prince of Wales, 99–100, 148, 151, 175; and Hilliard, 145–6; and Oliver, 151, **152–5;** and Robert Peake, 152–5 *passim,* 168, 169; death and funeral, 153, 155, 169, 174

Hentzner, Paul, 24, 32, 87, 135–6

Herbert of Cherbury, Edward, 1st Baron, 112, 164, 170

Heriot, James (Court jeweller), 155, 174

Herne, William (Serjeant-Painter), 187

Hertford, Edward Seymour, 1st Earl of, 65, 170

Hertford, William Seymour, 2nd Earl of, 170

Hilliard, Alice (artist's 1st wife), 31, 35, 53, 58, 103, 109, 166, 167; in France with husband, 61–8 *passim*; in father's will, 105–6; suggested burial date, 107–8, 166. *See also father*, Brandon, Robert

Hilliard, Anne (artist's sister), *see* Avery, Anne

Hilliard, Brandon (grandson), 109, 167, 186, 187, 188

Hilliard, Charles (grandson), 167, 187, 188–9

Hilliard, Daniel (eldest son), 65, 69, 106

Hilliard, Elizabeth (eldest daughter), 69, 71, 107, 108; *and see husband*, Richardson, Thomas

Hilliard, Elizabeth (grand-daughter), 107

Hilliard, Rev. Ezekiel (brother), 31, 101, 106, 141

Hilliard, Frances (sister), 106

Hilliard, Francis (son), 73, 106

Hilliard, Jane (daughter-in-law), *see* Cullymore, Jane

Hilliard, Jeremy (goldsmith, brother), 31, 101, 106, 109

Hilliard, John (grandfather), 26

Hilliard, John (goldsmith, ?uncle) and family, **48–50,** 51, 57, 148–9

Hilliard, John (goldsmith, brother), 31, 35, 48, 50–1, 57

Hilliard, Laurence (*née* Wall, mother), 31, 75, 106, 167

Hilliard, Laurence (limner, son), 40, 75, 107, 137–8, 143, 166, 173, 174, 179, 186; freeman of Goldsmiths', 143, 166; father seeks Cecil patronage for, 70, **143–5;** Gutter Lane house and Clerkenwell property, 130–1, 166, 186,

187; mugged, 186; in father's will, 107–8, 179; royal limner, and in civil wars, 75, 144, 150–1, 180, 185–6, 188; marriage and family, 8, 109, 130–1, **166–8,** 180; will and death, **186–8.** *See also wife*, Cullymore, Jane

Hilliard, Laurence (Mrs Rich, Nicholas's grand-daughter), 167, 186, 187, **188–9,** 215(n.21)

Hilliard, Lettice (daughter), 84, 214(n.15)

Hilliard, Mary (sister), *see* Beane, Mary

HILLIARD, NICHOLAS, birth-date, 26–7, 147, 193(n.5); character, 8, 27–8, 41–2, 43, 45, 48, 54, 64, 76, 79–80, 95, 107, 118, 122, 123–5, 128, 129, 134, 149, 150, 180; early years, **25–36,** *and see* Geneva; apprenticeship, **34–5,** 50, 153, 180, *and see* Brandon, Robert; possible instructors in limning and engraving, 29–31, 51–2, 57; own apprentices and pupils, 31, **57–8,** 72–3, 129, 180 *and see* John Bettes the Younger, John Cobbold, William Franke, Laurence Hilliard, Rowland Lockey, Pieter Mattheus, ISAAC OLIVER, Richard Osbaldeston, John Pickering, Gualter Reynolds *and* William Smythe; marriage(s), family and home(s), 58, **107–8,** 127, 180, *and see* Hilliard *and* Brandon *entries and* 'Maidenhead, The'; money troubles, 46–8, 57, 64–5, 69, 73, 75–80 *passim*, 110, 125, 129, 137–8, 146–7, 174, and the £40 annuity, 46, 125, 129, 137–8, 139, 145, 180, 185–6, 188, 208(n.11), and tithes, grants, leases, etc. promised, 47–8, 75–6, 77–8, 124, 145–6, 196(n.30), *and see letters to Robert Cecil below*; imprisonment, 177–8, 180; will, death and burial, 109, 131, 145, 179, 190.

Letters to Robert Cecil, 8, 50, 81, 107, 134, 180. (1) *16 March 1593/4*, on Feckman and ?gout, 69–70, 123, 134. (2) *2*

June 1599 (Plate 28), on Charles Anthony and Mint, being 'in great extremes', Cecil's visit to France, 48, 80, 111, **123–5**. (3) *28 July 1601*, on apprentices, inadequate annuity, expense of royal service, is living with friends 'in the country' and seeks permission to travel abroad, seeks patronage for son Laurence, 32, 72–3, 77, **129,** 137, 143, 144. (4) *6 May 1606*, on limning Cecil, ?gout and son Laurence, 70, 137, **144**. (5) *1606*, on Queen's tomb, superiority of goldsmiths, 'envy' over Great Seal and 'doing well in other men's offices', inadequate annuity, 43, 99, 124–5, 138, 145, 149–50, 195(n.17). (6) *26 March 1610*, on ?gout, Laborer and road-mending, superiority of goldsmiths, 69, 147–50 *passim*.

As artist: renowned at home and abroad, 7, 23, 41–2, 57, 63–5, 92–6 *passim*, 118–20, 134, 136, 142, 168, 169, 175, 179–80; admires Holbein, 22, 28, 29–30, and Dürer, 20, 42–3, 52; French influence on, 66, and visits France, 28–9, 48, 54, **59–69,** 179; versatility, 37, 39, 122, 181; as limner, portrays jewels and costume, 28, 33, 39–40, 66, 94, 120, 136, 156, 180–1, use of gold and silver, 40, backgrounds and 'wet-in-wet' technique, 38, 95, 178, shape and size of miniatures, 66–7, 78, and their hidden meanings, 38, 86–7, 111; as goldsmith and jeweller, 29, 32–3, 37, 54–8 *passim*, 63, 65, 71, 74–5, 77, 147–50 *passim*, 170, 181; as engraver, 37, 50–2, 64, **121–5,** 187, *and see* Great Seals; as calligrapher, 8–9, 37, 111, 178, 179, 181, *and see* Plate 28; as alchemist, 122; ?heraldic work of, 168; ?large-scale portraitist, 128–30; relations with Oliver, 73, and their works compared, 84–5, 100, 111, 151, 173, **179–81**

Royal patronage of, see Elizabeth I, Queen; James VI and I, King; Charles I, King; *and* Henry Prince of Wales.

Miniatures (illustrated – plate numbers in brackets and bold type): man against flames (**3**), 24, 91; father (col. **2**), 26, 66, 187; wife (col. **3**), 66, 107, 187; self aged 30 (col. **1,** b.-and-w. **10**), 28, 66, 110, 179, 187; Thomas Bodley (**4**), 27, 136; young man in 1572 (col. **4**), 37–8; young Francis Knollys (**5**), 38–9; Queen Elizabeth in 1572 (**6**), 39, **40–1**, 47, 51, 66, 82–3, and later (col. **15**), 136; Jane Boughton (**7**), 7, **46–7**, 120; Leicester in 1576 (**8**), 50, 82; Alençon (**9**), 62; man among roses (col. **5**), 8, 66, **86–91;** Francis Drake (**11**), 66–7, 74, 81; Francis Bacon (**12**), 67; Walter Ralegh (**13**), 81; Charles Blount (**14**), 83, 109; man clasping hand (**18**), 86, **92–3;** unknown youth (**19**), 86; Southampton (col. **8**), **95–6,** 137; Leonard Darr (**20**), **101–5,** 166; unknown lady (**33**), 120; unknown lady (col. **16**), 120; 'Mrs Holland' (col. **17**), 120, 157; King James (**35, 36**), 142–3; Prince Charles (**39**), 143; 'Mary Queen of Scots' (**42**), **155–8,** 178; 'Henry Carey' (**46**), 178.

Works and possible works (mentioned): self as boy, 29; Protector Somerset, 29; 'Oliver St John', 37, 56; Queen Elizabeth, early, 39–40, in prayerbook, 62, various, 41–2, 136, in Drake and Armada Jewels, 51, 74, 'picture' of commissioned by Goldsmiths', 128–30, 'Phoenix' and 'Pelican' portraits, 130, 'fair table' for as New Year gift, 76–7, 'picture' of in son's will, 187; Northumberland, 46, 164; Alençon in jewel, 74; unknown man in 1577, 66; Drake now in Vienna, 74–5; miniatures in Gresley Jewel, 74–5; 2nd Lord Hunsdon, 76; Anthony Mildmay, 77–8; ?Essex, 87–8, and ?another, 109;

HILLIARD, NICHOLAS – *contd.*

Penelope Rich, 93–5; Bess of Hardwick, 114; Arabella Stuart, 114–18 *passim*; Anthony family, 125; John Donne, 134; Burghley, 132; Robert Cecil, 137, 144; Leicester, 187; King James (various), 142, 145–6, 174, Prince Henry, 146, and Prince Charles, 146, 174; Abraham Savery, 175; son Laurence, 187; William Herne, 187.

The Treatise, 7, 9, 22, 41, 42, 44–5, 52, 107, 136–7, 180, 182. On skills of foreigners, 19–20, 45, 66, on Holbein, 22, 29–30, on Dürer, 42–3, 52, and on women painters, 30; on Ronsard, 63–4; on supremacy of limning, 23, **43–4,** 62, 92–3, 183, and portrayal of 'face of mankind', 24, 42, 173, 181; on the artist, proper conduct of, and poor rewards for, 31, **44–6, 59–60,** 69, 73, 147, 158, 164; on portraying beauty, 40–1, 120, and dealing with sitters, 41, 45, 87; on Queen, Sidney and Hatton, 41–2; on studio techniques and materials, 22–3, 40, 46, and on jewels and precious stones, **33–4,** 39; on 'line', 'shadowing' and 'proportion', **40–3,** 52

Hilliard, Nicholas (?cousin), 49

Hilliard, Nicholas (unidentified), 107, 204(n.34)

Hilliard, Parnell (sister), 106

Hilliard, Penelope (daughter), 84, 214(n.15)

Hilliard, Richard (goldsmith, father), 25–6, 29, 31, 66, 69, 106, 187

Hilliard, Robert (son), 84

Hilliard, Thomas (grandson), 167, 187, 188–9

Hilliard, Thomas (painter-stainer), 188

Hoby family, *see* Cooke, Elizabeth

Hogenberg, Remigius (engraver), 51–2

Holbein, Hans the Younger, 21, 22, 24, 28, 29–30, 40, 56, 66

'Holland, Mrs', 120, 157

Hornebolte family (painters), 20–1

Hornebolte, Lucas (limner), 20–2, 29, 40

Hornebolte, Susanna (painter), 20–2, 30; *and see husbands*, Parker, John *and* Guylmyn, John

Hotson, Leslie, 90–1, 92, 201(n.12), 205(n.23)

Howard, Frances, Countess of Essex and Somerset, 113, **176–7;** *and see husbands*, Essex, Robert Devereux, 3rd Earl of *and* Somerset, Robert Carr, Earl of

Howard of Effingham, Lord Admiral, 108, 117

Hunsdon, Henry Carey, 1st Baron, 63, 76, 132, 157–8, 178

Hunsdon, George Carey, 2nd Baron, 76

imprese, **86–7,** 90–2, 111, 173

Islands (Azores) Voyage, 108, 134–5

Isleworth, 147–8, 162–5 *passim*, 184–6 *passim*, 189–90

James VI and I, King, 87, 94–5, 100, 108, 115, 118, 123, 137, 141, 142, 148, 151, 155, 156, 165, 183; character, 142, 151–2; artists employed by in Scotland, 55–7, 72; 'pictures' of commissioned for City and Rutland's party, 130, 142; employment of Nicholas Hilliard, 142, **145–6,** 150–1, **174,** 178–9, 180, 185, 188, and of Laurence Hilliard, 75, 150–1, 180, 185–6, 188

Johnson, Clara (sister of Cornelius), 165, 185, 189–90; *and see husband*, Russell, Nicasius

Johnson, Cornelius (painter), 119, 165, 180, 185, 189–90

Johnson, Nicholas (goldsmith), 70

Jones, Inigo, 152, 176

Jonson, Ben, 91, 147, 152, 176

Knollys, Sir Francis and family, 27, 38, 39, 73, 76, 82, 132

Knollys, Sir Francis the younger, 38–9, 194(n.5)

Knollys, Lettice, Countess of Essex and Leicester, 50, 82–4, 108–9, **113,** 137, 155; *and see husbands*, Essex, 1st Earl of; Leicester, Earl of; *and* Blount, Sir Christopher

Knox, John, 26, 27, 28

Knyvett, Catherine, Countess of Suffolk, 112–13

Kunsthistorisches Museum, Vienna, 62, 74

Laborer, William (goldsmith), 147–50, 180

Lanier family, 161–2, 182, 184

Lanier, Judith, **182–4;** *and see husband*, Norgate, Edward

Larkin, William (portrait-painter), 37, **169–70**

Leicester, Countess of, *see* Knollys, Lettice

Leicester, Robert Dudley, Earl of, 27, 50–1, 63, 83–4, 85–6, 93, 94, 108–9, 113, 115; and Queen Elizabeth, 23–4, 50, 51, 62–3, 75, 82, 133; and Hilliard, 27, 50, 75, 82, 83, 187

Leveson family, 121

Limming (treatise), 22, 44, 72

'limning', use of word, 7, 19, 172

Lloyd, Beric, 9, 199(n.12)

Lockey, Leonard, 71–2

Lockey, Rowland (limner, Hilliard's apprentice), 71–2, 114, 143

Lockington, tithes of, 75–6

Lomazzo, Giovanni Paolo, 136–7

London, City of, status, 103–4, 138–9, 140; citizens of, and their orphans, 34, 78–9, 139; Hilliard a citizen of, 69, 139, 180; Museum of, 32. *See also* Aldermen, Court of; Chamberlain, office of; Common Council, Court of; Companies; *and* Lord Mayors

Longford, John, 177; ?widow of, 179

Lonnyson, John (goldsmith), 51

Lopez, Dr Roderigo, 117

Lord Mayors of London, 103, 130, 139; Sir George Bond, 102–4; *and see* Darr, Leonard; Sir Thomas Leigh, 103–4; Sir John Leveson, 121; Sir Richard Martin, *see under* 'M'; Sir Abraham Reynardson, 119

'Maidenhead, The' (Hilliard's house), 70–1, 107, **126–31,** 167

Marlowe, Christopher, 93, 111

Marrett, John, 79, 201(n.30)

Martin, Sir Richard (goldsmith), Lord Mayor and Master of the Mint, 31–2, 51, 103, 122, 148; marries Anne Bond, 103; son marries Alice Hilliard's sister, 35, 166; and Feckman, 123; disgrace, 177–8

Mary I, Queen, 21, 25–7, 90

Mary Queen of Scots, 23, 54, 61, 111, 112, 115–16, 156, 160

masques, Jacobean Court, 152, 156, 176, 181

'Master John of Antwerp', 56

Masters, Betty, 8, 196(ns.32, 34)

Mathewe, Jacob (painter), 72

Mattheus, Pieter (Hilliard's ?pupil), 72, 99

Maurice, Prince, 171

Mayerne, Sir Théodore, 183

Melville, Sir James, 23–4

Mendoza, Bernardino de, 73

Metholde, William, 79

Metropolitan Museum, New York, 87–8

Mildmay, Sir Anthony, 77–8

Mildmay, Sir Walter, 75, 77, 129, 132

Millbrook, rabbit-warren at, 75

Miller, George, 79

Miniatura, see Norgate, Edward

miniatures, miniaturists, 19–24 *passim*; hidden meanings in, 38, 86–7, 152; blue and red backgrounds of, and 'wet-in-wet' technique, 38, 95, 178; highest

miniatures, miniaturists – *contd.*
 form of painting, 43, 152–3; expensive
 materials for, 46; alleged 'democratiz-
 ation' of, 101–2, 105; Blackfriars and,
 138–9; *and see individual artists, and*
 Norgate, Edward *and* Peacham, Henry
Mint, The, 32, 49, 51, 103, **122–5,** 148;
 and see Great Seals
Mint, Scottish, 56
Molescombe, Devon, 104–5
Monmouth, Henry Carey, 2nd Earl of,
 178, 214(n.17)
Moody, Michael (recusant), **115–18,** 121,
 175, 180
Mor, Antonio, 38
Moray, Earl of, 55
Morgan, Elizabeth, *see* Harding, Elizabeth
Morgan, Jane (Elizabeth's daughter), 185,
 188
Morgan, Pierce (Elizabeth's 2nd hus-
 band) and family, 185, 188, 189–90
Morton, Earl of, 55, 56
Moss, O. P., 9, 203(n.17)
Mouser, John, 79
Murdoch, John, 9, 151, 154–5
Murray, Sir David, John *and* Thomas
 (Jacobean Court servants), 152–4, 155,
 171, 174
Murrell, Jim, 7

**National Maritime Museum, Green-
 wich,** 74
National Portrait Gallery, London, 38,
 47, 66–7, 74, 128, 150, 185, 189
Naunton, Sir Robert, 133
Nethersole, Sir Francis, 183
Nevers, Louis de Gonzague, Duke of, 64
New College, Oxford, 131, 136
nicknames, bestowed by Queen Eliza-
 beth, 62, 81, 133
Norgate, Edward, 182–4; *and see wife,*
 Lanier, Judith
Northumberland, Henry Percy, 9th Earl
 of, 46, 163–4

Oliver, Benjamin (Isaac's son), 164, 170
Oliver, Elizabeth (1st wife), 97–9, 100,
 138
Oliver, Elizabeth (3rd wife), *see* Harding,
 Elizabeth
Oliver, Elizabeth (daughter), 164
Oliver, Epiphane (mother), 35, **72,** 98–9
 and 199–200(n.12), 138, 161, 164
OLIVER, ISAAC, birth-date discussed,
 71, close contemporary of Shake-
 speare, 8, 92; character, 8, 28, 110,
 158, 180; brought to London as child,
 and studied under Hilliard, 7, 29,
 35–6, 71–2, 73, 84, 97, 138, 142, 161,
 179; ?visits Holland in 1588, **85–6,**
 113; visits Italy, 113–14, 173; ?visits
 Rouen in 1596, 114; will, death, burial
 and monument, 172–3, 179, 190
 *Foreign connexions in London, and feels
 French,* 8, 72, 73, 85–6, 97–9, 113–14,
 138–9, 151, 159–66, 180, 185; homes,
 see St Peter-upon-Cornhill *and* St Anne
 Blackfriars *under* Parishes. *See also*
 Chamberlen, Colt, de Critz, Gheer-
 aerts, Harding, Hardret, Clara *and*
 Cornelius Johnson, Mathewe,
 Mattheus, Lanier, Norgate, Portier,
 Sonoy *and* Nicasius Russell *entries*
 As artist, renowned at home and
 abroad, 7, 110, 134, 137, 142, 151, 162,
 169, 173–4; style of realism, 84–5, 87,
 and sombre colours, 111–12, and con-
 trasted with Hilliard, 84–5, 100, 111,
 151, 173, **179–81;** handwriting and
 signatures, 111, *and see* Plate 30; con-
 tinental influences on, 111, 151;
 'tablets' and silver pen, 173; portrayal
 of children and use of stipple, **99–100,**
 and portrayal of hands, 155–6, 178;
 ?does large-scale copies in 1590s, 114;
 sense of '*maiestas*', 152 *and see*
 masques, Jacobean Court
 *Works (illustrated – plate numbers in
 brackets and bold type):* Colonel Sonoy

(15), **85–6,** 110–11, 113; man aged 71 (16), 86, 111; youth aged 19 (17), 86, 111; Essex (col. 6), 88, 111, 134; 'Prince of Wales' drawing (21), **99–100;** little girls (col. 10, 11), 100, 111; self-portrait miniature, (22 and col. 9), 110, 179, 185; man aged 27 (col. 7), **93,** 111; 'Arundel', (23), 111; unknown man (24), 111; three ladies (25, 26, 27), 111; 'Philip Sidney' under tree (col. 12), **111–12;** Herbert of Cherbury (31), 112, 164, 170; Catherine Knyvett (32), 112–13; 'Frances Howard' (col. 13), **113,** 204(n.7); 'Arundell Talbot' and endorsement (29, 30), 111, **113–14;** Richard Leveson (34), 121; Queen Elizabeth, unfinished (col. 14), **135–6;** Dorset (44), **169–70;** Queen Anne (37), and in masque costume (38), 150, 152; lady in masque costume (col. 18), 152; Prince Henry (40), 154; 'Lucy Countess of Bedford' (41), **155–6;** ?2nd wife (43), **159;** Princess Elizabeth (45), 171; Head of Christ (col. 19), 173

Works and possible works (mentioned): first known miniature, 71, 84; sketch of Essex, 88; copy of Veronese, 114; Burghley, 132; unspecified works for Queen Anne, 151; unspecified works by, or collected, for Prince Henry, **153–4;** three miniatures of Prince Henry, 152–3, 155; Prince Charles, 171–2; Princess Elizabeth, 174; Harding in-laws, 185, 188; works bequeathed in will, and other 'histories' and 'stories', **172–4,** 181, 184; destination of some works, 189–90 *and see* Charles II, King; Grantham, Elizabeth; *and* Harding, Anne

Royal patronage of, by Queen Elizabeth and her Court, 92–3, 135–6, 138; by Queen Anne, **150–2,** 169–70, 176, 180, 209(n.28); by Prince Henry, 151,

152–4, and attends his funeral, 155; by Prince Charles, 171–2, 173–4; by Princess Elizabeth, **171,** 174; ?royal picture-dealer, 154–5

Oliver, Isaac (son), 151, 164, 185, 189–90

Oliver, James (son), 99, 155, 164

Oliver, Joseph (son), 164

Oliver, Mary (daughter), 164

Oliver, Peter (limner, eldest son), 100, 102, 110, 138, 139, 151, 154–5, 158, 173, 179, 184; birth-date discussed, **99–100,** 186–7; ?drawing of as boy, **99–100,** and as man, 189, *and see* Plate 47; marriage, 163, 180, 189; royal limner, 174, 180, 183–4, 185; instructs Alexander Cooper, 184; ?limns Judith Norgate, **183,** *and see* Norgate, Edward; in father's will, 172–4, in Pierce Morgan's will, 185, *and see* Morgan *entries*; own will and death, 186–7. *See also wife,* Harding, Anne

Oliver, (Olivier), Pierre (Isaac's father), 29, 35, 72, 98–9, 138, 160–1

Oliver, Sara (2nd wife), *see* Gheeraerts, Sara

orphans, sureties for, **78–9,** 125

Orrell, Richard, 138, 145

Osbaldeston, Richard (Hilliard's apprentice), 143

Osborne family, 106, 108, 203(n.26)

Overbury, Sir Thomas, 175–7, 180

Pake, Rebecca, 118–20, 205(n.23); *and see* Crisp *and* Cullum families

Palmer, Andrew (goldsmith), 49, 148–9

Parishes, City of London: *Christchurch Newgate Street,* 99, 160–1. *Holy Trinity Minories,* 162, 182. *St Andrew Holborn,* 138, 161, 186. *St Anne Blackfriars,* importance of for foreign artists, 138–9; petition to Queen, 157–8; and the Oliver family, 8, 35, 37, 138–9, 152, 155, 157–8, 161, **164–6,** 169–70, 172–3, 180, 184, 185, 186, 190.

Parishes, City of London – *contd.*
St Bride Fleet Street, 71–2, 138, 169, 188; and Laurence Hilliard, 130, 167, 186, 188. St Giles Cripplegate, 49–50, 51–2, 138–9. St Mary Woolnoth, 34–5, 77. St Peter-upon-Cornhill, 97–8, 100, 102, 110. St Peter Westcheap, 31, 35. St Sepulchre-without-Newgate, 55, 72, 138, 161, 168, 169–70. St Vedast Foster Lane, 35, 58, 65, 69, 71, 75, 77, 103, 107, 108, 127, 131, 166
Parishes (City of Westminster): St Clement Danes, 162, 188. St Margaret Westminster, 21, 107–8, 166. St Martin-in-the-Fields, 22, 30, 84, 107, 109, 131, 140, 161, 177, 179, 182–3, 188, 190
Parker, John, 21; and see wife, Hornebolte, Susanna
Parma, Alexander Farnese, Duke of, 116–18, 175, 180
Parr, Queen Catherine, 21, 113
Paulet, Sir Amyas, 61, 62, 63, 65, 84
Peacham, Henry, 44, 169
Peake, Robert (Serjeant-Painter), 152–4, 155, 168, 169, 170, 174, 212(n.6)
Peake, William (portrait-painter), 153, 155
'pencil', use of word, 23
Pepys, Samuel, 146
Pereman, William, 177, 179
Philip of Spain, King, 73, 85, 90, 124, 132, 146
Pickering, John (Hilliard's apprentice), 57
'picture', use of word, 24, 142, 172
Pilon, Germain, 64, 66
Piper, Sir David, 87–8
plague, 21, 51–2, 126, 148, 184–5
Portier, Gérard, 164
Poyle, manor of, 77–8
Price, Owen, 188
Primaticcio, Francesco, 66
Privy Council, 60, 84, 133, 140, 150; Hilliard and, 79–80, 125, 127–8

Ralegh, Sir Walter, 81–2, 93, 102, 103, 108, 124, 133
Ranger's House, Blackheath, 169
Reynell, Sir Carew, 108–9
Reynell, Sir Richard and family, 108–9; and see wife, Brandon, Lucy
Reynolds, Graham, 7, 37–8, 161, 212(n.13)
Reynolds, Gualter (Hilliard's apprentice), 57
'Rialta', see Rich, Lady
Rich, Lady, 82–4, 93–5, 118, 180
Rich, Laurence, see Hilliard, Laurence (Nicholas's grand-daughter)
Richardson, Thomas (Hilliard's son-in-law), 107, 147
Ricroft, John (secret agent), 116; and see Moody, Michael
road-mending, see Laborer, William
Robinson, Christopher, 127
Ronsard, Pierre, 63–4
Rossi, Giambattista, 66
Rouen, 29, 35, 47, 71, 97, 114, 120, 138, 160, 184
Rupert, Prince, 171
Russell, Elizabeth (Maid of Honour), 157
Russell, John Lord (husband of Elizabeth Cooke), 156–7
Russell, Lady, see Cooke, Elizabeth
Russell, Nicasius (goldsmith) and family, 164–6, 180, 185, 189–90; and see wife, Johnson, Clara and grand-daughter, Grantham, Elizabeth
Russell, Sir William, 85–6
Rutland, Duke of, 67, 88
Rutland, Francis Manners, 6th Earl of, 87
Rutland, Roger Manners, 5th Earl of, 88, 142, 146
Rutlinger, John (engraver), 50–1, 52

Sackville, Richard, 3rd Earl of Dorset, see Dorset
St John of Bletsoe, Oliver, 1st Baron, 37, 56

Salisbury, 1st Earl of, *see* Cecil, Sir Robert

Savery, Abraham (recusant), **175–7**

Scaramelli, Giovanni Carlo, 63, 118

Scottish National Portrait Gallery, Edinburgh, 143

Segar, William, 114

Seymour, Edward *and* William, *see* Hertford, 1st *and* 2nd Earls of

Shakespeare, William, 47, 60, 64, 69, 71, 76, 87, 89–93 *passim*, 103, 112, 117, 147, 149, 157–8; on limning and limnings, 22, 24, 33, **95–6,** 125; at Court with Hilliard and Oliver, 92–3

Shoreditch, 127, 138–9

Shrewsbury, Countess of, *see* Bess of Hardwick

Shrewsbury, Gilbert Talbot, 7th Earl of, 114

Sidney, Sir Philip, 42, 47, 82, 83, 111–12, 134

Sidney, Sir Robert, 117, 127

Simier, Jean de, Baron de St Marc, 62

Sling, Richard, 145

Smith, Robert, 106

Smythe, William (Hilliard's apprentice), 57

Somerset, Countess of, *see* Howard, Frances

Somerset, Edward Seymour, Duke of, 29

Somerset, Robert Carr, Earl of, 146, 176–7

Sonoy, Colonel Diederik, **85–6,** 110–11, 113

Southampton, Henry Wriothesley, 3rd Earl of, 37, 95–6, 124, 137

South Pool, Devon, 104–5

Spenser, Edmund, 88–9

Stafford family, 27–8, 115–16

Stow, John, 31, 66–7, 79, 97, 102–3, 167

Streets and lanes, City of London: Bishopsgate, 71, 72, 102–3, 115; Cheapside and Westcheap, 31–2, 51, 53, 69, 70, 79, 103, 127, 153, 165, 166, 180, 185, *and see* Goldsmiths' Row *under* Goldsmiths' Company; Fleet Lane, 35, 72, 98–9 and Fleet Street, 140, 161, 186; Gutter Lane, 53, 70–1, 73, 107, 166–7, 180, *and see* 'Maidenhead, The'; Hosier Lane, 55, 168; Milk Street, 79, 108; Shoe Lane, 161; Warwick Lane, 161; Wood Street, 31, 53, 167

Strong, Sir Roy, 7, 20, 21, 30, 66, 87–9, 154, 193(n.11)

Stuart, Lady Arabella, 114–18 *passim*, 170, 175, 180

Stuart, Lord John, 188

Sturman family, 100, 111

sweet-briar, *see* eglantine

Syon House, 46, 163

'tablet', use of word, 22, 23

'Talbot, Sir Arundell', 111, 113, 114

Teerlinc, George, 20, 30

Teerlinc, Levina (limner), 20, 22, 30, 46, 58, 193(n.11); *and see* Benninck family

Thompson, Samuel (painter-stainer), 167–8

Thurland, Thomas, 54

Titian, 184

title-pages, engraved, 52–3

Totnes, Devon, 101–5 *passim*

Treatise concerning the Arte of Limning, A, *see under* HILLIARD, NICHOLAS

Tressell/Tressa, Charles (engraver), 52–3

Trumbull, William, 175

Turner, Anne, 176–7

Van Brounckhorst, Arthur (painter and lapidary), **55–7,** 197(n.5), 198(ns.9, 10)

Van der Doort, Abraham, 40, 114, 154, 171

Van Dyck, Sir Anthony, 139, 165–6

Van Zont, Adrian (painter), 72, 200(n.12)

vellum, use of, 22

Vertue, George, on Nicholas Hilliard, 29, 32–3, 57–8, 120, 142, 179; on Isaac Oliver, 71, 110, 113, 142, 154, 165,

Vertue, George – *contd.*
 173, 189, 190; on Peter Oliver, 184,
 186–7, 189; on Brandon Hilliard, 188
Victoria and Albert Museum, London, 7,
 24, 32, 40, 63, 66, 74, 86, 120, 142–3,
 169, 173, 183, 187
Vigenère, Blaise de, 64–5

Waad, Sir William, 121–2, 175
Walker Art Gallery, Liverpool, 128
Wall, John (Hilliard's maternal grand-
 father), 31
Wallace Collection, London, 121
Waller, Sir William, 109
Walpole, Horace, on Isaac Oliver, 71,
 110, 161; on Peter Oliver, 189; on
 Queen Elizabeth, 135, 136; on Oliver's
'Frances Howard', 113 and 204(n.7);
 on Samuel Cooper, 190
Walsingham, Sir Francis, 60, 62, 65, 74,
 77–8, 85–6, 93, 101, 108, 115, 132,
 133, 134
Warwick Castle, 88
Webster, John, 32, 168
Wheeler family, 165
White, John, 102
Whitney, Geffrey, 90
Winter, Carl, 66, 73, 183, 198(n.10)
Wood, Dean Owen, 126–7
Wood, Thomas (goldsmith), 31

Yale School of Music, 162, 210(n.6)
Yelverton, tithes of, 75–6
York House, 67–8